To Charlotte -
Per angusta ad augusta. Carpe diem, amor vincit omnia.

Acknowledgments

There are a number of people to thank for their support, guidance, and advice, and without whom this book would not be as road-tested, tried, and true as it is.

Charlotte Richardson, who pressed me to not write a "boring tome" that nobody would read. I believe I've achieved that goal. And Lindsay King, who does so much in my office. "Thank you" just doesn't begin to approach my appreciation for her efforts.

Cathleen Small and Mark Loundy were kind enough to reprise their roles as editor and technical editor, respectively, for this book. Their wise counsel made for a much more concise—and clear—read as I sought to turn the myriad thoughts, ideas, and scrawled notes into a cohesive tome that expands on the first. Thank you to both of you.

Jenika McDavitt, a Yale-trained psychologist who turned her passion for photography into her dream job, and author of the book *Psychology for Photographers*, who took the time to read and provide thoughtful feedback for the chapters on cognitive and subconscious thinking for photographers and wordsmithing a linguistically accurate lexicon.

The amazing duo of Jamie Rose and John Anderson at Momenta, who first asked whether there was going to be a chapter on working with NGOs—and then, when there was, offered their insights to make it better, as well as reading several other chapters.

Andrew Fingerman at PhotoShelter, who was kind enough to provide a few of the many, many people who are forgoing typical stock agency arrangements and licensing work themselves directly. And thanks go to those photographers, Dustin Ryan, Dan Herron, and Chris Daniels, for taking the time to share how making it on your own can be a successful endeavor.

William Briganti, Assistant Chief, Visual Arts and Recordation Division, Copyright Office at the Library of Congress, for taking a great deal of time walking step by step through the chapter on using the Electronic Copyright Office and providing valuable guidance that makes that chapter rock-solid. Chris Reed, Senior Advisor to the Registrar of Copyrights at the U.S. Copyright Office, also took the time to not only send me in the direction of William, but also offer his own insights and commentary on the chapter regarding image registries before departing for his dream job in Los Angeles.

Nick Crettier, William Foster, and Ralph Alswang, for lifting the veil on their own businesses for the chapter on business-to-consumer case studies, to provide insight into rates and their fluctuation between communities.

For the chapter on selling prints, Debra Weiss' counsel on correcting my mindset from thinking of "selling prints" and "fine art" as being related. She corrected me to consider that they are semi-related at best, which gave the chapter added perspective.

In working with a designer, Jessica Gladstone took the time out from her dual roles of creating beauty in design and teaching the next generation of designers, to read the chapter on working with a designer—and she wrote, in part, "I had very little to add," which suggested to me that I had it just right.

MORE Best Business Practices
for Photographers

John Harrington

Cengage Learning PTR

CENGAGE
Learning®

Professional • Technical • Reference

Australia • Brazil • Japan • Korea • Mexico • Singapore • Spain • United Kingdom • United States

MORE Best Business Practices for
Photographers
John Harrington

Publisher and General Manager,
Cengage Learning PTR:
Stacy L. Hiquet

Associate Director of Marketing:
Sarah Panella

Manager of Editorial Services:
Heather Talbot

Senior Marketing Manager:
Mark Hughes

Product Team Manager:
Kevin Harreld

Project/Copy Editor:
Cathleen D. Small

Technical Reviewer: Mark Loundy

Interior Layout: Jill Flores

Cover Designer: Mike Tanamachi

Indexer: Sharon Shock

Proofreader: Sue Boshers

For product information and technology assistance, contact us at
Cengage Learning Customer & Sales Support, 1-800-354-9706

For permission to use material from this text or product,
submit all requests online at **cengage.com/permissions**
Further permissions questions can be emailed to
permissionrequest@cengage.com

All trademarks are the property of their respective owners.

Cover photography of the United Airlines concourse at Chicago's O'Hare International
Airport, including Michael Hayden's SKYS THE LIMIT installation © 1990 John Har-
rington, All Rights Reserved. SKYS THE LIMIT artwork installation © 1987 Michael
Hayden, all rights reserved, used with permission. All other images © John Harrington
unless otherwise noted.

Library of Congress Control Number: 2014935360

ISBN-13: 978-1-305-09405-5

ISBN-10: 1-305-09405-0

Cengage Learning PTR
20 Channel Center Street
Boston, MA 02210
USA

Cengage Learning is a leading provider of customized learning solutions with office
locations around the globe, including Singapore, the United Kingdom, Australia, Mexico,
Brazil, and Japan. Locate your local office at: **international.cengage.com/region**

Cengage Learning products are represented in Canada by Nelson Education, Ltd. For your
lifelong learning solutions, visit **cengageptr.com**

Visit our corporate website at **cengage.com**

Printed in the United States of America
1 2 3 4 5 6 7 16 15 14

Although by this time I have several books under my belt, the art and commerce of producing coffee-table books (both as self-published projects and with third parties) has not yet presented itself to me, so Cameron Davidson, Karen Kuehn, and others provided insights based upon their own experiences, which made the chapter on publishing a book that much better.

The chapter on valuing video absolutely could not have risen to its current incarnation without the brilliant insights of so many people. Prior to the inception of this book as a follow-up to *Best Business Practices for Photographer*s, this chapter was to be its own white paper, with the idea for it germinating as early as 2010. Since then, I have had the good fortune to cross paths and forge friendships with a number of those I reached out to, all of whom thought it was a very important topic to cover. And I believe it is a cornerstone of this book. It was among the first chapters written because it had so many people whose wise counsel I was looking for to ensure that what was written was spot-on. William Foster was the first to take a pass at it, followed by Bethany Swain, Garrett Hubbard, and Pierre Kattar, all award-winning motion-producing journalists, who raised the chapter to a new level. Toby Marquez provided valuable insights as well. A call to longtime friend and colleague Vincent Laforet put the chapter squarely in the sights of Steven Poster, President of the International Cinematographers Guild, and that in turn had it being reviewed by Josh Siegel, whose many credits include his latest endeavor as line producer in *Any Day*. Josh deserves huge credit for beating on the chapter without mercy, for which I thanked him because it made the chapter that much better. With the chapter shaping up, it next went to Bill Frakes and Vincent Laforet, both of whom offered their wise counsel. Then it went off to Tom Kennedy, who offered comments and compliments. Corey Rich found time to offer feedback and suggestions, which helped shape it in its near-final form. Brian Storm, too, was gracious with his time, looking over it and offering comments. As the window was closing on the deadline for the entire book and this chapter was the last to be turned in, PF Bentley, a longtime friend whom I first met covering the Loma Prieta earthquake in San Francisco in 1989 and whom I have admired since, took the time to offer ideas and commentary that let me polish it into its final form—something I am really quite proud of.

Thanks to each of the many people who took the time on this chapter and all of the others. The book is that much better thanks to your ideas and suggestions.

About the Author

John Harrington, a Washington, DC–based professional photographer, has traveled the world from the Baltic region to the Caribbean, Eastern Europe, Mexico, and the United States. John was born and raised in the San Francisco Bay Area before moving to Washington, DC. A 2007 recipient of the United Nations' Leadership Award in the field of photography, Harrington's work has appeared in *Life, Time, Newsweek,* and *Rolling Stone,* and his commercial clients have included Coca-Cola, SiriusXM Satellite Radio, Lockheed Martin, and the National Geographic Society. His images from the Pentagon on September 11th, 2001, are a part of the permanent collection of the Smithsonian's National Museum of American History, and images from his efforts as a part of the team documenting the historic inauguration of Barack Obama in 2009 are also a part of that same Smithsonian collection.

John has produced three commissioned books for the Smithsonian, and the second edition of his book *Best Business Practices for Photographers* remains a bestseller. In the fall of 2010, a retrospective of John's first 20 years in the profession—*Photographs from the Edge of Reality*—revisited highlights of his career. John has lectured across the United States at events for the North American Nature Photography Association, the American Society of Media Photographers, the Advertising Photographers of America (now the American Photographic Artists), the Professional Photographers of America, and the National Press Photographers Association.

John concluded serving his second term as the president of the White House News Photographers Association in May of 2011. He currently sits on the boards of three professional photographic trade associations. He is ex officio as President Emeritus of the White House News Photographers Association and also serves as a national director on the board of the American Society of Media Photographers, as well as a national director on the board of the National Press Photographers Association.

Contents

Introduction

I have been pleasantly surprised to learn that this book's predecessor, *Best Business Practices for Photographers*, in its second edition, remains a bestseller on Amazon, even after being on the market a few years. It has also given me pleasant pause to learn that it has been picked up as required reading for many courses in photography schools around the country and has been translated into Chinese. In fact, as I was writing the last chapter of this book, I received an email from a professor on the East Coast asking for a review copy, as she is now teaching a class where it is the required book.

Often in the presentations I give, I work very hard to implore people to focus on the business aspects of photography. Usually, I talk about how Ansel Adams considered himself a commercial photographer, when so many photographers looked to him as a wanderlust photographer chasing the great American landscape. I figure that if people realized that those they look up to and admire as great photographers also considered themselves "in business" or focused on business, then perhaps they'll pay closer attention to their own business.

In the summer of 2013, U2's frontman, Bono, spoke to a crowd at Georgetown University in Washington, DC. Many in the world look to Bono as a man fighting for the downtrodden, suffering, and less fortunate. I have always been a fan of U2's music, and I have watched as Bono has entered the world stage with messages of hope as he became a statesman in his own right, using his celebrity to make a difference in people's lives. During his 2013 presentation, he spoke eloquently about how to support the people in developing countries. In speaking about foreign aid to suffering, he made a point that is easily extrapolated to the "starving artist" that lives hand-to-mouth while trying to eke out a living, often feeling as if accepting commercial work is "selling out to the man." Bono said, "[Financial] aid is just a stopgap... Commerce [and] entrepreneurial capitalism take more people out of poverty than aid."

Let me repeat that:

> "[Financial] aid is just a stopgap...commerce [and] entrepreneurial
> capitalism take more people out of poverty than aid."

My admiration for Bono just grew tenfold. He's right, of course. And so it is that one of the leaders of post-punk alternative rock bands yet again makes a prophetic statement.

Noah Bradley, in his 2013 blog post "Don't Go to Art School," writes that "graduates are woefully ill-prepared for the realities of being professional artists and racked with obscene amounts of debt. By their own estimation, the cost of a four-year education at RISD is $245,816. As way of comparison, the cost of a diploma from Harvard Law School is a mere $236,100"[1]

I would like to think that as more and more schools are requiring business classes as a core requirement, and the stories I hear from educators suggest that one of the requirements for a passing grade is to produce a viable business plan they can implement upon graduation, perhaps, just perhaps, the tide is changing.

[1]Source: http://www.medium.com/i-m-h-o/138c5efd45e9. RISD is the Rhode Island School of Design.

Author Eudora Welty gave this advice to other authors: "Write about what you don't know about what you know."

I submit that this book and its predecessor, *Best Business Practices for Photographers*, is a source for you to read about what you don't know about what you know.

You know, for example, that your work is valuable, and people should pay a price for the licensing of your work and for your time producing it. Yet as Warren Buffett famously said, "Price is what you pay, value is what you get." How do you parse that? Really comprehend it in a manner that not only makes sense to you, but also apply and live by that sentiment? Chapter 15 , "Price Is What You Pay, Value Is What You Get," will help you understand that.

When *Best Business Practices for Photographers* was first written in 2006, it was 352 pages, and for some reason with a more expansive second edition out, that first edition continues to sell. The second edition is 560 pages. Some suggested that I write a third edition; however, few of those best practices have changed. The ability to register your copyright with a CD of images and a form is still functional, but now there's an extensive and in-depth look at copyright and how to use the electronic copyright office to register your work, and there's a video tutorial online that even demonstrates that more.

While the camera models in *Best Business Practices for Photographers* have changed, many—if not most—of the messages of solid business practices are timeless. Thus, it just wasn't possible to add to the tome that is *Best Business Practices for Photographers*, and there wasn't really anything that I could see fit to take out at this time. Hence, *MORE Best Business Practices for Photographers* was born, a second volume to its predecessor.

It's possible to read just this book and garner a whole host of insights into the business of photography. Yet, even though there are references to *Best Business Practices for Photographers* and for completeness's sake I include excerpts from *Best Business Practices for Photographers* here, **this book is entirely new content**. I expect that if you haven't read *Best Business Practices for Photographers*, you will after reading this. And if you enjoyed *Best Business Practices for Photographers*, this one is written exactly the same.

For some time I have been looking to produce a white paper on the subject of pricing for video/motion work, and the chapter on that subject is, for all intents and purposes, that white paper—and could well have been its own book, at almost 50 pages. It is the chapter I spent the most time working on. It was among the first written, and it was then peer-reviewed over many months by friends and colleagues as they traveled around the world. Some read it midflight over the Atlantic, some while on sets, and some in the most remote regions of the world—such is the challenge of asking highly successful working professionals to review and comment on what you've written. I knew I had really arrived at the right point in that chapter's evolution when someone I hugely admire—someone who has commissioned, edited, and produced thousands of hours of motion content for the world stage and has been responsible for hundreds of millions of views—in what were brief comments, summarized his thoughts on that chapter by saying "the information is fantastic and hugely valuable, particularly for those making the migration from print/still work."

Yet there is so much more in this that will really accelerate what you learned from *Best Business Practices for Photographers* and take you new places. There's coverage of the Copyright Office's online submission process, to the new PLUS Registry, standards and ethics, price paid versus value received, considerations when producing a book, pricing your work as art, and even how to save money (and headaches) by converting to

an S-corp. Oh, and one of the chapters that I almost overlooked but that is so important is the one on how to work with nonprofits and non-governmental organizations (NGOs), and I am so excited to share that with you.

I often found time to write this book in the mornings, and near the end of this book I stumbled upon an article in *Entrepreneur* magazine that cited "12 Things Successful People Do Before Breakfast." Aside from waking up early, they "work on a top-priority business project" and "plan and strategize while they're fresh." Under the category of waking up early, this was a particular appropriate point: "Successful people know that time is a precious commodity. And while theirs is easily eaten up by phone calls, meetings, and sudden crises once they've gotten to the office, the morning hours are under their control. That's why many of them rise before the sun, squeezing out as much time as they can to do with as they please."[2] As someone who is likely self-employed, you may well find that you enjoy sleeping in and you don't have a boss to tell you that you can't. But that may be what's holding you back from your full potential. So, consider adjusting your schedule to rise by 6 a.m. instead.

It seems like not a day goes by that I don't field a phone call, an email, or an in-person question on the subjects covered in this book, and I'm happy to be available to people whenever I can, but I still do have a business to run, so sometimes those emails don't get answered or phone calls returned. Sitting in my inbox right now is an email inquiry from a colleague in Iowa looking for guidance and another email from a student in the United Kingdom trying to make a go of it. I'll pause here for a moment (you won't notice, dear reader) and try to help them. Okay, thanks for waiting—that was just over an hour, but it was time well spent.

I know, too, that this book is purely focused on business practices. Solid business practices are the cornerstone of a successful business, but not, per se, a successful personal life. A successful business may well support and make possible a successful personal life, but it is not the same. I am reminded, and I share it with you here, the sentiment that the Dalai Lama shared about what surprised him most about humanity.

> Man surprised me most about humanity. Because he sacrifices his health in order to make money. Then he sacrifices money to recuperate his health. And then he is so anxious about the future that he does not enjoy the present; the result being that he does not live in the present or the future; he lives as if he is never going to die, and then dies having never really lived.

It is my hope that this book diminishes your anxiety as you read about what you don't know about what you know, to paraphrase Eudora Welty, and that as you earn more per project and garner better clients who pay well—or, in the case of transitioning to motion, you know what to charge (and what's involved)—that you will be able to work less and live life more. Many people struggle or have jobs that are physically demanding and take their toll. Usually, these people are doing so for their families or friends, selflessly. Retirement income is largely necessary because (for the most part) our lifespan is longer than our workable years, and thus it is necessary to work so that you can set that money aside and not be a burden to the family or society. Striking the balance between working to live and feeling obligated to work (or overwork) is a challenge.

I am a firm believer in the notion that a rising tide raises all ships. Help your fellow photographer out, and whenever you can, pay it forward.

[2]Source: Goudreau, Jenna. *Entrepreneur* magazine. January 27, 2014.

Chapter 1
Sole Proprietor versus LLC/LLP versus S Corp

There are a variety of different types of entities under which you can conduct business, and not all of them carry the same benefit. This chapter discusses the several different types of business entities and provides examples of how they would apply to you.

You may have reasons for wanting to become a C corporation; however, for what almost every photographer reading this book needs, a C Corp isn't the best choice. A C corporation is taxed separately from an S corporation, whereas the profit from the S corporation is treated as income on your personal tax return. C corporations are typically reserved for major corporations. It's not about whether there are multiple shareholders, but rather about whether you want the corporation to be taxed separately. While I won't definitively tell you that you shouldn't be a C corporation (only a tax advisor with your specific financials can do that), I will tell you that more than likely you'll want to be a S corporation instead. So, we'll focus on the pros and cons of the other options.

Sole Proprietor

Many of you are likely sole proprietors, which means that you're reporting your income, losses, and expenses on Schedule C of your federal tax return. A Schedule C is a functional tool to do this; however, few tax- or liability-limiting strategies are involved.

One major issue in being a sole proprietor is liability. If you're a sole proprietor, there is no differentiation between you and your company when it comes to liability. So if, during the course of a photo shoot, someone gets injured or property gets damaged, when you get sued the lawsuit will name you personally, and if you lose you'll have to drain your personal bank accounts and then sell off your assets (cars, camera gear, and so on) and, yes, your house. This is yet one more reason to carry liability insurance for the business, but once you reach the limits of that insurance policy—for example, if it's a policy with a $100,000 limit, and you lose a lawsuit demanding $1,000,000—the rest of what is owed will come from you personally.

For more than 20 years, I was a sole proprietor. Ignorance was bliss until I got audited. As I extensively laid out in *Best Business Practices for Photographers* (Cengage Learning PTR, 2009), I suffered through the audit and came out the other side not owing the IRS an additional penny. However, as a result, I consulted with my accountant and asked what we could do to minimize the likelihood that I would have to undergo another audit. As I outlined in *Best Business Practices for Photographers*, statistics show that the likelihood of an audit for a corporation is a small fraction of the likelihood of an audit for a sole proprietor—and further,

that an LLC/LLP has the same audit risk as a sole proprietor. The choice was clear: An S corporation would limit the likelihood of having to repeat that experience.

If you transitioned from another career into photography, you probably made a thoughtful and learned transition, consulted with a lawyer and an accountant who helped you draft all of the documents to properly form your business, and so on. If you became a full-time freelance photographer because you were laid off; or you started freelancing slowly, right out of college; or you were making pictures as a growing side business to supplement your full-time non-photography job, then when you got to the end of the first year and realized you had income and a large tax liability, you likely had to scramble to find expenses to help reduce your profits (as you rightfully should). To avoid that issue, while a sole proprietorship is a default business entity, others exist that are much better.

LLP/LLC

LLPs (limited liability partnerships) and LLCs (limited liability corporations) have similar features. In an LLP, typically more than one person owns the company, and the owners want to limit their liability and formally define who owns what portion of the company and the responsibilities (if any) of those with an equity stake in the company. If you are a single-owner LLC, you will be taxed just like you were when you were a sole proprietor, reporting your expenses on the same Schedule C and paying taxes in the same way as before. If, however, you have a partner or partners, then an LLC is handled the same as an LLP. As an LLC owner, you're viewed by the IRS as self-employed, so the tax benefits are not as great as those of the S Corp (outlined later in this chapter).

A significant aspect of an LLC/LLP is embodied in the name—a "limited liability," where in the event of a lawsuit by a client, a vendor, or anyone else, the business's liability is not intertwined with your personal life. So, if someone gets injured on a photo shoot, the liability is limited, and there are far fewer ways that the person who filed the lawsuit could force you to sell your house to pay the debt of a legal judgment against the business.

The Small Business Administration defines an LLC as follows:

> A limited liability company is a hybrid type of legal structure that provides the limited liability features of a corporation and the tax efficiencies and operational flexibility of a partnership.

> The "owners" of an LLC are referred to as "members." Depending on the state, the members can consist of a single individual (one owner), two or more individuals, corporations or other LLCs.

> Unlike shareholders in a corporation, LLCs are not taxed as a separate business entity. Instead, all profits and losses are "passed through" the business to each member of the LLC. LLC members report profits and losses on their personal federal tax returns, just like the owners of a partnership would.

> In the eyes of the federal government, an LLC is not a separate tax entity, so the business itself is not taxed. Instead, all federal income taxes are passed on to the LLC's members and are paid through their personal income tax. While the federal government does not tax income on an LLC, some states do, so check with your state's income tax agency.

Since the federal government does not recognize LLC as a business entity for taxation purposes, all LLCs must file as a corporation, partnership, or sole proprietorship tax return. Certain LLCs are automatically classified and taxed as a corporation by federal tax law. For guidelines about how to classify an LLC, visit IRS.gov.

LLCs that are not automatically classified as a corporation can choose their business entity classification. To elect a classification, an LLC must file Form 8832. This form is also used if an LLC wishes to change its classification status. Read more about filing as a corporation or partnership and filing as a single member LLC at IRS.gov.

You should file the following tax forms depending on your classification:

- Single Member LLC. A single-member LLC files Form 1040 Schedule C like a sole proprietor.
- Partners in an LLC. Partners in an LLC file a Form 1065 partnership tax return like owners in a traditional partnership.
- LLC filing as a Corporation. An LLC designated as a corporation files Form 1120, the corporation income tax return.

The IRS guide to Limited Liability Companies provides all relevant tax forms and additional information regarding their purpose and use.[1]

S Corporation

When a corporation earns a profit of $50,000, for example, and you own the entire corporation, not only would the corporation pay corporate income taxes on the profit, but also you, as the shareholder, would pay taxes (again) on the $50,000 profit, because that income is considered a dividend. As such, you would be paying taxes twice on the same money—also called *double taxation*. Obviously, you want to avoid this.

In addition, consider this: Suppose your gross income in a sole proprietorship is $100,000. After reporting expenses on Schedule C of your federal tax return, you have a profit of $50,000. You'll pay:

$50,000 – $17,500 (28% federal tax) – $7,500 (15% Social Security/self-employment tax) – $3,500 (7% state tax[2]) = $25,000 (your after-tax income)

In other words, you will have paid $25,000 (or 50 percent) in combined taxes to the government.

Under an S Corp designation, consider the same gross income of $100,000 as in the sole proprietorship. After you report the same $50,000 in expenses, you can add in payments for your employees' Social Security and Medicare as expenses (even if your sole employee is you), thus reducing the corporation's profits. Using the same figure above, with a base of $50,000 you can add in $7,500 in additional expenses. So, the calculation for an S Corp looks like this:

[1]Source: http://www.sba.gov/content/limited-liability-company-llc.

[2]Some states tax you less than 7 percent, and some tax you more. Some regions have county or other taxes. Some have personal property taxes instead. While your state taxes may not be 7 percent, you're likely paying a different tax in your state that's comparable. However, some states offer serious tax advantages because there's no state income tax. Consider yourself fortunate if you live in Alaska, Florida, Nevada, South Dakota, Texas, Washington, or Wyoming. Or, if you live in Tennessee or New Hampshire, which tax only your dividend and interest income.

$42,500 – $11,900 (28% federal tax) – $2,975 (7% state tax) = $27,625 (your after-tax income)

As such, the difference between an after-tax income of $25,000 and of $27,625 is a 10.5 percent increase in what's in your pocket. In other words, the corporation is paying for your Social Security and Medicare, and it's doing so as an expense of the business. Of course, this is an oversimplification of taxes and tax rates, but it effectively illustrates one of the tax benefits of being an S Corp, even at modest income levels.

An S corporation starts as an LLC and then elects S Corp status with the IRS. The IRS reports that approximately 70 percent of corporations have elected to file as an S corporation. While some of the corporations filing are LLCs (like John Harrington Photography) that elect to be an S corporation for tax purposes, filing IRS Form 2553, some are plain corporations that then elect S corporation status. According to an October 15, 2013, article in *Forbes*:

> [B]usinesses concerned about company liability issues are often being advised to form as an LLC, not as a regular corporation (otherwise known as C Corp). It's suggested that this business form offers superior asset protection.[3]

From the IRS website on S corporations:

> S corporations are corporations that elect to pass corporate income, losses, deductions, and credits through to their shareholders for federal tax purposes. Shareholders of S corporations report the flow-through of income and losses on their personal tax returns and are assessed tax at their individual income tax rates. This allows S corporations to avoid double taxation on the corporate income. S corporations are responsible for tax on certain built-in gains and passive income at the entity level.
>
> To qualify for S corporation status, the corporation must meet the following requirements:
>
> - Be a domestic corporation
> - Have only allowable shareholders
> - including individuals, certain trusts, and estates and
> - may not include partnerships, corporations or non-resident alien shareholders
> - Have no more than 100 shareholders
> - Have only one class of stock
> - Not be an ineligible corporation (i.e. certain financial institutions, insurance companies, and domestic international sales corporations).
>
> In order to become an S corporation, the corporation must submit Form 2553 Election by a Small Business Corporation signed by all the shareholders. See the instructions for Form 2553 for all required information and to determine where to file the form.[4]

You'll need an attorney who is familiar with filing articles of incorporation in your state—and you can be all but certain that your accountant will have someone he or she recommends. In my case, the referral from my accountant to the attorney who set up my S Corp saved me $200, and the entire fee paid to the attorney was $750. Of course, every attorney charges differently, and I had to pay a $175 filing fee to the state to file the articles of incorporation.

[3]Source: http://www.forbes.com/sites/steveparrish/2013/10/15/death-of-the-s-corp-as-a-tax-election/

[4]Source: http://www.irs.gov/Businesses/Small-Businesses-%26-Self-Employed/S-Corporations.

One extra responsibility that came about was that I had to start paying myself as an employee. At first, the idea of doing this seemed daunting—this from someone who had already been in business for 20 years! However, with a little research I found some very inexpensive payroll services that do just that. For about $50 a month, I sent them the details on my corporate bank account and my personal bank account. Then, here's how the exchange went for me and two other employees:

> **Payroll Company (PC):** Hi, this is Annette from your payroll company, I'm calling to process payroll.

> **Me:** Okay, pay me $5,000 this month, pay the office manager $4,000 this month, and pay the post-production manager $3,000 this month.

> **PC:** Okay, your payroll will be processed on the 30th. Have a nice day.

> **Me:** Okay, thank you.

Alternatively, I have gotten emails from them:

> From: Robinson, Annette
> Subject: Payroll for 7897
> Date: April 22, 2014 1:16:17 PM EST
> To: John Harrington

> I am ready to process payroll.

> Have a great day!

> Annette

My emailed response is:

> From: John Harrington
> Subject: Payroll for 7897
> Date: April 23, 2014 2:11:46 PM EST
> To: Robinson, Annette

> Please process:

> Me: $5,000
> Office manager: $4,000
> Post-production manager: $3,000

> Thank you,

> John

I then get an emailed response from Annette saying, "Your payroll has been processed," and that's that.

A few days later, I receive an envelope with the details about the amount withdrawn from my business account, how much was paid on my behalf to the IRS, and how much was paid to the state, Medicare, and Social Security. There are no more quarterly payments that are the responsibility of the sole proprietor, and at the end of the year the payroll company sends me (as the head of the corporation) all the end-of-year tax paperwork I need and a W-2 for me as an employee.

Keep in mind that as an employee, you're legally an employee, so your ability to take money out of the company is limited. This is why you have to pay yourself through payroll. Drawing money from the company as you may have as a sole proprietor could cause you to incur tax penalties. If you need or want to take money out, you must do so via payroll. All you need to do is increase your payroll one month, and not only will you get the money, you will receive it less any taxes you owed. At the end of the year, you can give yourself a bonus, which is also taxed differently, benefitting you and not the IRS.

In the end, transforming into an S corporation is one of the smartest business decisions you can make. However, you should do it properly; getting your accountant's advice and having a lawyer do it for you is your best choice.

In an effort to illustrate (and demystify) the process, the following pages contain the bylaws and articles of incorporation for my business, John Harrington Photography, Inc. Following those documents, I've included the documents that are on file with my state. I hope this demystifies things so that when someone says, "Well, you have to form articles of incorporation, define your organizations' bylaws, and then file those with the state," you see that it's not as complicated as it sounds.

One last point: When I went to the bank to open my corporate bank account, the financial institution looked up my corporate records in the state's database to confirm the details of my corporate status. Also, you shouldn't receive 1099s from companies anymore, as corporations don't get 1099s.

BYLAWS OF

JOHN HARRINGTON PHOTOGRAPHY, LLC
(A Close Corporation)

ARTICLE I

Stockholders

SECTION 1. **Annual Meeting**. The annual meeting of the stockholders of the Corporation shall be held on a day duly designated by the stockholders within thirty-one (31) days after the close of the fiscal year of the Corporation, if not a legal holiday, and if a legal holiday, then the next succeeding day not a legal holiday, for the transaction of such corporate business as may come before the meeting.

SECTION 2. **Special Meetings**. Special meetings of the stockholders may be called at any time for any purpose or purposes upon the request in writing to the President of the holders of a majority of all the shares outstanding and entitled to vote on the business to be transacted at such meeting. Such request shall state the purpose or purposes of the meeting. Business transacted at all special meetings of stockholders shall be confined to the purpose or purposes stated in the notice of the meeting.

SECTION 3. **Place of Holding Meetings**. All meetings of the stockholders shall be held at the principal office of the Corporation or elsewhere in the United States as may be designated by the stockholders.

SECTION 4. **Notice of Meeting**. Written notice of each meeting of the stockholders shall be mailed, postage prepaid by the Secretary to each stockholder of record entitled to vote upon the books at his or her post office address, as it appears upon the books of the Corporation, at least ten (10) days before the meeting. Each such notice shall state the place, day and hour at which the meeting is to be held, and in the case of any special meeting, shall state the purpose or purposes thereof.

SECTION 5. **Quorum**. The presence in person or by proxy of the holders of record of sixty percent (60%) of the shares of the capital stock of the corporation issued and outstanding and entitled to vote thereat shall constitute a quorum at all meetings of the stockholders. If less than a quorum shall be in attendance at the time for which the meeting shall have been called, the meeting may be adjourned from time to time by a majority vote of the stockholders present or represented, without any notice other than by announcement at the meeting, until a quorum shall attend. At any adjourned meeting at which a quorum shall attend, any business may be transacted which might have been transacted if the meeting had been held as originally called.

SECTION 6. Conduct of Meetings. Meetings of stockholders shall be presided over by the President of the Corporation, or if he or she is not present, by a Vice-President, or if neither of said officers is present, by a chairman to be elected at the meeting. The Secretary of the corporation shall act as secretary of such meeting, or the presiding officer may appoint a person to act as secretary of the meeting.

SECTION 7. Voting. At all meetings of stockholders, every stockholder entitled to vote thereat shall have one (1) vote for each share of stock standing in his or her name on the books of the Corporation on the date for the determination of stockholders entitled to vote at such meeting. Such vote may be either in person or by proxy appointed by an instrument in writing, subscribed by such stockholder or his or her duly authorized attorney, bearing a date not more than three (3) months prior to said meeting, unless said instrument provides for a longer period. Such proxy shall be dated, but need not be sealed, witnessed or acknowledged. All elections shall be had and all questions shall be determined by a majority of the votes cast at a duly constituted meeting. Notwithstanding the above, a share shall not be entitled to be voted if any installment payable on it is overdue and unpaid. Upon the request of the holders of ten percent (10%) of the stock entitled to vote on such election or matter, such vote shall be taken by a ballot to be recorded and retained with the minutes of that meeting.

SECTION 8. Informal Action. Any resolution in writing, signed by all of the stockholders entitled to vote thereon, shall be and constitute action by such stockholders to the effect therein expressed, with the same force and effect as if the same had been duly passed by unanimous vote at a duly called meeting of stockholders and such resolution so signed shall be inserted in the minute book of the Corporation under its proper date along with a written waiver of any right to dissent signed by each stockholder entitled to notice of the meeting.

SECTION 9. Right to Inspection. Any stockholder, or his or her agent, may during usual business hours, and at the Corporation's principal office, or elsewhere as may be designated by the Corporation, inspect the Bylaws, minutes of stockholders' meetings, annual statement of financial affairs, tax returns and voting trust agreements on file at the Corporation's principal office. Upon representation by a stockholder, to any officer or resident agent, of a written request for a statement showing all stock issued within the previous twelve (12) month period immediately prior to the date of the request, the Corporation shall, within twenty (20) days from the date of such request prepare and have at its principal office a sworn statement of its President, Vice-President or Treasurer, stating the shares of securities so issued, consideration received per share and the value of consideration other than money as set in any resolution. Any one or more stockholders holding five percent (5%) of the outstanding shares of any class of stock of the Corporation may, in person or by agent, upon written request delivered to any officer of the Corporation, inspect and copy during usual business hours the Corporation's books of account, financial records

and its stock ledger, and may request from any officer in writing, a statement of the financial affairs and condition of the Corporation. Within twenty (20) days from the date of such request, the Corporation shall prepare such a statement of the financial affairs and condition of Corporation, verified under oath by its President or Treasurer, showing in reasonable detail the Corporation's assets and liabilities as of a reasonably current date.

ARTICLE II

Board of Directors

The Corporation shall have no Board of Directors. Instead, the assets and business of the Corporation shall be managed by the Stockholders of the Corporation.

ARTICLE III

Officers

SECTION 1. <u>Election and Tenure</u>. The officers of the Corporation shall be a President, a Vice-President, a Secretary and a Treasurer, and such other officers, including one or more other Vice-Presidents as the Board of Directors from time to time may consider necessary for the proper conduct of the business of the Corporation. An individual who holds more than one office in the Corporation may act in more than one capacity to execute, acknowledge or verify any instrument required to be executed, acknowledged or verified by more than one officer.

In the event that any office other than an office required by law shall not be filled or, once filled, subsequently becomes vacant, then such office and all references thereto in these Bylaws shall be deemed inoperative, unless and until such office is filled in accordance with the provisions of these Bylaws.

Except where otherwise expressly provided in a contract duly authorized by the Corporation, all officers and agents of the Corporation shall be subject to removal at any time by the affirmative vote, of a majority of the Stockholders entitled to vote, and all officers, agents and employees of the Corporation shall hold office at the discretion of the Stockholders or of the officers appointing them.

SECTION 2. <u>Powers and Duties of the President</u>. The President shall be the chief executive officer of the Corporation and shall have general charge and control of all its business affairs and properties. He or she shall preside at all meetings of the stockholders. The President may sign and execute all authorized bonds, contracts or other obligations in the name of the Corporation. He or she shall have the general powers and duties of supervision and management usually vested in the office of president of a corporation.

SECTION 3. <u>Powers And Duties Of The Vice-President</u>. At the request of the President or in his absence or during his inability to act, the Vice-President shall perform the duties and exercise the functions of the President, and when so acting shall have the powers of the President. The Vice-President shall have such other powers and perform such other duties, and have such additional descriptive designations in their title as may be assigned by the President.

SECTION 4. <u>Duties of the Secretary</u>. The Secretary shall give, or cause to be given, notice of all meetings of stockholders and all other notices required by law or by these Bylaws, and in case of his or her absence, disability, refusal or neglect to do so, any such notice may be given by any person directed to do so by the President, or by the stockholders upon whose written request the meeting is called as provided in these Bylaws. The Secretary shall record all the proceedings of the meetings of the stockholders in the form assigned to him or her by the stockholders or the President. He or she shall have custody of the seal of the Corporation, should such a seal be authorized, and shall affix the same. In general, the Secretary shall perform all the duties generally incident to the office of Secretary of a corporation, subject to the control of the stockholders and the President.

SECTION 5. <u>Duties of the Treasurer</u>. The Treasurer shall have custody of all the funds and securities of the Corporation, and he or she shall keep full and accurate account of receipts and disbursements in books belonging to the Corporation. He or she shall deposit all monies and other valuables in the name and to the credit of the Corporation in such depository or depositories as may be designated by the stockholders. The Treasurer shall disburse the funds of the Corporation as may be ordered by the stockholders taking proper vouchers for such disbursements. He or she shall render to the President and the stockholders whenever either of them so requests, an account of all his transactions as Treasurer and of the financial condition of the Corporation. The Treasurer shall also perform all other duties generally incident to the office of Treasurer of a corporation, subject to the control of the stockholders and the President.

<div align="center">

ARTICLE IV

<u>Capital Stock</u>

</div>

SECTION 1. <u>Issuance of Certificates of Stock</u>. The certificates for shares of the stock of the Corporation shall be of such form as shall be approved by the stockholders. All certificates shall be signed by the President or by the Vice-President and countersigned by the Secretary. All certificates for each class of stock shall be consecutively numbered. The name of the person or persons owning the shares issued and the address of the holder or holders shall be entered in the Corporation's books. All stock certificates surrendered to the Corporation for transfer shall be cancelled and no new certificates representing the same shares of stock shall be issued until the former

certificate or certificates for the same number of shares shall have been so surrendered and cancelled, unless a certificate of stock shall be lost or destroyed, in which event another certificate may be issued in its stead upon proof of such loss or destruction in the form of an affidavit made by the owner of such stock, setting forth the circumstances of the loss or destruction of the stock certificate.

SECTION 2. <u>**Transfer of Shares**</u>. Shares of the capital stock of the Corporation shall be transferred on books of the Corporation only by the holder thereof in person or by his attorney upon surrender and cancellation of certificates for the number of shares being transferred.

SECTION 3. <u>**Registered Stockholders**</u>. The Corporation shall be entitled to treat the holder of record of any share or shares of stock as the holder in fact thereof, and accordingly shall not be bound to recognize any equitable or other claim to or interest in such share or shares in the name of any other person, whether or not it shall have express or other notice thereof, save as expressly provided by the laws of the State of Maryland.

SECTION 4. <u>**Closing Transfer Books**</u>. The stockholders may fix the time, not to exceed ten (10) days preceding the date of any meeting of stockholders or any dividend payment date or any date for the allotment of rights, during which time the books of the Corporation shall be closed against transfer of stock, or, in lieu thereof, the stockholders may fix a date not exceeding ten (10) days preceding the date of any meeting of stockholders or any dividend payment date for the determination of allotment or rights, as a record date for the determination of the stockholders entitled to notice of and to vote at such meeting, or to receive such dividends or rights as the case may be; and only stockholders of record on such date shall be entitled to notice of and to vote at such meeting to receive such dividends or rights as the case may be.

<div align="center">

ARTICLE V

<u>**Corporate Seal**</u>

</div>

SECTION 1. <u>**Seal**</u>. In the event that the stockholders or the President shall direct the Secretary to obtain a corporate seal, the corporate seal shall be circular in form and shall have inscribed thereon the name of the Corporation, the year of its organization and the words "State Of Maryland".

ARTICLE VI

Bank Accounts and Loans

SECTION 1. Bank Accounts. Such officers or agents of the Corporation as from time to time shall be designated by the stockholders shall have authority to deposit any funds of the Corporation in such banks or trust companies as shall from time to time be designated by the stockholders and such officers or agents as from time to time shall be authorized by the stockholders to withdraw any or all of the funds of the Corporation so deposited in any bank or trust company, upon checks, drafts or other instruments or orders for the payment of money, drawn against the account or in the name or on behalf of the Corporation, and made or signed by such officers or agents; and each bank or trust company with which funds of the Corporation are so deposited is authorized to accept, honor, cash and pay, without limit as to amount, all checks, drafts or other instruments or orders for the payment of money, when drawn, made or signed by officers or agents so designated by the stockholders until written notice of the revocation of the authority of such officers or agents by the stockholders shall have been received by such bank or trust company. There shall from time to time be certified to the banks or trust companies in which funds or agents of the Corporation so authorized to draw against the same. In the event that the stockholders shall fail to designate the person or persons by whom checks, drafts and other instruments or orders for the payment of money shall be signed, as hereinabove provided in this Section, all of such checks, drafts and other instruments or orders for the payment of money may be signed by either the President, a Vice-President, the Secretary or the Treasurer of the Corporation.

SECTION 2. Loans. Such officers or agents of the Corporation as from time to time shall be designated by the stockholders shall have authority to effect loans, advances or other forms of credit at any time or times for the Corporation from such banks, trust companies, institutions, corporations, firms or persons as the stockholders shall from time to time designate, and as security for the repayment of such loans, advances or other forms of credit to assign, transfer, endorse and deliver, either originally or in addition or substitution, any or all stocks, bonds, rights and interests of any kind in or to stocks or bonds, certificates of such rights or interests, deposits, accounts, documents covering merchandise, bills and accounts receivable and other commercial paper and evidences of debt at any time held by the Corporation; and for such loans, advances or other forms of credit to make, execute and deliver one or more notes, acceptances or written obligations of the Corporation on such terms, and with such provisions as to the security or sale or disposition thereof as such officers or agents shall deem proper; and also to sell to, or discount or rediscount with, such banks, trust companies, institutions, corporations, firms or persons any and all commercial paper, bills receivable, acceptances and other instruments and evidences of debt at any time held by the Corporation, and to that end to endorse, transfer and deliver the same. There shall from time to time be certified to each bank, trust company, institution,

corporation, firm or person so designated the signatures of the officers or agents so authorized; and each such bank, trust company, institution, corporation, firm or person may rely upon such certification until written notice of the revocation by the stockholders of the authority of such officers institution, corporation, firm or person.

ARTICLE VII

Miscellaneous Provisions

SECTION 1. <u>Fiscal Year</u>. The fiscal year of the Corporation shall end on the last day of December, unless the stockholders shall fix some other date as the end of the Corporation's fiscal year.

SECTION 2. <u>Notices</u>. Whenever, under the provisions of these bylaws, notice is required to be given to any officer or stockholder, it shall not be construed to mean personal notice, but such notice shall be given in writing, by mail, envelope, addressed to such stockholder or officer at the address as appears on the books of the Corporation; and such notice shall be deemed to be given at the time the same shall be thus mailed. Any stockholder or officer may waive any notice required to be given under these bylaws by executing a written waiver of his or her right to receive such notice.

ARTICLE VIII

Amendment to Bylaws

SECTION 1. <u>Amendment</u>. The stockholders shall have the power and authority to amend, alter or repeal these Bylaws or any provision thereof, and may from time to time make additional bylaws.

JOHN HARRINGTON PHOTOGRAPHY, LLC
(A Close Corporation)

Unanimous Consent in Lieu of
Organizational Meeting
of Stockholders

The undersigned, constituting all of the stockholders of **JOHN HARRINGTON PHOTOGRAPHY, LLC**, a Maryland corporation (hereinafter referred to as the "Corporation"), in accordance with the provisions of Section 2-505(1) of the Corporations and Associations Article of the Annotated Code of Maryland, do hereby consent to and adopt the following Resolutions:

ARTICLES OF INCORPORATION

RESOLVED: That the Articles of Incorporation of this Corporation, filed with and accepted by the State of Maryland Department of Assessments and Taxation on the _____ day of _____ 2011, a copy of which is attached hereto as Appendix A, be, and the same are hereby approved and accepted.

BYLAWS

RESOLVED: That the Bylaws attached hereto as Appendix B, be, and the same are hereby adopted and declared to be the Bylaws of the Corporation.

OFFICERS

RESOLVED: That the following persons be, and they hereby are elected as officers of the Corporation, in the respective capacity set forth next to their respective names, the term of office of each person to be until the first annual meeting of the Shareholders, or until their respective successors shall be elected and qualify:

President :	JOHN H. HARRINGTON
Vice President:	JOHN H. HARRINGTON
Secretary:	JOHN H. HARRINGTON
Treasurer:	JOHN H. HARRINGTON

ISSUANCE OF STOCK

RESOLVED: That the proper officer or officers of the Corporation be, and they are hereby authorized to issue stock certificates for a total of ONE THOUSAND (1000) shares of the common stock of the Corporation, to the following named individuals in the amounts set forth opposite their respective name:

JOHN H. HARRINGTON 1,000 Shares

CORPORATE SEAL

RESOLVED: That in the event the stockholders or the President of the Corporation deem it necessary or advisable to obtain a corporate seal, the corporate seal shall be circular in form and shall have inscribed thereon the name of the Corporation and the year of its incorporation.

RATIFICATION OF PRE-INCORPORATION CONTRACTS

RESOLVED: That any and all actions taken, or contracts entered into heretofore by any incorporator or officer of the Corporation, either as an incorporator or as an officer, as well as any and all actions taken or contracts entered into by said persons as individuals acting for or in the name of the Corporation, be, and the same hereby ratified, approved and confirmed by the Corporation; and all such contracts hereby are adopted as though said individual has at such time as the contract was entered into, full power and authority to do so an act for or on behalf of the Corporation, and as if each and every act had been done pursuant to the specific authorization of the Corporation.

PAYMENT OF COSTS OF INCORPORATING

RESOLVED: That the President be, and hereby is authorized and directed to pay all fees, costs and expenses necessary for and incidental to the organization and qualification of the Corporation, including all legal and accounting fees and filing costs.

ANNUAL MEETING

RESOLVED: That the annual meeting of the stockholders of the Corporation shall be held on a day duly designated by the stockholders for the transaction of such corporate business as may come before the meeting. All meetings of stockholders shall be held at the principal office of the Corporation or elsewhere in the United States as may be designated by the stockholders.

FISCAL YEAR

RESOLVED: That the fiscal year of the Corporation shall be from January 1 to December 31, or such other period as may be determined by the Corporation.

STOCK RECORDS

RESOLVED: That the proper Officer of the Corporation shall cause to be prepared appropriate books and records with respect to the capital stock of the Corporation in which shall be recorded, among other things, the names and addresses of the stockholders and the number of shares held by each such stockholder.

LOANS

RESOLVED: That the Corporation be and is hereby authorized to accept loans from any of its stockholders and officers from time to time, should said loans be deemed to be necessary or desirable to the conduct of the business of the Corporation, provided that such loans be entered and carried as such on the books and records of the Corporation, including a record of repayment, and that the Corporation pay simple interest on each such loan at the then prevailing rate of interest, and that such loans from any of its stockholders, to the extent possible, shall have priority over any other loans which are repaid. The Corporation is hereby further authorized to make loans to any subsidiary and/or other entity in which the Corporation may have an interest.

RESOLVED: Such officers or agents of the Corporation as from time to time shall be designated by the stockholders shall have authority to effect loans, advances or other forms of credit at any time or times for the Corporation from such banks, trust companies, institutions, corporations, firms or persons as the stockholders shall from time to time designate, and as security for the repayment of such loans, advances or other forms of credit to assign, transfer, endorse and deliver, either originally or in addition or substitution, any or all stocks, bonds, rights and interests of any kind in or to stocks or bonds, certificates of such rights or interests, deposits, accounts, documents covering merchandise, bills and accounts receivable and other commercial paper and evidences of debt at any time held by the Corporation; and for such loans, advances or other forms of credit to make, execute and deliver one or more notes, acceptances or written obligations of the Corporation on such terms, and with such provisions as to the security or sale or disposition thereof as such officers or agents shall deem proper; and also to sell to, or discount or rediscount with, such banks, trust companies, institutions, corporations, firms or persons any and all commercial paper, bills receivable, acceptances and other instruments and evidences of debt at any time held by the Corporation, and to that end to endorse, transfer and

deliver the same. There shall from time to time be certified to each bank, trust company, institution, corporation, firm or person so designated the signatures of the officers or agents so authorized; and each such bank, trust company, institution, corporation, firm or person may rely upon such certification until written notice of the revocation by the stockholders of the authority of such officers institution, corporation, firm or person. Notwithstanding the foregoing, no loans, advances or other forms of credit for
the Corporation shall be valid or authorized unless evidenced in a written document that is executed by both of the Co-Presidents.

REIMBURSEMENT OF EXPENSES OF OFFICERS

RESOLVED: That the Officers of the Corporation shall be reimbursed for reasonable business expenses, including but not limited to entertainment, auto, travel, parking and meals, provided the Officer maintains and provides adequate records thereof to substantiate such expenses.

The foregoing Resolutions adopted upon unanimous consent are signed this _____ day of _____, 2011.

JOHN H. HARRINGTON

Entity Name: JOHN HARRINGTON PHOTOGRAPHY, INC.
Dept ID #: D14140065

General Information **Amendments Personal Property Certificate of Status**

Principal Office (Current):	2407 ECCLESTON ST. SILVER SPRING, MD 20902
Resident Agent (Current):	JOHN H. HARRINGTON 2407 ECCLESTON ST. SILVER SPRING, MD 20902
Status:	**INCORPORATED**
Good Standing:	Yes What does it mean when a business is not in good standing or forfeited?
Business Code:	Ordinary Business - Stock
Date of Formation or Registration:	05/26/2011
State of Formation:	MD
Stock/Nonstock:	Stock
Close/Not Close:	Close

Link Definition

General Information	General information about this entity
Amendments	Original and subsequent documents filed
Personal Property	Personal Property Return Filing Information and Property Assessments
Certificate of Status	Get a Certificate of Good Standing for this entity

CORPORATE CHARTER APPROVAL SHEET
EXPEDITED SERVICE ** KEEP WITH DOCUMENT **

DOCUMENT CODE _02_ BUSINESS CODE _03_

\# _____

Close _____✓_____ Stock _____✓_____ Nonstock _____

P.A. _____ Religious _____

Merging (Transferor) _____

Surviving (Transferee) _____

```
1000362001811902
```

ID # D14140065 ACK # 1000362001811902
PAGES: 0004
JOHN HARRINGTON PHOTOGRAPHY, INC.

 MAIL
 BACK

05/26/2011 AT 10:46 A WO # 0003813845

New Name _____

FEES REMITTED

Base Fee:	_100_
Org. & Cap. Fee:	_20_
Expedite Fee:	_50_
Penalty:	
State Recordation Tax:	
State Transfer Tax:	
Certified Copies	
Copy Fee:	
Certificates	
Certificate of Status Fee:	
Personal Property Filings:	
Mail Processing Fee:	_5_
Other:	
TOTAL FEES:	_175_

_____ Change of Name
_____ Change of Principal Office
_____ Change of Resident Agent
_____ Change of Resident Agent Address
_____ Resignation of Resident Agent
_____ Designation of Resident Agent
 and Resident Agent's Address
_____ Change of Business Code

_____ Adoption of Assumed Name

_____ Other Change(s)

Credit Card _____✓_____ Check _____ Cash _____

_____ Documents on _____ Checks

Approved By: _____

Keyed By: _____

COMMENT(S):

Code _____

Attention: _____

Mail: Name and Address ████████████

CUST ID:0002597265
WORK ORDER:0003813845
DATE:06-01-2011 03:55 PM
AMT. PAID:$175.00

ARTICLES OF INCORPORATION

OF

JOHN HARRINGTON PHOTOGRAPHY, INC.
(A Close Corporation)

FIRST: The undersigned, JOHN H. HARRINGTON whose post office address is
2407 Eccleston Street, Silver Spring, Maryland 20902, being at least (18) years of
age, does hereby form a Corporation under the general laws of the State of Maryland

SECOND: The name of the Corporation is:

JOHN HARRINGTON PHOTOGRAPHY, INC.
and it shall be a close corporation.

THIRD: The purposes for which the Corporation is formed are as follows·

(A.) To engage in the business of providing photographic services to
various clients.

(B.) To engage in and carry on any other business which may
conveniently and lawfully be conducted in conjunction with the business of the
Corporation.

(C.) To purchase, lease, hire or otherwise acquire, hold, own, develop,
improve, rent and in any manner dispose of real and personal property, and any rights
and privileges therein.

(D.) To borrow money, to issue bonds, notes, debentures and
obligations, secured and unsecured, of the Corporation from time to time, for monies
borrowed or in payment for property acquired or for any other objects or purposes of
the Corporation, for any of the objects of its business in any manner provided by law,
to secure the same by mortgage, deed of trust, pledge or other lien upon any or all of
the property and property rights, contracts, privileges or franchises of the Corporation,
wheresoever located.

```
CUST ID:0002597265
WORK ORDER:0003813845
DATE:06-01-2011 03:55 PM
AMT. PAID:$175.00
```

(E.) To conduct its business, so far as permitted by law, in the State of Maryland and in other states of the United States and the District Of Columbia, and in any and all territories of the United States and in foreign countries, and for and in connection with such business to hold, possess, lease, purchase, mortgage, sell and convey real and personal property, including stocks, bonds, securities of other corporations, and to maintain offices and agencies either within or anywhere outside the State of Maryland.

(F.) In furtherance of and not in limitation of the general powers conferred by the laws of the State of Maryland, and of the purposes hereinbefore stated, it is hereby expressly provided that the Corporation shall have the power to do any and all things set forth as its object and purposes, to the same extent and as fully as a natural person might or could do as principal, agent, contractor or otherwise, and alone or jointly with any other corporation, association, firm or person, and to do all and everything necessary or incidental to the accomplishment of the purposes or the attainment of any one or more of the objects and purposes enumerated above or for the protection or benefit of the corporation.

(G.) The Corporation shall be authorized to exercise and enjoy all the powers, rights and privileges granted to or conferred upon corporations of similar character by the laws of the State of Maryland now or hereafter in effect, and the enumeration of the foregoing powers shall not be deemed to exclude any powers, rights or privileges so granted or conferred.

FOURTH: The post office address of the principal office of the Corporation in Maryland is 2407 Eccleston Street, Silver Spring, Maryland 20902.

FIFTH: The name and post office address of the Resident Agent of the Corporation in Maryland is **JOHN H. HARRINGTON**, 2407 Eccleston Street, Silver Spring, Maryland, 20902.

SIXTH: The total number of shares of stock that the Corporation has authority to issue is ONE THOUSAND (1,000) shares, all of one class, common, and having no par value.

SEVENTH: After the completion of the organizational meeting of the Directors and the issuance of one or more shares of stock of the Corporation, the Corporation shall have no Board of Directors. Until such time, the Corporation shall have one Director, whose name is **JOHN R. HARRINGTON**.

IN WITNESS WHEREOF, I (we) have signed these Articles of Incorporation on this __26__ day of ___May___, 2011 and acknowledge the same to be my act.

John H. Harrington

I hereby consent to serve as Resident Agent for JOHN HARRINGTON PHOTOGRAPHY, INC.

John H. Harrington

Chapter 2
Brick-and-Mortar Locations

There is value to having an actual office and/or studio. Having a physical workspace to go to every day facilitates a number of things, not the least of which is a work-life balance. However, there may be economic reasons why your business is operating in a corner, room, or floor of your home. This chapter presents a few reasons why it may be better for the business to have its own address, as well as a few drawbacks.

The Studio

If you're a studio photographer—and by this, I don't mean a family/senior/baby portrait photographer—you'll need a space to bring clients and/or a space to shoot items/objects. From models to sets and from small objects to cars, innumerable items need to be photographed in a studio. Many photographers that focus on food photography also need a studio with a kitchenette built in so that food can be prepared and photographed in close proximity to the cooking area. And models with makeup and wardrobe changes need dressing rooms to accommodate those aspects of a studio photo shoot, too.

Photographers who do family/senior/baby portraits often now work "environmentally" in parks or other scenic areas, largely because they don't have studios. However, studios can be of significant value for these types of photographers, especially if they're working in a locale with significant weather swings. A portrait photographer with a studio can work year-round in Chicago, whereas those without studios have snow and inclement weather hamper their outdoor shoots. And of course, boudoir photographers really need a studio space with a feel and décor suitable to soothing often-nervous clients.

Location, location, location: That's the mantra of the real estate market, and it applies here, too. If clients never visit your studio, then you can be located in the warehouse district between Jack's Fresh Fish and the Oriental Trading Company. Simply having a wide and clear workspace gives you the area you need to make images. Whether you're getting items shipped to you for catalog photography or you're building sets, a studio is just an enclosed space in which to work. However, if you think you may have clients coming on set for a shoot, the last thing you want is for them to think your studio is in a sketchy neighborhood—or, worse yet, to walk to their car at the end of the day feeling unsafe. Instead, if affordability is an issue, find a venue on the outskirts of town, which may be more cost-effective. Be aware of nearby parking, amenities, and other conveniences, too.

One other benefit of having a studio is that it's rentable. Getting your studio on the list of local rental options can generate significant revenue that sometimes pays the monthly rent. Photographers rent studio space for a number of reasons. A local photographer may only occasionally need a studio, for example, or an out-of-town photographer may temporarily need a space to shoot. In most midsized metropolitan areas, a good starting point for a small space is no less than about $500 per day for rental. (Don't do half-days—shoots never go as planned, and if your second client shows up for load-in and your first client's shoot is

running late, it's a problem. It's just better not to do half-days.) New York City, Los Angeles, and other major cities will command higher rates; studio rental rates there can begin at $1,500 to $3,000 a day. Many of these come equipped with a receptionist, and equipment is available for rent along with hair/makeup spaces, client lounges, and so on. If you're in a rural community, a rental charge of $200 to $300 per day may be more appropriate. The bottom line is that the rental charge is likely a line item on the other photographer's estimate, so price it profitably.

Sharing a space can also be an economical way to get into a studio and work in a collaborative environment. Each photographer has a small office/workspace, and the photographers share the studio space as shoots arise. The opportunity to bounce ideas off colleagues and engage others can boost your morale and give you a fresh perspective, too. The challenge, of course, is that you must recognize to what degree the other photographer is your competition. You should tread with caution, as jealousy can arise and might make for difficult co-working situations.

The Office

Yes, I know, your home office probably suits you just fine. You might say to yourself, "How can I justify a $1,500 monthly lease when I can run the business from my home?" Setting aside that a prospective client in this day and age might use Google Maps to see that your address is in a second-floor walkup in the Sleepy Pines condo community and that the car in front of your building is a 15-year-old Ford Taurus "beater car" and might judge you on this, having a physical space to go to work to every day can be a good thing. You could even sublease a small office in one of your clients' suites—not only to grow that relationship to the point where you're the client's go-to in-house photographer, but also to get a prestigious address and a receptionist!

There are, of course, tax benefits to having a home office. And there's no commute, and you can monitor and look after your children. However, when your office is in your home, there's no escaping work—it's there all the time.

Speaking of prospective clients looking up your office on Google Maps, having a formal office space lends you a significant degree of credibility. Prospective clients will perceive you as more accessible and trustworthy if you have an office. Also, if you plan to have people working for you, there comes a point when having your staff at home is too much, and a defined office is best.

The Office/Studio Retail Space

While an argument on a brick-and-mortar office can be made either way if it's just you (and maybe an employee or two) commuting to a defined workspace and your clients are not coming to you, if your clients will come to your office/studio for consultations (for weddings, family portraits, and so on), for sessions in a studio, or to review their images, then having a physical office for this to occur is beneficial and in many instances will result in greater profits.

About 20 years ago, I attended a lecture by a photographer named Charles J. Lewis. To this day, I recall clearly parts of that day-long lecture. One point he made was the value in bringing the client into his studio to review the results of a family portrait session. Usually it was just mom and dad, and he had a small room that looked like a living room, about 10×20 in size. At one end of the 10-foot section, he would put a couch.

Behind the couch was a projector that would project the various images into a 16×20 or 20×30 frame on the wall. The entire session would be shown in that dimension. Below the frame was another couch, designed to give the photo on the wall above it perspective. The key point, Charles said, was that both couches were actually loveseat-sized, so that the couple would sit intimately together on one, and the photo on the other end would look larger and more suitable above the smaller couch. The presentation would be completed, and the couple would select the family photo. Once that was done, with the photo now projected into the frame, they would discuss the sizing. When the family would say, "Oh, we only need an 8×10," Charles would walk up to the wall and hold up—from 20 feet away—an 8×10 frame within the 16×20 or 20×30 and ask whether that was the size they wanted. Inevitably, it was too small. Sometimes he would decrease the zoom of the projector to 8×10, and his clients would see that you couldn't appreciate any of the details in the image at 8×10 size from 20 feet. It was an amazing way to sell clients on wall-sized family portraits that could be appreciated from anywhere in the room. However, this sales tool could not have been effectively implemented without a retail office space.

Most people don't wander the streets and think, "Oh, I'll pop in and get a portrait today," while wearing street clothes. A portrait session is nearly always planned ahead of time, so the concept of foot traffic isn't terribly significant. However, for portraits it makes sense to have a convenient location for clients who call and book sessions, or for those who come in, speak with someone in the studio, browse a few samples, and plan to come back for a scheduled session.

Many higher-end studios that have consultation and shooting spaces have them in a strip mall or in a small to midsized mixed-use building that has retail spaces on the first floor and either offices or residences on the floors above. Some photographers in smaller communities have their spaces along main street. Most higher-end studios won't be located in major shopping malls—they leave those to the "glamour shot" studios of the photographic world—but these higher-end studios typically do advertise in malls. In major shopping malls, there are often large walls in the high-traffic areas where a photographer can hang a series of five to ten 16×20 framed images, along with a brochure holder. It's essentially a large advertisement for the photographer's studio, and it's a soft sell that encourages prospective clients to take a brochure and then visit the photographer's studio.

Consider, though, the genius of Apple. For a very long time, they sold their products only either directly via online portals, through third-party online retailers (such as MacMall), and at large big-box retailers. The problem was in the presentation and customer service. On May 19, 2001, Apple opened their first retail store—I was on hand as Apple's photographer commemorating the event. Apple was tired of third-party retailers defining the Apple experience—and in some cases, ruining it. If you've never set foot in an Apple Store, it's worth doing so to understand how the experience is far and away different from walking into a Best Buy. Seeing how Apple promotes and presents their products is key. Unless you're looking to buy a simple accessory, such as an iPhone case or a pair of earbuds, everything requires the assistance of an Apple employee, allowing them to engage you. At Best Buy, the stock for every product is right there, from printers to computers—you just grab it and go to the checkout line. At Apple, the associate goes in the back and gets what you need for you. If Apple, which was doing well with third-party retailers, made a success out of defining their retail experience, you can, too.

When your clients walk into your studio, they should feel like you're a luxury brand. Whether you mimic the sleek look of an Apple Store or you capture the plush look of maroon carpets, creamy brown walls, and leather couches, spotlighting your best work on the walls in ornate, gilded frames, if you're a family and senior-portrait photographer, defining your clients' initial experience will help them appreciate that you're a substantial business that commands premium rates.

If you're primarily a wedding photographer, your studio might have a fairytale look with lots of whites and pastels, and comfortable seating areas with sample albums on coffee tables. As you come to know the finer florists and stationery stores in the area, you might collaborate and share a space where you can, in turn, share clients. This can cut down on overhead and give you the opportunity to work in a creative environment with others you're not competing with.

For photographers who do motion work, the brick-and-mortar location isn't just about having a place to sell clients on your services; it's also about having an editing suite set up to accept clients into your workspace during the collaborative post-production editing process. The outer area of the space can have flat screens rolling your highlight reel; however, most clients who walk through your doors will have already booked you, so this is an opportunity to show them all of the other amazing things you can do, to gain a few more assignments from them in areas they might not have thought about having you work.

The Cons

Although there are many upsides to having a retail space, there are also a number of cons. You're almost always saddled with a yearly lease, so if you choose the wrong location, you're stuck for a year. You'll also be focused on serving a clientele that is within driving distance of you—in other words, you may become a destination retailer. In tourist areas, your small retail location may serve as a meeting or jumping-off point to head to the beach (or the slopes) to do an on-location portrait, rather than doing the shoot there— meaning you really only needed the storefront without the studio.

Several years ago, I was a presenter at the American Society of Media Photographers' Strictly Business 2 traveling seminar. One of the presentations we interspersed throughout the day included a video of one photographer who wanted to impress upon our audience not only the importance of having a studio, but also the importance of owning it. The idea was that building equity in your studio could allow you to eventually sell the property and garner a good profit. This is important to consider; however, keep in mind that pros and cons of real estate investment are unique to an individual, and advice on how to invest in real estate fills entire sections of bookstores and libraries, and is beyond just a paragraph or two in this book. Consider carefully, consult your accountant and financial advisor, and do your own due diligence. I've presented the idea here simply as something to look into.

However, if you're just starting out as a studio photographer, or if you're looking to expand your services to include studio work (whether business-to-consumer or business-to-business), it may be a good idea to rent a studio on an as-needed basis. Small studios can rent for as little as $100 for a half-day to $300 to $500 for a full day, but it can go up from there. However, if you're on the hook for $1,500 to $5,000 a month in lease payments, perhaps the occasional $500 check for a studio rental is a better financial decision for you.

Whether to own or rent is a business decision that should be grounded in what makes economic sense. It's easy to make the decision to buy cameras, for example, but at what point do you stop? Do you need them or just want them? How many camera bodies? These are easy business decisions to make and justify (or not), but justifying a recurring $2,000 rent or mortgage payment is different and more substantial.

If you're going to choose a retail location, consider the process that McDonald's uses to choose a retail location. They look at the community's demographics—economic makeup, nearby thoroughfares, ease of access, and myriad other details. You should consider all of these factors and then some. Look into your

competition and their retail operations. If you have the potential to rely on foot traffic, how did the retail businesses that were at the location you're considering fare? Why did they close? It's easy to find out about the previous tenants, and with some due diligence you can find them and ask why they closed their doors.

From past tenants, you can learn everything from details about crime in the area, to realistic foot-traffic expectations, to landlord problems. Don't hesitate to call—the worst that can happen is they'll tell you nothing, and then you're no worse off than before. The last thing you want is to have just spent $20,000 to install and decorate an interior, and shortly after you've opened have the previous tenant come in and share with you all his horror stories about the location. Do your due diligence and research.

Chapter 3
Pros and Cons of Insourcing and Outsourcing

Many reasons exist for insourcing and outsourcing the variety of work that is involved in the business of photography. You're probably familiar with the term *outsourcing*, but you may wonder what I mean by *insourcing*. I mean not doing a task yourself—rather, hiring someone to come in and do the work for you. Now let's look at the various tasks and roles you might decide to insource or outsource.

Post-Production

In QuickBooks, our accounting software of choice, we have several categories for the line items we list on invoices:

- Fee for photographic service
- Post-production
- Output method—online gallery

Using those, we can periodically take a look back at the post-production category of income. For press conferences, receptions, and galas, for example, we charge for post-production and the processing of images from raw files to a client-appropriate format, such as JPEG. To process images from raw to JPEG, we charge:

- 100 images or fewer: $125
- 101 to 250 images: $250
- 251 to 500 images: $500

Client-Appropriate Files

Client-appropriate file size is generally 3,000 pixels on the long side (which means 3,000 pixels tall for a vertical or 3,000 pixels wide for a horizontal). Not only do most clients not need full-resolution files from the camera, but also files from a 30-megapixel (or more) camera can sometimes crash the average computer. Also, with most clients' rights packages, they don't need full-resolution files. So, we downsize raw files to ones that won't crash their computers. Note, however, that for magazine clients, we typically deliver full-resolution files because their photo departments can handle larger files, and we know they need (and like) the flexibility of the full file size for their layout possibilities. Additionally, if your client is an organization that is using the photos solely online, and that is their rights package, then a client-appropriate file size could be much smaller—say, 1,000 pixels on the long side.

The deliverable of 100 images or fewer typically applies to very short press conferences or small receptions. We bill out our post-production at $125 an hour, and we have estimated that it takes approximately one hour to ingest the images from the card into the computer and into our editing software; add metadata; color-correct, crop, tone, and rate the images; and then export them to JPEGs. For 100 to 250 images, which is where the majority of our assignments fall from an image-production standpoint, we figure on about two hours. For larger events with a receiving line or all-day conferences, upwards of 500 images is about right, and for those events we figure on four hours.

Events/Press Conferences: How Much Post-Production?

There is a lot of discussion about how much post-production a client should get and how much they expect.

Take, for example, a photograph of two people shaking hands or engaging in animated conversation at a reception. In this case, post-production essentially is to make the image look its best, meaning that the people on the outskirts of the frame get cropped out, as well as, say, the exit sign above the subjects' heads. We also usually do a highlight recovery, bring up the midtones, and adjust exposure. The likelihood that the image will need to be taken into Photoshop is about zero. We can do these corrections in Lightroom, Aperture, or Camera Raw.

For a picture at a podium, we make similar tonal adjustments and tighten the crop where necessary.

However, for wedding images, many photographers go through a significant series of processing steps to give the images a finished and polished look. Much of this can be accomplished in Lightroom or Aperture; however, the photographer also needs to use Photoshop. For most wedding photographers, the line "We will deliver 300 finished high-resolution images on a DVD" indicates that this work is done as part of the package price.

For portraits of a lawyer or a company executive on seamless, our finished deliverable includes a single image, retouched and with blemishes removed, including fly-away hair, and so on.

The plan changes when we're doing high-end advertising or annual report work. A digital-package rate of $750, $1,500, or $2,500 includes having our digital workstation on site for client review. The client reviews all un-retouched images, and then we charge a per-image charge for retouching. We also get image specifications from the client, such as exactly what dimensions and DPI they want and what color space we should deliver the images in.

How We Rate Our Images

We produce tens of thousands of images a year. We may shoot 300 to 500 images for an event, 50 to 100 images for a quick portrait session, and the same amount for many ad jobs. For a wedding, 1,000+ images isn't uncommon. Sorting through them is a massive undertaking, which is why we have a full-time post-production manager on staff. As these images are edited, we apply ratings.

- **One star: Suitable for delivery to client.** Anything that is in focus, properly lit, with subjects' eyes open and with no unattractive expressions gets a one-star rating.

- **Two stars: Best of multiple images.** Suppose I shoot a series of 10 to 15 images of a speaker at a podium from the same angle. Say in seven of them the subject has a bad gesture, has eyes looking down and/or closed, or is looking away. This leaves three to eight images, and within those three to eight there will probably be one to four two-star images.

- **Three stars: Best images from a particular shoot.** Every shoot has a few "signature" images that would be the best for a news release or that the on-site client reviewing the images saw and liked. These images get three stars because they're the best of the shoot. Often after a few months, we go back through our shoots and look at just the three-star to see what we can use to update our portfolio.

- **Four stars: Portfolio candidate.** From time to time, when there's just a really great image, my post-production manager will give the image a fourth star. This image is likely destined for my portfolio.

- **Five stars: Reserved for future use.** We don't use this rating. Over the course of a year we may have several-hundred four-star images. After five to ten years, we'll have upwards of 1,000. We're reserving the fifth star for that point, where the best of the best of the best will get a fifth star.

If, therefore, over the course of the year we shoot 100 assignments, and they average $250 per assignment (with some being the lower-quantity jobs and others being the higher quantity), that means $25,000 in income. We can run a report in QuickBooks showing exactly how much that billing category generated, and then decide whether our time would be better spent shooting, looking for more work through networking opportunities, or making a choice to step away from the office and spend more time with the family. It's easy to justify doing so when the numbers show you can do it.

You should consider these things if you are a wedding photographer and offering a package price to your clients. How many hours do you spend working on their images? While most wedding photographers do a level of post-production similar to what we do for our corporate/commercial clients, wedding photography can require a whole new level of work to really make the images amazing. Images are made to look dreamy and otherworldly, and seemingly every pore on a bride's face is erased. How many hours are you spending on these things?

For our commercial/advertising clients, it's critical to have a digital technician on the shoot. That person handles ingesting the images from a tethered camera or, if we're not shooting tethered, ingesting images as we go for client reviews and approvals. And, in some instances, the digital technician is delivering images to remote clients and stakeholders for the "remote art direction" service we offer to some clients. Afterward, the level of post-production necessary for commercial/advertising clients is high, and it's all but given that we need the digital technician to manage those images and the associated workflow.

When all is said and done, hiring someone to handle your post-production is one of the smartest things you can do. If nothing else, as you are starting out and growing your business and you are charging for those

services, it is a separate revenue stream for you when you have downtime. And as your business grows, you have already accounted for the cost of that time (in real terms and in opportunity cost), so it's easier to hire someone.

The question, then, is whether to outsource or insource. By that I mean, do you ship off the work (by hand if local, by overnight delivery if not local, or by FTP), or should you hire someone to work in your office/studio part time or full time? Some of the most successful wedding photographers I know have a local person do the post-production for them.

When you have a new post-production person, the value of investing time with them in house initially is immeasurable. You have a specific style and approach for how you want your finished images to look, and your post-production person must learn it. For example, cropping out the inevitable exit signs that magically glow above people's heads in every event, which you didn't see when you were shooting, is critical to making your images look their best. Cropping out distractions makes a difference, too, as is toning down hotspots and bringing up midtones. However, these are all subjective changes, and you having your imprint on the final images is important because it's your deliverable and how your client will judge you. So, you need to be sure your post-production person works in your style.

Should You Localize Your Cloud or Use a Remote Solution?

There was a time when you had several choices for cloud-based storage of your images. At that time, while I was exploring the options, I also thought, "Why not just keep the images local and figure out a way to have clients—from their remote location—view and download images from the computers right in my office?"

One solution is an application called axle. The axle software is largely designed around managing video, but it also handles a wide range of other media file types. It has been widely praised at NAB and has won a number of awards. It handles all manner of raw camera files, as well as processed images in PDF, PSD, and many other formats, so check them out at www.axlevideo.com.

Figure 3.1 shows a common networking solution using the axle software. This software is unlike Lightroom or Aperture, because assets can be managed across a network, with proxy files representing full-resolution files when the master drives are offline. The software does not have any still-image manipulation capabilities, so it would be something you would have in addition to your Lightroom/Aperture solution.

Many people don't know it, but the Amazon we rely on for acquiring any book we've ever dreamed of reading makes a great deal of money from their Amazon Cloud Services back end. Their networks and servers provide a bare-bones system that countless businesses run off of. For many enterprise needs, they're great. Most of you reading this book are likely using many of them already, and you just don't know it. It's also likely that many of the players that offer you cloud-storage solutions use Amazon's servers and provide their own feature-rich front-end software to manage your images. On a daily basis, we rely on one that doesn't: PhotoShelter.

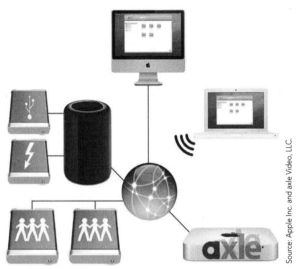

Source: Apple Inc. and axle Video, LLC.

Figure 3.1 *In this network layout, the primary workstation is the Mac Pro, which has a USB and a Thunderbolt drive attached to it with media assets, and there are two shared NAS drives also connected to the hub. The axle computer (here a Mac Mini, but it can be other computer types) connects in parallel to the other machines and creates proxy content on its own hard drive or any other external drive you designate. Then, other machines on the network, whether via hardwire or wireless, can access all of the assets via a web-based interface, downloading, uploading, and making comments on the assets. In turn, the primary workstation can continue to manage the content directly from the drives connected to it or via any standard web browser (Safari, Chrome, Firefox, IE, and so on), and the axle computer will monitor the connected drives at configurable intervals to see whether new content has been added and update itself accordingly for all users to view and manage.*

PhotoShelter (www.PhotoShelter.com) is an often-evolving storage and client access tool that solves the need to always have our computers and network on and accessible (also called uptime). Our entire client-delivered archives are there. We don't use them for storage of our RAW or DNG files; we store those offline on hard drives in our office. But if a client ever needs access to finished images, they're on our PhotoShelter archive. Rather than try to describe the features PhotoShelter provides and the services and prices they offer, I encourage you to check them out yourself. Prices are about $50 a month (if not less), and they are worth every penny.

In-Office Staff

Over the years, I've had varying numbers of people working in house for me. When I was transitioning from film to digital, there were a number of projects that demanded time. I would sit there and stare at cabinets full of my slide-film assignments, knowing that if I had them scanned, they could be earning money. I also was dealing with a backlog of copyright registrations and other projects that weren't critical to the day-to-day operations of the business but nonetheless were important. So, I hired a special projects manager.

Special Projects Manager

The special projects manager managed all those things, as well as outsourcing some of the large-format image scanning we needed and then ingesting the images into image catalogs. She managed the keywording of the scans we opted to do in house, and she managed the photo librarian we had also hired in house to get the rest of my slides organized to begin with.

Office Manager

On a more critical note are the day-to-day operations of the business. Having an office manager to answer phones, send out estimates, prepare and send out invoices, reconcile banking statements (you could have an accountant do this, too), and otherwise keep the business side of things on track is critical. The office manager can even do some of the work that a producer would do in planning and booking airfare, and obtaining permits and so on for larger shoots. Of course, few things beat a local producer who knows the locale you'll be shooting in, but for smaller projects the office manager can do this.

When my office manager was out on maternity leave, and when I was in between office managers, I was reminded of just how important this role is and how much I rely on the office manager to keep things running smoothly.

One thing my office manager almost never does is negotiate contracts with clients. If there's a question about rights or why an estimate came in where it did, I take those calls. There's a fine art to negotiating, and when there are thousands or tens of thousands of dollars on the line, I want to be the one to handle that. However, when I have been out shooting, it's nice to come back to the office and have the office manager say, "I sent out four estimates today, and two of them have already come back signed."

When you're starting your business, you'll have plenty of time to do all these things yourself. However, as you get busier, these projects will encroach on your evenings and weekends, your family time, and your "I need to take a break" time. When that begins to happen, take a serious look at hiring an office manager—it will give you back a quality of life.

Retoucher

If you're doing a great deal of high-end advertising work, having an in-house retoucher is a wise investment. Further, I want to be sure to differentiate this category of work from post-production work, which we discussed earlier. Retouching is an incredible art form. Simple retouching involves tasks such as removing dust spots that were on your camera's sensor and that appear as black specks in the sky of your image. Slightly more advanced retouching includes removing flyaway hair, wrinkles, and facial blemishes on a portrait subject. It gets more complicated when you do a group of 11 people and then later have to shoot the twelfth person separately and have a retoucher seamlessly insert that person into the group. And it gets more and

more complicated from there, such as compositing multiple images—there is no limit to the creative options a retoucher can use to make your images something they never were. Or, you might have in mind a plan to produce the original images knowing that aspects of the finished images can only be done through retouching.

Retouchers that you outsource to can range from about $25 per hour to $300 an hour or more. If you need only occasional retouching work done, then outsourcing is your best choice. However, if you have the need for an in-house retoucher, you are also most certainly billing for those retouching post-production services.

Additional Photographers

In *Best Business Practices for Photographers*, I addressed the value of being the lead photographer and bringing in other photographers on an *ad hoc* basis—while making sure that you are the one providing the direction to manage them. This is a form of outsourcing, and then there's the costly form of this same concept—insourcing. If, for example, you're a school portrait photographer, it makes sense to have employees whose full-time (or seasonal) job is to make photographs. In the sports-event-photography business, for example, you may want to have a team of photographers covering the event while you manage the tent and sales area—and then expand even more and have multiple operations like that at the various sporting events in your community. From equestrian competitions, motocross/BMX, and so on, there are numerous day-long or multi-day events where having a staff of photographers is very lucrative.

The challenge, however, is that not every type of photographic service can operate like this. Take for example, a magazine shoot. To some extent, when a magazine needs a photographer they can do the research themselves or call a photo agency such as Magnum Photos, ZUMA Press, or Black Star (the agency that represents me, along with hundreds of other photographers) and trust that the agency will provide a photographer of a certain caliber. However, if a magazine, ad agency, or design firm visits my website and sees my work, they likely want me and my style. That's not always the case when we're talking about covering a press conference; however, for a stylized cover or genre of ad, it really does need to be me, and substituting in someone other than me can be problematic.

Second Photographers at the Same Shoot as You

For a number of events, having a second photographer is critical. For example, at a wedding the lead photographer is likely the owner of the business, and he is supplemented by a second photographer who assists with lighting setup and other non-camera aspects of the shoot, photographs the groomsmen getting ready, and shoots a second angle during the ceremony while the main photographer covers the final touches of the bride getting ready and the key angles during peak ceremony moments. In some scenarios, it can be effective to have someone on staff full time doing post-production work and then also have them shoot with you on weekends. However, many second photographers at weddings are aspiring wedding photographers themselves, looking to gain experience before hanging out their own shingle.

Another time when you might need a second photographer is when you're covering an event and are responsible for the VIP reception, but you still need coverage of the general reception. When a client asks you to do both, you often can discuss with them the value of having a second photographer. If you do this type of work often, having someone on staff is valuable, because you both will learn how to coordinate coverage.

For certain situations, there are critical moments where you need a second angle. Covering an important horse race or multiple angles of a professional football, baseball, hockey, or basketball game means having multiple photographers on staff. Staffing up with people who all work well together means you'll get better coverage and more consistent deliverables for the end client. Remote cameras can give you a good second angle, and these are often invaluable, especially when you can put a remote camera somewhere where you couldn't put a person with a camera, but the brain and body of a second photographer can often be better where possible.

Overseas Post-Production

Over recent years, the news has been replete with stories about companies "off-shoring" certain business services. Off-shoring is simply having an overseas business provide a service for you. If you're in the U.S., this means any company outside of the 50 states. This off-shoring happens in various aspects of business, from customer service to sweat-shop manufacturing, sometimes with horrible results. In some instances, laborers earn as little as $5 a day for something that we might otherwise think should be worth $100 or more a day. Some companies have even been shamed into ending the practice of off-shoring operations.

Not a week goes by that I don't get an email offering me film scanning, retouching, or post-production from an overseas service provider. Often they offer retouching for $1 a photo with a two-day turnaround. When I was scanning all of my film to digital, I did a cost-benefit analysis of doing all of my medium- and large-format film, and it was simply less expensive to use an overseas provider than to do it in house. In that instance, the overseas production facilities were run from a U.S. domestic base of operations, so I shipped my film to the businesses headquarters in the U.S., and they bundled up my images and those of other photographers and sent them overseas, where they were scanned, adjusted, captioned, and keyworded. Then, they returned them to me. Although I was able to handle all of my 35mm film in house, this was the best solution for all the other film formats I had.

Following is an email inquiry we received in our office offering services to us from overseas.

Yet I did have a concern. How would these overseas operators handle my digital files and respect my copyright? Different countries have different mindsets about copyright. Are my images sitting in some stock archive overseas that I don't know about? I can only hope that the decision I made to do that didn't indirectly release my images to other parties, and I'll likely never know.

Sample Outsourcing Email Inquiry Service Offer

We are one of the best digital images retouching/editing studio located in China. We provide all kinds of image editing solutions to different companies all over the world.

We provide best quality service in best price.

Our image editing services are: -

- Cut out/masking, clipping path, deep etching, transparent background
- Dust cleaning, spot cleaning
- Colour correction, black and white, light and shadows etc.
- Beauty retouching, skin retouching, face retouching, body retouching
- Fashion/Beauty Image Retouching
- Product image Retouching
- Jewellery image Retouching
- Real estate image Retouching
- Portrait image Retouching
- Restoration and repair old images
- Wedding & Event Album Design.
- Vector Conversion

You can try us by sending a sample image for free test to judge our quality work.

For Outsourcing: Hand-Deliver, Ship, or FTP?

When you're delivering images, you can use a variety of solutions, and in many instances you'll want to manage the deliverables yourself. However, what's the best way to do that?

If your provider is local, your best solution is to exchange the drive by hand. Some providers will come to you, get a hard drive, and deliver the finished results on the same drive. Others will want you to bring the drive to them and pick it up. This is the safest solution; however, you should be absolutely certain that you have at least one backup (and preferably two) of the RAW files before you turn them over to a third party. You never know what disaster could befall them, from something as simple as losing your drive, to the drive crashing while with the provider, to the provider being the victim of theft, eviction, fire, and so on. You also should have an agreement with your provider that precludes them (or allows them, if you're so inclined) to use your images in their portfolio.

Shipping a hard drive can be an issue if it's not properly packaged. (Usually the original packaging works well.) As we move into a solid-state world, SSD drives can minimize drive failures because they have no moving parts. However, the same concerns about fire, crashes, or missing packages means you need to have multiple backups of your RAW files. Large USB drives could make shipping very easy, too—easier than shipping a hard drive—so consider that instead.

One easy solution is to FTP your files. This is certainly the best solution if the client is an international shipment away, because Customs hassles alone make it difficult to manage files back and forth, and the costs can be high. Many Internet service providers have sufficient bandwidth to make it easy to FTP files. At the end of the night, you just drag and drop a folder of images, and your recipient gets them a few hours later.

One risk, however, is that some service providers have hidden caps. For example, in Verizon's Consumer Terms of Service (as of November 2013):

> AUTHORIZED USER, ACCOUNT USE, AND RESPONSIBILITIES.
> Restrictions on Use. The Service is a consumer grade service and is not designed for or intended to be used for any commercial purpose. You may not resell, re-provision or rent the Service, (either for a fee or without charge) or allow third parties to use the Service via wired, wireless or other means. For example, you may not provide Internet access to third parties through a wired or wireless connection or use the Service to facilitate public Internet access (such as through a Wi-Fi hotspot), use it for high volume purposes, or engage in similar activities that constitute such use (commercial or non-commercial). If you subscribe to a Broadband Service, you may connect multiple computers/devices within a single home to your modem and/or router to access the Service, but only through a single Verizon-issued IP address. You also may not exceed the bandwidth usage limitations that Verizon may establish from time to time for the Service, or use the Service to host any type of server. Violation of this section may result in bandwidth restrictions on your Service or suspension or termination of your Service.

A few highlights:

- "…you may not…use it for high volume purposes, or engage in similar activities that constitute such use (commercial or non-commercial)."
- "You also may not exceed the bandwidth usage limitations that Verizon may establish from time to time for the Service…"

At what point would you know? When it's too late? This is "consumer grade," so perhaps you want to foot the bill for $250 to $500 a month for a business/commercial-grade service? Or perhaps FTPing thousands of RAW files to/from an outsourced service provider is too much.

I've heard stories of people having high-speed Internet throttled down to DSL or shut off completely. Sometimes it's 250 GB a month; sometimes it's 1 TB a month. There doesn't seem to be any rhyme or reason to it. Further, the download speeds don't seem to be as capped as uploading. With the general use of much of the Internet to be streaming of videos, these are all downloading in nature. Uploading is always slower for consumer plans. For example, when you see a plan that offers speeds of 15/5 or 50/25 or 75/35, those are the download/upload speeds measured in Mbps, or megabits per second. Verizon, for example, suggests that a speed of 5 for the upload allows you to upload 250 MB of photos in seven minutes, whereas an upload speed of 35 allows for the same number of images to be uploaded in just under a minute. As such, there's a risk of overusing your Internet and getting banned. Be sure to investigate your Internet service provider's fine print to get a handle on what constitutes over-usage before you get banned.

Chapter 4
The Value of Offering Internships

Over the last 15 years or so, more than 50 interns have made their way through our office. It's been our pleasure to watch many of them learn and grow into their own existence in photography.

Some have gone on to work for *The New York Times*, the National Geographic Society, AOL, *People* magazine, NBC, and other establishments. Others have gone on to work for community newspapers around the country, and many have left to start their own photography businesses—some even competing in the same market I am for similar work. Some have gone on to illustrious careers lecturing around the country, authoring books, and doing webinars.

I am a firm believer in the value of interning. Although that is the common term, the original title for those in this role was "apprentice." Prior to the formalization of higher education, if you wanted to be a plumber, a blacksmith, a weaver, or even a physician, you would work with someone experienced in that field and learn the profession slowly and methodically. Just standing there holding a pipe wrench, watching the plumber work, and having the opportunity to ask questions gave you the experience to eventually go out on your own.

An apprentice or intern has no idea about many of the things that we, as photographers, understand as second nature. How many ways are there to trigger studio strobes? Hardwired? Wireless? How do those work? What if you forget the right hardwired cable and something is wrong with the wireless triggers? How about using an on-camera strobe to trigger the packs using the slave? Oh, but they're not syncing? That's right, because the pre-flash mini-flashes are triggering the slave, and putting your on-camera flash on manual 1/64 power will do the trick. While we know these answers intuitively, an intern watching a photographer troubleshoot through these issues learns an invaluable lesson.

One of my favorite movie scenes is from the original *Karate Kid*. Daniel, played by actor Ralph Macchio, is pleading for training from karate master Mr. Miyagi, played by Pat Morita. After several refusals and much pleading on the part of Daniel, Mr. Miyagi, who has a junkyard with dozens of cars in his front yard, instructs Daniel to go wash and wax every car. Mr. Miyagi also tells Daniel that he is to do whatever Mr. Miyagi says, no questions.

> **Miyagi:** First, wash all car. Then wax. Wax on…
>
> **Daniel:** Hey, why do I have to…
>
> **Miyagi:** Ah, ah! Remember deal! No questions!
>
> **Daniel:** Yeah, but…

Miyagi: Wax on, right hand. Wax off, left hand. Wax on, wax off. Breathe in through nose, out the mouth. Wax on, wax off. Don't forget to breathe, very important.

Mr. Miyagi instructs Daniel on how to make a circular motion when "waxing on" in the clockwise direction, and then to "wax off" in a counterclockwise direction. Later in the movie, Mr. Miyagi teaches Daniel a very exacting way to paint a fence, with upward and downward strokes. Daniel doesn't understand the point of the exercise, and when he finally challenges Mr. Miyagi, he learns that those assignments—repetitive motions—were actually training his muscles to do karate moves. Daniel was learning the moves, even if he didn't know it.

So, too, are many of the things interns learn in a well-done intern program. I don't ask an intern to do anything that I wouldn't do or haven't done. Further, if an intern wasn't around, who do you think would do what I'm asking? That would be me. Countless times I've crossed paths with past interns who have recounted that something they learned during their internship was something they either didn't realize they had learned or was something they thought they'd never need to do themselves.

Interns/Apprentices: A Historical Perspective

Early apprentices for famous artists were responsible for all the menial tasks in an artist's studio—mixing the paints, priming the canvases or wood, and in some cases, after some time, copying their masters' paintings. Leonardo da Vinci started as an apprentice for well-known sculptor Andrea del Verrocchio. The student succeeded the master, and Leonardo went on to much greater fame than del Verrocchio. Similarly, master chef Gordon Ramsay started as an apprentice for a catering company, and famed fashion legend Alexander McQueen started out apprenticing in a tailor shop.

In a 2002 interview with *Rangefinder* magazine, Gregory Heisler was characterized as an "apprentice photographer" under his self-described "idol," Arnold Newman. Despite repeatedly being told by Newman that he wasn't interested in having an intern, Heisler flew to New York to see Newman. He said, "I ended up getting the job and started working for him the next week." Heisler was cited as having learned "a tremendous amount about the business and art of photography." Heisler also apprenticed under highly regarded photographer Eric Meola.

The Importance of Paying Your Interns

One of the biggest questions is whether to pay your interns. You may think, "I can't afford them, but I want to give them some of my wisdom," and countless photographers have taken the approach that an unpaid internship is fine as long as the intern is gaining valuable knowledge. However, I think if you're considering having an intern, you need to read the following document about the Fair Labor Standards Act from the U.S. Department of Labor.

The document on page 42 makes it clear that there are likely very few instances where you can legally have an unpaid internship.

Another issue regarding paying your interns is that paying them teaches them that they do have value, even when just starting out. This point of experience can carry them over to some of their first assignments. If you're paying your interns minimum wage—let's say that's $8 an hour—then they are worth $64 a day for

their work as an assistant in the field of photography. So if they're worth that much just as an assistant, shouldn't they be worth more if someone contacts them to do a shoot?

I understand the conundrum interns face: "I need the experience, so how else can I get that?" Completely capable people are pleading with you to take a chance on them. I have had many people offer to come and work for me for free so they can learn how to run a photography business. The answer is always no. It's not right. Instead, come to town, and we'll get lunch or have a cup of coffee.

I'm happy to have a conversation or two about how a person can advance his or her career without that person having to engage in a full internship. Before that, he should have read this book and *Best Business Practices for Photographers*—after all, why ask a question that is already answered in the books?

If someone wants experience in a particular subject—say, shooting an outdoor portrait—he can complete self-assignments. Instead of taking the call from a local magazine that wants the person to shoot for photo credit, he can do the same portrait concept of a subject for his portfolio.

In other words, these aspiring photographers should make themselves the client. That way, they can do exactly what they want. Once a photographer has a demonstrated skill set on his website as revealed by his portfolio, people should hire him based upon what he shows.

Benefits of Hiring an Intern

One benefit of hiring an intern is that you get to try someone out. Many people are looking for jobs, and if you advertise a job, you'll get a flood of resumes. And then once you've gone through the trouble of hiring someone, you have to hope they'll be a good fit. Particularly in a small office, personality matches are important. You'll have to hope the new employee gets your sense of humor, for example, or isn't uncomfortable if you swear like a longshoreman. And of course, you'll have to hope that person is diligent and detail-oriented, and takes pride in his or her work. But the beauty of an internship is that during the two to three months of the internship, you'll learn all of these things about the person. If it seems like a good match, at the end of the internship you can always offer the person an opportunity to stay on—even if it's just a month (or three) extension. Or, if you're confident that the person is a good fit, you can offer him full- or part-time employment.

Another benefit of an internship is that you quickly learn that having people do things with and for you solves that age-old problem of "if I just had someone to do X for me." Interns want to experience those things in your business. Having someone be an extra pair of hands is incredibly valuable and can really help you get things done in the office or studio.

When I brought in my first intern almost 20 years ago, she was a member of my extended family but eager to learn about photography. She was paid. Now, I can tell you that I did the math and thought, "That's $60 a day times five days a week times four weeks a month—that's $1,200 a month! I don't have an extra $1,200 a month sitting around, let alone $14,400 a year!" I kept focusing on the money. What I wasn't focused on was the benefit of having her there to answer phones or work on projects. After about a month, I found I was being so productive that I actually had time to take a break and turn to some longer-term strategic projects I had wanted to tackle but just hadn't had a chance to.

U.S. Department of Labor
Wage and Hour Division

U.S. Wage and Hour Division

(April 2010)

Fact Sheet #71: Internship Programs Under The Fair Labor Standards Act

This fact sheet provides general information to help determine whether interns must be paid the minimum wage and overtime under the Fair Labor Standards Act for the services that they provide to "for-profit" private sector employers.

Background

The Fair Labor Standards Act (FLSA) defines the term "employ" very broadly as including to "suffer or permit to work." Covered and non-exempt individuals who are "suffered or permitted" to work must be compensated under the law for the services they perform for an employer. Internships in the "for-profit" private sector will most often be viewed as employment, unless the test described below relating to trainees is met. Interns in the "for-profit" private sector who qualify as employees rather than trainees typically must be paid at least the minimum wage and overtime compensation for hours worked over forty in a workweek.*

The Test For Unpaid Interns

There are some circumstances under which individuals who participate in "for-profit" private sector internships or training programs may do so without compensation. The Supreme Court has held that the term "suffer or permit to work" cannot be interpreted so as to make a person whose work serves only his or her own interest an employee of another who provides aid or instruction. This may apply to interns who receive training for their own educational benefit if the training meets certain criteria. The determination of whether an internship or training program meets this exclusion depends upon all of the facts and circumstances of each such program.

The following six criteria must be applied when making this determination:

1. The internship, even though it includes actual operation of the facilities of the employer, is similar to training which would be given in an educational environment;

2. The internship experience is for the benefit of the intern;

3. The intern does not displace regular employees, but works under close supervision of existing staff;

4. The employer that provides the training derives no immediate advantage from the activities of the intern; and on occasion its operations may actually be impeded;

5. The intern is not necessarily entitled to a job at the conclusion of the internship; and

6. The employer and the intern understand that the intern is not entitled to wages for the time spent in the internship.

If all of the factors listed above are met, an employment relationship does not exist under the FLSA, and the Act's minimum wage and overtime provisions do not apply to the intern. This exclusion from the definition of employment is necessarily quite narrow because the FLSA's definition of "employ" is very broad. Some of the most commonly discussed factors for "for-profit" private sector internship programs are considered below.

FS 71

Similar To An Education Environment And The Primary Beneficiary Of The Activity
In general, the more an internship program is structured around a classroom or academic experience as opposed to the employer's actual operations, the more likely the internship will be viewed as an extension of the individual's educational experience (this often occurs where a college or university exercises oversight over the internship program and provides educational credit). The more the internship provides the individual with skills that can be used in multiple employment settings, as opposed to skills particular to one employer's operation, the more likely the intern would be viewed as receiving training. Under these circumstances the intern does not perform the routine work of the business on a regular and recurring basis, and the business is not dependent upon the work of the intern. On the other hand, if the interns are engaged in the operations of the employer or are performing productive work (for example, filing, performing other clerical work, or assisting customers), then the fact that they may be receiving some benefits in the form of a new skill or improved work habits will not exclude them from the FLSA's minimum wage and overtime requirements because the employer benefits from the interns' work.

Displacement And Supervision Issues
If an employer uses interns as substitutes for regular workers or to augment its existing workforce during specific time periods, these interns should be paid at least the minimum wage and overtime compensation for hours worked over forty in a workweek. If the employer would have hired additional employees or required existing staff to work additional hours had the interns not performed the work, then the interns will be viewed as employees and entitled compensation under the FLSA. Conversely, if the employer is providing job shadowing opportunities that allow an intern to learn certain functions under the close and constant supervision of regular employees, but the intern performs no or minimal work, the activity is more likely to be viewed as a bona fide education experience. On the other hand, if the intern receives the same level of supervision as the employer's regular workforce, this would suggest an employment relationship, rather than training.

Job Entitlement
The internship should be of a fixed duration, established prior to the outset of the internship. Further, unpaid internships generally should not be used by the employer as a trial period for individuals seeking employment at the conclusion of the internship period. If an intern is placed with the employer for a trial period with the expectation that he or she will then be hired on a permanent basis, that individual generally would be considered an employee under the FLSA.

Where to Obtain Additional Information
This publication is for general information and is not to be considered in the same light as official statements of position contained in the regulations.

For additional information, visit our Wage and Hour Division Website: http://www.wagehour.dol.gov and/or call our toll-free information and helpline, available 8 a.m. to 5 p.m. in your time zone, 1-866-4USWAGE (1-866-487-9243).

U.S. Department of Labor
Frances Perkins Building
200 Constitution Avenue, NW
Washington, DC 20210

1-866-4-USWAGE
TTY: 1-866-487-9243
<u>Contact Us</u>

* The FLSA makes a special exception under certain circumstances for individuals who volunteer to perform services for a state or local government agency and for individuals who volunteer for humanitarian purposes for private non-profit food banks. WHD also recognizes an exception for individuals who volunteer their time, freely and without anticipation of compensation for religious, charitable, civic, or humanitarian purposes to non-profit organizations. Unpaid internships in the public sector and for non-profit charitable organizations, where the intern volunteers without expectation of compensation, are generally permissible. WHD is reviewing the need for additional guidance on internships in the public and non-profit sectors.

Prior to your first day with an intern, having a list of projects for the intern's downtime is essential to keeping her productive and happy. If your intern comes to you for projects to do and ends up sitting there for half a day surfing the web, her morale will plummet. Here are several things you can ask an intern to do:

- Update your list of insured items for your office insurance policy
- Make portfolio or wall prints of your best pieces
- Research a prospective client (firm or individuals)
- Prepare and process all of those copyright registrations you've been meaning to do
- Organize miscellaneous files (images, contracts, letters, and so on) on your hard drive(s)
- Clean your lenses/cameras
- Do some asset dissolution

Asset Dissolution

There is a degree to which using the term "asset dissolution" is akin to calling your trash collector a "sanitation engineer." Should you instead list the project as "Sell my old stuff on eBay?" The fact is, you likely have a great deal of equipment that is losing value because it's a generation (or more) old, and you're no longer using it. That asset will continue to lose value, so why not sell it? Tasking an intern with this project not only teaches her about the value of gear, but also educates her about what she might have to pay for it used. You can have an intern manage your listings, get your approval on minimum opening bids and reserve prices, and manage the packing and shipping of sold gear.

One point to be concerned about is whether to consult with your accountant about the asset dissolution. Selling old gear could generate income on the sale of a business asset, and some or all of that income could be considered profit—and, as such, taxable income. So, check with your accountant about that.

Assessing Intern Candidates

How do you assess a candidate? Each year we get more than a hundred applications for internships. They come from all over the world and from Ivy League and other prestigious universities, such as Oxford, Yale, and Princeton. Every review cycle brings applicants from RIT, Missouri School of Journalism, Kentucky State, Brooks Institute, and so on. We are very public about whom we've had intern and how candidates should go about applying. And so, you'd think people would pay attention to what we're asking for—a resume and cover letter. Nope.

The first cut comes when we get an email saying someone wants to intern, and what does he need to do? You're out. Sorry. If you can't follow printed instructions on our intern page, you're out.

The second cut comes when there are typos in the document. Sorry to be so cutthroat, but if you can't properly spell "photographer" or spell check your document, what are the chances that you'll pay attention to the myriad details necessary when keying in metadata from a shoot or typing up an estimate? Will you get my client's name wrong? Will you spell "John" as "Jon"?

Then the third level of cuts begins. I'm not bringing you in to be my partner. I'm also not bringing you in to shoot. Don't tell me *what* you can do for me; tell me *how you can do something* for me. Tell me you're a hard worker, that you are committed to doing whatever it takes to get a project done, including staying late and getting up early. Tell me you don't complain, because I don't—at least, not to the client. Oh, and don't

tell me you're an expert or have advanced skills in anything unless you actually do. If you're still in school, don't tell me you have advanced—or even intermediate—skills in Photoshop. You don't. When someone lists "advanced Photoshop skills" on her resume, one of the tests we do during the interview is to ask what the shortcut is for Levels, Curves, or some other feature that a person with truly advanced Photoshop skills would know. If you're not doing keyboard shortcuts, you're not "advanced." Sorry.

Also, understand what the internship is about, specifically. Will you go on shoots? If you can't figure that out by looking at the intern history page, you're out. Will you learn lighting? Sure, but our internship is about learning the business aspects of the business of photography. Tell me you have strong organizational skills and are eager to put them to use managing the projects you're assigned. And, if you're going to do a video resume and send me a link to it as a part of your intern application, make certain that the other videos on your YouTube or Vimeo account don't show your college hijinks—that's almost as bad as me seeing all of your party photos when we review the photos of you on social media. Oh, and now that I've put this book out—the reality is, if you haven't read this chapter and applied the do/don't messages in it, it's likely that now you're out, too.

In *Best Business Practices for Photographers*, I mentioned a conversation I had with the manager of the famed Prime Rib restaurants in Washington, DC. When asked how he had such consistently great servers, he said, "We hire gentlemen and teach them to be waiters," because, for the most part, you can't teach a man to be a gentleman. They either are or they're not. So, too, I can't teach commitment, drive, passion, and stick-to-it-iveness. I can teach you what an f-stop is. I can teach you how to ingest. I can teach you my lighting kit. I can teach you how to file receipts. I can teach you how to negotiate. I can teach you how to price your work.

What are the odds that the lighting you cite—"I'm familiar with Broncolor"—is going to be my lighting kit? How about "I'm familiar with Canon cameras." That's nice, but what if I'm a Nikon user? However, saying you're familiar with the principles of lighting equipment and that you'll be sure to apply that to learning my brand of lighting equipment before the internship will go far. It's a plus if you figure out what lighting kits I use. The information is out there.

During its heyday, *U.S. News & World Report* had a solid intern program. They were known for their hard-hitting investigative journalism pieces, and nowhere was there any information about their intern program. Why? Because their mindset was that if you want to be a journalist (or photojournalist) for *U.S. News*, you should be able to demonstrate the ability to figure it out—investigate it and get it done.

There is also much concern about how unpaid internships serve the privileged few, and what about those who can't afford to move to a distant city for three months and cover their own room, board, and transportation? I share that concern, which is why, in part, I encourage you to pay interns unless there is some specific requirement of an educational program that the internship be unpaid.

Lawsuits abound in the "free labor" arena of interns. ProPublica.org keeps a list of ongoing intern lawsuits. These lawsuits create a chilling effect in the arena of internships.

In a November 2013 article in *Forbes* on the subject of lawsuits against *Condé Nast* and their unpaid/underpaid internships ($300 to $500 for the duration of a summer-long internship), they wrote:

> The main argument against unpaid/underpaid internships mentioned in *The New York Times* and *The Wall Street Journal* is that they are only available to privileged young people, whose parents are able to foot the bill for their stay. If in New York City, as *Condé Nast* is, the cost can be extraordinary.

Consider this, however. *Condé Nast*, for example, has 25 different publications. If you assume between one and five interns at each of them, that's between 25 and 125 (essentially) free employees. Who do you think will do the work the interns did now that they are gone? Some of the work will temporarily be absorbed by existing staff, but eventually more people will have to be hired. Or, the work that needs to be done will actually be done by paid interns, once the organization realizes the value they bring to shouldering the workload.

The Intern Agreement

It's important that there be a written agreement between you and the intern. We actually have two.

Our first agreement spells out what's required and the information we need from the intern. We also collect their school contact information in the event that we need to contact someone at their school. Usually there's someone, but not always. We also tell them what they'll be paid, how often, and that we report those payments to the IRS. Following is my agreement, and you're welcome to use it as is, but I recommend contacting a lawyer familiar with employment law in your jurisdiction so you don't run afoul of the laws in your state.

Our second agreement is a non-disclosure agreement. As we are very open and candid about everything in our office, and in this age where people announce on social media everything and anything, we want to be sure that there is a level of security about what goes on in our office. In years past, it was not uncommon for us to be doing a project for Kodak one week and Fujifilm the next. The last thing we needed while on the Fuji job was for an intern to say to the client, "Wow, this is cool! We did a job for Kodak last week!" That would've been the end of our work for Fuji. In Washington, DC, we have similar concerns in working for both Democrats and Republicans, and being privy to all manner of details.

John Harrington Photography Incorporated
Intern Agreement

Intern Information:

Intern Name: _____ School: _____

Intern Address: _____ Contact Information: _____

During School Year: _____ Intern Email:_____

Information for security clearances on shoots: Periodically we will want to take an intern on an assignment that requires security clearance either due to the location of the shoot or because of who will be attending an event. These jobs may come up at the last minute, and it will facilitate the process to have your information on hand. The information below will also be used for the filing of all necessary tax documents to report your income.

Full Legal Name:_____

US citizen ☐ Yes ☐ No DOB: _____/_____/_____

SS#: _____ - ____ - _____ City & State of Birth _____

Is there anything in your past, such as a felony conviction, that would preclude you from passing a security clearance? This information is not a part of the decision-making process to be used in determining whether to offer you the position, as your receipt of this Agreement means you have already been offered the position. This information is being requested only to determine if you will be able to participate on the above referenced assignments where a security clearance is required.

☐ Yes ☐ No

If "Yes" please explain:

Advisor Information (for current students):

Primary Advisor: _____ Email: _____

Phone:_____

Terms of internship:

You will be paid $_____ every two weeks (based on $ _____/hour for a 40-hour work week). And while your work schedule is at least the hours listed below, you may also be required to work early mornings, evenings, and weekends as assignments require. This income will be reported on a 1099 at the end of the year to the IRS, and it is your responsibility to pay any necessary taxes on your income.

Start Date: _____/_____/_____ End Date: _____/_____/_____

If you are currently enrolled in school, please be sure to check when you'll need to be back at school, any family functions you can't miss, scheduled vacations, holidays, travel time, etc. before finalizing your start and end dates with the office.

Scope of internship: Main intern duties (not comprehensive):

- Assist on shoots (includes a fair amount of lifting of heavy photo & lighting equipment)
- Post-production of images, including burning and shipping of CDs
- Special projects as required (i.e., in the past, interns scanned much of John's back catalog of images on film to be posted to stock image databases)
- Ongoing organizing and packing of photo equipment before and after shoots, and ensuring ready status of all battery-powered equipment
- Office work as necessary (filing, organizing, etc.)

Intern responsibilities (not comprehensive):

- Transportation to and from office—on time!
- Dress in the office is presentable but casual: nice jeans, solid-color T-shirts, no flip-flops.
- Dress on shoots may be more formal, so always have a suit-type outfit available.
- Summarizing what's been done and what remains to be finished in an end-of-day e-mail to your office supervisor.
- Provide John or the office manager with biweekly invoices.

What the intern may take away from their experience:

- How to make a living as a photographer

- How to charge appropriately

- How a business runs

- How to negotiate with clients

- Knowledge of the estimating and invoicing process

- Knowledge about post-production of images

- Familiarity with an array of equipment—photographic and computers

- Interns are welcome to borrow equipment from John in order to gain more experience and improve their portfolios

Intern Agreement:

I, _____, believe I can fulfill the requirements of the above-described internship and agree to abide by the conditions listed. Also, that I may be best prepared to maximize the experience I will have read John's book *Best Business Practices for Photographers* prior to day 1 of the internship.

_____ _____

Signature Date

John Harrington Agreement:

I, John Harrington, agree to provide learning assistance and supervision to the intern and certify that the intern will be exposed to the areas outlined above.

_____ _____

Signature Date

John Harrington Photography Incorporated
Agreement

For Confidentiality of John Harrington Photography Incorporated
and Client Information

Effective Date: {Start Date of Internship}

John Harrington Photography:	Recipient
John Harrington Photography, Incorporated	{name}
2407 Ecccleston Street	{address}
Silver Springs, MD 20902	{City, State, Zip}

This Agreement shall govern the disclosure of information by John Harrington Photography Incorporated, a photographic business operated in the jurisdiction of Montgomery County Maryland, its clients (both direct and indirect), client subsidiaries and affiliates that hereinafter shall be referred to as "Photographer/Client," to the Recipient named above. If a company name is identified as Recipient above, the person signing this Agreement acknowledges that he or she is binding the entire company, its employees, contractors, subcontractors, representatives, and affiliates and further represents that he or she has the authority to do so.

1. "Confidential Information" as used in this Agreement shall mean any and all proprietary and non-proprietary information including patents, trade secrets, product names, product descriptions, product functionality, manufacturing processes, persons' names, likenesses, locations or whereabouts, current or future job titles, employment status, descriptions of health, personal status, business forecasts, sales or marketing information or plans, or other personnel information without limitation.

2. Recipient agrees that it will not disclose, make use of, reproduce, or disseminate in any way Confidential Information of Photographer/Client to any person, form, or business, except to the extent necessary for negotiations, discussions and consultations with authorized representatives of Photographer/Client, and any purpose Photographer/Client may hereafter authorize in writing.

3. If Recipient is an Individual:

 Recipient agrees that it shall use all possible care to protect the Photographer/Client Confidential Information from disclosure.

 If Recipient is a Company:

 Recipient agrees that it shall disclose Photographer/Client Confidential Information only to those of its employees, contractors, sub-contractors, or representatives who need to know such information and who have agreed, either as a condition of employment or contracting services or in order to obtain the Confidential Information, to be bound by terms and conditions substantially similar to those of this Agreement.

4. Recipient agrees that it shall treat all Photographer/Client Confidential Information with the same degree of care as it accords to its own confidential information and Recipient represents that it exercises reasonable care to protect its own confidential information.

5. Recipient's obligations under Paragraphs 2, 3, and 4 with respect to any portion of Photographer/Client confidential Information shall terminate when Recipient can document that such Confidential Information (a) was legally in the public domain at or subsequent to the time it was communicated to Recipient by Photographer/Client through no fault or action of Recipient; (b) was rightfully in Recipient's possession free of any obligation of confidence or subsequent to the time it was communicated to Recipient by Photographer/Client; or (c) when the communication is in response to a valid order by a court or other governmental body, was otherwise required by law, or was necessary to establish the rights of either party under this Agreement. In the event Recipient receives a court order, or is otherwise required by law to disclose any Confidential Information, Recipient will (i) notify Photographer/Client immediately upon receipt of such court order, and (ii) file any information disclosed in response to such order under seal and/or request that the court seal such Confidential Information. Except as may ultimately be required by such court order or law, Recipient's obligations with regard to such Confidential Information, as set forth above, will remain in full force and effect.

6. All materials (including, without limitation, documents, drawings, sketches, models, designs, or schematics) furnished to Recipient by Photographer/Client shall remain the property of Photographer/Client and will be returned promptly at its request, together with any copies thereof.

7. Recipient acknowledges that it does not acquire any licenses or contributory copyright claims to any work performed under this agreement, and shall not attempt to obtain such rights. In the event a claim is made and is successful, Recipient agrees that it will permit and participate in the transfer of those rights and copyrights back to Photographer/Client without objection.

8. Recipient will not assign or transfer any rights or obligations under this Agreement without the prior written consent of Photographer/Client. Any attempt to transfer all or part of Recipient's rights or obligations without such consent shall be null and void and of no effect.

9. This Agreement shall govern all communications and services between the parties that are made during the period from the Effective Date of this Agreement to that date on which Recipient receives from Photographer/Client written notice that subsequent communications and/or services shall not be so governed, provided, however, that Recipient's obligations under Paragraphs 2,3, and 4 with respect to Photographer/Client Confidential Information which it has previously received shall continue perpetually unless terminated pursuant to Paragraph 5.

10. This Agreement is governed by and construed in accordance with the substantive laws in force in Montgomery County Maryland.

11. This Agreement may only be changed by mutual agreement of authorized representatives of the parties in writing.

12. All notices or reports permitted or required under this Agreement shall be in writing and shall be by personal delivery, facsimile transmission or by certified or registered mail, return receipt requested, and shall be deemed given upon personal delivery, five (5) days after deposit in first class mail (postage prepaid), or upon of receipt of electronic transmission. Notices shall be sent to the address set forth at the beginning of this Agreement or such other address as either party may specify in writing, if notice is sent to Photographer/Client, it shall be sent to the signatory.

13. The Recipient acknowledges and agrees that due to the unique nature of Photographer/Client's Confidential Information, there will be no way to adequately remedy at law for any breach of its obligations. The Recipient further acknowledges that any such breach will result in irreparable harm to Photographer/Client, and therefore, that upon any such breach or any threat thereof, Photographer/Client shall be entitled to seek appropriate equitable relief, including but not limited to injunction in addition to whatever remedies Recipient may have at law. The Recipient will notify Photographer/Client in writing immediately upon the occurrence of any such unauthorized release or other breach.

14. Notwithstanding the date or dates of execution of this Agreement, this Agreement shall be deemed to have commenced on the Effective Date written on the first page of this Agreement, and that this Agreement may be signed in counterparts. The parties also agree that a signature transmitted via facsimile shall be deemed original for all purposes hereunder.

In WITNESS WHEREOF, the parties have executed this Agreement as of the date first written below.

John Harrington Photography: Recipient:

_____ _____
Signature Signature

_____ _____
Print Name Print Name

_____ _____
Title Title

_____ _____
Date Date

Clause 7 is important, and it's not specifically NDA related. That clause is:

> Recipient acknowledges that it does not acquire any licenses or contributory copyright claims to any work performed under this agreement, and shall not attempt to obtain such rights. In the event a claim is made and is successful, Recipient agrees that it will permit and participate in the transfer of those rights and copyrights back to Photographer/Client without objection.

The purpose for this clause is twofold. The first is that I may have set the camera's angle, framing, lens, f-stop, shutter speed, and lighting. However, I may have to stand away from the camera and ask the assistant to trigger the shutter. On a technicality, that may give the assistant some possible claim that it's actually his photograph, because it was his action that fixed the image in a tangible medium, which is what is required to obtain copyright, even if I gave him clear instructions about when to trigger the shutter. Or, the assistant may have made a suggestion that resulted in his idea being incorporated into the final image. In either case, I don't want him to come back and try to claim copyright or joint copyright to the work. Clause 7 addresses this concern.

Giving Back

There is a value in giving back. There is a benefit to you. There's obviously a really big benefit to the intern. But there's also a significant benefit to the photographic community, regardless of whether they're in the same town as you.

I was attending a symposium at the Library of Congress and had the pleasure of listening to famed astrophysicist Neil deGrasse Tyson, who was speaking about how another famed American astrophysicist and author, Carl Sagan, had influenced him at the genesis of his career in science. He said:

> We are not who we say we are or who we want to be. We are the sum of our impact on others.

I have tried hard to live by that credo. It applies so well to one's own children, but beyond that, to children who are adopted or cared for by a foster family. It applies to being a good shepherd to those who work with you or for you and to the people in your community. You can add to the sum of your impact simply by making a cheery greeting to a stranger passing by on the street, or by taking the responsibility for and nurturing the passion in another creative soul to grow in what you have the pleasure of calling your line of work.

Yes, some measure of business and economic value should come from having interns, but more important than that is the benefit to others and this community we love.

Chapter 5
Principles, Standards, and Ethics

Hundreds of tomes are dedicated to discussing principles, standards, and ethics individually. Combined, you could likely fill a library with books on just these topics. So, understand that I am just scratching the surface of these topics with these few pages.

Principles

Principle is defined as "a fundamental truth or proposition that serves as the foundation for a system of belief or behavior or for a chain of reasoning."[1]

Perhaps as a street photographer, one of your principles is to avoid using strobes, and instead use only natural light or augmented light that already exists in the scene you're photographing. Now, some might suggest this is a "best practice"; however, you may believe that your use of artificial lighting not only alters the scene with the use of supplemental light, but also alters the activity within the scene by producing a distracting flash of light. One of my principles when doing performance photography was that because my $500 camera flash can't possibly light the performing artist better than the $10,000 (or $100,000) lighting that was artfully set up for the performance, I didn't use strobe for performance photography. Again, it's not about not using strobes as a best practice, but rather as a principle. While many venues where musical acts perform will preclude the use of flash photography, there are many who don't specify that or prohibit it. As a photographer, I strive to not be a distraction, and in performance photography a single flash of my strobe would've not only distracted the performing artist, but also interfered with the audience's experience.

Robert Capa once said, "If your pictures aren't good enough, you're not close enough." His Capa-esque fundamental truth set forth his belief that it was necessary to be up close and personal as the only way to engage with subjects to intimately tell their story. This is true with sports photography as well; many of the up-close-and-personal images of athletes really do make viewers feel much more like they were actually at the event. Applying these rules to govern your behavior when making sports images allows you to bring an up-close-and-personal approach to your telling of that athlete's story.

Perhaps one of your principles is that you won't produce photography that is used contrary to the principles of good health. For you, that means you won't produce photography for tobacco companies. Perhaps you have concerns about damage to the environment, so working for oil companies or others that you perceive to be polluting the environment is objectionable to you. Or perhaps you believe that your creative talents are best used to serve the underprivileged, and as such you prefer not to work for commercial endeavors or corporate America, where you see commercialism as running rampant and damaging the fabric of society.

[1]Source: *Oxford Dictionary* (American English), Oxford University Press.

Principles can change. Change isn't a single event, however; it is a process that evolves over time. At some point, you may be able to see a tipping point where your principles begin to evolve. For example, if you have no issues with shooting for a tobacco company, it may be that once a family member is diagnosed with lung cancer from years of smoking, your principles evolve in the direction of not shooting for the companies you associate with the loss of that family member. Or, you may be happy to be the "hired gun" making photos for both nongovernmental organizations and commercial interests serving a community struck by natural disaster. Yet perhaps you learn that the commercial interests are serving the community to boost their PR and are taking away from the NGO's efforts, so you decide that your talents are better served promoting the altruistic NGO.

Your principles shouldn't change based upon who's talking to you. You should decide your photographic principles in the quiet contemplation of what you want to do with your life and your creative talents. If you have doubts, questions, or concerns, you can reach out to those you respect and admire, and ask for their guidance and insight so you can square in your mind what drives, sustains, and nurtures you.

Standards

A standard is defined as "a required or agreed-on level of quality or attainment."[2]

Plumbers undergo an apprenticeship that typically requires three to four years of on-the-job paid training, with a set number of hours required to achieve the status of journeyman plumber, which then gives the plumber a license after passing an exam. Becoming a master plumber requires many more years of experience, continuing education each year, and more exams. While journeyman plumbers often do the day-to-day plumbing, master plumbers are typically the business owners who know the legal ins and outs of what's necessary to operate a plumbing business.

After graduating from college and then medical school, aspiring physicians have to do a residency, which is a paid position usually at a hospital. Only after completing that can the doctor practice basic medicine as an attending physician. A resident may have the initials MD after her name, but she's technically still a student, not a full-fledged doctor. To become a specialist or board-certified doctor, years more training are required.

So what gives with photographers? Of course we're not brain surgeons, and a mistake on our end doesn't mean a flooded basement, but a mistake *could* cause a client to be sued because we included someone else's intellectual property or a trademark in our photograph that we then licensed for commercial use without their permissions. Or, we could say we had a model release, license an image, and then have the subject sue the client. We could manipulate a photograph, and then the manipulations could be discovered, causing embarrassment to the client and us. Or, we could set up a shoot in a place that requires a permit (which is most places these days) and find ourselves and our client unceremoniously ejected. Or, we could undertake a shoot without the proper insurance, and when calamity strikes, everyone would be liable.

The American Photographic Artists (APA) association provides a high standard for its members. Regarding forms, on their website they say, "APA believes that efficient and professional business practices are essential for success." APA also cites their support for standards in digital imaging, supporting Universal

[2]Source: *Oxford Dictionary* (American English), Oxford University Press. One of the challenges facing professional photographers is that there isn't a license, per se, that allows you to hang out your shingle and call yourself a photographer. Yet, even with a degree in photography, there is no obligation to uphold a standard—in professionalism, pricing/rates, or even quality standards.

Photographic Digital Imaging Guidelines (UPDIG) with "15 clear and understandable guidelines as well as a best practices document prepared by the UPDIG working group of photographic international trade organizations."

The Professional Photographers of America (PPA) take things one step further. They offer a certification program so you can become a Certified Professional Photographer, or CPP. PPA suggests that "clients in every industry seek out credentialed professionals, as the public recognizes certification as a sign that one is an authority in the field. A CPP designation offers potential clients an assurance, not just of quality, but of technical skill and artistic expertise." They go on to demonstrate the value in a certification when it comes to price by citing, "The digital era has made it much easier for inexperienced part-time and fly-by-night photographers to throw their hat into the ring, undercutting professionals with rock-bottom prices. Certification is an easy way to help consumers understand and appreciate your level of experience and talent." The PPA requires recertification every three years through education and training. For PPA members, there are Photographic Craftsman (Cr.Photog.), Master of Photography (M.Photog.), and Master Artist (M.Artist) certifications.

The challenge is that none of these standards, regardless of trade association, is required. They're all great ideas and ideals to strive for, but there's no way the associations can take your license away, per se. You must set your own standards and live by them. Understand that if you have standards only when it's convenient, you'll likely fail when it's most necessary to uphold them.

Ethics

Ethics is defined as "moral principles that govern a person's or group's behavior." Legendary photographer the late Cornell Capa, brother of the previously mentioned Robert Capa, characterizes the book *Truth Needs No Ally* as "an inspirational handbook for a new generation of photojournalists, a book generously laced with a personal philosophy, a code of ethics and practical career suggestions…. It is the contemporary bible for all those who want to become photojournalists, take documentary photographs and create images from imagination." Capa knew the author, the late Howard Chapnick, well. I knew him as the founder of the Black Star Picture Agency, which represents me, and while I have worked with his son, the current head of Black Star, for much longer than I knew Howard, my respect for him and the principles espoused in his book remain a cornerstone of my commitment to the truth and high ethical practices.

The National Press Photographers Association lists their code of ethics as follows.[3]

> Visual journalists and those who manage visual news productions are accountable for upholding the following standards in their daily work:
>
> 1. Be accurate and comprehensive in the representation of subjects.
> 2. Resist being manipulated by staged photo opportunities.
> 3. Be complete and provide context when photographing or recording subjects. Avoid stereotyping individuals and groups. Recognize and work to avoid presenting one's own biases in the work.
> 4. Treat all subjects with respect and dignity. Give special consideration to vulnerable subjects and compassion to victims of crime or tragedy. Intrude on private moments of grief only when the public has an overriding and justifiable need to see.

[3]Used here with permission of the National Press Photographers Association, http://www.NPPA.org.

5. While photographing subjects, do not intentionally contribute to, alter, or seek to alter or influence events.

6. Editing should maintain the integrity of the photographic images' content and context. Do not manipulate images or add or alter sound in any way that can mislead viewers or misrepresent subjects.

7. Do not pay sources or subjects or reward them materially for information or participation.

8. Do not accept gifts, favors, or compensation from those who might seek to influence coverage.

9. Do not intentionally sabotage the efforts of other journalists.

The NPPA's list goes on to encourage seven additional ideals that visual journalists should adhere to:

1. Strive to ensure that the public's business is conducted in public. Defend the rights of access for all journalists.

2. Think proactively, as a student of psychology, sociology, politics and art, to develop a unique vision and presentation. Work with a voracious appetite for current events and contemporary visual media.

3. Strive for total and unrestricted access to subjects, recommend alternatives to shallow or rushed opportunities, seek a diversity of viewpoints, and work to show unpopular or unnoticed points of view.

4. Avoid political, civic and business involvements or other employment that compromise or give the appearance of compromising one's own journalistic independence.

5. Strive to be unobtrusive and humble in dealing with subjects.

6. Respect the integrity of the photographic moment.

7. Strive by example and influence to maintain the spirit and high standards expressed in this code. When confronted with situations in which the proper action is not clear, seek the counsel of those who exhibit the highest standards of the profession. Visual journalists should continuously study their craft and the ethics that guide it.

The American Society of Media Photographers (ASMP) has a member code of ethics, which they list to encourage professional and ethical interactions with clients, as a recommended set of responsibilities that photographers have to their clients, colleagues, and the photography profession.[4]

They are:

Responsibility to Colleagues and the Profession:

1. Maintain a high quality of service and a reputation for honesty and fairness.

2. Oppose censorship and protect the copyrights and moral rights of other creators.

3. Foster fair competition based on professional qualification and merit.

4. Never deliberately exaggerate one's qualifications, nor misrepresent the authorship of work presented in self-promotion.

[4]Used here with permission of the ASMP, http://www.ASMP.org.

5. Never engage in malicious or deliberately inaccurate criticism of the reputation or work of another photographer.

6. Never offer or accept bribes, kickbacks or other improper inducements.

7. Never conspire with others to fix prices, organize in illegal boycotts, or engage in other unfair competitive practices.

8. Donate time for the betterment of the profession and to advise other photographers.

Responsibility to Subjects:

9. Respect the privacy and property rights of one's subjects.

10. Never use deceit in obtaining model or property releases.

Responsibility to Clients:

1. Conduct oneself in a professional manner and represent a client's best interests within the limits of one's professional responsibilities.

2. Protect a client's confidential information. Assistants should likewise maintain confidentiality of the photographer's proprietary information.

3. Accurately represent to clients the existence of model and property releases for photographs.

4. Stipulate a fair and reasonable value for lost or damaged photographs.

5. Use written contracts and delivery memos with a client, stock agency or assignment representative.

6. Give due consideration to the client's interests before licensing subsequent uses.

7. Do not manipulate images for use in a journalistic context in a manner that can mislead viewers or misrepresent subjects.

How do you choose which picture(s) to send to a client—or if you're the editor, which ones to publish—given that an accurate photograph might simultaneously misrepresent the story? For example, consider a news conference with a beleaguered public figure holding his head high, resolute in the face of criticism—except for the moment when he reaches up to scratch his nose and look down at his prepared remarks. The six photographs taken with the motor drive during that second reveal a single image that looks like the public figure is remorseful or downtrodden. Is it ethical to publish that photograph when the rest of the official's actions show his resolve?

Ethical failings abound as photojournalists strive to alter the news within their photographs by enhancing smoke, removing other journalists from the image, or otherwise reframing reality in the pressure cooker that is the demand to get "the shot." Enhancements to color, sharpness, and saturation have disqualified many photographs from competitions, yet how many images not subject to judges and competitions have made their way into publications around the world for public consumption?

Questions about the ethics and messages of manipulating and altering photographs in fashion magazines have arisen, calling into question what this says to today's youth, who strive for a perfection that doesn't exist in nature but is presented as real on magazine covers and in fashion spreads. Laughs can be found on

websites like Photoshop Disasters (www.PSdisasters.com), where you see things that repeatedly cause you to say "Oh no, they didn't!"—but at what point do you stop and just say "That's just wrong?"

With the rise in what's called "citizen journalism," everyone with a photo-capable phone becomes a journalist. CNN has iReporters and FOX has uReporters, yet people with an agenda slip in and simultaneously skew the ethics of reputable news organizations and make a mockery of the shoddy controls they have lessened in the quest to "get it first." During 2012's Hurricane Sandy, which struck much of the East Coast, more than one news outlet was tricked into believing that 50-foot waves were crashing into the Statue of Liberty; the images were actually movie stills from 2004's *The Day After Tomorrow*.

Recommended Reading

Chapnick, Howard. *Truth Needs No Ally*. Columbia, MO: University of Missouri Press, 1994.

Ratavaara, Nina. *Ethics in Photojournalism*. Germany: GRIN Verlag, 2013.

Chapter 6
Cognitive and Subconscious Thinking and Photographers

As a photographer, when you engage a prospective client, you're engaging your "people person" skills. Even if you're a studio photographer who photographs still-life objects, you have to convince a person to hire you, and then that same person (or his colleague/client) must approve of your work. And if you're a wedding/portrait photographer, you're dealing with people at every turn.

As such, everything about you—from your phone number to your address to the words you use (and don't use)—creates an impression. Disagree? If you were living in New York City, where the area code is 212, how do you think some of your customers would react to a phone number of (212) 666-1234? What if your company address was 666 Main Street? I realize this is an exaggerated example, but it makes an impression. Similarly, when the phone number is (212) 555-1000, you feel like you're calling a business. That "1000" comes across as a big business. How about an 800 number?

Appearances always count. But appearances can be tailored to the client. Recently, I made a portrait of a longtime friend, and I brought my normal kit for when I'm traveling light—two bodies, two strobes, and three lenses, all zooms covering from 14mm to 200mm. Yet I could've arrived with just the single body, the 70–200mm lens, and one strobe, because that's all I used and all I expected to use. I was doing the portrait in a large area with a lot of reflected light. I had a white wall behind me, and I bounced the strobe over my head, creating a big softbox out of it. There was no pomp and circumstance, and my friend was very happy with the images.

However, a week prior, I had a client for whom we rolled in eight cases of equipment, a rock-and-roller cart that becomes a mobile desk, and a digital workstation with a 27-inch high-end monitor with a monitor shade, and I shot tethered with two assistants. This client, an art director, required the dog-and-pony show—a demonstration that she was getting something of significant value for the five-digit budget she had signed off on. To be honest, she didn't *require* it, but it was the right show of capability to demonstrate the weightiness of this shoot. There were a number of pieces of equipment (one case has eight different softboxes, for example) we likely wouldn't use (and indeed we didn't), but sometimes laying them all out demonstrates that you've got every necessary tool in your kit—even if the reality is that you knew what you wanted before you left the office.

In these examples, I was selling—subconsciously—an experience. Did the art director feel like she got what she paid for? Yes, she did.

A Sense of Urgency

You have only so many hours in a day, days in a week, weeks in a month, and months in a year. Because your time is finite, the degree to which you maximize income for any given block of time will result in more revenue.

Businesses are replete with examples of fabricated sense-of-urgency concepts: "One day sale only," "for a limited time," "only a few spots left," "be one of the first 100 callers to receive your free gift," and so on. And in Hollywood movies, early in the storyline you find out that an asteroid is headed toward Earth, or the Caped Crusader must foil the evil villain within two days to avoid destruction of Gotham, or even that the end of the world is upon us!

One way to create this sense of busy-ness and demand in your prospective clients' eyes is to return calls right after you've concluded a shoot, so you can say something like, "I'm on my way back from a shoot now, but I'll get you that estimate as soon as I'm back in the office. You can also establish a sense of high demand by discussing past shoots. If your call in the afternoon is for a shoot and you did a similar one earlier in the morning, you can say something like, "Earlier today we wrapped a shoot very similar to this—it's something we do frequently." In Washington, DC, there are a lot of congressional hearings, so when I receive a call to cover one on behalf of a client, it's easy to say, "Sure, I was just on Capitol Hill a couple of days ago." In the client's mind, this creates a high degree of comfort about using you for their assignment. This is not about artificially inflating your own importance; rather, it's about providing cues to help your clients feel secure that they've hired the right person for the assignment.

Now, back to the sense of urgency. Because our time is always limited, I make a point of expressing this to prospective clients in the email that has the contract attached. The boilerplate language is:

> As of today, we are still available on [insert date here]; however, we don't guarantee or commit our photographers' time until we've received the signed estimate back.

This suggests that—at any time—the client could lose the spot we've penciled in for them. In fact, it makes that very clear. In looking back over the last three months of emails in my inbox, I found the following client email snippets that illustrate this point:

> Hi John,
>
> I hope you had a great weekend. I just wanted to follow up with you to make sure you saw the signed contract come through on Friday so we're confirmed in your calendar.

Or this:

> Hi John,
>
> We fully intend to send back signed forms to secure the timeslots on July 18 and July 25. Our finance/legal team is moving slowly due to the end of the fiscal year, so hopefully we'll have signed documents Monday. Can we still reserve the time?

Or this:

> Hi {Office Manager},
>
> Please see the signed contract attached. Would it be possible to schedule a call with John on Friday or Monday to review the schedule for the day and our shot list, and can you confirm our reservation of John's time?
>
> Please let me know what times work best for the call on Friday or Monday.

In each of these three instances, the clients recognize that they don't have a lock on my time until they've signed on the dotted line committing to it. This is all because we make it clear that "we don't guarantee or commit our photographers' time until we've received the signed estimate back."

And, to the point about *our photographers'* rather than *John's* time: Sometimes I'm already booked for a day or timeslot, so I will bring in a trusted colleague to do the shoot. This works well when it's coverage of, say, a press conference. However, it doesn't work when it's an ad shoot and the client is looking specifically for me to do the shoot. However, we use that language to maximize our flexibility on this issue.

Lastly on the issue of urgency, there's the "buy now for a discount" approach. Many a wedding photographer who has done a bridal show knows that if his wedding package price is normally $4,000, offering a 10 percent discount (or including a parents' album) for all weddings booked at the show will entice people to commit, because who wouldn't want to save $400? How about a 15 percent discount if booked at the show or a 10 percent discount if booked within a week of the show?

Telling clients you have only *X* number of spots left or that you have only *Y* discounted spots left works, too. Saving money creates a pressing urgency. This concept applies to family portraits (for example, discounts for smaller prints when purchased at the same time as a 16×20 framed wall print) and even pre-billing a late fee and giving a "discount" for timely payment.

Creating a sense of urgency and limited supply for high demand will encourage the fence-sitters to engage you and your services.

Working for Free?

When people see something that says "free"—whether it's a free lunch, a free vacation, or a free whatever—the natural inclination is to ask, "What's the catch?" When you see a "buy one get one free" sale and do the math, you realize it's essentially a 50 percent off sale. In point of fact it's often *not* a 50 percent off sale, because the fine print always says "of equal or lesser value," so the free item is always the less-expensive one, and you're not getting an exact 50 percent off unless each item is priced the same. However, most people don't realize it's not the case, and many opt to buy a third item, too. They don't see the catch in the "free" offer.

When you get the request from a prospective client to work for free, it's not really free to you. Aside from the loss of your time to market or work for someone else, which you are able to give away for "free," you're still losing that time you could be using productively. Collaboratively working with a makeup artist and model(s) on a project is practice and comes with more freedom to experiment; and if there's a problem, then because your portfolio is essentially the end "client," it's okay. Taking a call from a client who has hired a makeup artist and models and who says it will be good experience for you is working for free. That catch in this case is that you're giving your rights away to the client and not getting paid. You're also teaching the client that you're not worth being paid. In the client's mind, he won't assign a value to you or your time.

Further, you're almost certainly not free to explore and experiment with looks and ideas you have, or to bring to life an idea that you feel is missing from your portfolio.

When you're thinking about working for free, remember that your expenses continue whether you're getting paid or not. Because you still have to pay all the bills that keep you in business, each day has a net cost associated with your business existing. Free is never free. There's always a catch.

Being a Premium Brand

Sometimes clients can't afford you. That's okay. Those that really want you will come back when they have a more reasonable budget. Sometimes they'll come back because the photographer they ended up hiring left a bad taste in their mouth, and sometimes they'll come back because they want the premium level of service, quality, and experience you offer when the job really counts.

Premiums have value. People filing past the first-class seats on their way to coach see the value in the larger seats, the smell of the chocolate-chip cookies being served midflight, and the opportunity to board first and stow their bags instead of being forced to check their carry-ons—all of these perks represent a premium on the standard level of service. Walk into J.C. Penney and see how long it takes a salesclerk to ask you if you want help, compared to the time it takes in Nordstrom or Saks. When I walk into any store I'm unfamiliar with and I'm looking for a particular item, I will immediately seek out a clerk to get directions, because I don't want to wander aimlessly for 20 minutes when I can get to my item in less than 3 with some help. Time is money, and whereas at J.C. Penney the clerk likely can't tell you about the benefits of one brand over another, the Nordstrom clerk can talk about the materials used, how the item you're looking at is currently in fashion, and how well it will pair with another item.

So, too, your knowledgebase about what it takes to make a great photo is of value. What angle do you use to minimize someone's weight concerns? What lighting can minimize that appearance? Can you manage things when power blows or equipment fails? How good are you at drawing together resources to make a complicated shoot a success—models, wardrobe, production trailers, and so on? Are you just the person who owns a camera with a few lenses, or are you someone who can make the proverbial silk purse out of a sow's ear on a complicated shoot?

Don't apologize for your prices or what you charge as add-ons. Apologizing will just devalue them in the client's mind. Put your rates out there (either online or each time you send a quote) and stand behind them. When a client wants something additional (a rush job, emails, or the like), note the additional cost and then be silent.

Men Are from Mars, Women Are from Venus

Men Are from Mars, Women Are from Venus is the title of a great book. I recommend it if you want to plan for a better relationship or improve the one you're in. The general premise of this book is that men and women think very differently.

Take for example, shopping. When a man and a woman enter, say, a department store looking for something specific, that's one thing. However, when a woman wants to browse, the man will often get very fidgety, and

frustrated. However, as as outlined in the book, if the woman simply said, "I'm looking for a pair of brown socks," the man would (usually) dutifully seek out every pair of brown socks he could find and present them to his partner for approval or disapproval. Further, in most cases, even if the trip doesn't end in the purchase of a brown pair of socks, the man will be less frustrated than if the mission wasn't presented in the first place. I recognize that this could be perceived as potentially sexist, and I will leave that question to be answered by those who have read the book, but there is substantial scientific evidence that men and women think differently, and this example is one that is outlined in the book.

Similarly, men and women approach hiring a photographer very differently. As crazy as it sounds, if the photographer is male and a man is calling to book the shoot, the two can instantly form a bond over shared love for a sports team or perhaps the VIPs the photographer has shot in the past. That's not to say that there aren't women who are huge fans of their local sports teams, but relatively speaking, that's not as often the case as it is with male prospective clients. I will also point out that this doesn't work in all instances—in fact, many a male wedding photographer I've spoken with has reported that very little discussion about the mood, feeling, or level of services comes into play when speaking with the soon-to-be husband. And many a female photographer has spoken about the differences they experience when talking to prospective brides and grooms, and having to switch between mindsets mid-conversation. One female photographer I spoke with mentioned to me that she walked into a couple's home and, noting that the groom-to-be was a Washington Redskins fan, commented to him about the team's win earlier in the week. She felt that one moment of bonding caused her to win the groom over, and it became a much easier meeting—and from that point on, she could connect with the bride-to-be about feelings and moods and so on.

Taking into account the differences between how men and women tend to think can be useful in shaping how you interact with clients. Also, it's important to recognize that these are generalizations that, while largely applicable, do not apply in every situation. The key is to be very focused on what your client's needs are and to shape what you offer to best illustrate how what you do meets those needs.

What Are You Selling?

I realize that for many of you, you're not selling a physical product; rather, you are licensing intellectual property. However, for this section, I'll use the term *selling* for simplicity's sake.

Although most of our first experiences with Apple Computer (now officially known as simply Apple Inc.) were largely with their computers, as of the first quarter of 2013, just 13 percent of their revenue came from Mac sales. A full 60 percent came from sales of iPhones and iPads.[1] Apple knows what they're selling, and it's no longer computers, which is why they changed their official name.

If you're a family portrait photographer, although your finished product may be a framed 16×20 perfectly retouched and hanging on the family's wall, what you're *really* selling is the ability to coax and cajole a group of family members to all look good at the same time, dressed in a complementary way, posing in a nondistracting setting. You need only look through the thousands of really bad portraits on the website awkwardfamilyphotos.com (try browsing that website when you're looking for a self-esteem boost) to know

[1]Source: "These Charts Tell You Exactly How and Where Apple Makes Money Right Now." *The Atlantic*. January 23, 2013.

that what you're selling isn't so much that end print, but rather all of the services and creative ideas that lead up to a great result.[2]

If you're an event photographer—whether for weddings, bar and bat mitzvahs, press conferences, or all-day symposiums in hotel ballrooms or convention centers—you're selling the ability to tell a story in a way that conveys the feel of the event. This might be intimate and celebratory for a wedding, outgoing and celebratory for a mitzvah, thought-provoking and insightful for a symposium, or newsworthy and important for a press conference. Your ability to tell those stories—where you get only one shot at getting it right—is what you're selling. For these events, there are no do-overs. There is significant value in the skill to make it happen when there's only one opportunity. You're not going to ask the bride and groom for a retake of their recessional, and no CEO will stand at a podium and redo the unveiling of the latest product or gizmo because you flubbed capturing it the first time.

In advertising and other commercial photography, often you're selling a vision and a creative idea, as well as the ability to execute it within a limited timeframe, consistent with multiple layers of client approvals. You're also selling your ability to troubleshoot and navigate stumbling blocks along the way. These skills should not be underestimated or undervalued.

Knowing whether you're selling an outgoing, team-building, problem-solving, enthusiastic approach to the assignment of the day or the ability to spend endless hours alone in a studio to get just the right shot of chocolate dripping over ice cream for the ad campaign for the next great ice cream brand is very important. You're ultimately selling you and your creative vision and abilities to get things done. Do not underestimate that.

It's All in the Perspective

We all know that everything is relative. No matter how good your photographic services are, they're always being compared to others' services. When people look at your website, chances are they'll like your photographs—until they visit someone else's website, at which point there's a chance that they won't like yours as much anymore. In advertisements targeting women, showing images of other women—especially those who are easily recognizable as moms—softens the message and breeds a familiarity with the viewer. Similar techniques are used when advertising to minorities and men. Consider this: When was the last time you saw an advertisement for a set of wrenches, and the person using them was a woman? Save for the misogynistic use of a scantily clad woman holding the tools suggestively, I'd say almost never.

In his book *Influence: The Psychology of Persuasion* (HarperBusiness, 2006), Robert Cialdini addresses the concept of the contrast principle. Students studying psychophysics are introduced to the concept of perceptual contrast using three buckets of water. One contains hot water, the second contains cold water, and the third is room temperature. Placing one hand in the hot bucket and one in the cold bucket, the student is then instructed to remove her hands and put them both into the room-temperature water. Relatively speaking, each hand will register a different reaction to the same room-temperature water. A person's perspective is colored by his experience and viewpoint. By having each person simultaneously experience different

[2]Note that you still want to sell the end product—if all you show on your website is JPEGs of your files (as opposed to showing a few pictures of finished 16×20s hanging on walls), don't be surprised when your client only wants to order digital files. According to Martha Barletta, author of *Marketing to Women* (Kaplan Publishing, 2007), women tend to buy with the end use of a product in mind, so be sure to show off the end use of your images. Show your finished products early and often, while also emphasizing the skills and experience clients will receive if they purchase your services.

temperatures and then the same temperature in the room-temperature bucket, it becomes clear very quickly that people can have different perspectives on the same experience depending upon the circumstances from which they are coming to that experience.

Retail clothing stores—especially the higher-end ones—will often pair a shirt and a tie to demonstrate how they would work well together. I have fallen for this before—I've looked at an attractive shirt and then, seeing the tie laid on it, I've opted for the tie too, even though I have a closet full of ties. Similarly, a family portrait photographer may offer "upsell" pairings by offering a framing option that complements a 16×20 wall print of the family. The incremental charge of $200 on top of a $1,500 print isn't too hard to swallow.

In *Best Business Practices for Photographers*, I spoke in detail about how and why we charge $65 to process and prepare an image from an assignment to be emailed to a client immediately after the assignment is concluded. We typically do not include what could be two to three emails on the initial estimate for the emails resulting from the coverage of a press conference or other news event because, while we know that more often than not the client will want it, it will bump us over the $1,000 mark, and the $1,000 figure is likely a breaking point for many clients. (I'll address pricing points like this later in the chapter.) Further, why include it unless the client indicates definitively that they want it? Instead, while the per-emailed-image charge is listed on the paperwork as an option, we don't raise it until after the event. Then, when the client is asking for them, we do refer to "a nominal charge per image," and about half the time they ask. When we respond "$65 per image for the processing and prepping of each," in light of not only all the work we've done for the $1,000 figure, but also, the tens of thousands of dollars that it cost to put on the event, $200-$300 in emails is a rounding error.

Sometimes when we get a call from a prospective client, there's a bit of sticker shock when we quote for a single executive portrait $1,000 or so for a lit portrait on seamless. When we sense that, we always ask, "How much were you anticipating paying?" Often the answer is "somewhere between $200 and $300." These clients came to think of these rates perhaps because that's what they saw the last time they were in a shopping mall. Typically, these types of prospective clients learn a bit more as they shop around to other photographers and find a similar pricing structure. Are there cheaper photographers than me out there? Of course. However, they're not charging $200 to roll into a client's office, set up lights, shoot the portrait, and retouch the blemishes away. And remember that sometimes the client isn't right for you, and that has to be okay.

The Theory of a Misattribution of Arousal

I know this chapter is getting very deep into the mind of the prospective client. Previously, I mentioned how some tool manufacturers use attractive women in bikinis to, well, make their tools more attractive. This concept is, at its core, a byproduct of the misattribution of arousal theory.

So, first the theory: In 1974, in the *Journal of Personality and Social Psychology*, Donald Dutton and Arthur Aron published the findings of a study they conducted. A group of men was interviewed while standing high on a suspension bridge. As a control group, a second group of men was interviewed after they had crossed the bridge and their sense of fear and adrenaline rush had subsided. The interviewer for both groups was an attractive female who offered her phone number to the male subjects in case they had any other questions. Those who answered the questions on the bridge demonstrated a significantly higher rate of arousal from the same woman (and thus called her) than did those who did not have a heightened state of awareness. This arousal of the senses in the subject caused by crossing the bridge therefore then caused the men to misattribute their aroused state to the woman.

This theory was tested again after vigorous exercise and by several other groups of scientists, which validated the theory. Considering now that it is validated that a person can misattribute their aroused state from crossing a bridge to their desire for an attractive person, so too can people misattribute positive feelings associated with how you present yourself to your ability to provide a photographic product or service for them. For example, if when you hand a prospective client your business card, if it's a hefty paper stock and looks expensive, the client will misattribute that physical cue into positive thoughts about you: "Oh wow, he must be expensive and good if he can afford nice cards like this." Or, if your prospective client has a warm drink in his hands when you meet, he'll misattribute "warm and pleasurable" to you as he experiences the warm beverage.

People also misattribute and misinterpret other cues. For our purposes, I'll restate this as a misattribution of *appeal*.

First, consider the wedding photographer. Suppose a wedding photographer shot a series of six weddings over the course of two months and was looking for new portfolio material. Arguably, the photographer's capabilities haven't changed in six months, and we'll assume for this discussion that all six weddings were staged with about the same quality of flowers and décor, and perhaps even in the same venue. If the photographer looks through the wedding photos for a wedding that will best demonstrate his ability, likely they all will be about the same. However, the wedding that features the most attractive couple will likely be the best choice for the photographer's portfolio. In this scenario, the photographer can take advantage of a misattribution of appeal—the appeal of the attractive wedding couple is, by transference, assigned to the couple considering the photographer, who are either consciously or subconsciously thinking, "Oh, the photographer will make me look that beautiful, too"—even when that may not be possible.

For the portrait photographer, the concept is the same. Many family portrait photographers will, for example, showcase a highly decorated soldier in formal dress, adorned with all his medals on his chest. It's a powerful photo, to be sure. A family portrait photographer also would do well to showcase a photograph of a mother looking beautiful and motherly with a newborn, as many women will identify with that role either as one they experienced or one they hope to experience someday. In the same vein, having a photograph of a popular person (whether a celebrity, a politician, or a local hero) can causes a misattribution of appeal that benefits the photographer.

A product photographer would do well to showcase her ability to photograph a well-known product. A beautifully photographed image of a Rolex or a piece of jewelry in a blue Tiffany box causes a misattribution of appeal—the prospective client with a product to sell will think, "Well, if she's good enough to do a Rolex watch, she's good enough for my product."

How does this relate to your everyday interaction? Well, in theory, you should be judged simply by the quality of your work—the finished product—period. However, as Jim Hennig says in *How to Say It: Negotiating to Win* (Prentice Hall Press, 2008), "when people like you, they want to work with you." Just as you command more respect when you are appropriately attired, if you come across as easygoing and amenable, people will believe that you'll deliver better results than if you are a difficult person to deal with.

When we deliver a CD or a DVD, the disc is labeled and attractively packaged. Our web gallery could well have been a private Flickr gallery; however, we have a customized façade to our PhotoShelter gallery. For clients who want a USB thumb drive, we have custom-labeled drives.

The same ideas can apply to phone numbers as well. Which comes across as a business number: (202) 544-4578 or (202) 255-4500? Choosing a number that expresses—even subtly—that you're a business is

critical. And having sequential numbers is beneficial. Our main office number is (202) 544-4578, and our fax number is (202) 544-4579. When you are looking to select your business phone number, these small things create a marginal misattribution of appeal; the person dialing the number feels like you're a business because they're dialing what seems like more of a business number because it's a hundred (-4500) or a thousand (-4000) number. Sometimes these numbers are at a premium, but it's worth paying for.

And finally, when you're on the phone with a client while headed home, do you say, "I'll give you a call when I get home" or "I'll give you a call when I get back to the office" or "I'll give you a call when I get back to the studio"? Many of you reading this have a home office—don't refer to it as such. Even if it is your home office, referring to it as such puts you at a disadvantage. There is also a misattribution of *dislike*, and it may be subliminal.

Incremental Pricing

Over the years, I've had many clients ask for rush services or emailed images, each of which adds to the bottom line on the final invoice. Sometimes, I can be pretty sure that a client will want a select few images emailed the same day. However, I'm not always right with that assumption. So, instead of including the additional charges in the bottom line of the estimate, we outline what it will cost in the event that they opt for it the day of the event.

When it comes to corporate and commercial work, because we outline that for the included fees and expenses we will produce, say, "up to X images of children on a white seamless" or "between five and six views of the building," it is clear to clients that when they say, "Oh, just one more," there's an added cost. At that point, there's either a verbal discussion about the additional charge (this isn't the best idea, but for a regular client you're comfortable with, it can work) or the formal execution of a "change order" that allows that change to take place and outlines the associated fees. However, unless we know for certain what additional services (or time) a client will want, we don't include it in the estimate; rather, we allow it to increment up naturally. If we're not careful, in some instances we may accidentally run over client price-break points they have set in their head that we don't know about, and we don't want to do that because that means risking losing the entire job altogether. So, we instead outline what we feel is necessary in most circumstances as we calculate the bottom line, but try to minimize adding in things that could push us past their break point.

That begs the question about client breakpoints. First, it's important to deconstruct the price, to a degree. If the project is $1,000, don't just say $1,000. Deconstruct the pricing so that the client has a degree of understanding about what goes into that. From the photographer's fees, to the post-production fees, to other expenses (such as a $30 seamless backdrop), and so on, these things help clients understand quantitatively where you are coming from. It also helps break through a client's mental threshold for what they are initially willing to pay for photography services.

A 2009 study by Raghubir and Srivastava demonstrated that people will more readily spend 20 $1 bills than one $20 bill, and they'll more readily spend five $20 bills than a single $100 bill. This is known as the *denomination effect*; we are averse to spending a single large bill even if the smaller bills add up to the same amount. Breaking down your services helps a client conceptualize spending that $1,000 differently—not as $1,000, but as several increments of $50 to $200. Because they're less used to spending $1,000, they tend to overvalue that $1,000 as being more important or serious, and they are less likely to spend it than they are to spend an equivalent amount in smaller parts.

In many clients' minds, the price points are $500, $1,000, $2,000, $2,500, $3,000, $5,000, $7,500, $10,000, $15,000, $20,000, $30,000, $50,000, and so on. That said, consider the $1,000 job. Because the comma is there, it seems significantly more expensive than $985. Further, a round number like $1,000 seems much more open to negotiation than $985, and it helps when you've deconstructed the $985 to demonstrate where that figure came from.

In retail pricing, $1.99 is perceived as cheaper than $2. I can't imagine using a $X,XXX.99 price in the photography services I provide; however, I am far more likely to price a stock license at, say, $1,090 or $1,110 than I am $1,100. A study in the June 2005 *Journal of Consumer Research* titled "Effect in Price Cognition" discussed how what they call the "leftmost digit" affects decisions, so even though 1 is a lower number than 9, the absence of a comma taking the rate into the thousands is significant. As such, $1,000 seems much higher than $999. Further, the concept of "fractional prices" suggests subliminally that the rate either is calculated in a specific (and thus less negotiable) manner or is priced at the lowest possible rate. There is a great deal of dispute about the effect (or lack thereof) of the psychology of pricing; however, in my experience it applies significantly to clients hiring a photographer. Doesn't $4,150 seem a more substantive and less negotiable rate for a wedding package than $4,000? A price of $4,000 seems to be negotiable. It's not fractional, whereas adding in the $150 makes the number fractional—that is, $150 is a fraction of $1,000.

In the wedding arena, wedding packages are to a degree priced within pricing "bands." When you're searching online for wedding photography services, the bands are usually in the thousands. For example, on TheKnot.com, the pricing bands are as follows:

- Under $1,000
- $1,000–$1,999
- $2,000–$2,999
- $3,000–$4,999
- $5,000 and over

So, here's where the "initially" priced concept comes into play. If your bare-bones wedding package is $2,900, but adding in an album, an engagement portrait, and so on would take you to $3,500, you can get yourself listed in the lower $2,000–$2,999 pricing bracket and hope to demonstrate, once they've seen your website and service level, why you're the best choice for them. Once a couple has fallen in love with your style and personality, it's far easier for them to increment themselves up to where you would like them to be—and just as importantly, where you know they will need to be to ultimately be happy with their wedding photography.

This isn't setting your value to an amount lower than you want to be perceived as, per se. You're not undervaluing yourself, but rather offering the lowest bare-bones package you can in order to be found within the search results of a lower price bracket, knowing that the client will likely increment themselves up with additional options that would take you above their original price break-point.

Chapter 7
Marketing: An Overview of Its Importance

I'm not going to start by telling you the hundreds of ways you can market your business—there are dozens of books on the subject. Please take a moment to review the list at the end of this chapter, understanding that if I've listed the book it's because it's worth far and away more than the few dollars that book will cost to add to your library. That's why this chapter is called an overview.

In a 2013 video interview titled "How Clients Really Decide Which Photographer to Hire,"[1] noted portrait photographer Gregory Heisler said:

> The business is about relationships…people aren't hiring a photographer, they're hiring a person… We spend ages on our new portfolio…and all they care about is either "Can he do it for the price?" or "Well, is he a nice guy?" Art directors hire people like we hire people.

Marketing is about getting that first shot at a client—the goal is to get them to commit to you. Once they've done that, you'll sink or swim based on how nice you are far more than how good you are. Don't misunderstand—good is an expected given. But how the client perceives you to be—nice, easy to work with, on time, well dressed, and so on—makes up some key marketing points.

Years ago, I learned a critical point about marketing from the *Guerilla Marketing* handbook: For a prospective client to do business with you, they have to have engaged in your marketing efforts a total of nine times. Now, engagement can be something as simple as looking consciously at one of your ads or brochures. Engaging could be browsing your website or even reading an email you sent. Or, it could be having a phone call or an in-person interaction. The challenge is that for every three times that you attempt to engage the prospective client, they only actually engage once. So, that means if you send three emails, the prospective client will likely read or view only one. Send a promotional postcard? Two out of three times, it'll get tossed in the trash with the rest of the day's junk mail. Place an ad in the local print publication or a source book for advertising-agency clients? Again, one out of three times they'll see and focus on it; they'll ignore the rest as they flip through the pages.

Simple math thus tells you that in order to engage and do business with any prospective client, to achieve those nine engagements you'll need to make 27 efforts. But there's a catch, of course. A prospective client has to actually be a prospective client. If the person to whom you're making outreach never needs a photographer, then she's not a prospective client. Marketing wedding photography services in an elementary school or a nursing home will yield next to no prospective clients. Marketing those same services in a bridal-gown boutique? You have a higher likelihood of finding a prospective client. This is called targeting.

[1]http://vimeo.com/77555936.

Targeting is the holy grail of marketing, which is why so much effort and energy is spent on what is ominously called "big data." As the saying goes, if you're not paying to use a product, you are the product. In other words, Facebook, for example, is mining your every interaction. What web pages you visit, how long you stay there, and your influence level are based upon the number of your friends. Facebook aggregates all sorts of information on you and then sells it to advertisers. So does Google. If you, for example, are constantly searching for information on a particular brand of new car, it's far cheaper for an automotive manufacturer to advertise to you than to the consumer who just flips past the car ads in a magazine or on TV. Why not take the sniper approach? Much more effective.

Business-to-Consumer Marketing

Business-to-consumer marketing, commonly referred to as B2C, is such a broad marketplace that it's hard to know where to begin. There is a great deal of research that is done and marketed to restaurants and other social businesses (bars, clubs, and so on). In 2011, the Pew Internet and American Life Project released the results of a survey.[2] Of the people they surveyed who get information about local businesses, the sources they rely on most are:

- The Internet: 47%
- Newspaper: 30%
- Word of mouth: 22%
- Local TV: 8%
- Local radio: 5%

I think it's fair to set aside local television and radio as places where photographers not only don't market, but aren't likely to find the right cost-benefit ratio for marketing.

Word of mouth is marketing, but you have little control over whether and how others promote (or criticize) you via word of mouth.

According to the Pew study, those who rely on newspapers fall into the demographic of living in a rural community, being over 40, and being non-Internet users.

For those relying on the Internet, usage breaks down to be a 2:1 margin of search engines over other websites of a topical nature. Further, the demographics indicate people under 39 years of age in both urban and suburban communities.

What does this mean? Well, the reality is that for all intents and purposes, a large majority of B2C marketing efforts should be on the Internet, because that's where it's most effective. Further, almost all B2C marketing will be localized. In other words, while marketing to businesses (like a national magazine that needs a portrait shot in your community or an ad agency from out of town that needs something shot locally), your consumer marketing for services such as weddings, rites-of-passage ceremonies, family portraits, and so on are best served via an online presence.

[2]http://www.pewinternet.org/2011/12/14/where-people-get-information-about-restaurants-and-other-local-businesses/. Note: According to a footnote in the report, "the figures for these sources listed in the bullets sometimes exceed the total because respondents were allowed to give multiple responses."

Yes, some B2C clients get their information from local print publications, and at 30 percent that figure should not be dismissed. However, that advertising is static and should consist of images that will drive clients to your online presence, where they can better engage you.

As such, between the 47 percent online researchers and the 30 percent print-publication researchers, you've covered 77 percent of your prospective market. Because you can't control word of mouth, you now have a good idea of where to direct your B2C efforts.

One caveat: The notion of not being able to control word-of-mouth advertising is generally true. However, as a B2C marketer, you can entice your clients to push word of mouth in a tasteful way. Consider this: You've just done a family portrait or a portrait of a child, and you sense that the client really loved the results. They want to order the $1,200 framed 11×14 on canvas, but they also want the $100 set of wallet prints. Given what you know your real cost is for the 25 wallet prints, you could email the client and say:

> Dear Jane –
>
> We're so happy you love the portraits we did of your family, and we sure enjoyed working with everyone on such a fun shoot! We also know how much friends like to learn about these experiences on chat groups, email lists, forums, and blogs. So, if you'll be willing to share the story of your experience with a link to our website, we'll say thanks by including a 25-wallet photo set, which is a $100 value! Just send us a copy of the email from the email group list as it was sent or a link to your blog post, and we'll include those wallet prints in your enlargement order.
>
> Sincerely,
>
> John

When photographers used to put a couple's photo on their website or in their portfolio, it was a suggestion that that couple was among the finest—all validated by the photographer, who has clearly seen it all. Then photographers began, innocuously enough, sharing their latest weddings on their blogs—not for the couple, per se, but for their friends and colleagues. That soon morphed into brides expecting to be featured on the photographer's blog (with glowing words about the amazing event) and to get a first look at a select few images of their big day before all the photos were delivered.

At first it was something that newlyweds could share with guests and friends. It has since morphed into an entirely new word-of-mouth beast of a marketing machine. Brides share these things on wedding sites such as TheKnot.com, and on social media sites, such as Facebook. These "shares" are today's word-of-mouth marketing and should be encouraged whenever possible. Remember, whatever you post should have tasteful watermarks with your URL on them.

Business-to-Ad/Design/PR-Firm Marketing

Ad, design, and PR firms are used to booking photographers on a regular basis. This is good and bad. It's bad because they likely already have a stable of consistent and capable photographers with a track record of success whom they call on and have a relationship with. It's good because it's a target-rich environment, as almost everyone there has multiple photographic needs.

As discussed in *Best Business Practices for Photographers*, your subject lines are critical. They have to mean something to the person reading them. Subject lines such as "Hi John" or "As we discussed" will get trashed.

A subject line such as "Photo update – a few images from Sweden" is better. And "Mouthwatering images from dinner at the Ritz" will get attention for your food-centric photography clients.

Unlike the business-to-business marketing addressed in the next section, the problems that resulted from massive overuse of email promotions has rendered them all but ineffective. Advertising and design firms get hundreds of these emails a day, crushing their inboxes. You can use services such as Agency Access or Yodelist to find prospective clients, but a direct connection to them will be necessary.

When the firm is a large one, they almost always will have an art buyer, and those are often your best bet and an under-considered person to focus on. One point made in a lecture by creative and marketing consultant Suzanne Sease was that some providers are called "service buyers," and there seems to be some confusion about the role that title fulfills. From some of the responses she received when she shared that title, I concluded that people with that title are largely buying printing, web hosting, and other commoditized services, rather than creative services, which do not fit well into a commoditized model.

Commoditized Services

A commodity is an item that is easily interchangeable and interoperable, such as a can of soup or a roll of toilet paper. Photographers who operate under a commoditized model for their services are forced to compete largely on price, which is a losing proposition. Avoid being considered a commodity at all costs, and do everything you can to distinguish yourself and your services as unique.

The last thing you want to do is trip when trying to put your best foot forward. Make sure you've done the research necessary to know what a person has done and whether she's still doing it before contacting her about that work and working with her on that client in the future.

When choosing to market to a prospective client, it's critical to understand the various specialties a firm handles. Resources such as Accounts on the Move will tell you which ad agency just won a client, project, or new campaign and will allow you to precisely market your photography to that agency in a way that fulfills their needs. If you're a food specialty photographer, knowing that Campbell's Soup was just won by ACME Advertising lets you send a congratulatory email and a link to your work to those who won the account, in the appropriate city. The Chicago offices of We Make Wonderful Ads might have no clue that the New York office of the same name won the Pillsbury account for baked goods. We use LinkedIn to learn as much as possible about prospective clients after we find out who in that firm won the work. In the next section on marketing directly to businesses, I'll explain how easy it is to figure out someone's email address. However, it may be more effective to use a service like Agency ComPile, which offers a free subscription.

Sending a congratulatory email with a link to your work (ensuring that the work is similar to the client's past campaigns or similar to the campaigns shown on the firm's website) is of significant value. Make sure, as previously noted, to have a great subject line. Something like "Congratulations on ACME winning the Nike account!" will likely at least get your email opened.

If you're looking to break into a firm to work for an existing account, you can use a service like AdForum and AgencySpy to do the necessary research.

On all levels—local, regional, and national—ad agencies like to win awards, and they put in their best work, which not only includes photography, but also who their clients are. Spending time doing research at

all levels of the contests will garner you a truckload of information to find campaigns that have work you like and that you could do, and all the insights necessary to make outreach to those clients to win that work for yourself.

Business-to-Business Marketing

Unlike when you engage an advertising, design, or public relations firm, where they are used to hiring photographers on a regular basis, business-to-business (or B2B) marketing has a much steeper learning curve. You may be marketing to a B2B client who has rarely, if ever, hired a photographer before. Often there's sticker shock; however, that is often tempered by the reality that the person hiring you isn't the one paying the money. As long as your compensation fits under a budgetary line item, you're usually okay.

First consider why a company would hire a public relations firm. Usually that company has a PR person who does a variety of tasks. However, when there's a huge marketing push for a new product or the company needs to be reactive to adverse publicity (because of a product recall or a company scandal, for example), that PR person can't handle the surge of workload. So, the company brings in someone to lighten the load and to help effectively resolve the matter.

In much the same way, your job will include making the project you're tasked with easy for the person who hired you. Saying things like "We'll handle finding and booking all the models" or "We get the subjects to review and approve their portraits and all the retouching before they leave the shoot so you're not chasing them down afterward" can make life easier for the client. So does telling a client, "We'll bring our studio to you and work in your conference room so all the stakeholders can have input without having to travel to us, saving all the associated downtime." You have to take on much more of a producer, project manager, and/or problem-solver role. The easier and more seamless you can make the project, the better. Your marketing to these clients should reflect that.

Usually, your prospective client will be the creative director, graphic designer, communications manager, or public relations manager. Locating these individuals in any company is pretty easy—especially the last two, for whom you can just visit the pressroom section of the company's website. If it's a small company, with very little effort you should be able to identify the hiring decision-maker. Then, start with a phone call that goes something like this:

> Hi, this is John Harrington, and we're looking to expand the group of clients we work with. I would love to email you from time to time to share with you the assignments we've been doing. Would it be okay if I sent you an email on occasion?

When the person says yes, say thank you and wrap up the call. Don't start with the horrible "I'd like to speak to the person who handles your photography needs" line. That will get you a "Please take me off your call list" request. Have the person you need to speak with figured out before you call, and if for some reason it's the wrong person, they'll likely tell you, and then you can ask whom you should contact.

You'll notice the query doesn't ask for their email address. You should be able to figure it out. How hard is it to figure out that because Ricardo Johnson is the creative director at Acme Widgets, his email is going to be RJohnson@ACMEwidgets.com, Ricardo_Johnson@ACMEwidgets.com, or Ricardo.Johnson@ACMEwidgets.com? A follow-up email sent shortly after the call should go something like this:

> Dear Ricardo,
>
> Thanks for taking the time to speak to me a few minutes ago and for being receptive to the occasional email. My website with all my latest work on it is http://www.JohnHarrington .com, but attached is something not on the website that I produced just last week.
>
> Thanks again, and I look forward to sharing a few images from time to time!
>
> Best,
>
> John

That email should also include your signature block at the bottom. Don't send it 30 seconds after you get off the phone, but within 15 to 20 minutes. You've just executed two of the nine contacts with a prospective client, and you've established permission to market to them. Then, send the prospective client an email about once every two weeks. Weekly will be too much for you and for them, and monthly is too long of a gap.

In the end, the degree to which you can make your clients' jobs easier and, as Heisler said, how easy and nice to work with you are will determine how successful you'll be in marketing and growing your business.

Recommended Reading

Adler, Lindsay Renee. *The Linked Photographer's Guide to Online Marketing and Social Media.* Boston: Cengage Learning, 2010.

Gladwell, Malcolm. *Blink: The Power of Thinking Without Thinking.* New York: Back Bay Books, 2007.

Gladwell, Malcolm. *Outliers: The Story of Success.* New York: Back Bay Books, 2011.

Gladwell, Malcolm. *The Tipping Point: How Little Things Can Make a Big Difference.* New York: Back Bay Books, 2002.

Heath, Chip, and Dan Heath. *Made to Stick: Why Some Ideas Survive and Others Die.* New York: Random House, 2007.

Kerpen, Dave. *Likeable Social Media: How to Delight Your Customers, Create an Irresistible Brand, and Be Generally Amazing on Facebook (and Other Social Networks).* New York: McGraw-Hill, 2011.

Levinson, Jay, and Jeannie Levinson. *The Best of Guerrilla Marketing: Guerrilla Marketing Remix.* Irvine, CA: Entrepreneur Press, 2011.

Piscopo, Maria. *The Photographer's Guide to Marketing and Self-Promotion.* New York: Allworth Press, 2001.

Scott, David Meerman. *The New Rules of Marketing & PR: How to Use Social Media, Online Video, Mobile Applications, Blogs, News Releases, and Viral Marketing to Reach Buyers Directly.* Hoboken, NJ: Wiley, 2013.

Stone, Amanda Sosa, and Suzanne Sease. *The Photographer's Survival Guide.* New York: Amphoto books, 2011.

Chapter 8
Your Brand and Your Image

Actors have brands. For example, when was the last time you saw Arnold Schwarzenegger doing an intimate love scene? Is John Goodman identifiable as an action hero? Would Britney Spears or Lindsay Lohan ever be believable in the role of a brainy academic? These aren't criticisms; they are observations about how these actors live their brands. And just like actors have brands, so do you. Your brand is who you are.

A whole host of branding consultants can help you identify your brand. Among the best is someone I turned to more than a decade ago—Beth Taubner of Mercury Lab (www.MercuryLab.com). I spent my early years consulting with brand genius Elyse Weissberg, who passed away. I then meandered for several years before hiring Beth. It's been far too long since I worked with her, but her early insights and advice were very helpful.

This chapter doesn't endeavor to define you or your brand; it can't possibly do so. What it can do, however, is get you started thinking about all of the aspects of branding—and the value in hiring professionals to do something that you may not be a professional at.

Much of what we do as photographers is hard to quantify. It's easy to say, "It takes $24 in materials and supplies to build a widget, so the company should charge $48 as a wholesale price, and thus full retail price on that same product is $96." Yet how do you quantify the value of a Picasso? Certainly, the canvas and oils are all but irrelevant in the pricing model. So, too, was the cost of a roll of film for Richard Avedon.

Emotional Branding

Appealing to clients' emotions can help you garner an ongoing relationship because clients feel connected to you, and they like how your work makes them feel and how it brings their ideas to life. The key to successful emotional branding is to engage your client at a level that goes beyond just loyalty. You want the evangelist clients who say, "You need someone to shoot *X*? You've got to go with *Y*; don't bother considering anyone else!" Or, to go one step further, you want the clients who, after working with you, go back to their colleagues and, apropos of nothing, say, "Oh man, I just had this shoot that was about to go south, and John Smith, the photographer, completely saved it!" You should strive for that level of commitment.

Brand Architecture

Your brand architecture—that is, your branding on your website, business cards, email logos, contract banners, letterhead, equipment labels, and CD/DVD labels—all should be the same. Unless you're a multi-faceted photography company that, say, provides advertising work, weddings, and senior portraits using different variations on your name, you are what's called a *single-brand* or *monolithic brand*. Many people will ascribe brand architecture to the inter-relationship between brands under a single umbrella company, but I

would submit that within your company there is a structure of architecture to all of the facets of your marketing that needs to feed back to your single endeavor. For example, Toyota is a monolithic brand, whereas for General Motors, there's Chevrolet, GMC, and so on, all under very distinct nameplates.

Diluting your brand can be very dangerous to your bottom line. One example of diluting a brand comes from misperceptions about a photographer's abilities. Many corporate or commercial clients will discount the abilities of a photographer who lists weddings on his website as a service he provides. For this reason, your brands should be separate. In fact, there may be substantial value in differentiating your brands between editorial work, commercial work, and weddings and family portraits.

There is a theory that the jack-of-all-trades is the master of none. In a large area like New York City, serving a niche is important; however, in smaller communities, you may need to do many different things. But if someone from New York City calls to get a portrait done for a commercial need in your community, they'll discount you if they see weddings on your website—even if you're the best in town, they'll decide to fly in a big-city photographer to do the work. Seriously.

Business Names and Taglines

Creating a business name is critical, and there may be a place for a tagline, too. Between high school and college, one of the businesses I started was a boat-cleaning service using my SCUBA certification. My tagline was "Down deep, we care." I intended the double entendre, and I'd like to think I did a pretty good job of coming up with a catchy phrase at the tender age of 19. Taglines like "When your image counts" or "We make your memories last forever" can drive a client to remember you, but an advertising agency's art director will roll his eyes at both taglines as he closes the window with your webpage displayed. The first tagline might apply to a portrait studio, and the second to a wedding or rite-of-passage photographer; certainly neither would apply to a corporate or commercial photographer.

In Chapter 10, "The Wordsmithing of a Linguistically Accurate Language Lexicon," we'll talk at length about using proper language in your communications. Similarly, your brand language is critical. Would you say "We shoot family portraits" or "We produce luxury portraits for discerning clientele"? And the difference between "we shoot," "we photograph," "we take photos," "we make photos," and "we create photos" is all about brand language. "We produce" suggests more effort, energy, planning, and work than the other choices.

Do you get offended when someone asks you to "snap a few photos, please?" Snap?! Seriously?! That's the antithesis of good brand language. You may want to read Chapter 10 on language closely and review Chapter 6 on cognitive thinking with this concept in mind.

Also beware of the importance of multi-language marketing. If you want to market to an English-speaking and a Spanish-speaking community, spending the few dollars on someone who is a native-speaker in that language will help to minimize any major language missteps!

Using a Designer for Your Brand

Do you get upset when you hear about a designer doing a company's portraits? Shooting the products? Well, imagine how much a designer laughs when she looks at a poorly designed website with typos and bad brand implementation! Just like you might look at a website and say, "Couldn't they get someone to do some decent portraits?" or "Why are all those product shots so flatly lit?" a designer might look at a website and branding and conclude the same about you. And because the designer is likely the person considering hiring you, your photos have to be that much better to compensate for the bad branding and presentation, which may be a turnoff for the designer.

Self-employed designers or those who work in a small shop typically charge between $75 and $150 an hour. Once you've had a consultation to tell them what you want, they will usually present their ideas as a first draft. Sometimes it's spot-on, but sometimes you'll want something combined, and the designer will come back with a second round. Round and round you'll go until you have the result you want.

For example, let's talk about logos. Logos should be clean and easily recognizable. They should render well in color and black-and-white. They should look good as watermarks on photos. And they should be completely original. Hiring a professional designer will help you avoid the possibility of inadvertently copying someone else's brand idea. You can be inspired by someone else's whimsical typeface to market their pet portraits, but you don't want to copy the same font, look, and feel for your own logo.

The next three spreads contain the first, second, and final versions of the logos for a project I was working on to promote a business with a longtime colleague, Charlotte Richardson. We needed to pull together a joint logo for both a photographic-services idea and a productions idea, as well as business cards for a division of the business we were looking into marketing to attorneys. The idea was that the productions segment would be a broader provider of high-end advertising and would allow video productions to be a part of it, whereas the photographic-services segment would be a more event/portrait level of service, slightly less high end than what a production would call for. Once we got to the final logo series, we were able to pull together treatments for business cards, too. Our designer, Jessica Gladstone (www.GoodToBeGlad .com), did an amazing job.

Version # 2

A: Top - Optima Bold
 Bottom - Futura Cond. Medium

B: Top - Cambria Reg.
 Bottom - Calibri Regular

H + R

Productions

H + R

Productions

H + R

Productions

H + R

Productions

H + R

Productions

H + R

Productions

DESIGNER NOTES: Logo Designs Proof#2
Client: John Harrington Photography
Designed by goodtobeglad,
www.goodtobeglad.com • 703-472-2743

C: Top - Optima Bold
Bottom - Franklin Gothic Book

D: Top - Lucida Grand Regular
Bottom - Calibri Regular

H + R

Productions

H + R

Productions

H + R

Productions

H + R

Productions

H + R

Productions

H + R

Productions

☐ **NEEDS CHANGES AS INDICATED ABOVE**

APPROVED_____

DATE_____

A-1 **HARRINGTON + RICHARDSON**
Photographic Services

A-2 **HARRINGTON + RICHARDSON**
Photographic Services

B-1 **HARRINGTON ┼ RICHARDSON**
Photographic Services

B-2 **HARRINGTON ┼ RICHARDSON**
Photographic Services

B-3 **HARRINGTON ┼ RICHARDSON**
Photographic Services

DESIGNER NOTES: Logo Designs
Client: John Harrington Photography
Designed by goodtobeglad,
www.goodtobeglad.com • 703-472-2743

C-1 HARRINGTON + RICHARDSON
Photographic Services

C-2 HARRINGTON + RICHARDSON
Photographic Services

D-1 HR HARRINGTON + RICHARDSON
Photographic Services

D-2 HR HARRINGTON + RICHARDSON
Photographic Services

D-3 HR HARRINGTON + RICHARDSON
Photographic Services

☐ **NEEDS CHANGES AS INDICATED ABOVE**

APPROVED_____

DATE _____

Final

HR HARRINGTON + RICHARDSON
Photographic Services

HR HARRINGTON + RICHARDSON
Productions

HR HARRINGTON + RICHARDSON
Productions

HR HARRINGTON + RICHARDSON
Productions

☐ **NEEDS CHANGES AS INDICATED ABOVE**

APPROVED_____

DATE _____

DESIGNER NOTES: Logo Designs Final
Client: John Harrington Photography
Fonts: Top = Cambria Regular; Bottom = Calibri Regular
Colors: Black, Gray/K=60 (silver when possible),
 Green: C=90, M=38, Y=96, K=36

Designed by goodtobeglad,
www.goodtobeglad.com • 703-472-2743

HARRINGTON + RICHARDSON
P h o t o g r a p h i c S e r v i c e s

JOHN HARRINGTON

John@Attorney-Portraits.com
Washington, DC
office: 202-544-4578; cell: 202-255-4500

www.Attorney-Portraits.com

HARRINGTON + RICHARDSON
P h o t o g r a p h i c S e r v i c e s

JOHN HARRINGTON

John@Attorney-Portraits.com
Washington, DC
office: 202-544-4578; cell: 202-255-4500

www.Attorney-Portraits.com

HARRINGTON + RICHARDSON
P h o t o g r a p h i c S e r v i c e s

JOHN HARRINGTON

John@Attorney-Portraits.com
Washington, DC
office: 202-544-4578; cell: 202-255-4500

www.Attorney-Portraits.com

DESIGNER NOTES: Business Card Designs Proof#1
Client: H+R Photographic Services
Designed by goodtobeglad,
www.goodtobeglad.com • 703-472-2743

✸ **NEEDS CHANGES AS INDICATED ABOVE**

APPROVED_____

DATE _____

When we worked with our designer, we didn't have her design or code a website, blog façade, or other online materials or even design a letterhead. However, she is more than capable of doing that. All of the design work we asked her to do took her about six hours.

Coordinating Your Brand across Your Business

Whether you want a whimsical feel or a dark and moody approach, everything has to be coordinated across your business. We have a professional voice for our voicemail, and the words we use on the website to describe what we do and who we are are important.

Do you offer discounts? Tiffany, for example, never has sales. Never. Hermes only puts seasonal items on sale, their classic items never go on sale. While I am not completely opposed to sales or promotional pricing, they should be done with significant consideration to how they could diminish people's perspective on the value of you and your brand.

How do you dress when engaging with clients, both in meetings and on shoots? Your attire is an adjunct to your branding.

If you have a physical studio, it should have the same look and feel as your branding. Do you use modern fonts and crisp whites on your website? Then your studio's reception area and furniture should be modern as well—minimalist. And make no mistake about it, with Google Maps and today's Street View technology, even if a client isn't coming to your studio, he may well look it up on Google to see what your place of business looks like!

Something as simple as having all Pelican cases, all black soft cases, or all cases of a similar brand with the same color palette can make a difference. What's that, you say? Who cares what your equipment cases look like? Shouldn't you be judged by your photos alone? In a perfect world, sure. But in the real world, a cohesive look and feel is just one more subtle way to lend credibility and professionalism to your brand. When you dine out, do you judge the service and whether the wait staff are well dressed and look professional? How about the restaurant's general atmosphere? Just like you don't judge a meal out solely on the food, your business isn't solely judged on the quality of your images.

Our deliverable platform, PhotoShelter, allows us to brand that platform with our website's look and feel, even though they don't host our site. This creates a seamless feel between our website and their site. We use a service called PhotoFlashDrive (www.PhotoFlashDrive.com) to brand the USB drives we use for client deliverables. They'll even brand hard-drive enclosures. From crystal thumb drives to wood, metal, and plastic, you can choose from hundreds of materials to complement your brand.

For some time, you could brand the nameplate and a few other graphics in Adobe's Lightroom software, so that when a client was looking at images, the subtle message of showing your logo instead of "Adobe Lightroom" provided a more customized experience. Now, Adobe takes it one step further, allowing you to customize their splash screen on launch. So, this splash screen:

Can be changed to this:

Simply go to the Preferences option, General tab, and ensure that Show Splash Screen During Startup is checked. Then, on the Presets tab, uncheck Store Presets with This Catalog and click Show Lightroom Presets Folder. Within that folder, create a folder called Splash Screen. If there is already a folder called Splash Screen, whatever is in there will be the splash screen each time you open the program. If there isn't, Adobe will use the default screen. So save whatever images you want within a 900-by-600-pixel area.

If you work with a designer, he will also help you choose colors, or you may have a palette in mind. Colors say a lot, and you need to communicate the right messages with your colors. For example, pinks and pastels are obvious colors for weddings. Bright colors could be good for children's photography. Rich, deep colors are often good for "serious" photography. And while you may have selected the right colors for fonts, what

about background color? Think beyond white and black—what colors? How about logo color? What colors contrast well with one another? What colors print well? When they're considering you for an assignment, clients may print out your webpage and turn off the Print Background Colors option when printing from a browser. If you have black backgrounds and white text, all the text will disappear. One trick is to choose a medium gray to go against the black, so your information will print!

Once you've chosen your base or primary color, you can use an amazing application, Adobe Kuler, to find complementary colors. If you have Adobe's Creative Cloud, it's easily accessible right in the cloud.

Colors can say you're edgy, romantic, soft, or hardcore. Google "color theory," and you'll launch yourself into a whole new, critically important world of wonder. You may enjoy reading it to help you make better images from a color standpoint, but perhaps you should leave it to the expert designers when it comes to your website and logo design. After all, this is what they do for a living.

Google "branding for photographers," and you can begin to explore how other photographers take this stuff so seriously, as well they should. Searching through the websites for inspiration will ensure that you're well versed in what should be done when you connect with the right designer.

One thing a designer will do is ask you what you don't like about your current website, as well as what websites you really like the look and feel of. Just as you can deconstruct a photo into what makes it appealing or distracting, a good designer can distill common themes from the websites that inspire you, and he can bring together a collection of ideas to give a cohesive look and feel to all your client-engagement tools.

Chapter 9

Do You Need to Have a Niche or a Style?

Although you don't *need* to have a niche or style—and in fact in some cases it can be limiting—in today's world, you can have your cake and eat it too. Consider a photographer whose style is gritty journalistic style, with no strobes. On a separate website, that photographer can also feature his bubble-gum-bright wedding photography. With multiple websites, it's entirely possible for a photographer to showcase multiple styles. I will say, however, that I've had prospective clients call me for a commercial job and say that they found me by looking at photographer listings and choosing a photographer who *didn't* show weddings on his website. Funny thing is, I've done weddings (though it's been a while now), and I would happily do one again. But after having heard this more than once from a client, I would definitely put up a specialty website just for my wedding work.

Generally speaking, your niche is your area of photography. Weddings are a common niche, as are family portraits (which include senior portraits). In *Best Business Practices for Photographers*, we also discussed rite-of-passage photography, which includes bar and bat mitzvahs. Another niche is youth sports, and there's also commercial/corporate, advertising, editorial news, and editorial portraiture photography.

The size of the market you're in can dictate whether you need a niche. In New York City, where you can't swing a dead cat without hitting a photographer, having a niche is critical to standing out. In smaller towns, you usually have to be more of a generalist. Yet even in a town like Jacksonville, Florida, you'll find sports photographers, rite-of-passage photographers, food photographers, and so on.

And within your niche, you have a style. For example, in editorial portraiture, there's journalistic style, brightly lit style, a lit style that looks natural, and theatrical on-set portraits where an entire set is built around an idea. Or, there are portraits done on seamless. As another example, in weddings, there are documentary and glamour/high-fashion styles. And even within these styles, you can do all sorts of post-processing on images to take them to the next level. A documentary wedding photographer can push the envelope in the post-processing to create a dreamy quality to the images.

Different schools, too, produce different styles. Brooks Institute of Photography and Rochester Institute of Photography produce many photographers who have highly stylized studios or do bright on-location types of photography. On the other hand, Western Kentucky University and Syracuse University produce photographers with much more of a journalistic style. Of course, anecdotal evidence exists to dispute these generalizations, but there's some truth in the fact that styles can influence a photographer and, in fact, be self-perpetuating.

So what's your style? And do you have a niche? If you're trying to figure this out and not having much success, ask someone else to look at your work. Often a fresh pair of eyes can see something you're overlooking.

If you don't know what your niche is, ask yourself what you like to photograph. Looking for the adrenaline rush of a war zone, or perhaps the rush of getting that shot of the bride and groom going up the aisle in their first moments as husband and wife? Want to see the joy in a baby's eyes or tell a CEO how you're going to make him look authoritative and in charge? Or maybe you want quiet time in the studio, collaborating with a chef to showcase his dishes as not merely food, but cuisine.

When you find your style, people will say you've "found your voice." However, the idea of "if you shoot it, they will buy" doesn't necessarily apply. Among the millions of images out there, your work has to stand out and be seen.

Find a Viable Niche

The challenge is that if you have a niche that no one else is doing (yet), it should be commercially viable—or else it's just an expensive hobby. Then, you should work to grow that niche. Case in point: Photographer Aaron Jones, also known as "the Hosemaster," developed a technique that used powerful lights in fiber-optic lines to allow the photographer to, while working in a totally dark or near totally dark studio, literally paint light into a scene. So, while working in a dark studio, you could photograph a pair of shoes where you painted the logo inside of the shoe on the heel clearly and perfectly, and then you painted the shoe itself, and then you de-focused the entire scene slightly and painted the rest of the area being photographed. This resulted in an otherworldly (and previously unseen) style of photography that became all the rage—so much so that Aaron began selling the device he had patented to do it. Although the technique fell out of vogue several years later, initially the style was so distinctive that it was immediately noticeable and quite appealing. These days, that same tedious process can be accomplished in Photoshop in less than three minutes. So it helped that the Hosemaster's technique came into style pre-Photoshop, during the era of film.

Chapter 10

The Wordsmithing of a Linguistically Accurate Language Lexicon

Let's first break down the title of this chapter, word by word:

> Wordsmith: A person who works with words, especially a skilled writer
>
> Linguistically: Of or relating to language
>
> Accurate: Correct, truthful, factual
>
> Language: Mechanism to communicate
>
> Lexicon: Collection of words to utilize for a given task[1]

While anyone can make a photo, not everyone can make a compelling photograph. And the best bodies of text are written by professional copywriters. Designers are offended when we think we can lay out brochures and marketing materials better than they can. When you're working on developing language for a contract, website marketing text, a biography, or emailed letters to prospective clients, those who edit and write copy for a living are invaluable. This chapter presents the importance of language and parses sentences, words, and meanings, so you can say what you mean.

That Depends on What the Definition of "Is" Is

The ability to parse words is almost infinite in nature.

During impeachment proceedings, then-President Clinton famously said, "That depends on what the definition of 'is' is."

That statement is one of the more famous misstatements and obfuscations by a president (let alone anyone else!), and it surely didn't pass the American people's "smell test." In fact, I've often used it as a shorthand

[1]Source: *Merriam-Webster.*

way to demonstrate the absurdity of a comment someone else has made. However, let's take a look at what was said, just to try to understand his point.

During a deposition on January 17, 1998, regarding the case of Paula Jones (who had accused President Clinton of sexual harassment), Clinton's lawyer, Robert Bennett, stated with regard to White House intern Monica Lewinsky, "There is absolutely no sex of any kind in any manner, shape or form, with President Clinton."

And this is where the problem arose. Approximately a year later, during Clinton's deposition as a part of his impeachment proceedings, he was asked a question about Bennett's statement: "Counsel is fully aware that Ms. Lewinsky has filed, has an affidavit which they are in possession of saying that there is absolutely no sex of any kind in any manner, shape, or form, with President Clinton. That statement is made by your attorney in front of Judge Susan Webber Wright, correct?"

Clinton answered, "That's correct."

The lawyer deposing the president then asked, "That statement is a completely false statement. Whether or not Mr. Bennett knew of your relationship with Ms. Lewinsky, the statement that there was 'no sex of any kind in any manner, shape, or form, with President Clinton' was an utterly false statement. Is that correct?"

The president responded, "It depends on what the meaning of the word 'is' is. If the, if he, if 'is' means is and never has been, that is not—that is one thing. If it means there is none, that was a completely true statement."

The discourse went on for a few moments, then returned to this: "You are the president of the United States, and your attorney tells a United States District Court judge that there is no sex of any kind, in any way, shape, or form, whatsoever. And you feel no obligation to do anything about that at that deposition, Mr. President?

Clinton answered, "I have told you, Mr. Wisenberg, I will tell you for a third time. I am not even sure that when Mr. Bennett made that statement that I was concentrating on the exact words he used. Now, if someone had asked me on that day, are you having any kind of sexual relations with Ms. Lewinsky—that is, asked me a question in the present tense—I would have said no. And it would have been completely true."

The key word is "is."

The statement "There is no sex of any kind" is being linguistically broken down. "Is" is a present tense. Had the statement been "there is and there was no sex of any kind," that would've covered the intent of the question. Precision of language is critical. I present this example as a very well-known story about how language can be exacting. In the end, despite the president delivering a linguistically accurate statement, the American people did not feel that he was being honest with them.

How Does Your Word Choice Make People Feel?

When you're talking to clients, use words of encouragement. People want to be told they look great. When a client steps in front of the camera we tell them that. As Warren Beatty, as cited in Frank Luntz's *Words That Work: It's Not What You Say, It's What People Hear* (Hyperion, 2007), said, "People will forget what you say, but they will never forget how you made them feel."

Sometimes it feels like the only thing people hate more than having their photograph taken is going to the dentist. I've seen people come up with all manner of excuses for why they can't have their photograph taken.

About 10 years ago, I found myself in a law firm with almost 100 attorneys. The office manager was desperate to get people's portraits, yet everyone seemed to have other obligations. We arrived, and she had only been able to schedule six portraits. After each session we would pull the images up on a laptop and show people the photos. We walked them through the shots and helped them find the best one. When they made their choice, we would pull the image into Photoshop and quickly fix all manner of wrinkles, thick necks, frown lines, and so on. We did this right in front of people, and they were amazed.

After each portrait was finished, I would wrap our session by saying, "I hope that wasn't too painful," and each of them said, "Oh no, not at all. It was actually much easier and more fun than I thought." And I would say, "Please let your colleagues know how quick and painless it was"—and lo and behold, they did. By the end of the day we had done almost 30 portraits and were scheduled back for two more days to do the rest of the firm.

It's worth noting here that this, among many other reasons, is why we charge by the shot/portrait. A $2,000 job became a $20,000 job, and it's because of the words we used to change how people thought about what we were doing. We shifted their thinking from distaste to enjoyment, and the gentle nudge of "I hope that wasn't too painful" got them thinking that it really wasn't! To this day, we use the same subtle language to coax people's thinking in the right direction.

During client pitches, we often encourage a prospective client to visualize—or, as Luntz says, "imagine"—a final image. This engages the creative side of their brain, and it allows you to take prospective clients on a visual journey into the world you're proposing to create for the assignment you hope to win.

Choosing Just the Right Words

In Frank Luntz's, *Words That Work*, he wrote that "the people are the true end; language is just a tool to reach and teach them, a means to an end." As such, if your goal is to reach your prospective client (and I can't imagine what else it might be), choosing just the right words is critical to connecting with them.

Listening to what your clients say in response to you, your work, or your words is critical. For example, one of the portraits in my portfolio is of a young bullfighter in Mexico. I took it more than 20 years ago, and frankly, I'm tired of it. However, when I share my portraits with prospective clients, they always comment on it, so, as was said of Hollywood legend Robert Evans, "the kid stays in the picture."[2] Just as I'm tired of seeing that same photo, you may be tired of saying the same thing in your emails or promo pieces. Yet if your words work, keep using them.

We have carefully reviewed every sentence in our contracts and cover letters to ensure that we are conveying just the right confident tone and demonstrating that we are the right photographer for the assignment. Our wording works, so we keep it.

Now let's delve further into "words that work," as Luntz would say, for photographers.

[2]This quote is often misattributed as having been said by Robert Evans, but actually it was said by studio executive Darryl Zanuck about Robert Evans in 1957, when others in a movie were threatening to quit. Evans stayed. Evans later used the phrase as a title for his autobiography and the film adaptation of the book.

Wordsmithing Various Sentiments

There are a variety of sentiments you will want to express to a prospective client. Whether it's characterizing a service you offer or refining the nuances of the salutation and closing of correspondence, these details matter.

Luxury Portraits

Luxury portraits: What does that really mean? I first saw this characterization of a portrait shoot when I read details about Jenika McDavitt's portrait business. She characterizes herself as a "luxury portrait photographer in Baltimore, Maryland, who specializes in creating vibrant, lasting images to adorn your home."

Who wouldn't want to learn more about a "luxury portrait" session? I envisioned a dark sedan pulling up to the subject's home, with a chauffeur-driven trip to a location with an air-conditioned star trailer, a full assortment of catered options, and separate hair and makeup persons. But I knew that while Jenika *could* provide this, it wasn't likely what she meant. Instead, she meant that her portraits would exude the luxury and style that a high-end client would look for. To be sure, no price-shopping prospective clients would book a session with her—yet they might aspire to when they could afford it. With this simple description, Jenika sets the bar high for prospective clients and their expectations of her.

Jenika also refers to the images as "vibrant" and "lasting," and even more significantly, she assures clients that they will "adorn" the home. "Adorn" means to "make more beautiful or attractive." Jenika doesn't say "images to hang in your home," as that would be a significantly less colorful characterization of what the photos will do; it's a utilitarian statement. But "images to decorate your home" sounds kitschy or campy, like how you might characterize using a fake floral arrangement. "Adorn" contains a much more classy, even luxurious, meaning.

Photographer versus Photography

When I was starting out in photography, one of the people I turned to for advice and counsel was Elyse Weissberg, a highly regarded consultant (and for those lucky enough, a photographer's rep) in New York City. Elyse has since gone on to her great reward, but her messages live on. This is one of them: When I was trying to decide whether I should be "John Harrington Photographer" or "John Harrington Photography," she enlightened me to the fact that "Photographer" was just one person, and "Photography" was a company with possibly multiple people working for it. It was a business that other businesses would want to work with. Some businesses shy away from working with a one-person operation, so why not present myself as a full-on business? And with that, John Harrington Photography was born.

Sincerely Yours versus Sincerely versus Yours Sincerely

Often cultural differences can define how you close a letter. Closing a formal letter is tricky and sometimes depends upon the country as well. In the United Kingdom, for example, people use "Faithfully Yours" when they're unfamiliar with the other person, whereas in the United States using "Faithfully" is rare and brings an air of "faith" (and thus religion) to the correspondence. "Yours Sincerely" and "Sincerely Yours" are used essentially synonymously to close a letter. In the United States, this has been truncated to "Sincerely," and for many communications it's a good way to formally close your correspondence. For professional correspondence, "Sincerely" is likely your best choice among these three.

Thanks versus Thank You

Ending a letter with "Thanks" is very informal, and "Thank You" is an expression of appreciation—usually for considering or doing something requested in the communication. It's usually short for "Thank you for your time/assistance/consideration."

Best versus Best Regards versus Regards versus All the Best

To end something with "Best Regards" is to add a superlative to your admiration. To "regard" is to think of someone in a certain way, so "best regards" is like saying "my best thoughts to you." "Regards" is just a shortening of the same sentiment. Using "All the Best" suggests you're sending "all the best" to the recipient as you close the letter.

While "best" is meant to be a shortening of that same sentiment, the word's proximity to your own name brings the sentiment to a new subliminal position.

> Best,
>
> John

In this instance, the association between "Best" and my name creates a word association between the two, suggesting that "John" is the "Best." That's a nice sentiment to leave in the mind of a client, right? In *An Introduction to the Psychology of Language* (Psychology Press, 2013), sub-sentence structure is addressed at length and throughout the book. There are left-to-right associative dependencies, which allow one to expect "the association adjective-noun, in that order, within a phrase," so the juxtaposition of the adjective "Best" with my name causes that adjective to apply to me, by my name.

Your Words and Phrases Must Answer "Why You?"

In this extremely competitive world, you have to give the client the answer to the question "Why you?" or they will go with someone else. Often, confidence in the fulfillment of the services you will provide is key. Of course, you don't want to promise what you can't deliver. Maybe the answer is also, "I'm the only professional photographer within three hours of you."

That certainly makes you the best and only viable choice. However, a better angle is likely, "I've done what you're looking for with exceptional results hundreds of times." Or maybe, "When you want a portrait that really shows who you are, I'm the guy." Or, "You only have one shot at great photos when you're recessing up the aisle or sharing your first dance. There are no redos on those images. We're skilled and experienced in capturing those moments each and every time. Why trust your big day to anyone else?"

The "only one shot" scenarios come up often for me, whether it's 30 seconds in the Oval Office or a quick handshake in a receiving line with the celebrity of the day.

It is also important that your answers to the "Why you?" question make sense in terms of the client's needs. If it's not an "only one shot" scenario, don't sell that. Instead, maybe it's "We get it right the first time" or "We do remote art direction in real time so you don't have to leave the office." But be careful with that last one, because many art directors love getting out of the office and out on shoots. If so, instead talking about the amenities of the shoot may answer the question.

"Why" isn't always something you think you bring to the table. For some clients, the "why" is largely a "why not" about someone else. For example, I have one client whose "why John?" is because the photographer they used prior to me had promised same-day image delivery and failed to deliver, and the company's CEO was upset that the photos didn't arrive on time. So on my first assignment for the client, they actually insisted that one of their staff accompany me back to the studio and wait while we processed the images. We have rush surcharges, which they were happy to pay, but in this case the "why" was because we had promised same-day delivery—and while they believed us, they still wanted their staff to take possession of the images as soon as possible. To this day, the client calls on us multiple times a year for all manner of premium-level service, and they happily pay all quoted and appropriate charges for that level of service.

It's important to understand that the "why" can be any number of things, and often can be different things for different people. For example, for the aforementioned client, the most pressing problem was timing—they had to get the images as soon as possible. For, say, a family portrait, the most pressing problem might be whether the toddler in the shot is going to have a meltdown or otherwise ruin the photo. Listening to the client's needs and answering them with your "why"—such as the fact that you're the undisputed baby-whisperer in your community—will help them choose you.

Cadence

Of course, once you know the "why," getting everything into its proper cadence is key. Your style of delivery must exude confidence in both spoken and written communications.

Merriam-Webster defines "cadence" as:

ca·dence noun \ˈkā-dən(t)s\

: the way a person's voice changes by gently rising and falling while he or she is speaking

: a falling inflection of the voice

: a rhythmic sequence or flow of sounds in language

To that end, I will say it's hard to express cadence in writing. But let's do what we can. Before we get started, remember that your communication must be authentic and in your own voice. If you choose to use my sentences, phrases, or arguments, make them your own with a tone and cadence that works for you. Stilted speech, as if you were reading from a script, will come across as inauthentic.

If you say to someone, "You're John Harrington," and at the end of the sentence the tone falls lower, you're saying, in effect, "Hey, you're John Harrington!" However, if at the end of the sentence the tone rises, you're then asking a question: "You're John Harrington?" You can see how the cadence in this simple sentence can produce two different effects.

When I ask a client why I lost a job, I say in a very casual tone, "Oh, who'd you end up going with?" The "oh" is a soft, dropping "ohhhhh" that rolls off my tongue with a slight pause between the "oh" and "who'd"—the comma there represents about a two-breath pause. I say this softly and comfortably, and I've said it hundreds of times (which, yes, means I've lost hundreds of prospective assignments!). It just rolls out.

The question begs to be answered and almost always is. But now imagine if I said something like, "So who did you choose instead of me?" The tone is different no matter how you ask it. The difference between "who did" and "who'd" is significant, like the formal versus casual relationship between "I did not do it" and "I didn't do it," plus the use of "instead of me" can make someone feel bad.

When talking to a prospective client about a shoot, you might say, "We're definitely interested in this project! In fact, we just wrapped up a similar shoot a week ago!"

Adding "definitely," enunciating the word with confidence, adding "in fact," and emphasizing the word "fact" as if it's a bona fide fact, with a pause for effect, makes the statement that much more of a fact. (As if a fact can be anything more or less than factual!)

Lastly, the enthusiasm of the statement and your cadence when you deliver are important to the overall message that you are the right photographer.

Now, I recognize that I am getting very "meta" in these things, and to a large degree you're probably saying, "I just want to make photographs; I don't want to think about all of this." Realize, though, that you really *are* doing all these things; you've likely just not ever thought about it. Further, you use a cadence and organized discourse when you're engaging, cajoling, or otherwise breeding a familiar bond with the subjects you're photographing.

Organizational Messaging

Focusing on cadence is key, but your message will enhance that significantly. For example, when a client asks for same-day images and can we deliver that, here's how the exchange goes:

>**Client:** How soon do we get the photos?

>**Me:** As soon as you need them. Tell me, how soon do you need them and for what purpose?

>**Client:** Well, we need them the same day as the event to get them out to the press.

>**Me:** Okay, no problem. Now, here's my question: Do you need all of them the same day or just a few key shots for press and a blog posting? I ask because there's a nominal fee per image if it's just a few, or we run into rush charges if you want everything the same day.

>**Client:** Well, when can we get everything?

>**Me:** Our normal turnaround is two business days. If you want everything the next business day, the rush charge is 100 percent, and if you want everything the same business day/ASAP, then there's a 200 percent surcharge.

>**Client:** Okay, I'd like…

The client's inquiry about turnaround is a normal, almost everyday occurrence for me. My first response is to say "as soon as you need them," which is reassuring for the client. But I don't leave it there; I probe further: "How soon do you need them and for what purpose?" If it's an editorial client, they have production deadlines to meet. If it's a PR client, they often have same-day press deadlines. A corporate client may try to get material back in the same day as well, while a bride may just want to plan when her proofs will arrive after she gets back from her honeymoon.

Next, the client tells me they need them on the same day. There is a potential false assumption that they need "all" of them, when in fact they may need just a few. They then ask when they'll get everything, so now it's clear they are curious about getting all of them. So in this scenario, we're talking about a press conference a company is holding, and we're coming at it from the standpoint of the company's side. If it were an editorial client covering the same event, the answer would be the same but the deliverable would be different. The deliverable for an editorial client would likely be the best two to three images, properly captioned, for publication. The deliverable for the corporate client, really, is the same thing—immediately, but full documentation of the event at a later date.

We then let the client know why we're asking—"I ask because there's a nominal fee per image"—giving them pause. Then we use the "we're a team" "we" in the next point: "or we run into rush charges if you want everything the same day." If the client really only needs a few, at this point they will ask, "Well, how much is it per image?" to which we respond, "We've outlined this in the paperwork we've sent, but it's $65 per image. If we get into a bunch of images, that can drop down." In this alternative/additional response, we first tell the client it's in the paperwork and then we tell them it's $65 per image. We then also tell them, abstractly, that the rate can drop if it's a lot of images. Nearly always, the client wants two to five images, which translates to an increase of $130 to $325 for the work—and yes, this does also translate into additional work/effort on our part, and we have to bring our laptop/digital workstation to the shoot.

Next, the client wants to know when they can get everything. It's important to note here that while our role is to deliver what the client wants when they want it, we don't start by telling them what the rush charges are. We first tell them that the normal turnaround is two business days, and that's an important distinction. "Business days" means something. If a job takes place on Saturday morning, then our post-production person doesn't even begin looking at the memory cards until Monday morning. So, turnaround for that is two days later, or Wednesday morning. If the client wants the work midday Tuesday, then the images have to be done under the "next business day" turnaround. If the client wants them Monday, then that would fall into the "same day" turnaround. This is the case even though "same day" would be Saturday if we hadn't included the modifier "business" to say "business days."

This is also the case if we end a job, say, Wednesday at 8 p.m. The clock doesn't start ticking until Thursday morning, so a normal turnaround would be at the end of the day Friday, two solid business days later. Next business day would be Friday morning (or late Thursday night if we were feeling generous), and same day/ASAP would be as soon as possible on Thursday.

We've had clients who, for a Saturday morning job, have wanted images later in the day on Saturday, or for a Wednesday evening job wanted the images by midnight. Can we do it? Sure, of course. It then becomes a 250 percent rush surcharge, with that extra 50 percent being what we need to have our post-production person work on a weekend or late into the night.

The Importance of Listening

As the saying goes, we were given two ears and one mouth, so we should use them proportionately. Whenever you're speaking with a prospective client, listen. If it's a PR client, listen to them pitch to you about their event. If it's someone looking for headshots, listen to their sensitivities or concerns. If it's a bride, listen to her talk about her dream wedding—prompt her to tell you about it if necessary. Ask her how she got engaged, and then listen. Listen to a parent when her child is going through a bar or bat mitzvah, and ask her all about the big day and how she feels about her child growing up. Listen as an art-director client describes

the creative process that they spent days on, through multiple revisions and client approvals. Listen, listen, listen. The more you listen and ask open-ended questions, the better. Engage the client, get them to be invested in you, and demonstrate that you care about their project/event.

Often a client will present to us, say, a shot list, a crazy turnaround time on hundreds or even thousands of images, or a highly unreasonable budget constraint. Here's how those exchanges might go:

> **Client:** So, did you get a chance to look over the shot list we emailed?
>
> **Me:** Yes, and we're glad to have it, as it really does let us know what you're looking for from this event. The challenge we'll face is that the list is pretty extensive, with multiple iterations for your principals to be doing a lot of posing, and they may resist after a while. We will, of course, work to get as many as possible—will you have someone staffing us to facilitate as many of the shots as possible?

Now, let me break down that response. First, I provided a positive affirmation of the shot list. Honestly, they can be nice to have, but usually they're overkill.

Next, I say, "The challenge we'll face...." There are two important points in there. With "we'll," I've made it clear that we are a team in this. I didn't say "The challenge I'll face"—that would suggest that I am on the hook and seems defensive. And saying "the challenge you'll face" gives the impression of "it's not my problem, it's yours."

Now let's look at the word "challenge." A challenge is something to overcome. It's something people typically take on themselves, with an expectation that they will succeed. The word is a positive one, as compared to "problem," which is filled with negativity and often stops a progressing thought process in its tracks.

I then wrap the challenge point with commentary on the likely level of objection by the principals to standing around for every variation of grouping/shot, which also demonstrates that I've done this before. I then reacknowledge that I'll work toward the client's goal and ask if there's someone to assist/provide cover.

The "assist" portion of that request is because having someone on hand who may well know the players in the scenario can really help you make the most of the shot list. The "provide cover" portion of that request is really important, too. If, at the end of the event, I report that I couldn't get everything on the shot list, it could be easily (albeit incorrectly) surmised that I'm just making excuses for why I didn't do my job. However, someone on the client side of the equation can make the same statement and validate that I did all I could to make it happen, but it just wasn't possible.

> **Client:** So, I know you'll have a full day of shooting, but we'd really like to have images for a rotating slideshow throughout the day, so attendees can see what's going on and even see themselves at the conference.
>
> **Me:** Sure, that's not a problem at all. The challenge we'll face is that there are a number of activities going on, and downloading, editing, and then delivering to your AV people a thumb drive of images takes me away from the important task of covering the activities. So, we can bring in our post-production person and have them on-site with a digital workstation to handle that workflow so I can keep shooting while they are working on getting those images to you. I can provide you with the additional cost to have that position staffed for the duration of the event, if you'd like.

First, I tell the client it's not a problem, because it's not. Often a CEO or a president of a company will make a request like this in an offhanded "Hey, wouldn't it be cool if attendees could see themselves" way, without really understanding the logistics behind the request. As such, the client is looking for me to solve their problem, which is why I say it's not a problem. Then, that being said, I use the "challenge we'll face" phrase and outline the logistical concerns, which again demonstrates that I've done this before.

I also point out that of course the client doesn't want me, the photographer, doing the task myself, when I should be shooting. I then refer to not "our assistant," but rather the much more substantial "our post-production manager," which demonstrates that this is serious/important. I also don't refer to my laptop as just a laptop, because, well, it's not. It's a high-performance, top-of-the-line Mac that has Photoshop, Photo Mechanic, and Lightroom installed and custom-configured with the right metadata, export presets, available disk space, card reader(s), and so on necessary to efficiently and effectively process client images.

I then point out that of course there's an extra cost for the extra equipment and labor, and I offer to provide an estimate for that. Most of the time when I provide that estimate, the client decides it's cost prohibitive, which is fine with me. However, either way, the client understands that I take this request seriously.

> **Client:** Our client is really budget-conscious for this project, so let me know what your estimate would be for this. We only have $2,000 to get all of the photography done.

> **Me:** Sure, we'd be happy to do that and will get one over to you as soon as possible. One of the challenges we'll face with that in mind is that you're looking at a variety of images on our website that called for X, Y, and Z. So there may seem to be an expectation that we can deliver a $5,000 shoot on a $2,000 budget, and that's likely not going to be possible. However, let me see what I can do, and I'll get something over to you via email as soon as possible.

Again, "We'd be happy to do that" positively affirms that I will send the estimate. I then tell the client we'll get it to them as soon as possible. This lets the client know I appreciate the time-sensitive nature of what's going on. Then, I return to "one of the challenges we'll face" language and move on to "you want a $500 widget but you only want to pay $50." I let them know to not expect our budget to hit that, and then I tell them we'll send over the estimate. Which I do. I try to go into more detail on this so that a prospective client understands exactly what goes into the $5,000 shoot they want for $2,000, and then they are more inclined to find the balance necessary to deliver what they want.

The Power of "No" Revisited

In *Best Business Practices for Photographers,* I talked about the power of saying no to clients who offer you a bad deal. Yet perhaps "Just Say No" wasn't enough, so let me take it a step further.

In August of 2012, the *Journal of Consumer Research*[3] published an interesting and insightful article about how to refuse something.

In the first part of a study conducted, there were two groups. One was instructed to say "I can't." In the world of photography, this might mean, "I can't sign a contract that gives away my copyright." The other group was instead told to say "I don't." Again in photography, this would put forth a more powerful, "I don't sign contracts that give away my copyright."

[3]Volume 39, No 2. "Empowered Refusal Motivates Goal-Directed Behavior."

Once the test subjects had repeated the phrases, they were posed a series of questions in writing and asked to answer them; however, the questions were actually not a part of the research. At the conclusion of the questionnaire, as subjects left the room where the study was being conducted, the person collecting the papers offered each participant a free snack—the choice was either a granola bar or a chocolate bar.

The results were astonishing. Those who were using the words "I can't" opted for the candy bar (an unhealthy choice) almost two-thirds of the time, while those who were empowered by "I don't" instead chose the healthier granola bar at almost the same ratio.

Next, the researchers studied how effective "Just Say No" is. Three groups of women were engaged in a study that called upon them to focus on an exercise routine that they should do (and thus wanted to do) on a daily basis, such as walking, running, or going to the gym. The control group was encouraged to "Just Say No" to the idea of missing a workout over a 10-day period. The second group was encouraged to say "I can't miss my workout," and the third was told to approach it with "I don't miss my workout." The control-group result was that three in ten actually worked out for all ten days. Only one in ten of the group who used "I can't miss my workout" did it, while eight out of ten of the "I don't miss my workout" group completed the workout over the 10-day period.

Thus, it's not only important to "Just Say No," it's also important to say no in just the right way.

Recommended Reading

Hennig, Jim. *How to Say It: Negotiating to Win: Key Words, Phrases, and Strategies to Close the Deal and Build Lasting Relationships.* Upper Saddle River, NJ: Prentice Hall Press, 2008.

Herriot, Peter. *An Introduction to the Psychology of Language.* New York: Psychology Press, 2013.

Luntz, Frank. *Words That Work: It's Not What You Say, It's What People Hear.* New York: Hyperion, 2008.

Luntz, Frank. *Win: The Key Principles to Take Your Business from Ordinary to Extraordinary.* New York: Hyperion, 2011.

Chapter 11

Social Media: Etiquette, Expectations, and the Law

The oxymoron is that social media is both extremely important and irrelevant. It's seemingly everywhere, yet it's invisible.

Take CEO Jim McCarthy's comment about social media in *Forbes'* "CEOS: What Were the Breakout Tech Trends of 2013":

> [I]t's disappearing from sight…. The evolution of social is dispersed and private. In 2013, this change became real, with the advent of things like Snapchat, Whisper, and the ascendency of Tumblr. In the future, people will use more platforms, use them more privately, almost like we use email…. Think of it like a whale in the ocean. You can occasionally see the fins or a waterspout, but what you can't see beneath the surface is much, much larger.[1]

The key is to be where your customers are. Wedding clients aren't looking for photographers on LinkedIn; they're more likely to stumble upon you on Pinterest or your Facebook business page, for example. Your marketing efforts on social media platforms are going to require a great deal more effort than traditional marketing. Social media requires constant attention and a feel of personalization even when you're hitting large groups of people. If your social media seems canned or a retread of other items—too many retweets, for example—your audience will know and go elsewhere.

The Issue of Rights

Before we get into the different major social-networking services, we should discuss an overarching issue that is a problem regardless of platform. It deals with the rights to your photographs that each platform requires as a part of your agreement to use the service.

Within the legal agreement that is part of using the service, each platform requires you to grant it rights far and away beyond what's necessary for what you think you're using the platform for. The agreements include words and phrases like "perpetual use," "relinquish the right to end the agreement," and so on. In July of 2013, the American Society of Media Photographers put out a white paper titled "The Instagram Papers," where they note in the Executive Summary:

[1]Source: http://www.forbes.com/sites/tomtaulli/2013/12/25/ceos-what-were-the-breakout-tech-trends-of-2013/

> [T]he agreement gives Instagram perpetual use of photos and video as well as the nearly unlimited right to license the images to any and all third parties. And, after granting this broad license to Instagram, photographers also relinquish the right to terminate the agreement. Once uploaded, they cannot remove their work and their identity from Instagram. Additionally, in the event of litigation regarding the photo or video, it is the account holder who is responsible for attorney and other fees, not Instagram.[2]

The problem is that the above characterization could well apply to all of the platforms. While Facebook owns Instagram and has a unified Terms of Service, Flickr has the same Terms of Service as other Yahoo! offerings. Those, including Tumblr and Twitter, all have at their core a user base who is supposed to be uploading content they own the rights to—which, as noted above, the platforms then take rights to. Pinterest, however, takes it one step further, because effectively, Pinterest has at its core the widespread infringement of others' copyright by encouraging users to gather in one place content that's not theirs. First, here's Pinterest's current Terms of Service regarding what rights you grant them:

> You hereby grant to Cold Brew Labs a worldwide, irrevocable, perpetual, non-exclusive, transferable, royalty-free license, with the right to sublicense, to use, copy, adapt, modify, distribute, license, sell, transfer, publicly display, publicly perform, transmit, stream, broadcast, access, view, and otherwise exploit such Member Content only on, through or by means of the Site.

Pinterest, like Instagram, requires the above agreement to be "irrevocable" as well as "perpetual." In 2012, Pinterest issued a statement regarding the matter of copyright infringement, which read in part:

> Pinterest is a platform for people to share their interests through collections of images, videos, commentary and links they can share with friends. The Digital Millennium Copyright Act (DMCA) provides safe harbors for exactly this type of platform. We are committed to efficiently responding to alleged copyright infringements. We are regularly improving our process internally with the help of lawyers who are experts in the field of copyright.

Pinterest and its supporters point to a 2007 ruling in the case of Perfect 10 v. Google. In the case, Perfect 10, a website with images of women deemed to be perfect in beauty, was suing Google because the images that its users were paying to see (and which were generating advertising alongside them) were showing up in Google's search results. The initial court decision—and the resulting appeal and loss by Perfect 10—gave rise to the notion that what Google was doing was considered fair use because they were just using thumbnail images, not full-sized images like those on the Perfect 10 website. The difference, however, is that Pinterest transfers from wherever your photograph is—at full resolution whenever possible—and maintains them on their servers without your permission, and it does so while removing references to the image source. However, because of the DMCA, as long as Pinterest takes down whatever images you file a DMCA claim to have removed, they won't be held liable under the current laws.

If you are okay with giving away all of the above rights, then by all means use the platforms. Just know that once you begin to do so, you may be unable to extract your images from those services, along with the liability that arises from their presence there. Perhaps you see a mechanism to drive traffic (and thus sales revenue) from the services, or perhaps you're looking for positive affirmation of your work as an artist. The key is to make these decisions with full knowledge of what you're giving away in exchange for what you're getting in return, and to be comfortable with that.

[2]Source: https://asmp.org/articles/instagram-papers.html

Facebook

A Pew research study reported what most people already know: Facebook is the preferred network of 57 percent of all American adults.[3] While 2013 saw an incredible rise in Facebook use and their acquisition of Instagram, a number of media outlets are talking about how teens, turned off by their parents being on Facebook, turned to Twitter and are using similar short-message/visual services, such as Snapchat. Also, there are actually alternatives to Facebook now. Remember MySpace? Right…I almost forgot about them. When MySpace was king, Facebook came along as the only real alternative to it. Now there are many others. While no one is predicting Facebook will go the way of MySpace, this lack of predictions of a Facebook demise is more the result of Facebook being better poised to evolve, according to the CEO of Muck Rack during a CNBC interview in October of 2013. The Pew survey seems to agree, suggesting that Facebook's ability to engage users is still superior to other services.

Consider Facebook's ability to market or demonstrate a product. As a photographer, your photo is your product. Giving prospective clients the ability to see your images means they can see that you're capable and talented.

The key is not to oversaturate your prospective clients/friends/followers with too much. No one likes a friend who calls multiple times a day. Sharing once a week or a few times a month is a great frequency. And as you add content, be sure to share it in an engaging way for your client base. A wedding client isn't looking for family portraits or baby pictures (yet!), and a client looking for a portrait isn't looking for pictures of travel photography. Keep your products organized—for example, I suggest that you be so specific as to keep environmental portraits separate from portraits done on seamless or in a studio setting.

Once you've developed what is, in effect, a Facebook portfolio of your work, you might consider using Facebook ads. Many photography businesses are using them effectively. Numerous online articles and resources will tell you how to create effective ads, so rather than detail the process here, I'll simply suggest that you research how to create the best possible ad, and not just go at it haphazardly.

Is it worthwhile? That depends. Consider that if you're marketing wedding photography, you'd spend upwards of $1,000 to go to a bridal show. Or, if you're a commercial/corporate/advertising photographer, you may spend at least that much to advertise in *Communication Arts* or use an ad campaign through Agency Access or Yodelist. Instead, create a few separate ads and try them out.

Consider an ad for a family portrait. If you charge a $400 sitting fee and you want to get more business, you might offer a reduction of $100 off that fee. Three ways to market that would be:

$100 free – get $100 off a $400 sitting fee if you book by the end of the month!

Or

25% discount – Save $100 off a $400 sitting fee if you book by the end of the month!

Or

Save $100 on a $400 sitting fee if you book by the end of the month!

You can test all three of these ad styles and see which one gets the greatest response. Once you know this, you can better target your ads.

[3]Source: Pew Research Center's Internet Project survey, August 7–September 16, 2013.

You might wonder why Facebook is free to users. The simple answer is that if you're not paying for the service, then some part of you is what that company is selling. In the case of Facebook, they are selling your personal information to advertisers—not just your age and race, but also the things you like, who your friends are and what they like, the things you talk about, and also the things you dislike. This concept isn't new—"free with advertising" has been around for a very long time. Broadcast television stations, such as ABC, CBS, NBC, and FOX, all are free with advertising. And yes, to a small degree, they market to your demographic—during the winter season, people in northern parts of the country see ads for snow apparel, but people in the south don't. Certain advertisers localize their TV ads to make them more relevant to the community, and they certainly study the demographics of the people who watch a particular television show and advertise to them. (The obvious examples are all the toy ads that run during Saturday morning cartoons. You'd never see these during a prime-time showing of *Law and Order*, for example.) Facebook, with its ability to know all about you on a sub-granular level, is doing the same thing, just much more effectively. And now you, as a potential advertiser, can have at your disposal all of the metadata about prospective clients to very precisely identify them.

For example, when someone changes her status from "in a relationship" to "engaged" on Facebook, she would be the perfect prospective client to advertise wedding photography to. In fact, you can do that specifically to prospective clients within a certain radius around where you live.

The key is to market where your prospective clients are. If you're a commercial/corporate photographer, perhaps your Facebook marketing is all "soft" marketing—an ongoing "here's what we've been up to lately" update so all your clients see your latest work and travels. By soft marketing, I'm referring to the fact that you're not sending out messages with "book your portrait session with us now," but rather, you're creating brand awareness so that when someone needs a photographer, you're at the front of their mind because you're known to them via your constant updates on Facebook. Or maybe they see a Facebook posting you've done and are reminded that they need to book a photographer for something.

Lastly, the sooner you separate your "Jane Doe" Facebook account from your "Jane Doe Photography" Facebook account, the better. That way, you can differentiate your "I'm going to the club with some friends" updates from your "Here's Jane and John on the dance floor during their first dance" updates. Your clients don't need to know what you're up to in your free time, or how much free time you have at any given moment. And your mom and siblings can enjoy your personal updates on your personal page, but they can also "like" your business page and see what you're up to professionally.

LinkedIn

With 22 percent of adults in the U.S. using LinkedIn, according to the same Pew Research Center study mentioned earlier, people are on LinkedIn at a critical mass. LinkedIn's user base is much more tuned to business networking than Facebook, with its social aspect. There are platforms for engagement and dialogue; however, your LinkedIn efforts will take a decidedly different approach from your Facebook efforts.

Further, you can do research on clients through LinkedIn. You can look them up to see whether they're the senior art buyer for Amalgamated Advertising, for example, or if they're the assistant to the associate art buyer, which is likely one step above an intern.

In some cases, you may actually get calls from interns who have been tasked with finding a photographer who's local to a specific area. Don't discount those calls; just know who you're dealing with.

Obtaining endorsements from clients on LinkedIn can be very valuable—not just endorsements of a particular skill or expertise (though these are important, too), but a recommendation from a client. When prospective clients read recommendations like these, they will become far more comfortable with using you as their photographer:

- "I've used John's services, and he has my highest recommendation."
- "John will do whatever it takes to meet the needs of the job with the highest-quality results."
- "John's work is dependably good, the turnaround time is remarkably fast, and he is enormously personable. I would enthusiastically recommend John and his team to anyone seeking a photographer."

Pinterest

The Pew Research Study cites that 21 percent of U.S. adults are using Pinterest. That number breaks down to about 16 percent of women and 5 percent of men. With those percentages, it should be no surprise that the majority of potential photographic clients using Pinterest are brides. Photographers can use Pinterest to "pin" their photographs, effectively building their portfolio by type, and brides can use this platform to produce their dream wedding.

However, I've heard from several wedding photographers who've had problems with brides who use Pinterest as their example of how they want their wedding photography to look. Some photographers even decline to take on "Pinterest brides" because they have unreasonable expectations about what the resulting images will look like!

Every photographer knows they'll get a few "best" photos from any given wedding—sometimes it's right before the ceremony, when the father of the bride sees his daughter in her full gown; sometimes it's the first dance; and sometimes it's a quiet moment with just the newlyweds. The reality is that "pinned" bridal-inspiration photos are usually culled from the best moments from dozens of weddings. Is this a reasonable expectation for a bride to have?

In a February 2012 blog post, PhotoShelter CEO Allen Murabayashi pointed out that Pinterest is not for photographers; rather, it's an "aspirational pin board for women." He cites that 82 percent of visitors are female, and notes that "Pinterest hasn't shown itself to be a good referral mechanism for service-based offerings."[4] In a follow-up article two weeks later, Murabayashi reiterated that the comment about the percentage of female users being significantly higher wasn't meant to be critical of women, but rather to understand what he called the "psychographic make-up of the audience." He defended his position against commenters on his original blog post who said that Pinterest wasn't intended to serve as a direct client-referral solution, but rather to garner visibility. He noted:

> If you're getting lots of repins, but people are only using your images for "inspiration" (and not hiring you), then it has dubious value. [Or if] you're getting referral traffic, but that's not translating into bookings or sales, then it has dubious business value. It's not good enough to measure your business simply by saying I have 5,000 hits…. Those are just statistics. It doesn't represent qualified traffic. Unless you are tracking conversion of those statistics into paying clients, you're giving yourself a false sense of security over the real metrics that drive your business.

[4] Source: http://blog.photoshelter.com/2012/02/hey-photographer-pinterest-is-not-for-you/

Murbayashi ended his point by saying, "Don't tell me that 'but it's raising awareness and one day it'll pay off.' Show me the numbers that substantiate that claim."[5] I couldn't agree more. Yes, there are the few-and-far-between superstars on Pinterest, but the likelihood that you'll garner that status level is very small, so use Pinterest in moderation as just one of the tools in your marketing quiver. Understand the realities of that investment of your time and moderate your expectations.

Instagram

With 17 percent of online adults in the U.S. using Instagram according to the Pew Research Study, Instagram use is widespread. During a marketing presentation by Suzanne Sease, she stated that if you work for *Time* magazine, you almost have to have an Instagram account, as that's a ubiquitous way for the editors to see what their photographers (and potential photographers) are working on, and then they are better informed about possible future assignments. The benefit of having a presence on Instagram is to garner followers of your work, who might be inspired to hire you because of what they've seen. There are no advertising opportunities on Instagram as of this writing. Platforms like Snapchat are so private and fleeting that they're essentially a non-starter. They're not a vehicle for garnering a following or marketing yourself—they're texting with visuals.

In a December 21, 2012, article entitled "Instagram Still Has the Right to Commercialize Your Work (or Why You Should Read Terms of Service Carefully)," the Copyright Alliance stated:

> Although the language claims to be a "limited" license, there is nothing limited about it:
>
> It grants Instagram every right a copyright owner has the ability to authorize under the Copyright Act.
>
> The license grant is not restricted to uses necessary to operate the site, promote the site or even related to the site. With the exception of private content, the content posted to Instagram is licensed to Instagram for any use—even uses wholly unrelated to the site. Instagram underscores this point by making clear that only private content will not be distributed outside the Instagram Services.
>
> This overreaching license is coupled with a further requirement that the user agree that the works may be paired with advertising without any notice to the user. This is essentially the same issue users were concerned about in the proposed new terms of use:
>
> Instagram may place such advertising and promotions on the Instagram Services or on, about, or in conjunction with your Content. The manner, mode and extent of such advertising and promotions are subject to change without specific notice to you.[6]

I recognize that the above rights grab is theoretical, but it's a perpetual grant. Platforms like Hipstamatic and ProPic (www.ProPic.com) are much better choices.

In a September 2012 article in the British Journal of Photography, renowned photojournalist Ed Kashi notes of Instagram: "I love photography, so I completely enjoy the creativity and opportunities to make

[5] Source: http://blog.photoshelter.com/2012/02/pinterest-is-still-not-for-photographers-round-2/

[6] Source: http://m.copyrightalliance.org/2012/12/instagram_still_has_right_commercialize_your_work_or_why_you_should_read_terms_service

photographs virtually at any moment and share them with the world." The article goes on to point to photographers being able to make a "deeper connection with the general public." The article's author, Olivier Laurent, reiterates Suzanne Sease's point that "[c]onnecting directly and personally with that audience has almost become a requirement for photojournalists as the traditional print market [is] changing."

Later in the article, Kashi returns to the business side of the matter: "What concerns me is that this is yet another channel for creating and disseminating photography that does not bring in income. At least not yet…" Also that it "further feeds the devaluation of our craft and continues to contribute to the destruction of this field as a viable way to make a living."[7] As such, unless you can point to a viable model for either direct revenue generation or indirect revenue generation as the result of a following, using Instagram is not a good business decision.

Twitter

Using Twitter is a way to garner a following and build a community. You can tweet updates on your whereabouts and share your photographs to do so, but constant self-promotion will likely turn people off. The key—from a business standpoint—is to gain a following that is likely to book you and/or hire your services.

It's worth noting that photographer David Morel was successful in suing after two news outlets infringed his copyright by taking photographs he posted on Twitter and distributing them to the world. Interestingly, in the ruling, the judge found that re-posting and re-tweeting the images was acceptable, but that the commercial use of those photographs by its users was not. In other words, Twitter wasn't at fault in the lawsuit; the commercial entities that used Twitter to source the images were at fault. However, it's my opinion that if Twitter had a business relationship with those outlets, Twitter would've had the right to license those images for commercial use, and that may well happen down the line.

Watermarking Your Images

Your presence on social media should serve one overarching purpose: marketing. There's hard selling ("buy my product now"), there's hard marketing ("our product is the best"), and then there's soft marketing, where you simply showcase your work and garner a following, and people who desire your photography contact you. For example, you can share wedding images on Facebook, where you tag the bride and groom, who then share those photos with their network of friends. Aside from your name being connected to the photo as the person whose work was shared, you should have a watermark on the image to ensure that you will continue to get the benefit of that distribution. The same holds true when you share your commercial/editorial/corporate work on LinkedIn and blog about it. Regardless of where your images appear on social media, they should be watermarked.

How to watermark is another question, and there are a number of ways to do it. Rather than provide the technical details, which differ depending on what software you use, I'll provide some creative, experiential, and legal insights into how to watermark.

[7] Source: http://www.bjp-online.com/2012/09/the-new-economics-of-photojournalism-the-rise-of-instagram/

Creative

Many photographers choose to use their logo, and depending upon your logo, that may well work. However, for some photographers, the logo outside of the context of letterhead or a website just looks like a graphical block. It may be better to use your logo in combination with "Photograph by Jane Doe," with your swirly-typefaced "JD" initials adjacent to those words.

Experiential

The watermark should be present, but it shouldn't overwhelm or intrude on an image any more than it has to. TV viewers are familiar with the concept of "lower third" graphics, where viewers can see details about who is being interviewed, the location where video was shot, or even closed-captioning. In photography, too, placing your watermark in the "lower third" area of an image is a good idea. For consistency, you should probably have it appear in the same place on every photo, rather than having it wherever there's negative space in the image.

Legal

While this isn't legal advice, per se, it's legal insight. Your watermark should include a copyright notice of some sort. If you're doing a logo that's a half-inch on the lower third of the image, somewhere a small "©2014 John Harrington" should appear. If someone removes that notice, they usually become a "willful infringer," and the penalties in a copyright court proceeding become much more problematic for them if they've cropped that out of your photo, which is not that difficult to do. There are countless ways to do so— just do an online search for "how to remove a watermark," and you'll be surprised by how many YouTube videos there are and how easy it is to do. Further, there are legal ramifications under the Digital Millennium Copyright Act that preclude the removal of what's called "copyright management information" or "CMI."

Attorney Russell Jacobs writes in the *Northwestern Journal of Technology and Intellectual Property*:

> Some courts have held that the DMCA only protects CMI that appears on the body of the copyrighted work, or that appears in the area around the work… However, CMI on the back of the work, on a hyperlinked webpage, or in a statement at the beginning of a collective work would not. Other courts have declined to limit DMCA Section 1202 to CMI appearing directly on the work itself. This article favors the latter approach and argues that the plain language of the statute, as well as other sections of the United States Copyright Act, 17 U.S.C. Sections 101-810 (the "Copyright Act") and the statutory history of the DMCA, only require that the CMI appear with or be accessible in conjunction with the work.

The article goes on to cite that in the case of "*Kelly v. Arriba Soft Corp.*, decided just one year after the enactment of the DMCA, the court granted summary judgment against the plaintiff photographer on the DMCA Section 1202 claims. In that case, the plaintiff included CMI in the area around his photographs, but not directly on them, and the defendants' copies omitted the CMI."[8]

As such, while there have been other cases that have permitted a more expansive interpretation of the Act to allow for adjacent or nearby CMI, having it as a watermark seems to be your best solution.

[8]Sources: *Northwestern Journal of Technology and Intellectual Property*, Volume 11, Issue 3, http://scholarlycommons.law. north western.edu/njtip/

While no social media platform to date has been effectively able to get its users to transfer copyright to the work, the terms of service of all of them take a perpetual royalty-free transferrable right to whatever you upload, and most of them include the ability to make derivative works of your copyright, which could, in fact, include a version where they have removed the watermark (however, separate and distinct from that would be their removal of your copyright notice)—a violation of the law.

I encourage you to read the two citations from the DMCA law below, because it's the legal basis for you pursuing a claim that someone removed your CMI, which can often be a faster and less expensive route than a full-blown "I am suing you for copyright infringement" process.

Under the DMCA section 1202, it states:

> (a) False Copyright Management Information.— No person shall knowingly and with the intent to induce, enable, facilitate, or conceal infringement—

> (1) provide copyright management information that is false, or

> (2) distribute or import for distribution copyright management information that is false.

> (b) Removal or Alteration of Copyright Management Information.— No person shall, without the authority of the copyright owner or the law—

> (1) intentionally remove or alter any copyright management information,

> (2) distribute or import for distribution copyright management information knowing that the copyright management information has been removed or altered without authority of the copyright owner or the law, or

> (3) distribute, import for distribution, or publicly perform works, copies of works, or phonorecords, knowing that copyright management information has been removed or altered without authority of the copyright owner or the law,

> knowing, or, with respect to civil remedies under section 1203, having reasonable grounds to know, that it will induce, enable, facilitate, or conceal an infringement of any right under this title.

> (c) Definition.— As used in this section, the term "copyright management information" means any of the following information conveyed in connection with copies or phonorecords of a work or performances or displays of a work, including in digital form, except that such term does not include any personally identifying information about a user of a work or of a copy, phonorecord, performance, or display of a work:

> (1) The title and other information identifying the work, including the information set forth on a notice of copyright.

> [...]

Now, knowing this, under the DMCA section 1203, it then states:

> (a) Civil Actions.— Any person injured by a violation of section 1201 or 1202 may bring a civil action in an appropriate United States district court for such violation.

> (b) Powers of the Court.— In an action brought under subsection (a), the court—

> [...]

(3) may award damages under subsection (c);

(4) in its discretion may allow the recovery of costs by or against any party other than the United States or an officer thereof;

(5) in its discretion may award reasonable attorney's fees to the prevailing party; and

(6) may, as part of a final judgment or decree finding a violation, order the remedial modification or the destruction of any device or product involved in the violation that is in the custody or control of the violator or has been impounded under paragraph (2).

(c) Award of Damages.—

(1) In general.— Except as otherwise provided in this title, a person committing a violation of section 1201 or 1202 is liable for either—

(A) the actual damages and any additional profits of the violator, as provided in paragraph (2), or

(B) statutory damages, as provided in paragraph (3).

(2) Actual damages.— The court shall award to the complaining party the actual damages suffered by the party as a result of the violation, and any profits of the violator that are attributable to the violation and are not taken into account in computing the actual damages, if the complaining party elects such damages at any time before final judgment is entered.

(3) Statutory damages.—

(A) At any time before final judgment is entered, a complaining party may elect to recover an award of statutory damages for each violation of section 1201 in the sum of not less than $200 or more than $2,500 per act of circumvention, device, product, component, offer, or performance of service, as the court considers just.

(B) At any time before final judgment is entered, a complaining party may elect to recover an award of statutory damages for each violation of section 1202 in the sum of not less than $2,500 or more than $25,000.

[…]

And here's a concise summary that clearly makes the point:

Any person…may bring a civil action [for the]…Removal or Alteration of Copyright Management Information. No person shall, without the authority of the copyright owner or the law…intentionally remove or alter any copyright management information…. At any time before final judgment is entered, a complaining party may elect to recover an award of statutory damages for each violation of section 1202 in the sum of not less than $2,500 or more than $25,000.

So there, you'll see that you—as the copyright holder who has added CMI to your image—can elect to pursue $2,500 to $25,000 in statutory damages and you don't need to have registered your work beforehand to pursue these claims.

As such, I can't stress it enough: Watermark your images for every platform you share them on.

Chapter 12
Professionalism on the Job

Over my years of serving clients, there have been many times when my professionalism was tested. On many occasions, people have discussed political matters that I'm on the opposite side of, and there have been discussions with religious overtones, and so on.

There are countless things that can cause you to lose a client, and professionalism probably ranks close to (and in some cases could exceed) the quality of the final images. Consider an extreme: You're either decidedly pro-life or pro-choice, and you get called to photograph a women's health event or shoot portraits of women who are involved in women's health efforts or initiatives. The topic of ending a pregnancy comes up, and the conversation is clearly contrary to your position. If you speak up with your personal views on the subject, I don't care how great your photographs are, that's the last assignment you'll be doing for that client.

How about something less extreme? Knowing that your client is Dr. John Doe is important. Once someone has earned the title "Doctor," calling him "Mister" is a faux pas, and more often than not, the person will let you know. I once was on assignment at the Kennedy Center for a movie studio, and Colin Powell was there. I've photographed him a number of times over the years, and he's a very approachable person. I looked around for someone I knew who was the Chief of Protocol at the White House and could not find her. So, standing there with him, I said began with "Sir…," knowing that was a suitable expression of respect versus his other titles, and then continued, "While I first came to know you as General Powell, you most recently were a cabinet secretary, and I'm under the impression that a cabinet secretary's title is higher than a general, as generals report to the Secretary of Defense. But I wanted to check—is it more appropriate to address you as 'General' or 'Mr. Secretary'?" Normally it would be outside of protocol to ask this question of the person you're addressing, but since I was absent my go-to resource, and knowing he is approachable from having worked with him many times before, I knew it was more acceptable to ask the question. His answer? "General is a lifelong title you earn and keep, whereas Secretary is one you're given, so General is the more appropriate title." I could've just continued to use "Sir," and that is often my go-to solution, but these are the types of things related to being a professional that are important. I was then able to make a series of appropriate introductions to people whom the General was meeting.

When introducing one person to another, there are two considerations—age and social standing—and sometimes they conflict. When they do, social standing prevails. To explain this, suppose an elderly woman is introduced to the England's future king, Prince William. "Your highness, this is Mrs. Jane Doe." In your locale, it might be "Mr. Mayor, this is my grandmother, Mrs. Harrington." This would also apply to a youthful CEO and a middle-aged person he is introduced to.

The following sections detail several other things to consider, from attire to language, and from cell phones to discretion, all focused on how to demonstrate a level of professionalism that your client will appreciate more than you'll ever know.

Attire

There are different levels of appropriate attire depending on the work you do. The general overarching advice is that you should blend in. The less noticeable you are, the better. One my favorite books on the subject of attire is Alan Flusser's *Clothes and the Man: The Principles of Fine Men's Dress* (Villard Books, 1985). In it, Flusser goes into the details and history of all of the nuances of men's fashion, and gives you a great sense of how to dress for any occasion. While the book is some 30 years old, the principles still apply and are relevant today.

There are two key points to remember regarding attire: First, by your choice of attire, you're demonstrating respect for the client/event taking place. Second, the clothes you wear are essentially your "interview" clothes for everyone who sees you at work, given that you're undoubtedly hoping to gain more work in the future.

If you're working a wedding, a dark suit is appropriate for men, unless the entire event is black tie. Yes, I know you'd prefer to go in khakis and a blazer, or maybe even skip the blazer. Sorry, skipping the blazer is a mistake. And a blazer and khakis are a mistake if you should be in a suit—but less of a mistake than not wearing the blazer at all. First, the suit jacket (or blazer, if you must) lets you hide your external battery pack under your jacket. Second, you can keep an extra card wallet on the inside of the jacket and, in a pinch (although Alan Flusser would cringe at the use of them at all), slip a lens into one of the outside jacket pockets. In a sense, the jacket is a modern (and more attractive) photo vest. For women, a dark pantsuit with a jacket works well for the same reasons.

If it's a very casual event and the wedding party and guests are all in jeans, then I'd advise dark slacks, a button-down shirt without a tie, and a blazer. And if the wedding is on the beach, then try khakis, a white shirt, and a lightweight, light-colored blazer. I can't think of any circumstances where shorts would be an appropriate garment to wear when working. Female photographers should avoid skirts. Whether you have to be crawling around on the ground (which is difficult in a skirt), or getting up high on a ladder (where you might be exposing yourself), a skirt is a bad idea.

For a corporate or commercial client, the appropriate attire is again a dark suit for men or a dark pantsuit for women. You're trying to blend in and acknowledge your place in the hierarchy. A good guide is to think about what the CEO of the company would wear and follow that lead. For example, you can expect that the CEO will wear a suit to a press conference; however, if the company is doing a "service day" where they volunteer to do cleanup in a local park or paint the interior of a local women's shelter, then you can be darn sure the CEO won't be in a suit, but likely jeans and a polo shirt. Again, follow that lead.

On an editorial assignment, you are again trying to blend in. However, if your shoot is to do a portrait of a CEO or another senior executive, history is replete with stories of photographers who garnered additional time (and respect) from busy CEOs because they showed up in a suit, demonstrating their respect for the CEO—and, because of the suit (and appropriate conversation/rapport), they got extra time to produce a great result.

In all situations, making sure that your clothes are pressed and neat seems obvious, but I've seen far too many half-untucked button-down shirts with wrinkles. For women, modest jewelry is best, along with minimal (or no) perfume.

Dialogue and Discourse

Don't talk about religion, politics, or even sports. Don't swear, even if the client does. Don't gossip—not about anything. Not about previous clients. Not about anyone. Don't over-share. Your family and really close friends may care about your personal trials and tribulations, but your clients don't. They may feign interest, but they don't care, and you shouldn't expect them to. At the very least, they'll end up thinking you have too many problems to be reliable.

An exception to the "no sports" rule would be if you're meeting with a wedding couple and it's clear that the husband-to-be is a sports fan, given memorabilia around the house—or maybe when you walk into the couple's home he's watching a game before (hopefully) turning it off to meet with you. And of course, "no sports" doesn't apply when you're photographing an athlete or a sports-team owner.

And when you're speaking to Mr. John Doe, the proper initial exchange is "Hello, Mr. Doe," not "Hello, John." Using "John" suggests you're an equal to your client. If, after you've been introduced, Mr. John Doe, says, "Call me John," then calling him John is appropriate unless it makes you uncomfortable. When you're introducing yourself, don't just say "Hi, I'm John" unless it's a very informal situation. Using your full name is preferable.

Cell Phones: Talking and Texting

Don't talk on the phone or text in front of a client unless there's a critical reason why you need to, or the calls and/or texts are job-related—that is, related to the specific job you're working on. Otherwise, clients will feel as if you're not focused on the job at hand. When I've been standing in front of a client and my phone has rung, I've only taken the call with the disclaimer of "Oh, this is the producer for this job" or "This is the makeup artist, who should be on her way here"—something specific to the job at hand. Be absolutely certain that your ringer is off—and you may even want to silence the vibrating mode, too. Make a point of always checking the ringer as you walk into the assignment.

Hear No Evil

I have forgotten more secrets than I can remember: The bride who was having cold feet, the imminent merger that hadn't yet been announced, and the politician's vote being swayed for less than honorable reasons... When you're granted the privilege of proximity to very private events and details, you have a great responsibility to protect them. Some of our clients set forth their privacy expectations in a non-disclosure agreement (NDA). For interns and our staff, we also have an NDA.

You earn clients' trust by not repeating what you've heard, and by being a fly on the wall and not reacting when you hear something funny or unpleasant.

Be on Time

There's a saying in the military: If you're early, you're on time; if you're on time, you're late; and if you're late, you're doing push-ups until I get tired. In the business world, it translates to: If you're early, you're on time; if you're on time, you're late; and if you're late, you're fired. When you're booked to start an assignment at, say, 9:00 a.m., don't arrive at 9:00 a.m. Arrive with enough time to set up and begin working at 9:00 a.m.

Respect Everyone

Don't look down on the intern, the client's assistant, the caterer, or the busboy. Don't bring an attitude of superiority to the shoot. You're a partner and a vendor, not the king of the castle. Don't take anyone for granted, either, and be sure to express appreciation and graciousness wherever possible. Many a client has shared unpleasant stories with me about photographers with holier-than-thou attitudes and never hired them again.

Fulfill the Client's Request

Gregory Heisler once told a story about how he'd delivered a series of photos to a client, but it didn't include one of the shots the client had requested. Mario Testino was shown in the movie *The September Issue*—about the production of one of *Vogue*'s vaunted fall fashion tomes—saying he didn't want to shoot a celebrity in front of the Roman Colosseum because it didn't feel right. *Vogue*'s editor-in-chief expressed exasperation and called on her lieutenants to contact the famed Testino, asking for whatever he has—they want to see it. No dice—it doesn't exist. In Heisler's case, as I recall, he didn't work for that publication (or at least not that art-direction team) again. Testino, of course, has since worked for *Vogue*, but if he keeps up that mindset, I suspect that could change. Both photographers exhausted a degree of their goodwill in these instances, and while they have the stature, built up over time of delivering above and beyond what past clients have expected, their reputations preceded them.

There's a mantra among many photographers: One for thee, one for me. Fulfill the client's request, and then do the photo that you really want to do. Of course, the client will appreciate you delivering both, and maybe they'll see the photo you made for yourself and use that instead. However, it may be that the client has a very specific need, and what they use is what they needed.

Chapter 13
The Client Experience

Benjamin Franklin said, "The bitterness of poor quality remains long after the sweetness of low price is forgotten." Bill Gates famously said, "Every day we're saying, 'How can we keep this customer happy? How can we get ahead in innovation by this?' Because if we don't, someone else will." And Robert Gately said, "Customers expect good service, but few are willing to give it." The Macy's motto includes "Never fail to astonish the customer."

It's critical for clients to have a positive experience with you. It's a given, and expected, that they will get great results from your photos. Poor-quality results are a killer, but great results and a bad experience during the process are even more of a killer.

Clients will ultimately have two results from their interaction with you. The first is the finished product—a great photograph or motion production that was the reason the company came to you in the first place. The second is the result that largely dictates whether they'll come to you again—their experience in working with you.

Consider the real example of the early sports photographers on the sidelines at football games. Among them were some of the bitterest and most unpleasant people to be around. Yet they kept their jobs, because their unpleasantness was outweighed by their abilities. They had to use manual-focus lenses, shoot on transparency film with an exposure latitude of less than half a stop either way, and shift exposure as a player transitioned from shadows to bright light—all the while tracking a player running across the field and keeping the player in focus. But those days are long gone. Assignment editors no longer have to put up with bad attitudes or bad manners.

Early in my career, I was having an unusually candid conversation with an art director. She was discussing various other photographers she worked with. I felt a degree of discomfort at hearing of her dislike for my competitors, but I was also pleased that she felt comfortable enough with me to be so candid. She remarked on the wonderful quality of a particular photographer's work but then said, "I can't work with him, though; he's just such a pain."

Creating a positive client experience is crucial. According to a Customer Experience Impact survey, 86 percent of people are willing to pay more for better customer service, yet only 1 percent actually get an experience that meets their expectations.[1] In a 2011 Oracle survey, 89 percent of clients have switched to a competitor because of a bad client experience.[2] Harris Interactive released the results of their Customer Experience Impact survey, which showed that even when the economy is down, the "customer experience is a high priority for consumers. Sixty percent say they often or always pay more for a better experience."[3]

[1]Source: http://www.forbes.com/sites/christinecrandell/2013/01/21/customer-experience-is-it-the-chicken-or-egg/.

[2]Source: http://www.oracle.com/us/products/applications/cust-exp-impact-report-epss-1560493.pdf.

[3]Source: http://www.oracle.com/us/products/applications/cust-exp-impact-report-epss-1560493.pdf.

So how can you improve the client experience? You must attend to it from beginning to end. The following sections detail several areas to consider.

Initial Experience

Your prospective client's initial experience is critical. If you answer the phone and have distracting music, the television, or people laughing or chattering in the background, your client's initial opinion of you will suffer greatly. Good luck getting past that. And I know it seems obvious, but don't swear or be disagreeable on the phone.

Make sure the environment you're in is professional—keep the music off. In our offices, we have a rule that anyone in the office (staff or family members when present) knows to be quiet. And, my children know that when I'm picking them up from school in the late afternoon, they are to be silent when I say, "Daddy needs to make a phone call," or when they hear the phone ring. And, almost without exception, they remain silent during the calls. Because my kids never know when the call is business or personal, we make sure to practice that all the time—it would be unfair to expect them to know one call type from another. I also always use an upbeat tone during the call and strive to be enthusiastic about a shoot, even if it's my fifteenth portrait session in as many days.

Your voicemail is critically important too, because you won't always be able to answer the phone. I often get compliments on mine, likely because I paid a professional voiceover artist to record the voicemail message for both my mobile phone and my office line. People's opinions of your professionalism can be defined by how your voicemail sounds, so make sure they're left with a positive opinion. The cost to hire a voiceover person is actually much less than you might think. An Internet search for "voicemail voiceover" will return many offers for services between $100 and $150. Email the company a script, and you'll get a digital recording emailed back to you. Male or female, upbeat or authoritative, and even with varied U.S. or foreign accents—the beauty of a voiceover artist is that he or she can be anywhere in the world.

My voicemail message, which I outlined in *Best Business Practices for Photographers*, is:

> Hi, you've reached the offices of John Harrington Photography. We apologize that John's not currently available to take your call. Please leave a detailed message, and someone will return your call as soon as possible. Alternatively, you may contact John on his cellular phone at 202-255-4500. If you wish to leave a message here, please begin speaking after the tone. Thank you.

My cell-phone voicemail is:

> Hi, you've reached the offices of John Harrington Photography. We're sorry we're unable to answer the phone at this time. Please leave a detailed message, and John will return your call as soon as possible. Please begin speaking after the tone. Thank you.

Your emails are also important. Using a proper greeting such as "Dear John" or "Dear Mr. Harrington" is far more appropriate than starting an email with "Hey there!" Further, make certain there are no typos in your communication—especially in the client's name! And figure out important details, such as whether Christopher.Jones@ACME.com should be addressed as "Dear Christopher" or "Dear Chris." When you ask someone her name, be sure you know whether it's Catherine or Katherine or Kathryn, for example.

In addition, be timely in your client exchanges. Make sure your response time is no longer than about 48 hours. Clients will begin to think you don't care about them or their project if you're lazy about getting back to them.

On the Shoot

In the preceding chapter, we talked about the idea that if you're early you're on time, and if you're on time you're late. Clients don't like it if you're late. It makes them think you don't care about their important project. Be on time—and by that I mean be early.

It's important to be well organized—from your lenses to your equipment cases. If the client is standing next to you when you open your disorganized mess of a case, it's a signal to the client that you're disorganized. On the other hand, if they see your neat, organized case, they'll think the same is true of you.

We also covered attire in the preceding chapter. It should go without saying that during the course of the client's on-shoot experience, there should be a professional air. If you're with CEOs, you should be in a suit. If you're in a comfortable and casual studio setting, you can dress more casually, but there's still no excuse for T-shirts. Neat and clean at all times—that's the goal.

When you're on location for a shoot that will be longer than about 15 minutes, your clients will appreciate having a client production vehicle on site. Of course, having one increases the budget by $750 or more, but if the client is standing around in the elements for 30 minutes, he won't be happy. Giving clients a place to set up a laptop and get some work done will make all the difference. On low-budget shoots, your production vehicle might be as simple as a minivan or Suburban where the client can sit in a climate-controlled environment, make calls, and relax.

Another consideration is catering. I go into detail about catering in Chapter 24, "Valuing Video (or Motion) Production as an Adjunct to Still Photography: Know Your Limits." Suffice it to say, when you've got a crew and client to feed on a shoot that goes over a mealtime, you'll find it helpful to have done advance planning to find out your options. If you're not bringing in on-set catering, you want to be able to say to your hungry client, "Here are five menus from restaurants near here. Let us know what suits you, and we'll send the production assistant to take care of it."

Lastly, having a car service pick up clients from their office/hotel and then drop them off later saves the clients from having to hail a cab. When you don't have a production vehicle, that car can also serve as a private space for the clients to work.

Post-Shoot

When the shoot is complete, the client will want to see the images. Now—or better yet, yesterday. Famous vintner Paul Masson once said, "We will sell no wine before it's time." The same holds true for photography. Don't release your images before they look their best. You don't want to have to explain yourself; you want to let the excellent images speak for themselves. However, don't drag your feet. Deliver when you say you will. When a client has a problem accessing an online gallery, be timely in your response. And finally, be timely in your invoicing. Don't let two to three weeks pass between providing your services and billing for them.

Chapter 14

Establishing the Client's Needs for Level of Production (and Associated Budget)

There is a degree to which this chapter dovetails with the escalating level of production that occurs in Chapter 24, "Valuing Video (or Motion) Production as an Adjunct to Still Photography: Know Your Limits." As such, you'll see a few photographs here that are used to illustrate similar points there, but from a slightly different perspective.

When you get a phone call from a prospective client who needs an executive portrait done for $250, there's a serious disconnect between what they're thinking and what you are. Our baseline rate for a single portrait on seamless is about $1,000, so in a case like this, we're not likely to arrive at a workable solution. Our recommmendation would be to offset the cost by bringing in more than just the one person the client needs, and include some people who need updated portraits or who the client didn't initially think needed a portrait. In our case, although the first portrait on seamless is about $1,000, we don't charge $2,000 for two. In any case, the problem is that the prospective client saw portraits on my website and called me with the idea that their rate was applicable to what is shown on my website.

Variances in Service-Level Expectations

Let's first consider the architectural photographer. At a very basic level, an architectural photographer is someone who charges, say, $250 to photograph a house that's for sale, which includes the front yard, backyard, and five to eight images of the interior. But an architectural photographer is also someone who charges $5,000 to do a glorious front elevation of a multistory office building, a lobby shot, and two to three interior images of office space.

There are rights differences between the two, but one of the major factors that separates these photographers is the level of production. The $250 real estate photographer has plotted out his day and route to most efficiently knock out between three and five houses in a day, and the time of day doesn't matter for each house. On the other hand, the $5,000 photographer will have done a site visit to scout for the best time of day for each of the elevations being photographed. He will use this information to determine the best times of day for each interior (unless it's an interior without windows), and he will coordinate with the building manager to have interior lights set just right to blend best with the ambient light at dusk. He may get a permit to close the road so there are no cars in front of the building, or he may rent a cherry picker to get the angle and perspective necessary to best show the property. He will include in the final image trees that

have leaves on them, even if the image may have been shot in mid-winter, and he will remove street signs and other distracting elements.

Figure 14.1 *A highly stylized exterior shot after conducting a site visit and getting an elevated perspective from an adjacent building, which needed to be cleared by the building manager.*

In some instances, an on-site client wants to watch as the images are being captured. This adds a level of production because in most instances it calls for an on-site digital technician and a digital workstation. It also requires you to shoot tethered, or in a difficult situation, wirelessly sending JPEGs to the digital work-station. Any one of these situations will increase the level of production and thus the final cost.

In one instance, I was wrapping up a shoot in one location and had a window of an hour to get to my next shoot. My post-production manager was with me, and we were discussing how the day went. I made a com-ment about how she'd have the rest of the afternoon off. As we were walking to our cars, a panicked client at my next shoot, which happened to be a movie screening, called. The production company wanted to have an on-site photo editor to review, edit, and send out images right away, as several notable people had just confirmed their attendance at the screening, and the client made a point of telling me they also needed me to have my own Internet access. I looked in the breast pocket of my suit, checked the battery level on my wireless hotspot, and confirmed to the client that I would have a photo editor and high-speed wire-less Internet on site within an hour. Needless to say, my ability to pull out a skilled photo editor, a digital workstation, and a high-speed Internet connection significantly increased the level of production (and the

final bill). As an added bonus, the client was effusive in their praise and appreciation as the evening wound down, which solidified this new client as a solid client who will return again and again.

Figure 14.2 *As my post-production manager works on the laptop with guidance from the clients, I continue shooting in the green room as notable people make conversation before heading out to address the audience or watch the movie.*

In another instance, we knew in advance that the client needed an on-site instant review. We flew out to California to work on the rooftop of an automotive plant, where this automotive client wanted to highlight the fact that they were using solar panels to power the entire plant. Our client, the art director, wanted to see the images instantly, so in addition to the first assistant, second assistant, and hair/makeup person, we had the digital tech on site.

Figure 14.3 *Working in a constrained space on the roof of the building, the art director and digital technician both peer into the hood that allows them a reflection-free view of the image, which would otherwise be blocked out by the bright overhead sun. Meanwhile, the first assistant makes adjustments while the second assistant makes sure our large softbox doesn't blow over, damaging the other solar panels on the roof.*

In these instances, the level of production called for an increase in price. A digital technician with a digital workstation should start at an additional $750 for a shorter shoot, but $1,500 for a midlevel daylong production is very reasonable. If the digital technician and workstation call for on-site work for a high-level job, $2,500 is a very fair price to pay.

On some occasions, we've offered remote art direction. In such an instance, either we can let the art director screen-share with us (usually this only works when we're hard-wired into an on-site Internet connection) or we can email select images to the client. Alternatively, we can shoot and drop onto an FTP service or a site such as Dropbox, so the art director can view the shots and approve them before we move on. A word of caution here, however: Some art directors really enjoy getting out of the office and on location at a shoot. So, recognize that your client may want to be on set. This, of course, calls for an increased level of production, because you'll likely cater the shoot and have other accommodations for the clients. I've heard of photographers who have set up anterooms near the studio with Xbox big-screen gaming or other activities that might appeal to an art director who needs to be entertained between shots he has to approve.

Figure 14.4 *Working on the tarmac at a local airport, we had to shoot tethered into a digital workstation—and while our client was on site, we had to do remote art direction. In this instance, we were reshooting something that the client didn't like, and the decision maker was not on site. So, we'd shoot images, find ones we liked, and send them off to the decision maker for review and approval before moving on to the next shot.*

What's a Digital Workstation?

It's one thing to say "bring your laptop" and quite another to say "bring your digital workstation." First, "bring your laptop" doesn't quite connote a significant increase in value or cost. However, "bring your digital workstation" does. So, what *is* a digital workstation, beyond just a fancy name for a laptop?

First, a digital workstation is a top-of-the-line laptop that has not only all of the necessary software (for us, that's Photoshop, Final Cut Pro, Lightroom, and Photo Mechanic) properly installed, but also all of the metadata templates we use, as well as file-naming nomenclatures and ingest paths. Our mail application is set up so that images sent via attachments appear as attachments and not as inline graphics, a common problem when you're using Apple Mail and sending to a PC. We have a preconfigured WiFi connection, and we have the proper card readers to load images in as quickly as the motherboard bus will allow. We also have the proper tether cords to connect our camera to the computer and still be 30 feet away, because our cords are from Tether Tools and have repeaters built into them. We also have enough space on the computer's hard drive. Lastly, where called for, we have an external RAID drive to back up the files. Oh, and we even have thumb drives, too.

continued

What's a Digital Workstation? continued

Next up is an external monitor. The laptop monitor is color-calibrated, and so is the external monitor. The monitor is hooded when necessary, and we have a foldable rolling cart that lets us set up a desk-type workspace anywhere. For longer shoots, we can also bring in portable battery power to keep the laptop and external monitor going.

As for accessories, while we are very comfortable using the trackpad, having a mouse or a Wacom tablet on site can make things easier, too.

Do not underestimate or undervalue what you bring to the production with a digital workstation. Be sure to charge for it, and have a backup, too.

Planning for Client Needs across Service Levels

How is your client getting to the shoot? If a shoot is local, the client may drive himself. However, is this shoot at the level of production where having a sedan-type car service is called for? Of course, everyone could hail cabs, but something as simple as having a sedan pick up the client can make the difference between a happy client and one who doesn't feel properly attended. Especially if the shoot is out of town and everyone is (presumably) at the same hotel, you'll want to make it clear whether you're arranging the car services for them or they've agreed to do it themselves. In some instances, they may do it themselves to keep the expense off the books of this specific shoot and allow it to fall on another line item of their monthly retainer with their client, so be sure to address this with them. If you include car service and your client gets back to you and says they need to cut costs, you can ask them if they want to save money by just booking taxis. This will also let you know that the client is expecting a lower level of production than you first envisioned.

One of the old Hollywood adages is that you should never work with pets or babies because somehow, in some way, they'll upstage you. However, if the shoot calls for you to work with children or pets, you'll likely want a pet wrangler or a child wrangler.

In one instance, we had a shoot with a well-known actress who was to be walking several rescue dogs. The photo was destined for a time-sensitive marketing piece for a pet-food company. The actress was to repeatedly walk down a set of steps, but not with trained dogs who were used to being on set and doing something over and over—instead, with rescue dogs that were coming to appreciate the joys of being walked by their owners again. So in this instance, we had pet wranglers who were just out of the frame in the event that there was an issue between the dogs, and we also had extra dogs to get just the right mix of animals in the finished photo.

Figure 14.5 *Several pet wranglers were just out of frame for this shot.*

In another instance, we were working with toddlers for a photo shoot for a large corporation. We were in need of real kids—not actors—to engage both the camera and the adults, who weren't there but would later be added. The on-set child wrangler helped engage the kids so they showed the various expressions of joy and happiness that we needed for the final product. You can only do so much holding a squeaky toy over your head with your left hand while shooting and handling the camera with your right. This wasn't the local mall photographer trying to get the kid to smile; it was a large production for a major corporation. The level of production had increased for us.

Figure 14.6 *A child wrangler engaging the kids and making a hair adjustment between shots.*

Sometimes the call comes in for a client who wants, say, a house in the background of a shot. And while we find just the right house, there may be some home improvements called for. In such cases, we call in a stylist. In one instance, we had a production where the shoot was outside a home in a suburban neighborhood. The house was great but needed some sprucing up. The set stylist and her assistant took a trip to the local nursery and brought back a truckload of flowers that they planted so the home looked better, which greatly improved the shoot. If the level of your production allows for it, having a stylist is very helpful. A stylist like this will run you between $600 and $900 a day, although when the stylist becomes the set designer and has assistants under her, it can go up to $1,200 for a 10-hour day.

Figure 14.7 *A stylist and her assistant style the garden in front of the house.*

Not only did the stylist do the work on the front of the house, but she also located plastic grocery bags that didn't have any writing on them. Most bags have the store name on them, and some have text like "Thank You" on them—which brings us to prop stylists. The problem with bags that have text on them is that it's generally readable and distracts from the message in the image. And, if you're using bags that have a store brand on them, you need clearances for the trademarked company names on the bags. Further, if you're doing something that isn't specific to that store, the competitors of that brand will balk. For example, if the message for a government campaign to end obesity is about eating healthy, and you can see the brand for Safeway grocery stores on the bag, Giant Foods, Kroger, Whole Foods, and all the other grocery store chains won't want to use the photos.

Figure 14.8 *The result of the styled house and generic grocery bags.*

On another shoot, the level of production called for the props in the shoot to be styled. As noted in Chapter 24, a prop stylist can be invaluable when you're doing work where a prop such as a bottle of apple juice is visible. On one shoot, we didn't have the rights to use the labeling and trademarked names on a product that would be in the shot, so a prop stylist was hired to craft new labels—not just for that one product, but for an entire aisle shelf area where a dozen products would be visible in the shot. The last thing we needed was to have a company like Kraft or Ocean Spray see their logos in the background of the production we were working on and send a cease-and-desist order to us, followed up by a possible lawsuit. As with the set stylist, a prop stylist will run you between $600 and $900 a day, depending on where they are and how involved the project is. Almost all of them will give you a quote for your project after you outline the details.

Figure 14.9 *Here's an example of the bottle that had trademarked and copyrighted material that couldn't be used in the final visual (at left), as well as the styled product that was created and used (at right).*

On a shoot for a large hotel chain, we had several things to deal with. First, we needed to procure the props for the shoot—tables, chairs, the right glasses, and a water pitcher. Next, because the only time available for the shoot was with bright midday sun overhead, we had to erect a tent to soften the light on the subjects and table. We also had to have a separate blacked-out tent that would allow us to review the images, and so that when the subject looked into the dark tent, they wouldn't be squinting. Also, our tech scout the day before revealed that we would need to pull power from about 300 feet away. Lastly, because of the heat—about 100 degrees plus humidity—our hair/makeup person would work her magic inside the hotel, and we would have a number of fans blowing on the subject to reduce the heat so he wouldn't sweat through his shirt or makeup. Even though this shoot lasted for less than 20 minutes once the subject was on set, all of these elements had to come together for a significant level of production for this client. In this case, the hair/makeup was $450 for the day, each of the tents incurred a $100 charge, the digital workstation and post-production person cost $750, the fans were $75, and the hotel provided the tables/chairs/glasses/and so on at no charge.

If you're working on a shoot and you're on location, chances are you'll need workspace. Whether you need

Figure 14.10 *Tents erected outside a hotel so that our subject could appear with the hotel behind him. A significant level of production was necessary to make the final image appear simple.*

just a small table or room for wardrobe, hair, and makeup and a separate client workspace, your production budget could do well to include a production trailer.

As I'll note in Chapter 24, getting a production trailer is important to consider, especially if your shoot is

Figure 14.11 *The final image of our subject. It was seemingly very simple with the tent over him and the table so that the light was soft. Because he's looking into a black tent, he isn't squinting at all.*

subject to the weather.

Seating inside these RVs is designed for the needs and purpose. Some are gutted with lengthy desk areas, and some are not customized at all. If the production allows for it, separate trailers for you and the client is a good idea. While you and your team work in your trailer, the separate client trailer can allow the client to work privately.

Then there's the "star trailer"—appropriately named because it accommodates the stars. I won't even begin to go through all of the examples, but the latest custom-made top-of-the-line RVs expand left/right, and some even become two-story trailers. Comparing trailers has become a parlor game among the top celebrities. There are trailers that rent for tens of thousands a day, as well as custom one-off million-dollar trailers. Typically, the level of star trailer you need will be dictated by the star's contract. If it's not, then select one

that serves the talent from the wide variety available.

Otherwise, your budget will determine what and how many you can afford. At the very least, including one is a good idea; otherwise, try starting with one for the client, one for you, and one for the talent. You can always scale back from there.

A production RV typically starts at $500 a day and can go to $1,000 a day, plus mileage (usually somewhere around the standard IRS rate), gas (usually not marked up, but these things get about five miles to the gallon), plus about $5 to $10 an hour to run the generator. And there's always a cleanup charge of $50 to $100. Lastly, for $60 to $75 a day, you'll get wireless Internet. Oh, and then you have to pay to have the driver on hand. If it's a union job, the pay is union scale; otherwise, you're looking at about $300 a day. Thus, you're looking at a base charge of about $1,000 per day to factor in. If you're keeping your driver overnight, you can expect to cover his meals and lodging plus a per diem.

Some RVs come equipped with copiers at a rate of $35 or so per day. Of course, you can get a weekly rate, too—so instead of $750 a day, it could be $2,200 for a week, plus gas/driver/and so on. Myriad companies offer these services all over the country. Try an online search using "production trailer" and then the city or state you'll be working in. Almost all of them will travel to a destination for you if there's no one nearby.

Another level of production is the client's expectation for the amount of included post-production and retouching. For one shoot we had to drop in a blue sky and clouds when we had an overcast day, as well as retouch out power lines in the background. We included this as a line item, and it was part of the increased level of production this client needed.

The question is, are you expecting a fast-food experience where you order your burger, take your tray to the table, and bus it yourself, or do you want to walk into a white-tablecloth restaurant with music playing in the background and have someone serve you water, take your order, bring you a bread basket, , serve your burger, refill your water, and clear your plate? Same end result: You've satiated your appetite during mealtime with a hamburger. Same level of service? Not at all. Knowing the level of service that a client expects is critical. In the end, outlining everything you can think of will allow for a fruitful conversation about what level of production the client is expecting, and will also save any misunderstandings when you all get to the shoot.

Chapter 15

Price Is What You Pay, Value Is What You Get

I hesitate to cite something from 2013, because if you're reading this in 2016, you might think, "Oh, but that was three years ago…." Yet the sentiment and attitudes won't change much. Many (dare I say most?) of the practices and sentiments in this book are timeless. To that end, let's look at a highly visible criticism of photography and photographers made by two people who are recognized professionals within the creative space, because if they're suggesting this, then other solid professionals with a pedigree of experience may be thinking the same thing, and that paradigm needs to change.

In May of 2013, Marissa Mayer, Yahoo's highly regarded CEO, said, "There's no such thing as Flickr Pro, because today, with cameras as pervasive as they are, there's no such thing, really, as professional photographers."

A few days later, Mayer took to Twitter to say, "I worded my answer terribly. I really apologize for what it sounded like outside of the context and notion of Flickr Pro." She then reiterated the sentiment, saying, "It was a misstatement on my part and out of context."

Then, on September 10, 2013, Phil Schiller, Apple's senior VP of marketing, said, "It used to be the way you take better pictures is you learn to be a better photographer. You get bigger cameras, bigger lenses, you learn about all the techniques of light meters and gels and filters, and you can spend your lifetime learning how to take advantage of this and make it work for you. For the people who want to do that, that's great. For most of us, we just want to take a picture and have the iPhone take a better picture for us."

Schiller's a bit off the mark. Learning any new subject should begin with the fundamentals. A still image captures a moment in time, and the difference between just the right moment and everything else is huge. The shutter lag on an iPhone alone makes it hard to capture the precise moment you want for anything other than a static or slow-moving subject, not to mention the iPhone doesn't allow you to set the best shutter speed for your subject. We're now two issues into the point, so let's add a third and a fourth: What about depth of field and focal length (digital/effective, not actual), which come into play from a creative standpoint?

We, as professional photographers, are "the people who want to do that." In fact, we make a living when we "do that." According to the Photographic Marketing Association's 2011 report, "Rise of the Amateur," there are 110,000 full-time professional photographers and 1.4 million part-time professional photographers. Taking the larger number of 1.4 million, that's merely a fraction of the 308,745,538 people living in the United States. But let's take a closer look at this, because that population figure actually includes every citizen, including children.

Let's assume that the 23.5 percent of people who are under the age of 18 should not be included in the number of people who *could* be professional photographers. Let's also assume (and I may take some flak for this) that the 13.7 percent of citizens aged 65 or older are more interested in enjoying their golden years than in taking on a new career as professional photographers. That still leaves 190,804,742 people who *could* be photographers. In other words, 0.7 percent of the population consists of people who identify themselves as either part-time or full time professionals. If we use PMA's figure of 1.5 million (that's the 1.4 million plus 110,000) who are aspiring pros, then the 0.7 percent becomes just over 1 percent. So, yes, the vast majority of "most of us"—99.3 percent, to be precise—just want to take pictures, not make a living at it.

In a September 19, 2013, article in *Bloomberg Businessweek* entitled "Apple Chiefs Discuss Strategy, Market Share—and the New iPhones," the author Sam Grobart writes of Apple CEO Tim Cook, "To Cook, the mobile industry doesn't race to the bottom, it splits. One part does indeed go cheap, with commoditized products that compete on little more than price.... The upper end of the industry justifies its higher prices with greater value." Cook comments, "There's always a large junk part of the market. We're not in the junk business.... There's a segment of the market that really wants a product that does a lot for them, and I want to compete like crazy for those customers. I'm not going to lose sleep over that other market, because it's just not who we are. Fortunately, both of these markets are so big."[1]

The word "junk" in Cook's comment obviously refers to a physical product; however, this same sentiment—with the importance of value—is applicable across every business segment, whether service or product. It truly is a tenet of a solid business practice.

Often I encounter clients who are shopping price—price is their deciding factor. Our goal in looking for clientele is to foster relationships with clients for whom price is simply a detail, not a deciding factor.

Imagine dining at a restaurant and asking the server for "just one more" filet—and then expecting not to pay for it. It's the same in photography, with clients all too often asking for one more shot and then expecting they won't have to pay for it.

Whenever we consider a purchase, we ask ourselves whether it's worth it. Are we willing to trade, say, $20 in cash for a DVD that will provide two hours' worth of entertainment? Is the price right? What value do we receive? A two-hour movie classic from a few decades ago sells in the bargain bin for $5, and we get the same two hours of entertainment. What value is there in a new release? Above and beyond the two hours of entertainment, the value we also receive is intangible—we get to see a movie our friends are seeing and share our ideas about its quality. There's value in being able to engage in exchanging reviews.

Years ago, before the age of auto-focus, one of the hardest things to do was photograph professional sports—especially American football. On a 300mm lens at a focus distance of 100 feet at f/5.6, the total depth of field is 11.5 feet. A professional athlete can cover that distance in less than a second. There are countless stories of photo editors getting complaints about how difficult it was to work with some sports photographers. Yet those criticisms were often followed up with "but he can seriously follow-focus"—meaning that the photographer could manually track the player's progression with the lens's focus ring, maximizing the number of in-focus images captured during a fast-acting play. Thus, the value of these photographers was significant, yet the price the clients had to pay (in addition to an assignment fee) was having to deal with difficult photographers.

[1]Source: http://www.businessweek.com/articles/2013-09-19/cook-ive-and-federighi-on-the-new-iphone-and-apples-once-and-future-strategy.

The advent of precise auto-focus and exposure control, along with RAW file formats, has made the physical act of shooting sports far easier. That means these photographers have either aged out of the industry or cleaned up their act and are nicer to be around. Either way, it's a win.

Negotiating for Your Value

If you are unwilling or unable to negotiate, you will be the loser. Let me address the "unable" concept. Everyone negotiates. From what you're willing to pay for a house or a car to the almost daily negotiations while raising children, you do it. So thinking that you're unable to negotiate is incorrect. You may be inexperienced at or uncomfortable with doing it when dealing with clients, but it's not because you can't, it's because you won't. If that's the case, every client will dictate to you the price and rights of ownership of your finished result.

As in the example of the sports photographer, one thing to keep in mind is that part of the value you bring to the shoot is that people like you. Gone are the days when people had to work with a particular seller of products or services. People have more choices now, and they are willing to pay for a good experience. If you're a likable person who's easy to get along with, prospective clients will want to work with you.

Entering a negotiation without an alternative is a recipe for failure. If you have to take the job for any reason (usually financial), then it's like you're playing poker with a hand that doesn't even contain a pair of twos. It's a bluff. Here are a couple of alternatives:

- **Wedding photographer.** You're booked more than six months in advance. During any given negotiation, this takes the pressure of a looming rent payment off of you. If a bride and groom balk at your rates and packages, the alternative is that there likely will be another couple asking for the same day. Or, perhaps if your goal is to shoot only 40 weddings a year (a common goal for many established wedding photographers), that opens up that particular weekend, and the next couple will take another weekend.
- **Corporate/commercial photographer.** Suppose you talk to a client who is adamant about a demand for ownership of the copyright,[2] and that's a deal breaker for you. If you're worried about paying the bills that month, you're in trouble. Your alternative is that you can try to book another project on that day or another day that week, and then potentially use the open day to catch up on back-office work or market yourself to other clients. Or, another alternative would be to develop a rights package that meets your client's needs while preserving the rights you want (portfolio/self promotion, relicensing after client-use period ends, exclusive vs. nonexclusive, and so on).

Credible, Capable, and Confident

It's highly likely that before you receive an inquiry about your services, the prospective client is already familiar with your work—perhaps from reviewing your website or maybe because a trusted colleague recommended you for a job. That recommendation comes with significant additional value because it came from someone who likely has used you in the past; I'll address the power of a referral later in this chapter.

[2]Most clients don't understand the value of owning copyright, and in most cases they don't need to own it. A broad license usually is sufficient.

But however the prospective client became familiar with your work, they likely didn't call you because they saw you in the phone book.

Your ability to demonstrate that you have a track record of success is key to establishing a value to your work. A photographer with 20 years of experience photographing high school portraits almost certainly doesn't understand the requirements for hanging out of a helicopter to do air-to-air photography of another aircraft, or even the details to do air-to-ground images. Conversely, that gifted aerial photographer almost certainly doesn't know the best way to coax a smile out of an unruly ninth grader and the tricks to keeping the line moving on school-portrait day.

Don't underestimate the value you bring to the table when it comes to a proven history of success—usually best demonstrated by the images and videos on your website.

Being credible starts from the ground up. "I can make anything look great" isn't a credible statement when included in your skills description. "We approach every subject with an eye toward making it look its best" would be far more credible and includes "capable" and "confident" as expressions in the sentence.

Note that there's a fine line between "credible" and "confident." When you say, "We work with CEOs every day," when trying to instill confidence in the mind of a corporate client, isn't as credible as, "We work with many CEOs throughout the course of a month." If you're a photojournalist trying to illustrate to a photo editor that you can be sent to a war-torn country to document the latest catastrophe, talking about your capabilities and experience is key. Inserting comments about where else you've been and talking about what's important to them—"We have a primary and backup transmission solution so we can consistently get you the images you need on deadline"—will help convince them that you're the choice to send.

Referral Power

Earlier, I mentioned the power of referrals. This is among the ultimate in value—someone your prospective client trusts has endorsed you. Sometimes it's as simple as someone saying, "Oh, call Jane Doe," and sometimes the praise is more lavish: "Oh, you need a photographer for that? You *have* to call Jane Doe...." In such a scenario, the prospective client will get a far better idea of your value.

Your goal is to have what is referred to as an "evangelist" client—one who, after working with you, will share how great an experience it was to friends and colleagues, unprompted. It could be a reporter who says, "You know, I was working with Elizabeth, and the assignment was going south. The subject was uncooperative and didn't want to be photographed or give me an interview. Somehow, Elizabeth talked to her about her concerns, alleviated them, and the next thing I knew the assignment was saved. She's amazing; make sure you try to get her on your next assignment." Or maybe you're a commercial photographer who is working with kids, and the client just isn't getting the needed expressions out of the kids. In one instance we had this happen, and it took an imaginary purple chicken named Frank to come to the rescue. All of a sudden, the kids were excited, and that's all we talked about. Afterward, the client referred work to us, and whenever we got booked, the story of Frank came about. These referrals are gold for us—we love working with clients who love working with us.

The Value of Awards, Successes, and Titles

Titles and awards can add to prospective clients' perception of your value. Perhaps you were named "Most Creative Wedding Photographer of the Year" or you have a "Master Photographer" certification from the Professional Photographers of America (PPA). Or maybe you studied at a prestigious photography school. Or perhaps you've served on the board of your local professional trade organization or won an award. In the photography field, we don't have fancy initials after our names, such as MD, CPA, or PhD. However, when a prospective client is looking for a portrait, and your title is "Jane Doe, Certified Professional Photographer, Master of Photography" (both of which are PPA certifications), it will help you establish a value above and beyond that of the average photographer. Jane Doe's website bio might even include something like this:

> Jane Doe is a Certified Professional Photographer by the Professional Photographers of America and has been conferred with the prestigious degree Master of Photography as a result of her numerous awards for photography and her continued contributions to the photographic community.

Including these types of differentiators in your marketing materials helps demonstrate the value you and your creative talents bring to the prospective client's needs.

In *Best Business Practices for Photographers*, I discussed the notion of risk as a factor in pricing. Simply put, the question is this: If the shoot went south, could it be reshot at all or easily? You only get one shot at the couple recessing up the aisle after being pronounced man and wife, and you only get one shot at the kiss before they do so. One shot at the building imploding? Yes, indeed. You likely only have one shot at getting the actual check presentation on stage. If you miss it, you can always re-create it off-stage later, but it's not the same. The greater the risk for a client, the greater value you, as the experienced photographer in those environments, bring to the assignment. However, during the course of our conversations with clients, we often will share a recent similar experience or past success to demonstrate why we are the best choice for the project the client is inquiring about. For example:

- If an elected official in your town is participating in a press conference, you could recount the last time you worked with him. For example, "The last time I worked with the mayor I found that he…" or "The mayor is great about working with us to get the solid handshake photo your principal is looking to use in the company newsletter."

- If it's a wedding couple, you might say, "In all the weddings I've done, I've always found that the photograph the couple most enjoys is the one where they are walking back up the aisle" or "Oh, the wedding and reception are at Wayne Manor? I was there last month, and every time I'm there, I'm reminded of just how beautiful it is!"

- For a family portrait, you might try, "When I work with families that are gathering together, I often find that there's some perception that we're in a rush, and everyone wants to know how it's all going to work. So, I make it clear that this should be a fun and relaxing family activity and that there's no pressure from me. I tell folks that they'll all look great, and if there's a flyaway hair or a facial blemish, we'll be sure to take care of it in Photoshop. I tell them to relax and enjoy the time together. In the end, we always get compliments about how they enjoyed doing the portrait, and that's the memory we want people to have each time they look at the portrait hanging on their wall."

- If your subject is a busy CEO, you might get questions like, "How much time do you need to block out of her schedule?" We always say, "Well, we only need about five minutes where we are actually engaged with Ms. So-and-So, but it may require 10 to 20 minutes for hair and makeup." When we

get the incredulous response of "*Five* minutes?!?" we reply, "Oh, it'll take us some time to set up lighting and so on, but Ms. So-and-So is busy, just like every other CEO we've photographed, so we don't want to block out too much of her schedule. Now, if she wants multiple locations or looks and she has the time, we can extend that, but in our experience we can get one great shot in five minutes, often less." Busy CEOs appreciate that you value their time, and when you are in control of the shoot and get the image done sooner than they expected, it reflects well on you. With a simple comment of "I like this photographer; he gets things done quickly," you can expect a call back from the PR/marketing department for future work, as you've just been "blessed" by the CEO.

- For a news event or some other one-time-only event, you can comment that there are no do-overs if the photographer doesn't get the shot, and then talk about examples of just such an experience you had (which the prospective client may have seen on your website) to help enforce the idea that you're the right person for the job. "I've covered protests at the Capitol many times, and when the key people are sitting in and getting arrested, it's critical that I'm in a position to get the images that illustrate your point."

If you can communicate to your prospective client why you provide the best value for the job, you're far more likely to win. Price will become just a detail, not a deciding factor. In each of the above examples, we talk about the experience and the process, but we always wrap it up with a mention of the quality result— good handshake photos, couples' favorite photos, memorable family photos, great CEO portraits, and moments captured without do-overs. Focusing on the process—or the means to the end—and then the end helps make your point about how you're the right choice.

Demonstrate Your Value throughout the Process

Be sure to always dress the part. CEOs respect someone else dressed in business attire. So do brides and grooms. Shooting a fundraiser on a golf course? Dress like the rest of the golfers. Not attending to the detail of dressing the part starts you off on the wrong foot.

Consider the genius in jeans. Even before he opens his mouth, he will be judged as less than knowledgeable. I'm not saying this is fair; it's just how humans are hardwired. When you walk into a meeting with a banker, do you expect him to be in shorts and a T-shirt, or should he be in a pin-striped suit? That genius in jeans has to open his mouth and spout brilliance—and even then, there will be a question of whether he really knows what he's talking about. He will have to earn his way out of the misperception that his counsel is unreliable.

One experience I had along these lines was where I went to a last-minute assignment. It is my rule that I don't leave the office without a signed contract. However, about 10 years ago, the call came in at about 4 p.m. for an assignment for the next morning. Clearly, someone had forgotten to book a photographer. Our email exchanges following the sending of the contract suggested they wanted to use us. Yet the end of the day arrived, and no signed contract arrived via fax. With an 8 a.m. start, we made the mistake of turning up to the event. It was an event at a Chamber of Commerce with about 50 CEOs from around the country. Big CEOs. All in suits. I was in a suit, blending with the executives well, and located the woman I had been corresponding with via email. The moment I introduced myself, I knew I had made a mistake. She hadn't intended on booking me, I learned, and we both were appropriately apologetic for the communication breakdown. I let her know it was my mistake and that I would, of course, be departing.

However, before I stepped away from the conversation, the photographer she had booked turned up. He was in jeans and a rumpled button-down shirt. She looked at him and then back at me, knowing right then and there she had made a mistake. This client, when it was too late, had seen that my presentation of my appearance alone demonstrated that I was the better choice. I excused myself politely and headed back to the office. In this instance, there wasn't anything I could do—she had made her choice, realizing it was the wrong one even before the first photograph had been taken.

Chapter 16

Pricing Your Work: Business-to-Consumer Case Studies

First and foremost, you are not a commodity. What you bring to the table is a vision and skill set that allows you to bring into reality an image that is appealing to others. Now, if your vision is of black and white with a very small area of the image in focus and the rest very much out of focus, that's okay—there's a market for that somewhere. If your vision is to shoot in a style similar to Avedon, there's a market for that as well. Keep in mind that each community has a market that will only bear so much. If you live in rural Front Royal, Virginia—a rural town about 65 miles outside of Washington, DC—and you are a globetrotter who shoots advertising campaigns, then your market is not the local community, it's ad agencies (and their clients), which have much larger budgets.

Yet even though photography is not a commodity, many clients believe that a photographer is a photographer is a photographer. But as we all know, this just isn't true. Heck, even within a licensed field, such as physicians, where a minimum standard and all sorts of rules exist, some doctors are better (and thus worth more) than others. However, not every patient is savvy enough to discern this, and not every prospective client is savvy enough to see that you are worth more than the next photographer for X, Y, and Z reasons. So, let's first take a look at pricing insights for a few items in three separate communities.

Regardless of where you go in this country, several consistent pricing items are worth looking at when you are trying to determine your rates. For example, a pro-level camera costs the same at your favorite mail-order camera store whether you live in Front Royal, Virginia; Austin, Texas; or Washington, DC.

There is more variance in the price of gas, but not by much. When the national average for a gallon of gas was $3.65, the average for Virginia was $3.48, and the price in Front Royal was $3.35. By comparison, in the oil-producing state of Texas, the statewide average price of a gallon of gas was $3.50, and the average price in Austin was $3.48. Comparatively, Washington, DC's average price of gas was $3.88.[1]

In other words, when the national average price of a gallon of gas was $3.65, the price was 8.3 percent lower in Front Royal, 4.7 percent lower in Austin, and 6 percent higher in Washington, DC. So, comparatively, if the national average for a photographer's sitting fee for a family portrait is $400, then it should be $366 in Front Royal, $381 in Austin, and $424 in Washington, DC. To take it one step further, there's just a 14.3 percent variance between a rural community and a major metropolis in terms of price. So as you are establishing your rates, if you're looking at an established photographer's rates in another city and you see yourself as comparable in offerings, then there is no reason why you should be pricing any more than 14 percent below the other photographer's rates.

[1]Source: GasBuddy.com. July 29, 2013.

Let's look at one more item: a loaf of bread.[2] In Front Royal, a loaf of bread costs $3.49, whereas in Austin it is $3.63, and in Washington, DC, the same loaf of bread is $3.75. The variance in price is 7.5 percent between the low and the high.

Setting aside the commodities, let's look at some other data. In Virginia, the median annual income was $62,776, Washington DC was $56,566, and Texas was $49,195.[3] The 2010 census reported a total population for Front Royal of 14,440. The population 16 years and older was 11,616, with 7,335 listed as employed. In other words, there are a maximum total of 7,335 clients in the town. The remaining people were listed as either unemployed (480) or not in the labor force (3,801). The total number of households was 5,734, and the median household income was $46,307.

The 2010 census reported a total population of 28,417 for Austin County, Texas. The population 16 years and older was 21,917, with 13,257 employed. The total number of households was 10,502, with a median household income of $52,510.

The 2010 census reported a total population for Washington, DC, of 601,723. The population 16 years and older was 502,503. There were 337,523 people in the labor force, with 260,136 households. The median household income was $61,835.

For many people, New York City is considered an extremely wealthy city, able to sustain more expensive services across the board. The data on New York City showed a total population of 8,175,133, with a population over age 16 of 6,564,212 and with 4,154,195 in the labor force. The total number of households was 3,049,978, yet the median household income was only $51,270—in other words, in terms of median income, comparable to Austin, Texas. We won't delve into a case study for New York City, but an obvious question does arise about how a city as populous as New York might see cost of living and incomes rise (or fall). So, to that end, this information provides that insight.

In Front Royal the median home price is $209,900, and the median monthly rent for a two-bedroom unit is $750 (with a low of $625 and a high of $1,050). In Austin, the median home price is $291,000, and the median monthly rent for a two-bedroom unit is $1,976 (with a low of $900 and a high of $4,073). In Washington, DC, the median home price is $485,000, and the median monthly rent for a two-bedroom unit is $2,934 (with a low of $1,350 and a high of $3,950).[4]

As you can see, you really don't begin to see a huge variation in rates until you're talking about real estate. I could continue to cite figures and statistics, but I'm guessing you've reached a point of data saturation. So, to sum it up, many things are priced relatively similarly; however, a few things, such as houses (where the market decides the item's value) do fluctuate. To that end, we need to look at the sustainable rates for photographers in each of these communities.

So, why all these statistics? The fact is that often photographers are their own worst enemies when it comes to setting rates and fees for their time and talents, and establishing a markup on physical products such as prints. It's impossible for me to produce a statistical analysis of each community in the country; instead, where you are income- and community-wise should fall somewhere within these three example communities, which can help you establish what you'll charge various consumer clients for your services. It may be

[2]I've selected Walmart for this comparison because their negotiations and distribution models create the smallest variance in cost between manufacturing and distribution.

[3]Source: US Census 3-Year Average Median Household Income by State: 2009 – 2011.

[4]Sources: Zillow.com and Rentometer.com.

beneficial for you to review Chapter 15 when thinking about how to establish prices in light of what you read in this chapter.

I asked each of the three photographers in this chapter to provide pricing information for the same types of work:

- **Family portrait.** A family portrait consists of a sitting fee (if applicable, that fee is paid to reserve the photographer's date and time). I also asked for the prices for 11×14 and 16×20 finished prints, framed attractively.
- **Senior portrait.** I asked each photographer to price out three finished "looks," including the sitting fee, retouching, and a digital file of each of the three looks for social media. The senior chooses which of the three images to have printed and receives two 8×10's and six 5×7's.
- **Model/actor headshots.** I asked each photographer to price out three finished "looks," including the sitting fee, retouching, and a digital file of each of the three looks, with the understanding that the model/actor will use these images to produce his own comp cards and provide them to a talent agency for his own bookings.
- **Weddings.** This is a very individually packaged service, with dozens of potential permutations. I've asked each to provide the pricing for the "bare bones" package—the lowest the photographer feels she can offer and make a profit on a wedding—as well as the top wedding package. So that you can discern the details of each, I've asked the photographers to describe what the bride and groom get for each package. This way, as you're adjusting your figures based on their insights and your own individual needs and costs, you can compare effectively.

Nick Crettier: Small Community Photography

Nick Crettier has been a photographer for more than 30 years, starting in North Carolina and then spending time in Washington, DC, as a staff photographer for a university before moving to rural Virginia to raise his family. His wife works full-time at a nearby hospital, and Nick has made a name for himself in the local community; however, he commutes 65 miles into Washington, DC, when assignments call for it. Although Nick does not have a retail storefront, he does have a studio and office space built onto his home where clients come for portraits.

Nick does senior and family portraits, soccer-team photography, weddings, and corporate work.

Within 30 miles of the Front Royal ZIP code of 22630, the Professional Photographers of America listed 42 members as of December 2013. Nick is not among them. Within 10 miles, there are eight photographers.

Family Portrait

Sitting Fee (paid to reserve/hold his time): $100

Finished 11×14 framed: $150

Finished 16×20 framed: $225

Senior Portrait

Senior portrait package includes three looks; from the best look the subject receives two 8×10's and six 5×7's: $300

Model/Actor Headshot

Actor or model headshots include three looks and a digital file only of each: $225

Wedding Package

Bare-bones wedding package: $800

Details of this package (including hours of service and deliverables): Four hours of coverage, on-camera flash, 150 images on disc, $400 deposit with balance on delivery.

Top wedding package: $4,800

Details of this package (including hours of service and deliverables): Full-day coverage with an assistant that shoots some, two albums, disc of images chosen for album.

William Foster: Midsized Metropolitan Area Photography

William Foster has been a photographer for more than 10 years, starting in Sacramento, California, and moving to Austin, Texas, in 2013. His wife works full-time as a teacher, and William uses Austin as a home base to serve local clients while traveling internationally. William has never had a retail storefront or studio, preferring to go on location when portraits are needed.

William does family portraits, corporate work, and photography for retail operations, and he has recently added video to his roster of client services.

Within 30 miles of the Austin ZIP code of 78746, the Professional Photographers of America listed 303 photographers as of December 2013. Bill is not among them. Within 10 miles, there are 152 photographers.

Family Portrait

Sitting Fee (paid to reserve/hold his time): $125

Finished 11×14 framed: $250

Finished 16×20 framed: $360

Ralph Alswang: Major Metropolitan Area Photography

Ralph Alswang has been a photographer for more than 20 years, most of the time in Washington, DC. His wife works as a freelance reporter after serving a number of years as a senior reporter for a major weekly news magazine. Ralph has never had a retail storefront or studio, preferring to go on location when portraits are needed.

Ralph does family portraits, corporate work, and weddings.

Within 30 miles of the Washington, DC, ZIP code of 20008, the Professional Photographers of America listed 625 photographers as of December 2013. Ralph is not among them. Within 10 miles, there are 189 photographers.

Family Portrait

Sitting Fee (paid to reserve/hold his time): $500

Finished 11×14 framed: $45

Finished 16×20 framed: $75

Senior Portrait

Ralph does not market himself to this market, so his rates would be along the lines of a model headshot, as below.

Model/Actor Headshot

Actor or model headshots include three looks and a digital file only of each: $725

Wedding Package

Bare-bones wedding package: $3,000

Details of this package (including hours of service and deliverables): Six hours of wedding coverage. Up to 700 images on a DVD in JPEG format and all rights to reproduce the images.

Top wedding package: $7,200

Details of this package (including hours of service and deliverables): This includes an engagement portrait, four hours of coverage on the rehearsal day, and eight hours of coverage on the wedding day. For the wedding day, a second photographer is included. A custom 10×10 album with up to 50 images, and up to 700 images on a DVD in JPEG format and all rights to reproduce the images.

Chapter 17

The Importance of Registries and Your Participation in Them

Until recently, there was no easy way to learn the identity of a copyright holder or to access the current rights information for an image. On finding an image with outdated or missing metadata, researchers, photo editors, publishers, designers, art directors, archivists, and the public searched the Internet and a multitude of other resources to try to find the photographer. Even when the photographer had originally embedded contact and rights information in the image, that information was often removed, lost, changed, or outdated. In particular, rights information often becomes outdated a short time after an image is delivered. Why should you care about this?

Simply put, in the marketplace of today and the future, accessible rights information can make the difference between failure and success as a photographer. The public's tremendous appetite for content now requires that image-using clients manage hundreds of thousands or even millions of images on their servers. Managing the rights for all of these images manually is impossible. Your clients increasingly rely on automation to manage images. For that, they need access to current metadata with current rights information, in a machine-readable format. There is no other solution. Adding fuel to the fire, copyright law amendments around the world will soon allow for the use of your images without your permission if you cannot be easily found, even when your metadata has been removed. Not only do you have a professional responsibility to ensure that your product includes sufficient information to allow others to make use of it (or not), but given the evolution of the marketplace, if you do not do so, your prospects as a photographer are increasingly grim.

Orphan Works

When the first orphan works amendment to U.S. Copyright Law was introduced in 2006, many photographers were unfamiliar with the term. Roll forward to today, and every photographer knows (or should know) that an "orphan work" is any work for which the copyright owner cannot be identified *or* cannot be found *or* cannot be contacted in order to secure permission to use that work. Legislation has been introduced in the U.S. and in other countries to allow anyone to use your works if they fail to find you after a search. While this legislation in the past has failed in the United States, the specter of its reemergence remains, and to that end, being aware of what this is about is critical.

The concept is simple—when rights-holders of works (photographs, books, songs, films, and so on) cannot be identified or contacted for permission, current copyright law generally prohibits the use of those works. The orphan works amendments would allow the legal use of those works after a diligent search for the rights-holder fails. For example, suppose a documentary filmmaker finds important historical images in a box of old photographs, an old book, or an archive, with no information identifying the photographers, or

with only the photographers' names, but no contact information. The photographers may be long dead, or they may be alive and glad to grant permission to the filmmaker, but they can't be found. The filmmaker would be unable to make use of those works, and a piece of history (and our culture) would be lost. The orphan works amendments are an effort to preserve our history and culture by creating an exception to copyright law that would allow our works to be used if we cannot be found or contacted. The amendments would protect the users of orphan works from liability for copyright infringement and would provide for the copyright owner's compensation if that person eventually steps forward.

Sounds simple enough and reasonable enough. The problem is, of course, in the execution. The laws as they were written allowed for practically any image—even an image you created yesterday—to be deemed an orphaned work. And essentially, once a work is deemed an orphan, it's open season.

Now, that's a gross oversimplification of it; however, the key is in being able to be found. There are two ways to be found. The first is that if someone has your name, they can search a centralized registry for your name and contact information. The second scenario is where it gets really exciting. What if anyone in any country who finds one of your images on the web or in print could find you instantly, even if some or all of your information in the metadata had been removed from the image? Suppose all you needed to do was submit your contact info and your images once, to a single registry, and that the registry would create a unique "fingerprint" of your image, allowing anyone to find you simply by submitting a copy of your image in a search. Suppose that once you submit your work to one registry, a search of any registry would find you, either by a name search, an image ID search, or an image-recognition search?

As such, a potential client looking for the owner of an image need only submit the image to a registry, and the contact information for the image's owner will be returned in the search results. Enter the PLUS Registry.

The PLUS Registry

In October 2004, leaders in the publishing, design, advertising, photography, illustration, software, and cultural heritage industries joined together to create the non-profit PLUS Coalition. PLUS stands for "Picture Licensing Universal System," and its origins can be traced back to conversations in 2002 between PLUS co-founder Jeff Sedlik and then–Registrar of Copyrights Marybeth Peters about the growing importance of creating standards for identifying image rights holders and rights information. The Coalition established an industry-neutral Board of Directors with one seat (and one vote) for each industry involved in creating, distributing, using, and preserving images.

At the outset, 2,000 PLUS Coalition volunteers from 34 countries worked to establish global standards for the communication and management of image rights. These standards allow rights to be clearly communicated not just by humans (in all countries and any language), but more importantly, by machines. With the standards in place, PLUS then set about developing the PLUS Registry, a global registry designed to connect images to rights-holders and rights information. Initially, PLUS asked image creators and rights-holders to visit www.PLUSregistry.org, create accounts, and create registry listings. This was the first step in PLUS's mission to link all registries and applications to a source for image rights information. In 2014, PLUS is introducing the public beta-testing phase of image registration and search, to be followed by license registration and other additional features, all on a strictly nonprofit basis.

The PLUS Registry is a global hub connecting images to rights-holders and rights information. Without any advertising, as of October 2013, more than 22,000 people from more than 100 countries had added copyright-holder information.

In Chapter 5 of *Best Business Practices for Photographers*, I went into depth about how to use PLUS to generate licenses for your images. Visiting the registry and entering your information is free. Figure 17.1 shows the results of a search for "Harrington" in the PLUS Registry under Search by Name.

Figure 17.1 *In this shot of the PLUS Registry website, a search for the word "Harrington" returned six results in early 2014. My primary listing is #4; however, I'm also connected to the #3 listing, and I'm a point of contact for the #6 listing.*

My listing is #4 among the other listings. Clicking on my listing reveals the information shown in Figure 17.2.

Figure 17.2 *In this shot, my details are displayed.*

I have full control over the information there, and I can update it whenever necessary.

PLUS does not license images and doesn't handle licensing transactions. It is not a stock photo agency; it does not list, set, or even suggest pricing. Its sole purpose is to connect images to rights-holders and rights information.

PLUS accomplishes this using globally unique identifiers and image recognition. Anyone in any country who finds one of your images will be able to find you, either using the PLUS Asset ID found in your image metadata or, if no ID is present, using image recognition. They only need to upload a low-resolution copy of the image and click Search, and you will be found.

There is a mechanism to upload tens of thousands of images in an automated fashion. PLUS will pull all your metadata into the database by way of a free uploader based upon the rock-solid and highly regarded software Photo Mechanic. The software has a free mode that allows you to upload only; however, if you want to utilize all of Photo Mechanic's functionality, you can purchase a software license from Photo Mechanic. You can find both applications at www.CameraBits.com. If you visit www.PlusRegistry.org, you'll note that Search by Name also includes Search by Image URL, so if you provide the URL of an image file, the software will use image-recognition and fingerprinting technology to identify the image and return results (if any) for that image.

If you'd like to select an image from your own computer and see ownership information for it, Figure 17.3 shows the screen for that.

Figure 17.3 *Here, I have clicked Choose File and selected a file stored on my hard drive. Next I'll click the Upload button, which will send the image to the Registry to search for the image visually.*

In Figure 17.3, I've selected a file, and once I click Upload, the image will be sent to the PLUS Registry and compared to the millions of images already fingerprinted. If a match is found, the ownership information I choose to show would appear.

Through the PLUS Registry, you can upload every image you've taken and have PLUS (using the PicScout technology) fingerprint your image and store the fingerprint.

Figure 17.4 shows a screen where you would manage your image assets.

Figure 17.4 *I can view and manage all of the image assets I have uploaded to the PLUS Registry. Here you can see the nine images I have uploaded for the purposes of this example.*

Looking into the IPTC tab, the information that you had already put into the image is shown on the next two pages, as shown in Figures 17.5 and 17.6.

Figure 17.5 *After I click on the Asset, the details of that asset are displayed. Here I've clicked on the IPTC tab that appears in the navigation bar just below the image thumbnail. Figure 17.6 shows the details of the image after scrolling down.*

Sublocation:	Library of Congress
City:	Washington
State/Province:	DC
Country:	USA
ISO Country Code:	

The location above could either be the location shown in the image or the location from which the photo was taken. To make clear distinction use the two Location properties in the IPTC Extension panel.

IPTC Content

Headline:	Stevie Wonder at the Library of Congress
Description:	Steve Wonder at the Library of Congress to receive the Gershwin Prize, February 23, 2009 in Washington DC.
Keywords:	

Semicolon or comma can be used to separate multiple values

IPTC Subject Code:	News

Subject Codes are defined at **www.newscodes.org**, semicolon or comma can be used to separate multiple values

Description Writer:	John Harrington

IPTC Status

Title:	Stevie Wonder at the Library of Congress
Job Identifier:	
Instructions:	No rights granted without written license
Credit Line:	
Source:	
Copyright Notice:	© 2009 John Harrington
Right Usage Terms:	No rights granted without written license

Edit Save **Back To Top**

Source: Plus Coalition, Inc.

Figure 17.6 *Here is the second section of what is displayed on the IPTC tab that appears in the navigation bar just below the image thumbnail.*

Figure 17.7 shows the Description section of the metadata for an image of the Golden Gate Bridge.

Figure 17.7 *Here I've clicked on the Description tab that appears in the navigation bar just below the image thumbnail, and metadata that was in the image is shown.*

Figure 17.8 shows the Origin section of the metadata for another image, this one of President Nelson Mandela at the White House in 1994.

Figure 17.8 *Here I've clicked on the Origin tab that appears in the navigation bar just below the image thumbnail, and metadata that was in the image is shown.*

Just as every book published has an ISBN number, and every item sold in any large-scale quantity has a UPC barcode, so, too, will each of your images have a unique PLUS ID that connects your image back to you. While PLUS IDs are the cornerstone of the entire PLUS Registry, because the registry also serves as a hub to support other registries, it is designed to accept and recognize identifiers issued by other registries or authorities as well.

For years, photographers have rightly expressed concern about the ability to strip metadata out of an image that would remove information such as captions, keywords, and ownership information. Because this is an ongoing and pervasive issue, with no ability to lock metadata into an image, there needs to be a way to externally identify an image that has had its metadata stripped—arguably ignoring metadata because it can

be manipulated. Further, suppose you have an image that has metadata with a specific license that expires? With that static metadata, that's a problem. However, with the licenses and permissions stored in the PLUS Registry, when a client extends or expands a license, your ability to update that license in the registry means that it will dynamically be updated in the client's records as well when they check the registry to confirm they have the right to use the photo.

That said, there may be proprietary or confidential reasons why you'd want to preclude access to some or all of the licensing and rights information. You as the user control that—not PLUS.

The PLUS Coalition, while incorporated in the United States and the United Kingdom, is a global initiative solving a global challenge. Launched with more than 34 countries and now serving more than 100, it's an international endeavor. The beauty, of course, is that with PLUS—a nonprofit entity that cannot be bought or sold at any price—as a hub interconnecting all registries, if you are searching one of the registries, you're also searching all the registries worldwide. Thus, there is no competition between registries; PLUS collaborates with them all as they come online.

The question then becomes, How is it free and is there a catch? First, no catch. The registry is a co-op, functioning only on a cost-recovery basis. The listings of photographers and rights-holders and businesses are free. Registering an image with associated fingerprinting and licensing/metadata details requires a small contribution to the registry to cover the costs of operation. This contribution can be as small as a fraction of a cent. Together, contributions from all users make the PLUS Registry possible.

Chapter 18
Using the eCO for Online Registrations

In *Best Business Practices for Photographers*, I addressed the copyright registration of your work at length. At the time, I recommended that the best practice for group registrations was to use the paper Form VA, rather than the new Electronic Copyright Office, or eCO. My primary reasoning for doing so was that for many photographers, using the Group Registration option was the most effective and efficient manner of getting their work registered, and eCO was not set up to accept group registrations.

Because the Copyright Office has evolved and now allows you to file group registrations using their online system, I recommend using eCO; however, the paper Form VA still works just fine, too, although the filing fee is significantly higher. Before you begin to do group registrations online, you will need to contact the Copyright Office to be added to their pilot program described below so you can be assigned to a specific registration specialist who will handle your claims. Doing an online search for the Copyright Office's SL-39 will give you, in relevant part, the following information:

> The Copyright Office has adopted interim regulations governing the electronic submission of
>
> - Applications for registration of automated databases that consist predominantly of photographs
> - Applications for group registration of published photographs
>
> The interim regulations establish a testing period and pilot program to assess the desirability and feasibility of permanently allowing these applications to be submitted through the Copyright Office's electronic filing system (eCO).
>
> For permission to submit electronic applications to register copyrights in photographic databases or in groups of published photographs, call the Visual Arts Division at (202) 707-8202.

The Copyright Office has an extremely complex system to manage data and provide an enterprise-class front-end webpage for you to interact with, and myriad things need to change when they want to update their system, so making one change can be a complex and lengthy process. This solution that the Copyright Office has put forth as a pilot program allows for group registrations using eCO, but it's not documented.

In this chapter, I will document the steps to do a single eCO registration of an unpublished work. In this example of an actual registration, the work is a portrait of a single individual taken on one day. I will also provide an alternative course of registration to document how to do the same registration if that work were instead a series of portraits taken over the course of many days.

1. Visit www.Copyright.gov, and under Register a Work, click on eCO Login to arrive at the screen shown in Figure 18.1. If this is the first time you've visited this website, click on If You Are a New User, Click Here to Register. I won't walk you through that step by step, as you've likely set up accounts at a number of different online service providers, and the process is similar. Enter your user ID and password on this screen to log in.

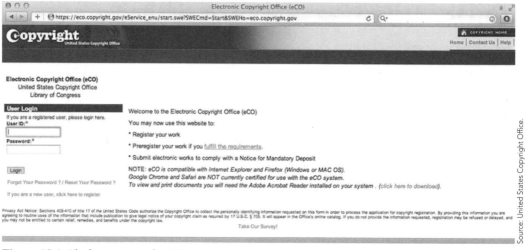

Figure 18.1 *The log-in screen for eCO.*

2. Once you've logged in, you'll see a welcome screen with a number of options on the left-side navigation area, as shown in Figure 18.2. Select Register a New Claim.

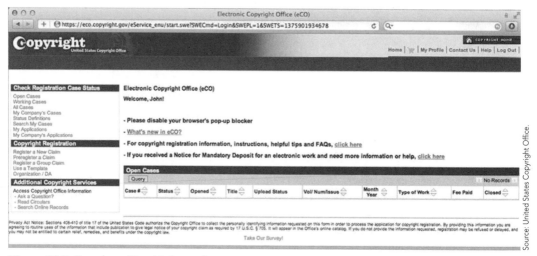

Figure 18.2 *Once logged in, this is your home screen.*

3. In the next screen, shown in Figure 18.3, the vast majority of you will want to check No for the first question and Yes to the second and third.

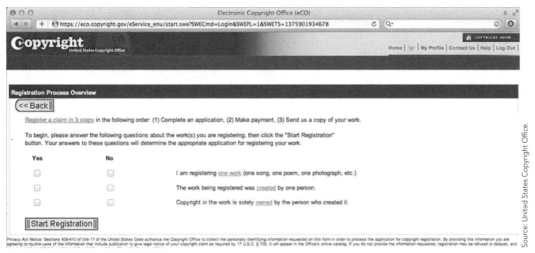

Figure 18.3 *This screen asks you to answer three questions before starting your registration.*

The Copyright Office considers a single image a single "work." So if you produce 1,000 images from a single shoot (that is, any number of images greater than one), then that would be considered 1,000 "works" in the eyes of the Copyright Office. As such, it's important to choose No for the first question.

As you become more familiar with the system, choosing "No" for the second question will cause the system to ask you other questions about who owns what you're registering and who created it. For example, if you're a husband-and-wife team, the answer isn't one claimant of Mr. and Mrs. John Smith; you would need to add in a second claimant by answering No to the second question. However, because the vast majority of you are registering your own work and you're the sole copyright owner to the work, I'll proceed down this path for this example.

4. Next click Start Registration, as shown in Figure 18.4.

5. Along the left side of the window, you'll see your progress marked by a red arrow, as shown in Figure 18.5. As you progress, you'll see checkmarks appear in the Completed boxes. At any time you can choose Save for Later and come back to complete your registration where you left off.

6. From the Type of Work menu, select Work of the Visual Arts, as shown in Figure 18.6.

Figure 18.4 *The three questions answered the way the majority of registrants would be completing them, and the way we are answering them for this registration.*

Figure 18.5 *The Type of Work page.*

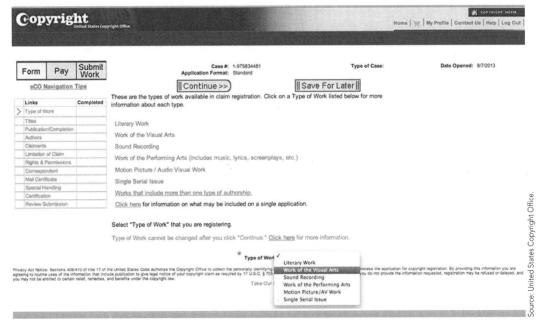

Figure 18.6 *Selecting Type of Work from the drop-down menu.*

Registering Motion Picture/AV Work

Many still photographers are beginning to offer video/motion as a part of their services. Although the example in this chapter is about using the eCO for still photography, the steps to register a motion picture or audio-visual work are very similar. However, instead of choosing Work of the Visual Arts from the Type of Work drop-down menu, select Motion Picture/AV Work and proceed from there. If your file sizes are large, you may find that the eCO system times out during the upload process. If this is the case, either find somewhere with a faster Internet connection or choose to have a packing slip printed later in the registration and send in your materials that way.

Another note here about the registration of motion/AV as it pertains to the audio portion of the work you're registering: If you are using copyrighted music (for which you must have a license), you will need to limit your registration to exclude the registration of the music. (Later in the process I'll include another sidebar noting this.)

Regarding the use/integration of still photography within a motion/audio-visual piece, you'll need to decide how you are registering them. If you've never registered the photos before, then including them in the registration of a motion/AV work will give them full copyright protection. If they have been or will be separately registered, then during the registration process you'll need to exclude the photographs. Again, I will note how to do that later in this chapter.

If you intend to use those same still photographs in other ways outside of the scope of this motion/AV registration, then I recommend doing a separate registration for the still photographs. However, be sure you don't attempt to register still photos twice—once in the motion/AV and then also separately—because doing so could invalidate your registration down the line.

Next, you'll choose the title of the work you're registering. For the sake of convenience, I'll include a section of *Best Business Practices for Photographers*, where I go into my recommended naming system for your work.

From *Best Business Practices for Photographers*: Title of the Work

I considered a number of methodologies to determine my nomenclature for my registrations. The most important things to keep in mind are that the title of the work should mean something to you and should facilitate your ability to locate and access the images at a future date. The Copyright Office strongly advises against using foreign punctuation marks or symbols such as lambda, epsilon, or other Greek letters. This will make matters difficult in the future, and because the eCO does not recognize Greek letters or other unusual symbols, including them in filenames will require extensive corrections and cause lengthy delays in processing. Using standard keyboard symbols is your best practice here. For example, if you typed something like "Café," the Copyright Office would use "Cafe" without the accent above the "e."

I consulted a number of people on the subject, most notably Jeff Sedlik, who is an expert in copyright registration and serves as a mediator, consultant, and expert witness in copyright litigation. Sedlik is not an attorney, but when it comes to copyright in photography, he is an invaluable resource. If you are taking someone to court and need an expert on the subject, he's your best resource. I considered the following titles for my registrations when cataloging an entire year's worth of work:

- John Harrington 2014 Collection 01 11,841 Photographs
- John Harrington 2014 Catalog 01 11,841 Photographs
- John Harrington 2014 Volume 01 11,841 Photographs

Although technically the title of your work doesn't matter to the Copyright Office—and further, it doesn't affect the rights you have—there's a problem with these titles. Using the words "volume," "catalog," or "collection" might cause the person you're suing (or more correctly, his or her lawyer) to attempt to make the claim that their infringement of six of your photographs from that registration is only a single infringement of a collective work, which might limit your statutory award to a maximum of $150,000, whether six or sixty images were infringed upon from that registration. Although this is not likely—in fact, I'd go so far as to say it'd be unlikely—it's beneficial to avoid that risk simply by being clearer in your title.

For works, I resolved to use the following titling nomenclature if I were registering an entire year's worth of work:

> John Harrington Miscellaneous Unpublished Photographs 2014 (ref#U1401), 10,102 files containing 10,102 photographs.

This nomenclature—annually delineated—is how I handled the titling when I needed to go backward to register previously unregistered work. This is how I would name the title of the work using the eCO.

Once I caught up with past unregistered works, I began registered images by month. When I was registering *unpublished* work, each month was named as follows:

> John Harrington Miscellaneous Unpublished Photographs January 2014 (ref#U1401), 4,378 photographs.

In this nomenclature, the "ref#U1401" is my own assigned reference number. The "U" indicates for my own internal reference that the images were unpublished, "14" is the year, and "01" indicates it was the first registration for 2014.

continued

From *Best Business Practices for Photographers*: Title of the Work continued

With respect to published work:

> John Harrington Miscellaneous Published Photographs January 2014 (ref#P1401), 4,378 photographs.

Note the "P" within the reference. In this, the "P" is not a published subset of the "U" registration, but just an example of how I would do the same registration were it a group of published photographs.

7. Here we've titled the work:

> John Harrington official Library of Congress portrait of Register of Copyrights Maria Pallante (REF#U1302) 101 files containing a total of 101 photographs

And this is where our step-by-step will take a detour.

 a. Option 1: If you are registering published photographs all published on the same day or a series of unpublished works, click Continue and then proceed to Figure 18.7. If you're doing a group registration of works taken and published on different dates, and you previously answered Yes to the three questions in the beginning, select Change Application and proceed to Option 2. If, however, you correctly answered No to the first of the three questions at the beginning, then from the Title screen select New* and then proceed.

 b. Option 2: For works that are published and taken across a span of dates, you can register the photos separately based upon the units of publication, or (and this is your better choice) you'll need to do a group registration, and it isn't really clear how to do this. The Copyright Office wants the inclusion of the words "Group Registration/Photographs" typed somewhere that makes sense (as a Previous or Alternative Title, in the notes section, for example), and they will give you a group registration.

One place it might seem obvious to do that would be near the end. Once you get to the step "Certification" (Figure 18.25) as you process down the steps on the left side of your screen, there's a Note to Copyright Office (Optional) choice, where it says, "This is the place to give any comments specific to this claim, the application, or the deposit copy, if necessary." As you want the words "Group Registration/Photographs" to appear on the certificate you receive, you'll want to do the notation as I am about to explain it. This would be the best practice for this type of registration.

8. When you arrive at the screen shown in Figure 18.7, it may not be immediately evident what you need to do. First click New*.

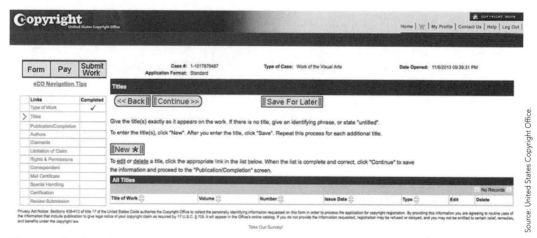

Figure 18.7 *The Titles screen.*

9. Next you'll see the screen shown in Figure 18.8. From the Title Type menu, select Title of Work Being Registered.

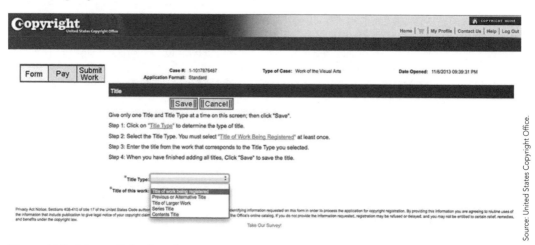

Figure 18.8 *Selecting Title of Work Being Registered.*

10. In the Title of This Work field, enter your title and then click Save. You can see what I entered in Figure 18.9.

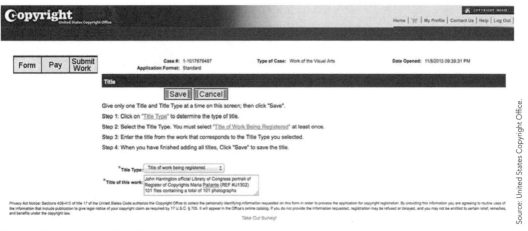

Figure 18.9 *Entering the title of work being registered.*

11. Now under Title of Work you'll see the registration title, as shown in Figure 18.10. Click New* again.

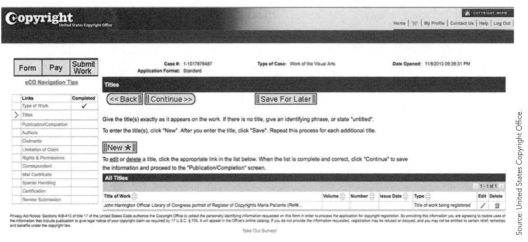

Figure 18.10 *The resulting Titles screen showing the title being registered.*

12. From the Title Type menu, select Previous or Alternative Title, as shown in Figure 18.11.

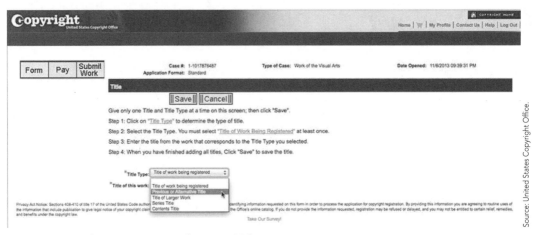

Figure 18.11 *Selecting Previous or Alternative Title.*

13. Enter GROUP REGISTRATION/PHOTOGRAPHS in the Title of This Work field. It is important to note that the total number of photographs (or the approximate number if the actual total is unknown) must appear somewhere in the title area (either in Title of This Work, as I show in these examples, or in Previous or Alternative Titles, also as shown). Click Save, as shown in Figure 18.12.

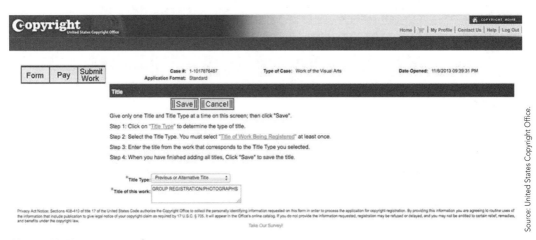

Figure 18.12 *Entering in the group registration text.*

In Figure 18.13, you can see both your work's title *and* the denotation that this is a group registration. Both of these items will now appear on your registration certificate.

If for some reason you don't know how many photographs you're registering, you can include the word "Approximately" and say "GROUP REGISTRATION / APPROXIMATELY 100 PHOTO-GRAPHS." If you *do* know how many photographs you're registering, you can also enter "GROUP REGISTRATION/ 101 PHOTOGRAPHS" and click Save, as shown in Figure 18.13.

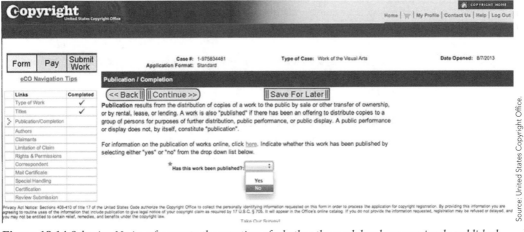

Figure 18.13 *Entering in a variance of text for the previous or alternative titles entry.*

Here is where you could detour once again. It requires extra work, but it's worth it. Using the downloadable spreadsheet referenced in the advanced registration process later in this chapter, this detour will add between 10 and 15 minutes to the registration process. However, when the Library of Congress characterizes the result of this detour as making your registration "more bulletproof," you know it's worth doing.

To that end, see the two subsections later in this chapter, titled "Adding Contents Titles to Your Registration" and "Advanced (and Bulletproof) Copyright Registrations."

Now that you've returned from that valuable detour, continue as below.

14. Click Continue, and you'll see a checkmark in the Completed field for Titles in the left progress area. You'll also move to the Publication/Completion screen, shown in Figure 18.14.

Figure 18.14 *Selecting No in reference to the question of whether the work has been previously published.*

15a. If you are registering unpublished works, select No from the Has This Work Been Published? drop-down menu. In the resulting screen, once you select No, enter the year of completion in the Year of Completion (Year of Creation) box and click Continue, as shown in Figure 18.15. For more information on this, please see the "From *Best Business Practices for Photographers*: Year in Which Creation of This Work Was Completed" sidebar later in this chapter.

Figure 18.15 *The Publication/Completion screen.*

OR

15b. If you are registering published works, select Yes from the Has This Work Been Published? drop-down menu, as shown in Figure 18.16. Select the appropriate answer from the Nation of First Publication menu and enter the year of completion and date of first publication in the appropriate fields (see Figure 18.17). The Copyright Office advises that if you are doing a group registration, you'll need to put the first date. So, if you shot a series of images between January 14, 2014, and February 15, 2014, enter January 14, 2014, as the first date. Note that because this is a group registration, later in the registration you'll need to specify the date range. On this screen there is no option to specify the end date in the range. The date range can and should be given in the Previous or Alternative Titles line, so you might enter "GROUP REGISTRATION/PHOTO-GRAPHS, published from 1/14/2014 – 2/15/2014."

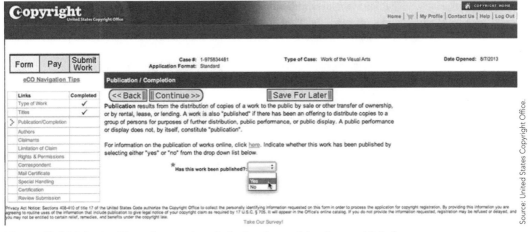

Figure 18.16 *Selecting Yes to the question of whether the work has been published.*

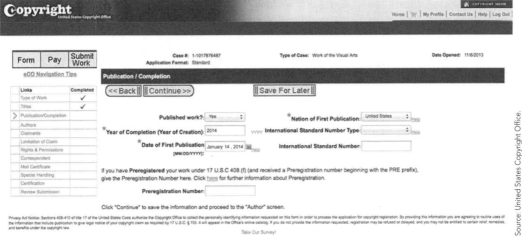

Figure 18.17 *Entering in the details for a published work.*

NOTE

It's important to note that if you're using a date like January 1st, be sure that was the date the first photograph was taken, because the Copyright Office sometimes questions whether that's the actual first date or just a guessed date or a placeholder. When we do registrations for a month, we will always do the first date—say, November 4—and the last date—say, November 28—the work was completed/published. The Copyright Office also sometimes questions date ranges such as December 1 through December 31, because it may appear that you are just including the entire month rather than the actual dates. It's important to be accurate on this. The nature of a date range of January 1, 2013, through December 31, 2013, as being accurate is a note that would be helpful in the Note to Copyright Office space later in the registration, because it could avoid their having to contact you.

16. If this is your first time doing a registration, you'll want to enter all of your information and check the box to indicate that you are the author of the Photograph(s), as shown in Figure 18.18. If you have previously done registrations on the site, click Add Me, and the boxes will be auto-filled.

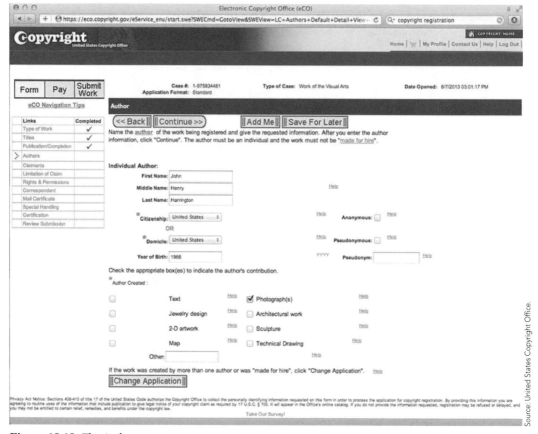

Figure 18.18 *The Authors screen.*

17. Next is the claimant—again, that's you. Click Add Address, and whatever address you entered when you set up the account will auto-fill into these fields (see Figure 18.19).

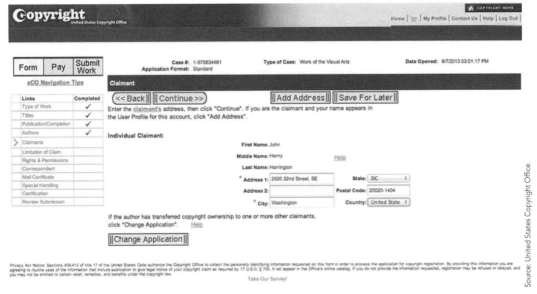

Figure 18.19 *The Claimants screen.*

18. The next screen, shown in Figure 18.20, is where you limit your claim. There are countless reasons to limit a claim. If you're photographing a piece of art or sculpture, your registration is not claiming copyright to that work, only to the photograph you shot. In the case where, for some reason, a collection of photographs may include some images that have previously been published and/or previously registered, they should be identified as specifically as possible in the Material Excluded area using the Other space. Because I previously marked that I was registering a photograph, the Copyright Office expects me to register photographs. If you think there might be any confusion about your intentions, you'll want to fill out this section. Otherwise, leave it blank. Alternatively, if you are creating new work from two previously registered photographs, you'll want to go through the process here by referring to the previous registrations and what new material you've added.

Figure 18.20 *The Limitations of Claim screen.*

Exclusions When Registering Motion Picture/AV Work

As noted in a previous sidebar, this is where you would exclude separately registered photographs or music when registering a motion/AV work.

19. Next you'll come to the Rights & Permissions page, shown in Figure 18.21. If you want other people to be able to discuss your registration with the Copyright Office, enter them here. For example, you may want your office manager or post-production manager to be able to speak to the Copyright Office about this registration, too. Choose Add Me to auto-fill the fields with your information.

20. Next up is the Correspondent screen, shown in Figure 18.22. If you want other people to be able to answer questions about your registration with the Copyright Office, enter them here. For example, you may want your office manager, post-production manager, or lawyer to be able to speak to the Copyright Office about this registration, too. Depending on the size of your organization, you may do it all, or you may have others doing specific aspects of the registration. That's why it seems duplicative—this website serves every type of business, small and large. Choose Add Me to auto-fill the fields with your information, and then choose Continue.

Figure 18.21 *The Rights & Permissions screen.*

Figure 18.22 *The Correspondent screen.*

21. Figure 18.23 shows the screen where you enter the address where you want the certificate mailed. Choose Add Me and then Continue.

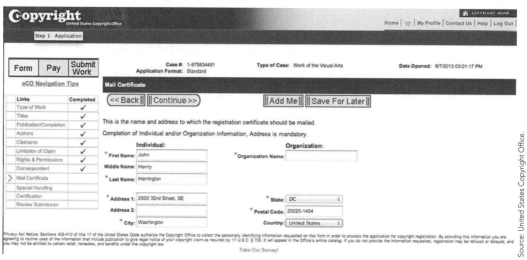

Figure 18.23 *The Mail Certificate screen.*

22. In the Special Handling screen, shown in Figure 18.24, you can note any special handling requirements. If you're checking any boxes on this screen, you've likely found yourself in a situation where you have a legal problem. If not, don't check any boxes; just click Continue.

23. In the Certification screen shown in Figure 18.25, check the box to certify that you are "the author, copyright claimant of exclusive rights, or the authorized agent of the author, copyright claimant of exclusive rights of this work."

A Note about Certification

The person doing the certifying must actually be a human being. By that I mean you cannot use something like John Harrington Photography, John Harrington Inc, or any other business name. That's why it says "individual" in the name field. You must include your name as a person, not as a business.

Your registration could be certified by a lawyer who works for you or even an office manager—whoever is authorized to do so on your behalf. In the Applicant's Internal Tracking Number field, I've used my reference number—in this case, U1302—which I also included in the registration title. If this is registration for photographs created on a single day or a group of unpublished photographs, then click Continue. As noted previously, you can send the office any comments here.

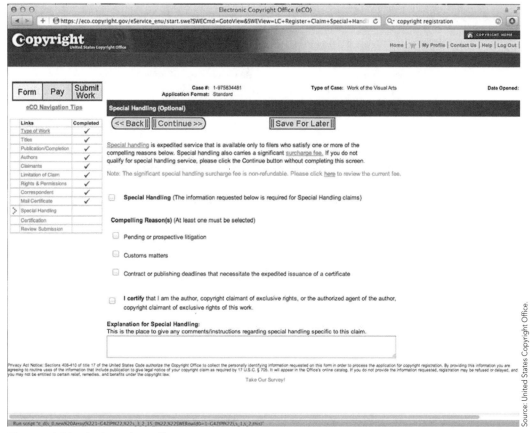

Figure 18.24 *The Special Handling screen.*

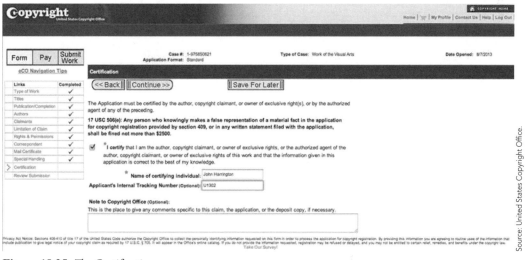

Figure 18.25 *The Certification screen.*

 A Note about Dates in a Group Registration

Important! If you are doing a group registration of published photographs, in the box marked for comments you need to also include the end date for the images being registered. This would need to be done if the date range was not given elsewhere on the application, such as in the title space. So with a date range from January 14, 2014, to February 15, 2014, you would enter in this box:

> Date range of publication of material included is January 14, 2014, through February 15, 2014.

The Copyright Office will add that information by annotation, and it will appear on your final registration certificate you receive in the mail and in the online catalog record. Including it in the Previous or Alternative Titles field avoids having to have the information added by a Copyright Office annotation. It is important that the start and end dates exactly match the earliest and latest images.

24. The next screen, shown in Figure 18.26, is where you'll review the text portion of your submission. If you do a number of similar registrations, choosing Save Template at the top of the screen lets you save for future use every choice you made and every field you filled out. This is a real timesaver, and in the future you can use the template as a starting point to go back and edit the fields.

25. Choosing Save Template shows you the screen in Figure 18.27. Name the template something and then click Save. When you return to the previous screen, choose Add to Cart.

26. Figure 18.28 shows the screen where you pay. In this image, it shows that the fee is $35. In a ruling announced March 24, 2014, and effective May 1, 2014, the fee for a standard registration is $55; however, fees for the registration of a single work (that is, one photograph) would remain $35. Review what's there and choose Checkout.

27. Setting up a DA, or Deposit Account, will make the payment process faster and easier for you in the future. Review the instructions on this screen and then click Continue. See Figure 18.29.

Figure 18.26 *The screen where you review your entire submission.*

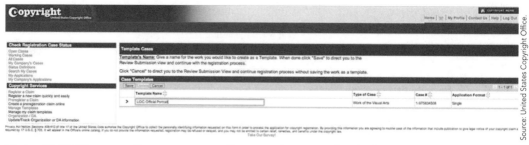

Figure 18.27 *The screen where you can save all your work as a template for future registrations.*

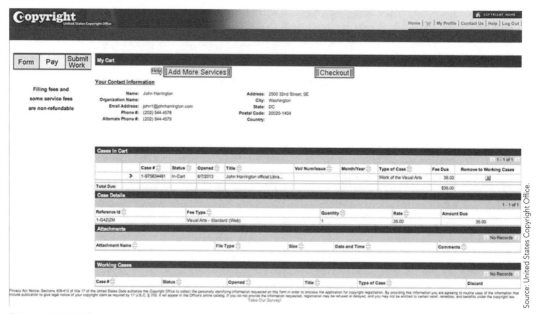

Figure 18.28 *The payment screen.*

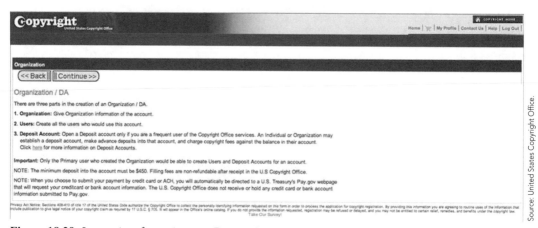

Figure 18.29 *Instructions for setting up a Deposit Account.*

28. Click New on the Organization screen, shown in Figure 18.30.

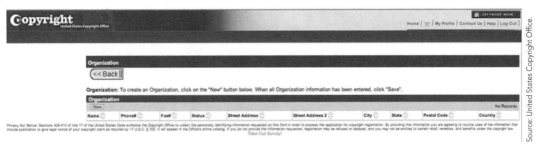

Figure 18.30 *The first screen to set up a Deposit Account.*

29. Enter your information in the fields that appear, as shown in Figure 18.31. Click Save when you're finished.

Figure 18.31 *The screen to enter your details for a Deposit Account.*

30. If you already have a Deposit Account, it will automatically link to your information (see Figure 18.32). Click the $ folder to pay using the linked account. It is the very small icon at the far right of the window. Alternatively, you can set up other methods of paying, but I recommend a DA.

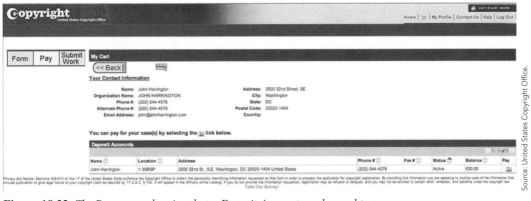

Figure 18.32 *The Pay screen showing that a Deposit Account can be used to pay.*

31. At the next screen, shown in Figure 18.33, review the information and then click OK.

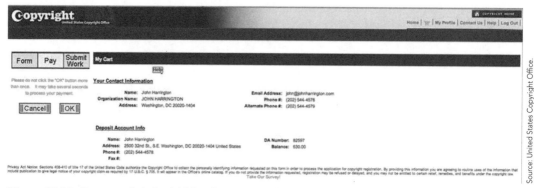

Figure 18.33 *Once you click the $ folder, this screen is the result.*

32. When payment is successful, you'll see the screen shown in Figure 18.34. Click Continue.

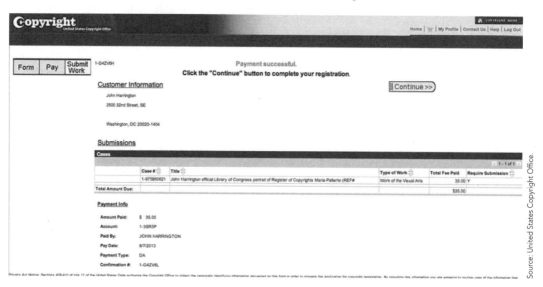

Figure 18.34 *This screen is confirmation that your payment was successfully made.*

33. Review the screen shown in Figure 18.35 and, when you're ready, click Upload Deposit.

34. If you haven't already prepared the files, be sure to go into the metadata and insert all of the correct information. Figure 18.36 shows the Synchronize Metadata window from Lightroom.

35. From Lightroom, I export all of the files to 1050×1050 pixels. The filename is in the format YEAR-MONTH-DATE_Description, as YYYYMMDD_Description_Sequence# (see Figure 18.37).

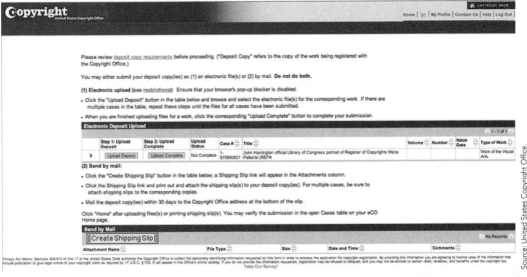

Figure 18.35 *The screen where you upload the images—referred to by the Copyright Office as your "deposit."*

Figure 18.36 *In Adobe Lightroom, the Synchronize Metadata screen.*

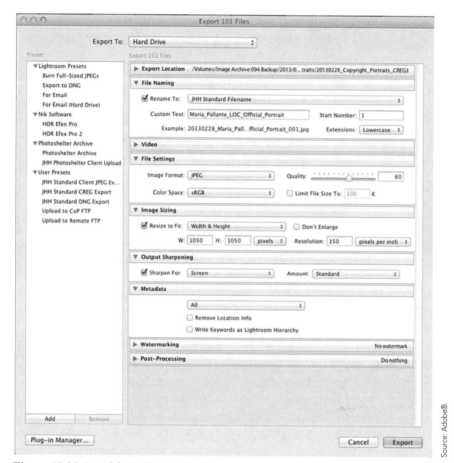

Source: Adobe®.

Figure 18.37 *In Adobe Lightroom, the Export screen.*

36. Once the images are exported into a folder, you can right-click (or Control-click on a Mac) and choose Compress to create a zip file, as shown in Figure 18.38. If you have a large registration, break it down into multiple zip files. Each file can take a maximum of 30 minutes to upload, so depending on the speed of your Internet connection, the number of images per zip file may vary. You'll need to figure this out with a bit of trial and error the first time.

The Copyright Office gives the following guidelines.

Network Connection	Ma18. File Size	How Many Files Can I Zip?
Typical modem (56 kbps)	11.3 MB	6 high-quality (low-compression) JPEGs taken with a 5MP camera
Fiber-optic cable (2 mbps)	170 MB	220 high-quality (low-compression) JPEGs taken with a 5MP camera

Figure 18.38 *In the desktop on a Mac, choosing to compress a folder.*

37. Individually select Choose File and select the file you want to upload (see Figure 18.39). You can do as many as you need, but they don't start uploading until you click Submit Files to Copyright Office. In the Brief Title section, be sure to provide a description of what's being uploaded. If you were breaking up your upload of 600 images into three groups, you might do this:

> Contents Titles 0001 through 0200
>
> Contents Titles 0201 through 0400
>
> Contents Titles 0401 through 0600

Figure 18.39 *The screen where you upload your deposit.*

38. You'll see a warning that once you upload files, they can't delete them or return them, as shown in Figure 18.40. Click OK.

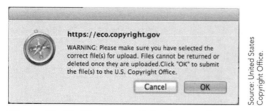

Figure 18.40 *The pop-up dialog box confirming you're uploading the correct files.*

A progress bar will show you how things are going (see Figure 18.41). Depending upon the upload size, you may want to go be productive elsewhere or let it run overnight. I recommend against using the machine for other things during this process, to avoid some other application crashing your machine mid-upload.

Figure 18.41 *The progress bar as the files are uploaded.*

39. The window shown in Figure 18.42 will appear when the files have uploaded successfully. You can continue to upload more or choose Close Window to proceed.

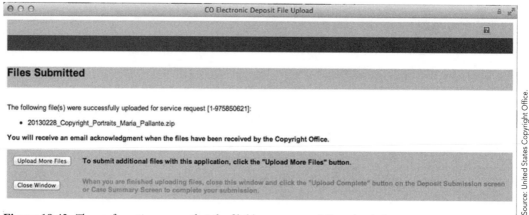

Figure 18.42 *The confirmation screen that the file(s) were successfully uploaded.*

40. On the next screen, shown in Figure 18.43, click Upload Complete under Step 2. Be sure you only click Upload Complete once all of the files you wish to upload as a part of your deposit are uploaded.

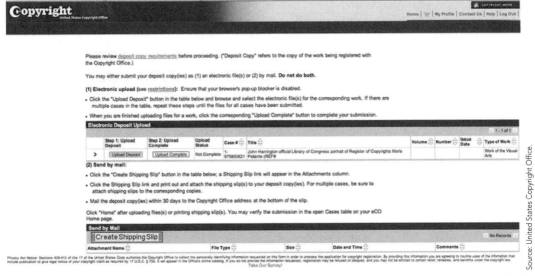

Figure 18.43 *The screen where you first chose to upload the deposit, and you now need to choose Upload Complete.*

41. You have to confirm that the upload is complete in the message box shown in Figure 18.44. Click OK.

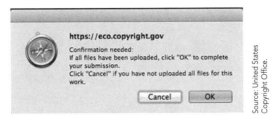

Figure 18.44 *A pop-up dialog box warning requiring you to confirm your upload is complete.*

42. If there were problems or you just wish to mail in a CD/DVD, click Create Shipping Slip to send your submission by mail, as shown in Figure 18.45. (Do not both upload and send in a CD/DVD; only do one or the other.) You will have 90 days to send it before someone from the Copyright Office will call to find out what happened, and your effective date of registration is delayed until the date the Copyright Office receives your deposits. As such, I strongly recommend the online-uploading submission process. A physical CD/DVD can get lost in the mail, damaged in transit, or even damaged during the secure intake process that the Copyright Office uses for all incoming mail, where the package is irradiated at an offsite facility. Better to use the online solution than risk sending in physical media that could get damaged. Further, the "all electronic" submissions are processed much more quickly.

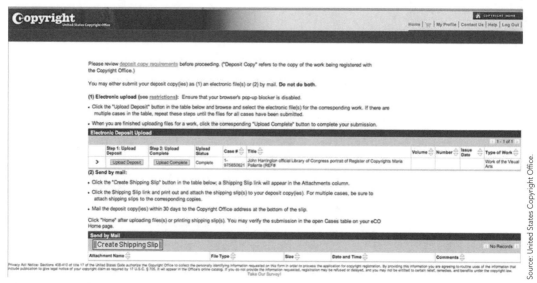

Figure 18.45 *The screen where you identify how you'll send your deposit. If you opt to not upload it as an electronic deposit, your alternative is to choose to create a shipping slip to accompany a CD/DVD you will send.*

43. If you created a shipping slip, you'll see a pop-up message telling you that you'll get a PDF attachment via email, as shown in Figure 18.46. Click OK.

Figure 18.46 *When you click Create Shipping Slip, this dialog box appears, and you will be emailed your shipping slip.*

You'll get an email from the Copyright Office with the subject line "Acknowledgement of Uploaded Deposit," reaffirming that you completed your submission. Figure 18.47 shows the email over top of the envelope I received from the Copyright Office. You'll note that I did my eCO submission on August 7, 2013, and the certificate was sent out from the Copyright Office just over a month later, on September 12, 2013.

Figure 18.48 shows the Certificate of Registration for my copyright to these photographs.

Figure 18.47 *The email received immediately following the submission, and the envelope that was received via the Postal Service with the actual certificate.*

Certificate of Registration

This Certificate issued under the seal of the Copyright Office in accordance with title 17, *United States Code*, attests that registration has been made for the work identified below. The information on this certificate has been made a part of the Copyright Office records.

Maria A. Pallante

Register of Copyrights, United States of America

Registration Number

VAu 1-138-675

Effective date of registration:

August 7, 2013

Title

Title of Work: John Harrington official Library of Congress portrait of Register of Copyrights Maria Pallante (REF# U1302) 101 files containing a total of 101 photographs

Completion/Publication

Year of Completion: 2013

Author

Author: John Henry Harrington

Author Created: photograph(s)

Citizen of: United States Domiciled in: United States

Year Born: 1966

Copyright claimant

Copyright Claimant: John Henry Harrington

2500 32nd Street, SE, Washington, DC 20020-1404, United States

Rights and Permissions

Organization Name: JOHN HARRINGTON

Name: John Henry Harrington

Email: john@johnharrington.com Telephone: 202-544-4578

Address: 2500 32nd Street, SE

Washington, DC 20020-1404 United States

Certification

Name: John Harrington

Date: August 7, 2013

Applicant's Tracking Number: U1302

Page 1 of 1

Figure 18.48 *The actual registration certificate.*

The following sidebars are from *Best Business Practices for Photographers* and are included here for convenience.

From *Best Business Practices for Photographers*: Year in Which Creation of This Work Was Completed

This is pretty straightforward, but of course there are always exceptions. If the assignment started December 31, suppose your assignment was to document the change of the New Year. In that case, your assignment would be completed on January 1 at, say, 1:00 a.m. Although I would register the images with a date of January 1 because that was when they were completed, your attorney might feel differently. Keep in mind also that any retouching or post-production processing would affect the date the work was deemed complete. Ask your attorney, because he would be the one defending the infringement on your behalf.

From *Best Business Practices for Photographers*: Date and Nation of First Publication of This Particular Work

For published work (and I make the assumption that it's published in the USA), on a printed form a range is acceptable, as previously noted. That is not currently the case when using the eCO. On printed forms, you can enter "circa" or "approximately," as noted below. This is not an option in the eCO.

This, from the Copyright Office:

> The Office recognizes that some commenters have previously expressed the view that photographers sometimes have difficulty knowing exactly when—or even whether—a particular photograph has been published. With respect to date of publication, it should be noted that the Office's longstanding practices permit the claimant some flexibility in determining the appropriate date. See, e.g., Compendium of Copyright Office Practices, Compendium II, Sec. 910.02 (1984) (Choice of a date of first publication)…. The Compendium of Copyright Office Practices, Compendium II, Sec. 904 states thOffice's general practice with respect to publication, including that "The Office will ordinarily not attempt to decide whether or not publication has occurred but will generally leave this decision to the applicant." 1) Where the applicant is uncertain as to which of several possible dates to choose, it is generally advisable to choose the earliest date, to avoid implication of an attempt to lengthen the copyright term, or any other period prescribed by the statute. 2) When the exact date is not known, the best approximate date may be chosen. In such cases, qualifying language such as "approximately," "on or about," "circa," "no later than," and "no earlier than," will generally not be questioned. Further in the regulations, it states "The date of publication of each work within the group must be identified either on the deposited image, on the application form, or on a continuation sheet, in such a manner that one may specifically identify the date of publication of any photograph in the group. If the photographs in a group were not all published on the same date, the range of dates of publication (e.g., January 1-March 31, 2001) should be provided in space 3b of the application."

Further, this from the Copyright Office's 37 CFR Part 202, [Federal Register: July 17, 2001 (Volume 66, Number 137)] [Rules and Regulations][Page 37142-37150]:

continued

From *Best Business Practices for Photographers*: Date and Nation of First Publication of This Particular Work continued

Each submission for group registration must contain photographs by an individual photographer that were all published within the same calendar year. The claimant(s) for all photographs in the group must be the same. The date of publication for each photograph must be indicated either on the individual image or on the registration application or application continuation sheet in such a manner that for each photograph in the group, it is possible to ascertain the date of its publication. However, the Office, while on the paper Form VA, they will not catalog individual dates of publication; the Copyright Office catalog will include the single publication date or range of publication dates indicated on the Form VA, whereas when doing an eCO registration, contents titles will appear in the catalog record and on the certificate. If the claimant uses a continuation sheet when filing a paper Form VA to provide details such as date of publication for each photograph, the certificate of registration will incorporate the continuation sheet, and copies of the certificate may be obtained from the Copyright Office and reviewed in the Office's Card Catalog room.

Adding Contents Titles to Your Registration

A highly recommended alternative thing to do is to add in one or more contents titles to your registration. Doing so allows for that contents title to appear on the certificate and provides greater descriptions that are included in the online catalog, which makes your images easier to search for. This could also have legal ramifications because adding a contents title is one way of satisfying the Section 409 requirement that requires you include the title of the work being registered. So let's suppose you were registering five photographs. You'd start on the screen shown in Figure 18.49.

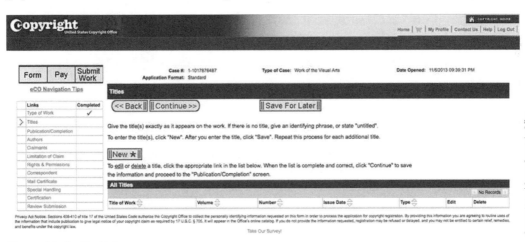

Figure 18.49 *The Titles screen.*

Enter your titles as before, first with the title of the work being registered and then, in the case of a range of dates, with "GROUP REGISTRATION / 5 PHOTOGRAPHS." Then click New* again and select Contents Title as shown in Figure 18.50.

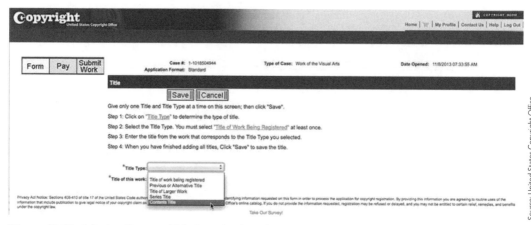

Figure 18.50 *Selecting Contents Title from the drop-down menu.*

For each of the five images, enter the titles one at a time, like this:

- U.S. Capitol at sunrise
- Grand Canyon at sunset
- Golden Gate Bridge at dusk
- Seattle Space Needle at night
- Miami skyline at night

At the end, your registration screen should look like what you see in Figure 18.51.

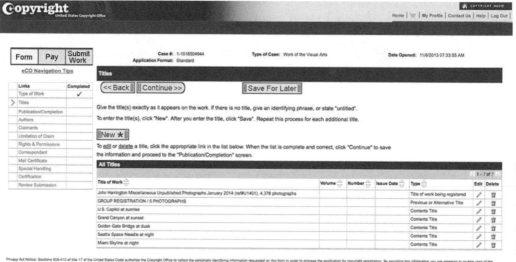

Figure 18.51 *The Titles screen with several contents titles shown.*

Say you were registering these 11 assignments produced during the month of January 2014, each shot on a single day:

- Photographs of the U.S. Capitol at sunrise, January 4, 2014
- Photographs of the Grand Canyon at sunset, January 6, 2014
- Photographs of Golden Gate Bridge at dusk, January 8, 2014
- Photographs of the Seattle Space Needle at night, January 10, 2014
- Photographs of the Miami Skyline at night, January 12, 2014
- Photographs of children on white seamless, January 15, 2014
- Photographs of an immigration protest, January 18, 2014
- Photographs of a press conference at City Hall, January 21, 2014
- Photographs of a river rescue by the fire department, January 23, 2014
- Portrait photographs of ACME Widgets senior executives, January 26, 2014
- Photographs of the menu items for Smokin' Joe's Barbeque, January 29, 2014

At the end, your registration screen would look like what you see in Figure 18.52.

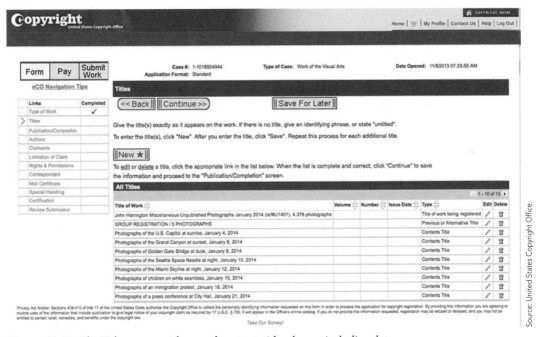

Figure 18.52 *The Titles screen with several contents titles shown, including dates.*

But take note: Only the first 10 lines are visible. You'll need to click that small black arrow at the top-right of the box listing the titles to see the additional titles. The first two titles on the screen are the title of the work being registered and the previous or alternative title, followed by the remaining 11 content title entries, so you will end up having a total of 13 entries, with only 10 visible on the screen at a time. Click the black arrow to show the remaining entries, 10 at a time. In this case, there are only three more lines to show, so the page scrolls past the first 3 lines to show the last 3.

Lastly, suppose you produced four assignments during January, and two of the assignments spanned multiple days. You could, for the other two assignments that were on a single day, denote that and then leave off the dates for the two multiday assignments. So, for these four assignments, you might have:

- Photographs of challenges of living in the Appalachian Mountains
- Portrait photographs of the CEO of John Doe Enterprises, January 10, 2014
- Photographs of a week in the life of a U.S. Border Patrol agent
- Photographs of the hotel interiors of the Ritz Carlton Resort in Miami, January 25, 2014

The resulting window would look like Figure 18.53.

All Titles						
						1 - 6 of 6
Title of Work ⇕	Volume ⇕	Number ⇕	Issue Date ⇕	Type ⇕	Edit	Delete
John Harrington Miscellaneous Unpublished Photographs January 2014 (ref#U1401), 4,378 photographs				Title of work being registered	✎	🗑
GROUP REGISTRATION / 5 PHOTOGRAPHS				Previous or Alternative Title	✎	🗑
Photographs of challenges of living in the Appalachian Mountains				Contents Title	✎	🗑
Portrait photographs of the CEO of John Doe Enterprises, January 10, 2014				Contents Title	✎	🗑
Photographs of a week in the life of a U.S. Border Patrol agent				Contents Title	✎	🗑
Photographs of the hotel interiors of the Ritz Carlton Resort in Miami, January 25, 2014				Contents Title	✎	🗑

Figure 18.53 *In the Titles screen, the All Titles window.*

At the end of the process, you'll have the opportunity to review your submission and see that each of the titles is properly listed.

Don't go overboard. There are technical limitations to the "Title of Work" category data-entry fields, and you can create a problem for the cataloging of your registration. You could get a certificate that is many pages long, but excessive numbers of titles (hundreds or thousands, for example, with a multi-hundred-page certificate) would therefore not transfer to their online catalog.

A best practice would be to individually zip each assignment and upload the zip file that correlates to the individual titles of work. So, using the above 11 assignments, your zip files would look like this:

- 20140104_US_Capitol_at_sunrise.ZIP
- 20140106_Grand_Canyon_at_sunset.ZIP
- 20140108_Golden_Gate_Bridge_at_dusk.ZIP
- 20140110_ Seattle_Space_Needle_at_night.ZIP
- 20140112_ Miami Skyline_at_night.ZIP
- 20140115_ children_on_white_seamless.ZIP
- 20140118_ immigration_protest.ZIP
- 20140121_ press_conference_at_City _Hall.ZIP
- 20140123_river rescue_by_the_fire_department.ZIP
- 20140126_ Portraits_of_ACME _Widgets_senior_executives.ZIP
- 20140129_ menu_items_for_Smokin_Joes_Barbeque.ZIP

Note that for Smokin' Joe's, you'll want to take out the apostrophes in the filename. It's a best practice to use only letters and numbers, along with the underscore (_) or dash (-) to replace spaces.

Alternatively, you could register by subject matter. So, a trip to the local botanical garden might be registered as State Botanical Garden Images, and your trip to France could be registered as Trip to France during the Summer of 2013.

Again, this aids in searching and organizing your copyright record in their online database, and it effectively satisfies the Section 105 requirement.

Advanced (and Bulletproof) Copyright Registrations

I use the word "bulletproof" with some pause when characterizing any copyright registration. A savvy attorney could try to invalidate your registration in myriad ways.

In addition to including the individual titles in the Content Title field, when they receive a registration application for unpublished collections, the Copyright Office sends a letter to the applicant, which includes, in part, the following text:

> Although listing all of your titles in the application is not a current registration requirement, we might require this soon for all collections filed electronically and, more importantly, some recent court decisions have ruled that a registration might not extend to any work that was not listed by title on the copyright owner's registration certificate. Thus, we are encouraging that you list files in order to make the most bulletproof registration.

So it's actually the Copyright Office that is characterizing your registration as "bulletproof" if you list every title in your registration.

How might you achieve this?

Let's start with a folder of files. In this case and for this example, we'll use just 19 files (see Figure 18.54).

Figure 18.54 *The folder showing 19 image files.*

Now you need to know a bit about using Microsoft Excel. Select all of the filenames and then select Copy, as shown in Figure 18.55.

Figure 18.55 *The 19 images selected and ready to be copied.*

Normally, if you went to another folder and clicked Paste, the actual files would copy over. However, if you go into Microsoft Excel, go to cell A1 (the top-left corner), and click Paste, each filename will be entered in an individual cell, as shown in Figure 18.56.

Figure 18.56 *Microsoft Excel with the 19 filenames pasted in.*

Now, to combine (or concatenate) all the files into one cell, you'll need a few formulas. Don't worry, they're pretty easy.

The first formula searches for and then removes everything to the right of and including the period, giving you just the filename itself, without the three-character extension. The formula is:

=LEFT(A1,FIND(".",A1)-1)

Type that into cell B1 and press Enter, as shown in Figure 18.57.

Figure 18.57 *The formula in the Excel cell.*

Figure 18.58 shows the result.

Figure 18.58 *After you press Enter, the contents of the cell have the file extension stripped out.*

Now we need to actually combine the files, adding in a semicolon between each filename. The formula to do so is:

=B1 & ";" & LEFT(A2,FIND(".",A2)-1)

That takes the contents of the cell above it (B1), adds to that cell using the ampersand (&), and then adds a semicolon. Again, the ampersand adds the contents of cell A2 to the left with the same removal of the .jpg extension, delivering the resulting combination of the two cells (minus the .jpg in both, and placing a semicolon between them).

Before you hit Enter, the cell looks like what you see in Figure 18.59.

Figure 18.59 *The cell before you press Enter.*

After you hit Enter, the cell looks like what you see in Figure 18.60.

Figure 18.60 *The cell after pressing Enter. The two files are combined and have a semicolon between them.*

One of the great things about Excel is that it will increment cell letters and numbers in a very methodical way as you copy a cell from one to another. So, next select cell B2 and choose Copy from the Edit drop-down menu or use the shortcut Ctrl+C (for PC) or Command+C (for Mac). You'll see the "dancing ants" around that cell. Next, click and drag from the cell right below it—B3—all the way to the end of the list of filenames. In this case, it would be B19. Once you've done that, you'll see what's shown in Figure 18.61.

	A	B	C	D
1	YYYYMMDD_Client_001.jpg	YYYYMMDD_Client_001		
2	YYYYMMDD_Client_002.jpg	YYYYMMDD_Client_001;YYYYMMDD_Client_002		
3	YYYYMMDD_Client_003.jpg			
4	YYYYMMDD_Client_004.jpg			
5	YYYYMMDD_Client_005.jpg			
6	YYYYMMDD_Client_006.jpg			
7	YYYYMMDD_Client_007.jpg			
8	YYYYMMDD_Client_008.jpg			
9	YYYYMMDD_Client_009.jpg			
10	YYYYMMDD_Client_010.jpg			
11	YYYYMMDD_Client_011.jpg			
12	YYYYMMDD_Client_012.jpg			
13	YYYYMMDD_Client_013.jpg			
14	YYYYMMDD_Client_014.jpg			
15	YYYYMMDD_Client_015.jpg			
16	YYYYMMDD_Client_016.jpg			
17	YYYYMMDD_Client_017.jpg			
18	YYYYMMDD_Client_018.jpg			
19	YYYYMMDD_Client_019.jpg			
20				
21				
22				
23				

Figure 18.61 *Cell B2 selected as the source cell and cells B3 through B19 as the cells to be pasted into.*

From the Edit drop-down menu, choose Paste (or press Ctrl+V on a PC or Command+V on a Mac), and the formula you entered into cell B2 will copy to each of the cells below it and increment the cell references in the formula. Figure 18.62 shows what it will look like now.

Figure 18.62 *A zoomed-out view of all the cells incrementing.*

My apologies that the limitations of this book make it impossible to see each filename, but I believe you can extrapolate from the previous examples that it combined them. Here's what the combined text looks like:

YYYYMMDD_Client_001;YYYYMMDD_Client_002;YYYYMMDD_
Client_003;YYYYMMDD_Client_004;YYYYMMDD_Client_005;YYYYMMDD_
Client_006;YYYYMMDD_Client_007;YYYYMMDD_Client_008;YYYYMMDD_
Client_009;YYYYMMDD_Client_010;YYYYMMDD_Client_011;YYYYMMDD_
Client_012;YYYYMMDD_Client_013;YYYYMMDD_Client_014;YYYYMMDD_
Client_015;YYYYMMDD_Client_016;YYYYMMDD_Client_017;YYYYMMDD_
Client_018;YYYYMMDD_Client_019

An Excel spreadsheet cell can contain a maximum of 32,767 characters. The formula to count the number of characters in a cell is:

=Len(A1)

Where A1 is the cell you want to count. In this case, entering in =Len(B19) as shown in Figure 18.63 delivers the result shown in Figure 18.64.

Figure 18.63 *Entering into cell B20 the formula that calculates the length of the cell above it, B19.*

Figure 18.64 *The result of the formula reveals that the length of cell B19 is 379 characters.*

This is important because the data entry fields on the Copyright Office's website allow 1,995 characters per entry. So here is the limit for the number of files to be registered using this filename:

YYYYMMDD_Client_001 and the semicolon makes a total of 20 characters.

1,995 / 20 = 99.75, or 99 filenames.

Taking out the word "Client" saves characters, so:

YYYYMMDD_001 and the semicolon makes a total of 13 characters.

1,995 / 13 = 153.46, or 153 filenames.

If, however, you produced more than 1,000 files on that day, the sequence would be "0001" and not "001," so that costs you a character, and 14 characters becomes 142 files per Contents Title line.

As such, it is necessary to develop some form of a file-naming system that allows you to register and name every file in the shortest manner possible. However, you will need some mechanism to identify and associate your filename with the date of first publication.

In my office, we register between 5,000 and 10,000 files a month. If you were registering unpublished works, you could use a four-digit filename between 0001 through 9999, which means a five-character unique filename when you include the semicolon. That's 399 files per Contents Title line. Doing 5,000 files of unpublished photographs would thus take up 13 complete "Contents Title" lines.

What if you were to introduce the alphabet? Introducing the 26 letters of the alphabet gives you much more flexibility.

26 × 26 × 26 results in 17,576 unique titles.

Using both letters and numbers, each character can be any one of 36 unique characters. That's the 26 letters of the alphabet, plus the numbers 0 through 9.

Thus, a three-digit filename would be:

36 × 36 × 36, or 46,656 different filenames

And as such, a three-digit filename plus the semicolon means four characters, or 488 files per line, so you'd need just 96 Contents Title lines to register a total of 46,656 files.

Currently, the major applications, such as Lightroom, Aperture, and Photo Mechanic, only increment in numbers, not alphabetically (and also not alphanumerically, from 0 to 9 and then A to Z), so the challenge would be to—in an automated fashion—rename the files.

The application ACDSee does this, though (see Figure 18.65).

Source: ACDSee.

Figure 18.65 *ACDSee set to rename a file and append to the beginning a three-digit alphabetical series.*

One other important thing to do is to use the application's mechanism to store the original filename in a metadata field within the file. If your normal naming nomenclature is:

YYYYMMDD_Client_00001

And you are renaming it to:

001

And the last filename you have is:

YYYYMMDD_Client_46656

And you have renamed that to:

ZZZ

You should still store YYYYMMDD_Client_46656 within the metadata of the file in the Original Filename field. Alternatively, when a software solution allows for alphanumeric incrementing, the file you upload would best preserve within the metadata both the three-digit filename and your original filename, so they would be:

001_YYYYMMDD_Client_00001 through ZZZ_YYYYMMDD_Client_46656

Limitations of the Copyright Office System

As noted earlier, the Contents Title field has a limit of 1,995 characters. While it is not documented anywhere, according to the Copyright Office, the "user will not know that limit has been exceeded until they attempt to save," when the system will give an error.

The total for your entire record—all the data and characters you entered—cannot exceed 99,999 characters, including spaces. Voyager, the eCO system, will not give you an error if you exceed it. The record will simply fail when it is exported during internal processing.

The Copyright Office estimates that the average claim, with one author and one claimant, contains about 1,300 characters. Here is the formula that the Copyright Office uses to calculate the size of a claim:

1300 + (CTLength + 17) × CTNumber = *record* length estimate

Where:

- 1300 is the estimated number of characters in the MARC Public Record for an average basic claim (all data fields used; one each author and claimant)
- CTLength = measure the length of the first Contents Title field by copying it to Word and finding the number of characters in File > Properties > Statistics
- 17 = constant number of MARC structural characters for each Contents Title
- CTNumber = total number of Contents Title fields

So, in one example I am registering 6,558 files. The filename format is:

0000_YYYYMMDD; (14 characters)

That's 91,812 characters. If you keep titles together on a single line, that works out to be 139 titles per Contents Title field. So, 6,558 divided by 139 gives us a total of 48 (47.17, but you have to round up) Contents Title lines.

However, using their formula above:

1300 + (1946 + 17) × 48 = 95,524 characters

That's room for 4,475 more characters. That's about two more Contents Title lines, for a maximum of 50 Contents Title lines:

1300 + (1946 + 17) × 50 = 99,450 characters.

Thus, a maximum of 50 Contents Title lines with 139 titles per line equates to a theoretical maximum of 6,950 individual titles per individual copyright registration of published works.

Earlier, I showed how you could do a three-character unique number with an alphabetical increment between AAA and ZZZ. Removing just one character gives you 13 characters per title instead of 14. As such, within the 1,995-character limit, you can fit 153 titles per line. Back to the formula:

$$1300 + (1989 + 17) \times 49 = 99,594 \text{ characters}$$

Thus, a maximum of 49 Contents Title lines with 153 titles per line equates to a theoretical maximum of 7,497 individual titles per individual copyright registration of published works.

What about unpublished works? With unpublished works, you get to drop the date indicator, and you could use then just the three-digit alphabetical increment. AAA; is just four characters. 1,995 divided by 4 means you could fit 498 titles per Contents Title line. As such:

$$1300 + (1992 + 17) \times 49 = 99,741 \text{ characters}$$

As such, multiplying 488 titles per line by 49 lines gives you a theoretical maximum of 23,912 filenames. This does create a problem with just using a three-digit alphabetical solution, because the maximum unique number of three-digit generatable characters is 17,576 (26×26×26). You'd need to use the alphanumeric renaming capability to get to 46,676; however, knowing that there's a maximum of 23,912 filenames per registration, you would need to do one registration of 23,912 filenames and then register the remaining 22,764 filenames on a second registration.

In case you were wondering, that would be 000 through HF7 for the first registration, and the second registration would be HF8 through ZZZ.

I have produced an Excel spreadsheet that automates for published works:

- The four-digit numeric filename that includes the YYYYMMDD for a maximum of 50 lines with 139 titles per line, for a maximum of 6,950 titles
- The three-digit alphabetical filename that includes the YYYYMMDD for a maximum of 50 lines with 150 titles per line, for a maximum of 7,500 titles

For unpublished works, it automates the three-digit alphabetical filename only, for a maximum of 488 titles per line, giving you a maximum of 24,400 filenames. Note, though, that this spreadsheet will work for up to 24,400 filenames, and as long as you're doing 17,576, you can use the three-digit alphabetical solution. However, for registrations beyond that, you'll have to use a three-digit alphanumeric renaming solution that currently doesn't exist in common photographic software renaming solutions.

This spreadsheet is available as a free download at http://www.Best-Business-Practices.com/resources/online_copyright_registration_excel_v1.xlsx and http://www.cengageptr.com/downloads.

As noted earlier, for published works the Copyright Office would prefer that you include the date of last publication as a part of the Previous or Alternative Titles field; otherwise, if you input the date of last publication in the Note section, which you can do, they will add it by annotating the certificate (see Figure 18.66).

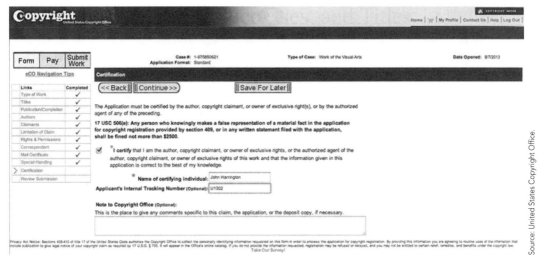

Figure 18.66 *The Note section where you enter the end date.*

If, during your automated process for published works, you use AAA_YYYMMDD as your filename, inform them as such in the Note field. You can state:

> Please note, the approximate date of first publication for each image is specified in the filename, in the format AAA_YYYYMMDD, where AAA is a unique identifier and YYYY is the year, MM is the month, and DD is the day of first publication.

So the entire contents of the Note field would be:

> The approximate date range of first publication of material included is January 14, 2014, through February 15, 2014. Please note, the approximate date of first publication for each image is specified in the filename, in the format AAA_YYYYMMDD, where AAA is a unique identifier and YYYY is the year, MM is the month, and DD is the day of first publication.

Of course, the citation January 14, 2014, would be changed to whatever your actual start date is (and consistent with what you entered earlier in the process), and February 15, 2014, would be changed to whatever your actual last date of first publication is.

It's worth re-quoting the Copyright Office:

> Although listing all of your titles in the application is not a current registration requirement, we might require this soon for all collections filed electronically and, more importantly, some recent court decisions have ruled that a registration might not extend to any work that was not listed by title on the copyright owner's registration certificate. Thus, we are encouraging that you list files in order to make the most bulletproof registration.

Published versus Unpublished: The Debate

Language on the Copyright Office website, derived from the copyright regulations, defines publication as such:

> "Publication" is the distribution of copies or phonorecords of a work to the public by sale or other transfer of ownership, or by rental, lease, or lending. The offering to distribute copies or phonorecords to a group of persons for purposes of further distribution, public performance, or public display, constitutes publication. A public performance or display of a work does not of itself constitute publication. 17 U.S.C. 101.

This means that displaying your work in an art gallery is probably not publication. My position, and one my attorney has stated he is comfortable defending, is this: I undertake assignments for which I am paid. There is a part of the contract that requires the client to pay, and there is also a part of the contract that grants rights to the client that allow them to further distribute the work to their clients, subscribers, viewers, or the like. We offer to our clients all images produced under the assignment, and their purpose is to further distribute that work, or display it publicly, and thus, meets the requirement for publication. As such, at the conclusion of each month, we begin the process of burning a CD of all the images we produced on assignment for clients, stipulating the dates as the first date of the first assignment and the last date of the last assignment—since we offer to clients the opportunity to have the images delivered to them same day, and they dictate when they would like to receive them.

The question comes up all the time: Is my posting the images online deemed to be "publication" correctly characterizing the images as such? The requirement by regulation is that the work must be distributed with the intent of further distribution or an offering of further distribution. Displaying your photographs on a website in and of itself would not necessarily constitute publication any more than displaying them in a physical gallery would. However, if the purpose of the website is for the licensing, sale, or further distribution of your work, then that would likely constitute publication. Also, if you post the images online and you anticipate that people are going to download them or print them out, that would argue in favor of considering the work to be published.

So, adding a line on your website like "These images are not available for downloading or your own use, they are for viewing purposes only" would sway in the direction of unpublished. However, because you are a photographer in the business of licensing your work, if the sentence read "These images are not available for downloading or your own use, they are for viewing purposes only. These images are available for licensing. Please contact us to obtain the appropriate license for the use you have in mind," then that would constitute publication.

Be sure to keep track of what you posted online and when you did to achieve "published" status. You don't want to sloppily publish images on November 5 of one year, get infringed on March 15 of the next year, and then, because you didn't keep track of things when you specified to the Copyright Office your date of first publication as April 10, ultimately have a big legal problem and possibly an invalidated registration of your work.

My recommendation is that you establish a relationship with a good copyright attorney and solicit his guidelines for your specific circumstances regarding what he is comfortable defending on your behalf.

In some instances where work is produced for a photo agency—even supposedly speculative assignments—their intent is to further distribute it as well. Further, posting images on a website in and of itself does not constitute publication, especially if it's a hidden section of your website. However, if it's in a section where there is an offering to license the work for a fee, such as a PhotoShelter section, that would constitute an offering for the purposes of further distribution and would meet the "published" requirements.

Further, the rulings in many cases state that the distribution of just a single copy to a single company or individual can constitute publication. Although case law deals with differing degrees of use and the inevitable inconsistencies among the various courts as to interpretation, an overarching guideline is whether a copy (and a copy can include an original) was distributed with restrictions on the further distribution or use of the copy. The only real reason that "published" mattered was that the origins of federal copyright required work to be published in order to enjoy the benefits of copyright, and that is the basis for much of the confusion that exists today.

Copyright expert Jeff Sedlik notes about some of the risks of registering images as published:

> Delivery of images (or an offering to deliver images) to a company for the purposes of further distribution or display is not necessarily publication and in nearly all cases is extremely unlikely to be deemed "publication" under the law if publication status at the time of registration is later challenged in a court of law. Delivery (or an offer to deliver) images to a "group of persons" for further distribution or display IS publication; however, a few businesses constitute a "group of persons," and ultimately a registration workflow relying upon an assumption that a business (such as a client or a stock agency) is a "group of persons" is a fatally flawed workflow unnecessarily exposing registrations to invalidation. While it is true that form CA may be used to amend a registration to correct an unintentional error in publication status from published to unpublished, it is also true that if the infringer can establish that you have routinely registered images using an incorrect publication status, your special remedies may be jeopardized. It is likely that the government would qualify as a group of persons. It is further likely that a public school would qualify as a group of persons because it is open to members of the public rather than the closed setting of a typical corporation.

Again, be sure to discuss this matter and your proposed workflow with an attorney, preferably the one you would call upon to defend your registrations down the line in the event of an infringement.

Recommended Reading

Duboff, Leonard D. *The Law, in Plain English, for Photographers*. New York: Allworth Press; Revised edition, 2002.

Krages, Bert P. *Legal Handbook for Photographers: The Rights and Liabilities of Making Images*. Amherst, MA: Amherst Media, 2001.

Lessig, Lawrence. *Free Culture: How Big Media Uses Technology and the Law to Lock Down Culture and Control Creativity*. New York: The Penguin Press HC, 2004.

Litman, Jessica. *Digital Copyright: Protecting Intellectual Property on the Internet*. Amherst, NY: Prometheus Books, 2000.

Patterson, Lyman Ray. *Copyright n Historical Perspective*. Nashville: Vanderbilt University Press, 1968.

Thierer, Adam D. and Wayne Crews. *Copy Fights: The Future of Intellectual Property in the Information Age*. Washington, DC: Cato Institute, 2002.

Vaidhyanathan, Siva. *Copyrights and Copywrongs: The Rise of Intellectual Property and How It Threatens Creativity*. New York: New York University Press; Reissue edition, 2003.

Chapter 19

Licensing Your Photography: Managing It Yourself

Over the years, a number of photographers have reported significant income from their stock photo agencies—Getty Images among them. Clearly, Getty has effectively leveraged their acquisitions and marketing efforts to become the largest stock photography provider in the world (currently). This chapter should not be seen as singling out Getty for problems that arise, especially given that the issues discussed are not unique to Getty; however, the issues do serve as an example of the challenges faced when you use an organization like Getty to generate revenue from your existing images.

Getty Images, Their Valuation, and That of Your Images

In August 2012, the Carlyle Group acquired Getty Images for $3.3 billion. Four years prior, another private equity firm, Hellman & Friedman, took Getty Images private after the company had been a publicly traded company since 2002; they paid a 39 percent premium for the company, or 2.4 billion, over the stock price valuation on the open market of somewhere between $1.5 and $1.6 billion. While Getty traded back in 2002 for $28.30 per share, in November 2005 it traded for $95.43 per share, so the $34 per share Hellman & Friedman paid to take the company private is less than a third of the company's peak valuation. A $900 million profit isn't much to sneeze at.

Just like private equity firms can see the future value of an investment, a professional photographer can look beyond the superficial aspects of a photo to see the real quality (or lack thereof) in an image. Private equity firms typically want to see a 30 percent return on their investment, although 15 to 20 percent is a more reasonable annual rate of return. If the deal at 15 percent had been done in a year, Getty should have sold for $2.76 billion; after two years, it should have compounded to $3.17 billion; at three years, it should have been $3.65 billion; and after four years, it should have been compounded to $4.2 billion. While this deal reflected about a 37 percent return on investment over four years, it didn't even make up a 15 percent annual return on investment over the four or so years it was held by Heller & Friedman.

The devil, of course, is in the details, and sources say Getty has taken much of the acquisition on in loans, more akin to a leveraged buyout. For photographers/content producers, each of your images was valued, according to sources, at $0.15 per image over the useful life of the image. So if you've got 10,000 images in the Getty archives, you're worth about $1,500 to Getty.

In March of 2013, Getty decided to offer 35 million of the images within their archives for free for any editorial use, whether to *The New York Times* or the niche blogger. The exchange was that you had to allow the image to appear within an embedded frame that allowed Getty to track the uses and views, and also place advertising within the frame. No reports suggested that the photographers would receive access to that data or to any revenue from the adjacent or overlaying advertising.

On March 29, 2013, one of the country's largest stock photo agencies, Getty Images, sent out this letter to contributors:

> Update on Connect Sales and Statements
>
> $0 transactions on your January 2013 Connect statement
>
> Many of you noticed $0 royalty transactions on your first Connect statement (January 2013) where we should have shown the micro-royalties (fractions of a cent). This was a processing error where some royalties earned under $0.00500 which were inadvertently rounded to $0. Going forward you can expect to see the royalty amount (out to five decimal points) for each image earned, even if it is under one penny. All fractional-cent royalties are then summed on the statement and rounded up or down to the nearest cent for payment.
>
> We have calculated any additional micro-royalties due to you for those zero transactions (which were fractions of a cent). If you are due an adjustment, we will add this adjustment amount to your payment on April 25th, however no royalty statement for this adjustment will be available. If applicable, you may see a description for that additional amount in your payment remittance advice as "Jan2013 Connect zero adj."

While the oldest known photograph dates to 1838, estimates suggest that by 1901, when the Kodak Brownie was introduced, just a few million images had actually been produced worldwide. Throughout the twentieth century, various estimates by organizations such as the Silver Institute and the Photographic Marketing Association International calculate that between the Brownie and the Kodak Instamatic in 1963, through to 2000, a total of 85,000,000 photographs have been shot. That figure has increased to the trillions since then, eclipsing the first 162 years drastically. And "good enough" has been the mantra of the consumer of existing images. The vast majority of images being used have been produced by nonprofessional photographers who are content to simply see their images being used and appreciated by someone else. Much like the Monday-morning sports talk about whose team won over the weekend (with ensuing bragging rights), the nonprofessional enjoys the validation of his creativity as an end user provides an endorsement by using a photo, giving him bragging rights of "ACME Widgets used my photo in their ads" or some variation thereof.

In the April 12, 2013, issue of the *Selling Stock* newsletter, Jim Pickerell, a highly respected analyst of the stock industry, reported in "Changing Photography Business":

> One of the problems image creators face is that a huge percentage of the revenue generated goes to middlemen not the creators. Twenty years ago image creators received 50% of the fees customers paid to use their images.

I agree, but let's analyze that further. Twenty years ago, a stock agency not only had ongoing relationships with image buyers, but they also had an expensive analog system for housing millions of images, and the labor costs were significant. A request came in for an image, and the agency often charged a "research fee" of $75 to $100 for the time necessary to locate the images that met the need. And organizing, packaging, and shipping them cost money. Then, regardless of whether the image was used, when the images returned there was labor involved in checking them for damage (or unauthorized use) and then refiling them in the library. Further, someone had to handle the billing as well. As such, even though 50 percent seemed excessive, there was at least a significant amount of labor involved in the process, and surely the agency earned their 50%.

Pickerell goes on:

> Today, not only have average usage fees dropped, but in most cases creators only receive 20% to 30% of the fee charged—and sometimes even less.… These organizations will take the lion's share of the revenue collected.

At a time when the automation of image licensing means that there's no physical labor involved in the research, delivery, return, and refiling of the images, the fact that creator percentages have gone down is largely a demonstration of the disregard agencies and content aggregators have for those that fill their archives with saleable imagery. However, one other contributing factor is that as the cost per license has dropped to a fraction of what it once was, there are still costs associated with the transaction, and those (mostly) static costs are the same for a $1,000 sale and a $1 sale.

On September 11, 2013, the *British Journal of Photography* published an insightful interview by Olivier Laurent. In the article, titled "Getty Images' Jonathan Klein: 'We Need New Economic Models,'"[1] founder and CEO of Getty Images Jonathan Klein wrote, "I think we also have a responsibility to try to prevent the commoditisation of our industry."

Laurent commented that "a lot of people in the industry blame Getty Images for the falling prices and for destroying the market of photography" and asked Klein to comment on this. Klein responded, in part, "We were there when royalty-free came, sure we grew it. We were there when micro-stock came, we grew it."

Klein went on to, in an almost mocking way, quote photographers who, upon taking on the task of licensing their photography directly, would say to him, "I don't need you anymore. I'll have a website." Klein went on to say, "And then they learned these fancy words: 'I'm going to dis-intermediate you.'"

On the contrary side, Klein does put forth:

> We need a share of the revenues generated around the imagery. The model: "Here's a picture, give me $100 and you can use it" will still continue and will still continue to be a big part of the industry. But in three to five years—no way. In three or five years, we'll be saying: "Here's our imagery. If you generate revenues on it, around it, relating to it, we want a piece of it." It's a bit like the YouTube Content ID model. And we've got the technology and are building that. We, today, do not get the value out of what our pictures do for our customers. It's a good enough model historically—we license [a] picture, it goes on the front page of a magazine, it's $500. If that magazine sells three million copies or doesn't sell any, we still get our $500. But because of the scale of these platforms, and these social platforms, we want more if it goes into the millions.

Klein's position on photographers licensing their own images is that it won't work because it won't scale. He uses as his argument that a photographer may get 10,000 visits, and that compares to Getty's 13,000,000. So, let's consider the folly of that argument, despite my feeling compelled to present his position here for your consideration.

First, a photographer isn't looking to "scale" like Getty is. Almost no photographers are looking to hire myriad positions in sales, marketing, IT, accounting, and so on. Let's compare "scale," though, for the sake of conversation.

[1]Source: http://www.bjp-online.com/british-journal-of-photography/news/2294014/getty-images-jonathan-klein-we-need-new-economic-models

At one point, pre-iStockphoto (Getty's microstock acquisition), the average stock photography license was upwards of $980. In the March 2013 apology letter Getty sent, they apologized for a rounding error that caused royalties to be reported as $0.00. So, what was that rounding error? The statement said, in part:

> …where some royalties earned under $0.00500…

So let's look at that. First, for entertainment purposes alone, how does that compare to the old average gross royalty of $980? It would take 196,000 stock sales at $0.005 to earn a single $980 sale. Now, how do you think the 10,000 visitors to the individual's stock website compare to the 13,000,000 visitors to the Getty website? The disparity between $0.005 and $980, expressed compared to 10,000 visits to an individual photographer website, would be 1,960,000,000. That's (rounding up!) 2 billion visitors. In other words, if you were getting 10,000 visitors to get one licensing fee of $0.005, do you think you could earn one $980 licensing fee if 2 billion people came to your website where you licensed your own stock photography? If so, you'd break even.

The letter goes on unapologetically, noting:

> Going forward you can expect to see the royalty amount (out to five decimal points) for each image earned, even if it is under one penny.

I can't see my way clear to justify the notion that any royalty of mine would be a fraction of a cent—unless it were under these "new economic models" Klein wants to see.

For example, at one point a stock photography license for the cover of *Time* magazine was $1,500. In August 2013, *Time*'s subscriptions were reported as 3,242,594. In this instance, the cost for the licensing fee—per subscriber—is $0.00046. The pay-per-view/pay-per-click concept is that as you sell more copies, the photographer should receive more in licensing. In this instance, and as we move toward all digital platforms, the charge per person viewing the image is appropriate. I submit that automated tracking of image views/downloads can now be engaged. In this instance, I would model it as:

$1,500.00000 Minimum cover licensing fee (good for up to 3,242,594 views)

$ 0.00046 Incremental licensing fee per additional view

I submit, however, that a new economic model, beyond the concept above, should be applied. First, the above should apply as a base. Then, if the manner in which you photographed, say, a person, caused viewers to mouse over the image or click on it, an intermediary site or pop-up window should give viewers the option to buy the products depicted in the shot, and an appropriate referral fee should be paid to the parties involved.

Compensation through Image Interaction

Consider a photograph of celebrity X taken by you, where you manually identify the people and products in the image or image-recognition technology (that already exists) identifies the products in the photograph. Perhaps a watch, a pair of shoes, a purse, a dress, and so on all pop up as purchasable. Amazon, for example, pays a royalty of about 5 percent as a referral fee on many sales if you drive a buyer to their

website. So with sites like Amazon, there's at least $5 to be made on a $100 purchase. How does that money get divided up? Certainly, the celebrity brings a "cool factor" to the item, but what if it's a regular model? What if that model signed a release giving you those rights? The magazine that invested in generating traffic would get a share, as would the celebrity (or model), as would the photographer (split with their stock photography agency/distributor).

Enter Stipple. Stipple is a good example of a technology that has hit upon what very well could be the future monetization of your content in a way never before possible. Here's how Stipple would generate revenue.

Suppose an image created contains a clear view of a watch selling for $100. The website on which the image appears gets 1,000,000 page views per month. Consider that the average rate at which a consumer "clicks-through" is 7 percent. Thus, from the 1,000,000 page viewers, approximately 70,000 viewers will decide to purchase the watch as a result of seeing the photo you produced. Next consider the abandonment rate of shopping carts, and there then becomes a 50 percent follow-through to purchase, bringing the total number of buyers to 35,000. This will result in $350,000 in gross sales.

The standard affiliate revenue from that is 15 percent, generating $52,500 in referral income.

Under (and according to) Stipple:

> 50 percent goes to the site that published the image: $26,250
>
> 10 percent goes to the photographer: $5,250
>
> 40 percent goes to Stipple: $21,000

Stipple takes the reasonable position that the websites that garner the most traffic are in a position to also control revenue. As such, the website that published the image gets the largest portion of the referral income. The model is fair, and the percentages may well change over time.

Stipple's portion of the referral fee is based upon their position that "Stipple has a lot of cost associated with revenue. In fact, the more successful a campaign (the more hits), the more it costs in server and bandwidth fees. Thus a large part of the Stipple 40% is to cover operating costs."[2]

Although 10 percent may seem low, through this model photographers can grow their income on a specific image multiple times, whereas the website that published the image has limits. The same image with the monetization links (say, a clickable square over the watch when you mouse over the image) can appear on a site like CNN, and there CNN is entitled to their percentage of the referral revenue. But the photographer can have that same image on a *USA Today* website, an *US* magazine website, and a *People* magazine website. In effect, a single well-done image of a celebrity wearing a watch could create multiples of the sale, significantly growing the photographer's income. Lastly, these referral-fee models are already commonplace across all consumer sales websites, such as Amazon.

If your images are going through a stock portal, you're then saddled with a split of 70 percent to them and 30 percent to you, or 60 percent to them and 40 percent to you—or, if you're lucky, 50/50.

[2]Source: Paul Melcher, VP of images for Stipple.

PhotoShelter

In the interest of avoiding paying a 70 percent commission to a middleman, a solution like PhotoShelter can provide significant imaging-licensing revenue within the current business models, and can position you to best be prepared for the new image-interaction models as they evolve. With PhotoShelter, you get a package that includes a customizable website, an online archive where images can be publicly searchable or kept private, an integrated e-commerce engine for licensing stock photos and personal-use downloads or selling prints and products, plus image-delivery tools for client access and project collaboration. PhotoShelter's transaction fees are lower than those of traditional agencies, at 8 to 10 percent based on your account tier—a far cry from the 70 percent or so that most other stock agencies are requiring. And for those, you just have a portal to license images, nothing more.

Let's look at three different examples for generating revenue using PhotoShelter.

Austin, Texas, Photographer

Dan Herron is a commercial photographer based in Austin who produces images for use largely in advertising and product photography, as well as doing on-location assignment work. Dan's website, www.Herron Stock.com, is the first result in Google for "austin stock photography" and other similar searches.

Dan shared, "I was with iStockphoto about 10 years ago for a year or two, and it was 20 percent on the dollar, and I thought that was a huge rip-off. I was with others as well, and I would get these checks, and they were for under $20 a month or they would give you a credit. I did that for awhile, maybe a year or two, and then cancelled the accounts because it wasn't worth it."

After looking around he came across PhotoShelter as a solution to set up his own stock photography website. "I've been with PhotoShelter since 2010. The majority of my income is from stock. Every quarter or so I'll get a custom gig from the site, but in the last six months I've averaged several thousand a month."

Dan is able to set up his own pricing structure on the website and have it be an automated process where clients can pay and download in an automated fashion. "In my pricing tiers, I sell a small web-resolution image for $19, and a large web-resolution image for $49, and my top fee is $399. I've had four of the $399 licensing in the last month alone. The custom assignments are $2,000 and above—in other words, a standard commercial assignment shoot to make it worth my while."

Charleston, South Carolina, Photographer

Dustin Ryan lives in Charleston, South Carolina, and produces a number of landscape images that he licenses for stock usage and sells prints of. After spending some time with a micro-stock agency and getting tired of being paid what he characterized as $100 and seeing 300 different instances of people licensing his photographs, he decided to take control of his licensing. Dustin sought out PhotoShelter for his stock licensing and a fine-art website, Fine Art America, to sell framed prints.

Dustin characterized it this way: "I'd rather make $150 off a single stock license, which is what I've found people are comfortable paying to use one of my images, than next to nothing through micro-stock. There's so many similar images on micro-stock that I wanted people to be able to see mine as something different." Through Fine Art America, Dustin uploaded a series of his images, and the website handles the rest, from printing to framing and shipping to the end client. "They handle it all within about a week, which is much

faster than even I could." Dustin found that with even a limited number of images selling as prints, he was netting over $1,000 a month. "I'd like to go out and produce some more, but I've not yet been able to find the time."

In Dustin's case, a single image licensed through PhotoShelter garnered more income than 300 different micro-stock sales, according to his numbers. Dustin points out that many people find his images via online searches for images by subject, and then he often engages the subject directly to find out further what they want. They are, of course, free to license the image through PhotoShelter, and sometimes they do, but Dustin uses the website not only for this direct "unattended" licensing opportunities, but also to engage with the client further for additional licensing needs.

California and Belgium Studios

Chris Daniels is the creative director for Izmostock.com, a global organization located in both Long Beach, California, and Brussels, Belgium, with production studios in India utilizing 40+ people there focused on imaging post-production. Izmostock and Izmocars is a multimillion-dollar organization, and globally it seems hard to argue with the notion that anyone comes close to the size, scale, breadth, and depth of their automotive-image offerings. Izmostock has two studios that, at about 13 models a week, produce images of more than 700 different cars per year, with full lines of cars dating back to 2007 and select cars as far back as 2003.

Izmostock's website really demonstrates the flexibility and customization available, making that solution a serious tool for the professional photographer looking to stake his or her own claim on licensing stock photography at a very high level.

While Izmostock began in 2003, they spent a period of time with Corbis around 2012. After that, Izmostock headed out on their own and hasn't looked back since. Izmo is part of a multinational company that serves automotive dealers and other businesses and consumers with images.

Daniels noted, "I used to work in the stock industry and worked for Corbis for a number of years, and Corbis represented my work and I personally experienced the downward trend from start to finish." While in 2003 Izmo started without a studio, 2006 saw them starting with their first studio, and they have been producing high-resolution stock ever since. "Once we established Izmostock's website and identified PhotoShelter as the best solution for that, we moved forward to build that site." Daniels went on, "Having 100 percent of the revenue rather than a minority stake is definitely a better solution. We also have the organic side benefit of driving search results that has been a major way for people to find us as a company where we set up larger image deals for regular subscriptions, and the feed for our historic and current model year content has been a very valuable tool."

Izmostock's key is in finding a very good niche and capitalizing on it. "What I can say is the nature of our content is studio automotive photography, which is very specialized, and people are using very specific search terms which bring them to us, ensuring we are on the top pages of results. Also, the ease of the e-commerce functionality makes it really easy for them."

Daniels concluded, "As a photographer, you get out of it what you put into it. I think PhotoShelter is a great way to get your content out in front of people and to maintain a relevance in the marketplace."

These three examples illustrate that you can manage the licensing and distribution of your photography yourself, and you aren't tied to a company that will give you pennies on the dollar for licensing your photography.

Chapter 20
On Being Published

For many years, I held onto the belief that if I was published in a magazine, I was worth something. The validation of my work and the dissemination of it to a publication's readership would demonstrate that I had arrived. Nothing could have been further from the truth. At its best, being published is marketing for you, but even that isn't always the case.

Never let a prospective client try to get you to work for free by saying, "It'll be good exposure for you" or "We'll give you photo credit." Don't let the lure of being published make that a viable option.

Gone are the days when a photographer used a "tear sheet"—literally a torn-out page from a publication—to showcase his work. Sure, listing on your website the prestigious places your work has been published can be valuable, but it's not a deal-breaker if you haven't been published.

We'll talk more about how to publish in Chapter 21, "Publishing a Book."

For Wedding Photographers

Usually, wedding photographers want their work published in some sort of "best wedding photographers" article. There's significant benefit in being able to say on your website, "As featured in *Bostonian Magazine*" or "Proud to be a Top 10 wedding photographer in *Chicagoland Magazine*." Also, showing up in magazines such as *Miami Bride* or *Washington Weddings* can be helpful, especially if your website is listed and set as a clickable link in the online version of the story.

Realize that in almost every circumstance, you'll be expected to provide free photography to these publications. Despite the fact that they *should* pay you a fee, the reality is that this mold has been broken for some time, and there's no getting around it. These magazines masquerade as editorial content when they're all just one great big advertisement. Your photo is really an ad for you; it just *looks* like editorial content. The magazine will tell you that it's free advertising for you—and, well, that's true. Wedding photography is one of the few places where the concept of "it'll be good exposure for you" holds true.

In addition, wedding planners, caterers, and florists may be more likely to recommend you if there's a chance that it will lead to wedding photos featuring their products or services being published in something like *Metro Area Weddings*. Many of the widely read wedding magazines, such as *The Knot* and *Modern Bride*, have very formal submission processes, which vary by publication.

For Editorial Photographers

By default, if you're an editorial photographer, being published is your lifeblood. The problem is, often your work doesn't "play" well, being relegated to a quarter-page or thumbnail photo when it really would've looked amazing as a full-page image, where the detail and nuance would've stood out. However, don't feel the compunction to self-publish a book. Unless you're doing it for close friends and family (and by that I mean fewer than about 20 copies), it will end up looking like "vanity press"—a book that serves to stroke your ego.

For Commercial/Advertising Photographers

Commercial and advertising photographers' work is almost always published without a photo credit, so from a marketing standpoint the value to you is zero. No one will know it was you who produced the work. However, there are books, publications, and annuals such as *Communication Arts* that showcase top campaigns and projects, and identify who did the photography, design work, illustrations, and so on. These publications can be influential in garnering future work.

Many commercial and corporate photographers undertake book projects in conjunction with a company, foundation, or government entity. It might be a book with photographs of all of the major intercoastal waterways in Florida, funded by the Florida Clear Water Foundation, which uses a grant from the Jane M. and John J. Doe Foundation. In some instances, a photographer may have spent years collecting images that form the beginning of a book along these lines, and they'll approach a foundation about expanding the book to increase awareness of the foundation's mission. The book may even be sold by the foundation as a fundraising tool.

However, you should avoid "vanity press." Unless you want to get into the business of publishing a book and then wholesale distributing it to retailers or individually shipping it through a retailer like Amazon—which will cost you $40 a month for a merchant account and a 30 percent commission on every sale—you're better off not engaging in the headache. I have numerous friends and colleagues who have spent tens of thousands of dollars on a book so they could say they were published—and they ended up with 2,000 books mildewing in their garage, a waste of space, time, and money.

For Photographers Who Sell Their Work as Art

If you're looking to generate significant income from your work as art, having that work appear in a book will often diminish the art's value because the image is no longer rare. If the book itself is the art, then that falls under Chapter 21.

Chapter 21
Publishing a Book

Many photographers want the prestige of publishing a book, which seemingly adds instant credibility. If a photographer is being considered for an assignment to document the restoration of, say, Mount Rushmore, it would be easy to point out, "Well, he did the photography for a book on the building of the National Japanese-American Memorial, so surely he's qualified!" Or, "Of course he should be hired to shoot the next Formula One race; he did a book on F1 in Dubai." All of a sudden, having a book elevates a photographer's status.

The challenge, of course, is that this mindset is based upon the very closed publishing industry, where if a photographer has a book published, it has been vetted by multiple people—some experts in their field—to arrive at a viable book on the subject. By extension, this makes the photographer/author somewhat of an expert on the subject. In reality, while the book publishing industry is still very closed with regard to major publishing houses, a photographer can pretty easily get a book published. Take something as simple as the production of a photo book using Adobe's Lightroom or Apple's Aperture. Both produce excellent photo books through their third party vendors. I've produced many, as Summer keepsakes for my children.

The truth of book publishing is that you won't get rich doing it. First, let's dissect the different types of books you might publish, so we're on the same page.

If you were to do a book on how to use a piece of photo-related software, the book would have about an 18-month lifecycle before the next version of the software comes out. Further, some people get advance notice of and insight into upcoming software releases, and their books will beat yours to press by four to six months. Lastly, as software enters cloud-delivery and subscription models, changes will happen so fast that your book might be outdated before it rolls off the presses.

That brings us to coffee-table picture books. The book that my publisher produced—*Photographs from the Edge of Reality* (Cengage PTR, 2010)—was a hardback (subsequently translated into Spanish, to my pleasant surprise), but it was not a coffee-table book. It told the stories behind more than three-dozen assignments I completed in the first 20 years of my career. Unless you're a well-known photographer with a substantial following online or recurring features in magazines (maybe you regularly do covers for *Rolling Stone*, *Time*, or *Vanity Fair*, for example), your book will be mainstream and will need to appeal the masses. In an instance like this, the book is first about you as the photographer/artist, and second about the images contained therein.

Most picture books are on a specific subject, and they are often referred to as "theme" books. There are hundreds, if not thousands, of coffee-table book ideas, whether it's a troubled waterway in your community, documentation of a unique lifestyle, or even a story about life in America. If you have an idea, how do you get it published?

Self-Publishing

The easiest way to get a book published is to do it yourself. No one will tell you no, and you will decide what goes in and what doesn't. Self-publishing also means you're paying for the entire thing. This is often done through a vanity press—a publishing house where the author pays to have his or her book published. There are a few different models of vanity presses, which we'll discuss in the next few paragraphs.

If you say you've had a book published, the first question people often ask is, "Oh, with what publisher?" That question is often meant to challenge the author to validate his credentials as a published author, because many suggest that a self-published book is little more than a really expensive portfolio piece and/or a great marketing piece for the photographer. Keep in mind, though, that as Darius Himes and Mary Virginia Swanson said in *Publish Your Photography Book*, "what you may not have is the experience and skills to achieve all that you want, from editing and design to marketing and distribution…. The learning curve with any first publication is huge. You are doing alone what an entire industry is set up to handle." Keep this in mind as you forge ahead.

With the advent of print-on-demand publishing houses, there can also be little financial risk to producing a book. An author only needs to pay to obtain a Universal Product Code (UPC), and then he can begin selling his book at places such as Amazon.com. If you go directly to the company that manages UPCs, there is an initial fee of $250 plus a $50 annual fee. The website for GS1 (previously the Uniform Code Council) is www.GS1US.org. This nonprofit organization is the only source for the number that makes up a barcode's core. Other companies may sell them, but they are reselling the numbers and serving as a conduit to GS1.

Amazon—arguably the largest online book retailer—also offers print-on-demand publishing, and you keep 80 percent of the royalties. On Amazon, the publisher will be listed as CreateSpace Independent Publishing Platform, and you're off. Another resource is MagCloud (www.MagCloud.com), which produces books and magazines with larger print runs at affordable prices.

A corollary to self-publishing is subsidized publishing, where it costs, say, $25,000 to produce a coffee-table book. The publisher requires you to contribute, say, $10,000 to the effort, and in return you get a specific quantity of books. The concept here is that going with a reputable publishing house who asked you to partner with them and share the costs will ensure that you have the prestige of the publishing house behind you. Other terms such as "joint venture" or "hybrid" publishing come into play here. Some publishers will ask you to cover the entire $25,000 figure, and often that figure is significantly higher than the rate the same print house would charge a bona fide publisher for the same printing services. Such is the reality of the hopeful person who wants the acceptance of being a published author.

In the end, if you want people to buy your book, a vanity press isn't the best solution. Stories abound about publishers who have found their way into the news by taking money and not delivering.

One variant on self-publishing is to use a crowd-funding solution, such as Kickstarter (www.Kickstarter.com) or Indie Voices (www.IndieVoic.es). A cursory search of Kickstarter lists several-thousand book projects in process, some overfunded and some languishing. Indie Voices, a new venture started by several major players in the publishing world, defines itself as the Kickstarter for independent media. A serious study of the professionalism of the pitch as it is posted on Kickstarter or Indie Voices, and how polished it looks, demonstrates that it's all very possible provided you put a solid effort in.

The key to fundraising is providing real rewards at the various pledge levels. For example, as the pledged financial contribution increases, you might offer signed prints in dimensions ranging from 5×7 through

16×20, a signed copy of the book, or a limited edition of the book with a slip cover, and so on. Photographer Karen Kuehn (www.KarenKuehn.com), with solid successes and a dozen titles to her name, said, "I also did a karma list in the back of several projects, listing the names of [the] patrons." Karen also suggests considering a funds-collection service such as www.WePay.com over PayPal. WePay has been around for five years and in 2010 served as the funding hub for Occupy Wall Street. In 2013, they funded $1.5M a day for crowdfunding platforms.

Producing a Facebook page for the book is important to build interest, and ads on Facebook can drive people to your project-funding page. Kuehn notes, "I find you have to really hustle daily to get pledges. It's best to touch base with people for results via phone or a personal email."

Book Deals

Getting a traditional book deal is a challenge. You're not the only one with the brilliant idea of publishing a book and sharing your vision with the world. Each year, scores of people want to do just that. Publishers can only publish so many books. In the past I have been commissioned to produce the photography for books where I provided an estimate for my time and expenses, and the bill for services rendered and rights granted was paid with no future royalties. For other books, I received an advance as payment against future royalties, then provided the text and images, and I received royalties each time the book was sold. I've also had my images used to fill an entire book without permission, and we had to settle the matter of copyright infringement, but that's another story.

Take, for example, a cookbook. If you're a well-known food photographer, you might pitch a proposal to produce a cookbook with a well-known chef. In all likelihood, the chef's name will carry the book, but it should say "With photographs by…." Also, you and the chef will split the royalties in some way—whether it's 50/50 depends on your negotiating skills. In most cases, the royalty rate will be either 11 percent or 12 percent, but never higher than 15 percent. Assuming the book sells for $29.99 at full retail, that gives it a wholesale price of about $15. As such, a 50/50 split on a 12 percent royalty of $1.80 means you'll earn $0.90 a book. So, to make $5,000 on the book, you'd need to sell just over 5,000 copies. What are the chances? Answer: Not very high.

Alternatively, you could do the math and figure out that if you just provided the photography to the chef, you might charge $5,000 (or more) for the multiple photo shoots over several days, licensing the photography to the publisher for one edition or one printing, and limiting the press run to a set amount, at which point an additional licensing fee would kick in.

Co-Publishing with a Third Party

One way you can get a book published is to work with a third party. Say, for example, you want to produce a beautiful coffee-table pictorial book about the San Francisco Bay. You might partner with the Bay Area Transportation and Land Use Coalition (now known as TransForm), the Bay Institute of San Francisco, Friends of the San Francisco Estuary, the San Francisco Estuary Institute, Save the Bay, the Marine Mammal Center, and the San Francisco Bay Joint Venture Program, to name a few. Putting together a proposal and then contacting them could very well yield a book deal.

Perhaps they have already done books, so they know the ropes of the publishing industry and already have contacts. Or, they may have no idea how to do it, but they have additional grant funds to spend; and if you bring them a fully planned proposal with a publisher, they may write the check and let you shepherd the entire process.

The key is to find partners that share your interest and are willing to commit their resources and contacts to a project you're interested in.

Finding an Agent

An agent, or rep (short for artist's representative or author's representative), is a rarity. That's not to say there aren't thousands of them who have hung out their shingle and said that's what they do—but do they really? The rarity is in finding one that's worth what they charge. Some will simply sit back and wait for you to bring them a deal that they will then negotiate for you, but you want one that has the industry contacts necessary to get you published and is also willing to make the cold calls necessary to pitch your book.

Agents—and these are separate and distinct from an artist's rep that will promote you to galleries and for exhibits—typically charge a commission of between 15 and 25 percent. The Association of Authors' Representatives (www.AARonline.org) has a database of more than 400 reps, and a listing in the Arts, Cinema, Photography category returns more than 30. The book *Writer's Market* lists a number of resources, and Publishers Global (www.PublishersGlobal.com) has a number of resources. Keep in mind, you could well spend weeks or months looking for the right agent.

Another solution is to look at books of the style and type you admire. Many authors will specifically thank their rep by name in the Acknowledgments section in the front of their book. This can be a good starting point, and once you've identified four or five possible reps, you can reach out to them. Unlike a written-word agent or rep, who is usually employed by a large company, the rep you're looking to hire probably works for himself or with a few partners, and is usually accessible and receptive to a phone call. However, you should be prepared to immediately send off a proposal (hopefully closer to finished form than draft form) via email at the end of the call. Many people talk a good game, but they'll expect you to commit your proposal in writing so they can evaluate it. It can be in either narrative form or in the Q&A form outlined in the next section.

Pitching Your Book

Getting your book pitched and accepted is the biggest hurdle. You have to give people a reason to say yes when they usually default to no. Whether you or your agent prepares the proposal, it should contain a few key points. Many publishers want to know whether a book is appealing to the educational market, because if a book hits its stride there, it will be successful and many printings can result. Also of critical importance are the books you identify as competing titles. If there are already two or three books on a subject, the publisher will look up the sales of those books using the BookScan service. So, the books you compare to yours must have been commercially successful with lots of copies sold. However, your competition can't be a brand-new book that is currently selling well. Rather, it has to have sold very well in the past, but now there's a need for a fresh new book on the topic.

Following is an example of a book proposal. This is a question-and-answer format that you would fill out if you spoke to someone who had a proposal form for all authors to fill out. Alternatively, you could collect all of the following information and include it in narrative form, accompanied by a few select photos or even a few page-spread layouts as an example. Any publisher will require a proposal similar to this, whether in Q&A or narrative form, before moving forward. They will want you to have answers to the questions, as outlined like this. You should also have the answers to these questions if you're doing a self-publishing project.

Title: American Icon – The Bald Eagle in Culture and Symbolism

Describe your book in one paragraph, as if it were a pitch to a bookstore:

The bald eagle has not only been a symbol of the United States of America almost since its founding, but a figure of immense importance for Native Americans as well. From iconic illustration of American might to the mystical qualities it has for indigenous peoples, few, if any, symbols carry such prestige. This book, through pictures and historical insights, reveals why the bald eagle remains so important to this day.

Book Details:

What is the primary subject area the book covers?

Nature, specifically the bald eagle

Is this book a series?

No, but it could be.

If so, provide details:

If the book does well, a series could be born.

What is the book about?

The bald eagle as both a figure of importance to Native America and an icon of American power.

Why is the topic important?

The bald eagle almost became extinct, and people have always been fascinated by it, so from a conservation standpoint and one that piques people's interests, it's important.

Why should we publish this book?

The bald eagle is appealing to people of all ages across racial and cultural lines, mostly in the United States. It has a timeless appeal, meaning a longer shelf life because it isn't time sensitive.

What is the book's angle/approach to the topic?

The book is a pictorial book that, through detailed images (many of them full page), reinforces the awe and beauty of this amazing bird.

Is this a new edition?

No.

Provide a proposed table of contents:

Introduction

1) The Historical Origins of the Bald Eagle

2) Where Can They Be Found?

3) Mating for Life

4) Bird of Prey – How They Feed

5) Their Symbolism to Indigenous Peoples

6) Their Symbolism as an American Icon

7) Future Outlook – No Longer Endangered

Describe the Market for Your Book:

The market for this book is broad. It is of interest as a gift because there is no particular political slant or agenda. The subject is immediately recognizable and appealing.

Who is the audience?

The audience for this book is cross-generational and cross-cultural. It is intended to be of interest to the general public and not one specific segment.

Is this title something that will sell as a textbook or in the educational markets?

This book is not designed as a textbook; however, it would be appealing to schools and libraries as a book that students might use to prepare a book report or to see, in detail, a bald eagle.

What books on the market would compete with this book?

There are other books on this topic, but most take purely a nature, or conservationist, approach. None examine that as well as the iconic and symbolic nature of the bald eagle.

List at least three books that this book would compete with. Please also provide your opinion about the book listed and why yours is different, as this will help our sales force market the book you are proposing.

Competing Title 1

Title:

Saving the Bald Eagle

Author:

Zaphod Beeblebrox

Publisher:

Galaxy Press

Year Published:

2001

ISBN Number:

123-456789-0

List Price:

$49.99

Number of Pages:

212

Colors:

4-color

Hardback or Paperback:

Hardback

Your Opinion of the Book:

This title approaches the subject strictly from the standpoint of wanting to save the bald eagle. While this is important, it misses out on why the bald eagle is so important to people.

Competing Title 2

Title:

Bird of Prey – The Bald Eagle

Author:

Atticus Finch

Publisher:

Mockingbird Press

Year Published:

2005

ISBN Number:

098-765432-1

List Price:

$34.99

Number of Pages:

178

Colors:

4-color

Hardback or Paperback:

Paperback

Your Opinion of the Book:

This book takes a look at the bald eagle as a bird of prey. It focuses on how the bird finds food and feeds its offspring. The pictorial visuals are good, but again, the book lacks the dimension that a bird such as a bald eagle can command.

Competing Title 3

Title:

The Bald Eagle – Symbol of American Might

Author:

Holly Golightly

Publisher:

Tiffany Press

Year Published:

2010

ISBN Number:

456-789012-3

List Price:

29.99

Number of Pages:

150

Colors:

4-color

Hardback or Paperback:

Hardback

Your Opinion of the Book:

This book is intended to illustrate the symbolism of the bald eagle to the United States, but it just doesn't do the bird justice. The book lacks the substance and weight of the bald eagle's historical importance, and again misses the multifaceted appeal that the bald eagle has.

How Would You Market the Book?

What top three features of this book make it appealing to a book buyer for a bookstore?

This book is visually appealing on both the front cover and the spine. The book is not odd-sized, so it will not create problems for stocking. This book is timeless, so it won't go out of date because of an event or a new version of software coming out.

What are the top three features of this book from the reader's/buyer's perspective?

This book makes a great gift. Unlike, say, the symbolism of giving a book about chickens or parrots, the symbolism of giving a book about bald eagles is not lost on the recipient. The book, while a beautiful picture book, also contains items of interest and insight that will leave the reader with a better understanding of the bald eagle. The book is timeless, so people will see long-term value in keeping the book.

What potential appeal does the book have for the academic market? If any, list three features that make it appealing to teachers.

The book has appeal in the elementary and middle school markets, and possibly high schools as well. The book is factual, so students using the book as a resource for a book report will be reviewing accurate information. The book approaches the bald eagle from an apolitical standpoint, so there is no liberal or conservative slant. The visuals in the book are large, so a teacher wanting to share the book with the class can hold up the book, and students in the back row will be able to see the visuals.

Marketing Considerations

Is the intended audience for the book represented by a trade association or other formalized group?

The book is appealing to environmental groups, groups focused on Native American cultural matters, bird watchers, and schoolteachers. From the Environmental Defense Fund to the World Wildlife Foundation, and from the National Association of Native Peoples to the American Federation of Teachers, many associations represent the core audiences this book appeals to.

What are the most important types of advertising outlets for this book?

Advertising in teachers' publications or magazines such as *Nature*, as well as online groups that focus on bird-watching.

What tradeshows or conferences are the most important related to this book?

The North American Nature Photography Association conference and the annual Bird Watchers of America conference, as well as the annual American Federation of Teachers conference, all would find this book appealing.

What mass emailing or group postal mail markets should we announce this product to?

The mailing lists from the World Wildlife Foundation, the Native Peoples of America Association, Birdwatching.com, and *Bird Watcher's Digest* all are perfect audiences for this book.

What chapter(s) should we disseminate to book reviewers to promote the book?

The chapters "Their Symbolism to Indigenous Peoples" and "Their Symbolism as an American Icon" would be appealing to many.

Are there any special events, festivals, venues, or other unique sales opportunities for this book?

The book can be sold at the numerous bird-watching festivals around the country throughout the year, and there are a number of Native American bookstores on reservations and at casinos where the book would sell well.

Are there speaking engagements or any online marketing opportunities you would be willing to do to promote the book?

I intend to present proposals to speak at various bird-watching conferences about the importance of the bald eagle. The lead times for these conferences are 9 to 12 months in advance.

Do you know anyone who is knowledgeable on this subject who would be willing to promote the product or review it on Amazon?

Yes, I have several colleagues who are very knowledgeable on the subject, and I intend to not only get their feedback during the production of the book, but to then encourage them to share that feedback on the finished book on Amazon.

About the Author

Author's legal name for contract:

John Henry Harrington

Name to appear on book cover:

John Harrington

Legal residence:

Washington, DC

Mailing address:

2500 32nd Street, SE REAR

Washington DC 20020

Contact phone number(s):

(202) 544-4578

Other books you have illustrated, authored, or co-authored:

Smithsonian's Our World series: Meet Naiche

Smithsonian's Our World series: Meet Mindy

Smithsonian's Our World series: Meet Lydia

Author bio:

For more than two decades, John has documented the world as a photographer. Growing up in California, John moved to Washington, DC, in the mid-1980s. An associate member of the International League of Conservation Photographers, John is a 2007 recipient of the United Nations' Leadership Award in the field of photography. John's work has appeared in *Time, Newsweek*, and *Rolling Stone*, and his commercial clients have included Coca-Cola, SiriusXM Satellite Radio, Lockheed Martin, and the National Geographic Society.

John has produced three commissioned books for the Smithsonian and the second edition of his book *Best Business Practices for Photographers. Photographs from the Edge of Reality* revisited highlights of his career. John has lectured across the United States to events for the American Society of Media Photographers, Advertising Photographers of America, Professional Photographers of America, and the National Press Photographers Association. John concluded serving his second term as the president of the White House News Photographers Association in May of 2011.

Packaging of the Book:

How should the overall look of the book be? Any special properties?

The book should be the dimensions of a standard coffee-table book that someone would be comfortable picking up and leaning back to enjoy flipping through. It should feel like a book of substance with lots of large photographs.

What cover ideas do you have?

The cover should be a glorious close-up photograph of a bald eagle in flight over snow-capped mountains, and I have several images that fit the bill.

Once you've completed the proposal, you'll want to find the acquisitions editor at a publishing house. A cursory search through the front pages of other similar books at various publishers will give you an idea who those people are. You can then double-check that information using LinkedIn—although that's not always current, it can be useful.

Acquisitions editors usually (but not always) work in certain genres, so that can be useful in knowing who to reach out to. Some publishers have specific people to pitch everything to, while others have online forms for you to pitch your idea. On a regular basis, these acquisitions editors meet with senior management and pitch the proposals they're interested in. If the proposal is approved, then it goes through Legal.

Copyright in and to Your Book

Many publishing contracts will suggest they be given copyright to your book as a part of the contract. Just as you have dealt with this matter in your business with clients wanting copyright, you should deal with the matter with a publisher. The publisher is granted first rights to your book (and you can subdivide the rights by geographic region, country, or both) and generally may continue to print the book for as long as there is demand. Once the book is deemed to go out of print (when a small number of books are sold within a six-month period), the rights to the work then revert to you, and you are free to then relicense the book or do with it as you wish.

Here is a reasonable clause regarding your rights in a publishing contract:

> You own and shall retain the copyright subsisting in the Work, and shall register the same with the Copyright Office of the United States at your expense. You understand and agree that notwithstanding your retention of copyright, you will not grant to any other party, or yourself exercise, the rights or any exclusive or non-exclusive rights co-extensive with the rights you grant to us herein, provided that we are in compliance with the terms of this agreement, and provided that the rights granted to us have not reverted to you. The rights granted to us herein are the exclusive right to print, publish, distribute, and sell copies of the Work, serialized versions of the Work, and revised versions of the work, in any printed or electronic form (and other methods or delivery vehicles as applicable, and to authorize others acting in our behalf and subject to the terms of this agreement to do so for the duration of the copyright, in all languages, throughout the world but not after the rights granted herein are reverted to you as provided for herein.

> Your name will appear on the title page, cover, and spine of printed copies of the Work and on the title page of electronic or other copies of the work as its author. We may edit, add to, or delete from the Work as we see fit. We may determine, in our sole discretion, the final content, form, and appearance of the Work. We may ask for your input regarding our changes, as we deem necessary. We shall also include on all published editions of the work the copyright notice "Copyright John Harrington, year date of first publication. All Rights Reserved."

In the event your copyright is infringed, you'll also want a clause like this:

> If the copyright in the Work is infringed, and the infringement involves rights herein granted by you to us and not reverted to you the parties shall cooperate in investigating and prosecuting any claim for infringement. Each party shall be obligated to notify the other in a timely fashion of any infringement of which it becomes aware. Each party shall then have thirty (30) days thereafter to indicate whether it wishes to participate in such an action, provided that such action includes rights granted by you to us herein and not reverted to you. If the parties proceed jointly, in such action they shall share all expenses, deducted from any recoveries, and recoveries equally. If either party decides not to participate in such action, it shall authorize the other to proceed in its own name and shall assign all rights to that party reasonably necessary to prosecute the claim. The party proceeding alone shall bear all expenses, and shall keep all recoveries from any prosecution of the claim. Nothing shall preclude you from independently pursuing any action, without obligation to us, that does not include rights granted by you to us, or which have reverted to you.

Royalties

If you get an advance, that's just what it is—an advance on what the publisher hopes will be the royalties they'll pay you. So, if you get a $2,500 advance (which the publisher typically will pay in installments as you deliver portions of the book) and your royalty rate is $1 per book, you'll get nothing for the first 2,500 books sold. After that, every quarter you'll get a report saying how many books have sold and an accompanying check for the royalties owed you. If the book fails to sell 2,500 copies, you still keep the advance with no obligation to repay it.

Here's a common royalty clause:

> The royalty paid is calculated based on our Net Receipts of all copies of the Work, future revisions, reprints and any other authorized printed embodiments of the work. Net Receipts is defined as the actual cash received by us, not the cover price of the Work, minus refunds for current returns and exchanges actually credited, and excluding money received for items invoiced separately on a customer's bill—such as shipping, handling, taxes, or other fees.

Sometimes electronic royalties are handled at a different rate, and with the rise of electronic editions, you'll want to ensure they are addressed. Here is a common clause for those:

> We will pay you a royalty of XX% of all Net Income for sales of all electronic copies of the Work or any derivative, including Internet and CD-ROM distributed versions. Net Income is defined as income received for the Work, minus direct costs incurred by us for electronically distributing the Work (i.e. amounts we pay in arms length transactions with unassociated third parties for shipping and handling fees, commissions, credit card fees, agency fees, licenses, foreign taxes, distribution fees, etc.).

Often international sales can cost more or be handled by a third-party distributor or publisher, so you and your publisher share in whatever income comes from those at a different rate.

We will pay you half of the royalty mentioned above for sales on all print copies of the Work made by us through third party sub-distributors distributing the work for us outside of the United States of original English language versions, special reprint versions or adaptations of the Work, sold outside the United States and its possessions.

There are a variety of other ways to split royalties, with lower royalty rates applying to educational sales, mail-order sales, book clubs, and so on. The key in your negotiations is to look out for your interests and to be fair to everyone involved.

Marketing Your Book

There is something tangible and wonderful about holding a physical book. Flipping the pages on an iPad or Kindle just isn't the same, and this is especially true with a photo book. This also means that your ability to convince people to buy your book because of that tactile experience is nearly nonexistent when you're selling online. Further, you'll be all but on your own as it relates to marketing, book tours, and so on. A publisher may take out a full-page ad in a publication, but if you're lucky, your book will be one of a half-dozen or a dozen books on that page. You'll also be responsible for coming up with a list of people who should be sent a review copy of the book, who then might write a review in a trade magazine or on their blog.

With the demise of so many brick-and-mortar stores—especially the big chains—now more than ever the independent bookstores will be critical to your success. Because they are independent, you are actually able to walk in with a case of books and walk out with a check. That's a bit of an oversimplification of the process, but the reality is that the person making the decision about your book is usually there every day, as the store owner. If your coffee-table book is of interest to the local community, they may well buy it.

Your book should have a presence on social media. One way would be a Facebook page. Amazon also offers author engagement opportunities. If your book is about a particular subject—say, about the Gulf Coast of the United States—cross-promoting the book in online forums and Facebook groups that focus on life around the Gulf is valuable. I'd also plot out a route from the Florida Keys all the way around to Corpus Christi, Texas, and identify every independent bookstore along the way. You likely could make this trip even before you've finished the book, showing off a promotional package of photos and a story summary. Then, you could identify the level of interest as well as a list of owners with whom you've begun a relationship. If your book was on the Great Lakes region instead, a journey from Green Bay, Wisconsin, around to Rochester, New York, could garner the same insights and bookstore leads.

A traditional publisher will usually have someone in-house to help with these things, but they are marketing dozens of titles so their time will be limited. It can be valuable to hire a publicist to market for you, but you'll want to set a limit on costs and a series of goals for the publicist to hit. Any publicist who objects to these two points in your agreement isn't seasoned enough, so look elsewhere.

If, in the end, you remain committed to producing a book, the best step-by-step guide I've found for photographers is *Publish Your Photography Book* (Princeton Architectural Press, 2011).

Recommended Reading

Himes, Darius D. and Mary Virginia Swanson. *Publish Your Photography Book*. New York: Princeton Architectural Press, 2011.

Chapter 22
Fine Art, Art, and Selling Prints: Valuation

Let's begin this chapter by asking an important question: What is your motivation for selling your photographs in the fine-art arena? Is it to sell fine art or just to make print sales? Are you looking to become famous? Make a lot of money? Earn accolades from other photographers? A number of photographers have moved into the fine-art arena and are selling prints, such as Peter Lik and Rodney Lough Jr. There is a distinct difference between fine art and just print sales, so consider your limitations and understand where you fit in this world.

Chasing fame—especially in the photography field—is a race you'll almost certainly lose before you even get started. Within the field of photography you might earn some notability—you might be the next Ansel Adams, Annie Leibovitz, Herb Ritts, Robert Capa, Richard Avedon, David LaChappelle, Henri Cartier-Bresson, Eddie Adams, Irving Penn, Alfred Stieglitz, or Mark Seliger—but I submit that outside of the photography field, your average person could identify maybe one or two of these big names (likely Adams and Leibovitz). Photography isn't like Hollywood, where you can name celebrities by the boatload. Within the photographic community, Ritts, LaChappelle, Cartier-Bresson, and Seliger are mostly known names, but usually within their genre. With the fragmented world of photography, your best bet at achieving accolades and fame is likely to take place within your community—whether it's a bohemian loft in SoHo or SoMa, or an online forum like Luminous Landscape. However, the accolades of your community almost certainly won't pay your rent or fund your retirement.

Fine Art versus Art versus Prints

The Oxford Dictionary defines fine art as "creative art, especially visual art, whose products are to be appreciated primarily or solely for their imaginative, aesthetic, or intellectual content." By that definition, the fine art hanging in museums and galleries around the world is just as fine of art as the $80 framed print hanging in your local coffee shop. The same dictionary defines art as "the expression or application of human creative skill and imagination, typically in a visual form such as painting or sculpture, producing works to be appreciated primarily for their beauty or emotional power" or "works produced by human creative skill and imagination" or "creative activity resulting in the production of paintings, drawings, or sculpture." Yet again, the definitions cross over one another, and they don't define the difference between fine art and art.

The term fine art is often used to describe art once it's reached a particular valuation, but that's just not right either. Sometimes, the differentiator is commercial art versus fine art, where commercial art is produced in larger quantities for a broader distribution and a fine-art producer produces his work on his own and then submits it to the public for (hopeful) acceptance and valuation.

continued

> ### Fine Art versus Art versus Prints continued
>
> Some suggest that it's just considering how many (and for how much) you're selling of what's produced. It's perfectly possible for a photographer to have sold his work for years for $200 and then somehow be discovered by a gallery owner. Suddenly, his work becomes worth $2,000 or $20,000. Does that suddenly make the prints sold at $200 fine art? Well, if nothing else, it does make it likely a good investment!

Most photographers will laugh at you if you say you're looking to make a lot of money in photography. It is certainly possible to earn a respectable living as a photographer, but none of the photographers I know or am aware of are hanging out on their yacht in the Caspian Sea. You must have passion and drive behind your work, and then there is the possibility of earning a living. Don't let your desire to be validated as an artist or to earn accolades drive you to devalue your work simply so you can say, "I've sold my work as fine art," because that's a recipe for disaster.

The market for fine-art photography is broad. Whether it's landscapes, cityscapes, street photography, otherworldly creations from a visionary mind, celebrity portraiture, or even concert photography, fine art spans broad genres of photography.

A December 2012 article in *Forbes*, titled "The Steady Rise of Fine Art Photography," cites an ArtTactic survey showing that there has been a rise in the confidence of photography as fine art, up 9.2% since May of 2012. What's remarkable, however, is that the biggest increase in that confidence took place in photographs that command over $100,000. Setting aside the multimillion-dollar valuations, this is a remarkable figure to contemplate. In addressing the question of photography being accepted as art compared to what has traditionally been considered valuable art, noted photographic collector Arthur Goldberg says, "Great art is great art…whatever the medium."

The ArtTactic survey listed modern and contemporary photographers that had a high confidence of valuation of photography as art. They are:

- William Eggleston
- Josef Sudek
- Man Ray
- Edward Weston
- Irving Penn
- Richard Avedon
- Garry Winogrand
- Robert Mapplethorpe
- Diane Arbus
- Manuel Álvarez Bravo

Of more contemporary photographers, they listed:

- Stephen Shore
- Edward Burtynsky
- Peter Beard
- Sally Mann

- Sebastião Salgado
- Philip-Lorca diCorcia
- Simon Norfolk
- Martin Parr
- Nobuyoshi Araki
- Robert Polidori

Examining these 20 artists' works should begin to help you understand how images can be valued and the market growth potential.

Understanding an Increasing Valuation

How valuable is a photograph? As an image gains popularity, it becomes more valuable only to the extent that there is a finite number of images in existence. Consider the value of the Twinkie snack cake. A few years ago, when news reports surfaced that Hostess was going out of business, Twinkies, typically sold at $5 a box, started selling on eBay for $80 to $500 and beyond. Indeed, a product's scarcity can increase its valuation. Of course, when Hostess was bought a month or so later, the company resumed production of Twinkies, again making hundreds of thousands of them a year. If an image is popular and as ubiquitous as a Twinkie, there's no way to monetize that.

Rodney Lough Jr. employs an interesting pricing model he terms an "appreciation level." Lough limits his editions to 500 prints, and after every 100 sold, the price goes up until they're all sold out. On his website, he alerts people to the increased level of appreciation, creating a time-sensitive situation and motivating people to buy.

Creating Editions

"Editioning" a print is simply making a promise to create a scarcity in an image. An original edition of a piece of art, for example, would be an oil on canvas. Any replicated versions of it would have to be a repeat of the first, manually done exactly as the first was. However, as modern reproduction techniques grew, an oil on canvas could be reproduced as a lithograph. While not as original as the original oil on canvas, the artist would agree to produce only a limited quantity and identify which reproduction the piece was in the print run. For example, 1/250 would indicate the first of 250 of that piece of artwork (and that usually took place by also adding a signature). These are promises that must be upheld, or lawsuits occur.

How valuable is a photograph? As an image gains popularity, it becomes more valuable only to the extent that others cannot obtain it. Ansel Adams didn't start editioning his prints until the 1960s. The historical backing for limited editions is based on the tradition of printmaking, where it was a labor-intensive process to produce additional prints. Just because you can now choose "Quantity: 100" in your Print dialog box, load up the roll of paper, and go to bed, that doesn't mean you should. As the artist, you have decided you only want so many copies of your work in the world. That's your prerogative.

By editioning your prints, you create a scarcity that increases the value. An edition of 1,000 or 2,500 is far too large to create a real scarcity. In my opinion, the top end of any edition should be 500. However,

editions of 100 and 250 will command much higher prices. Editions of 50 and 75 prints are often well-received figures. Note that these editions are across all image sizes, so that's not 50 16×20s and then another 50 20×30s. And, you'll need to keep meticulous records of any editions other than open editions. Andreas Gursky, whose photographs have commanded the highest prices on record, typically does editions of six and allows for two artist's proofs.

Depending on your jurisdiction, there are some consumer-protection laws about just what an "edition" means, so look into those, too. And if you decide to do posters or notecards, those may fall into an area that affects your edition size.

Editions are based on trust. Violate your clients' trust and you're done, and maybe even sued. Don't try to figure out ways to work around an edition that's done by trying to use a new process, new inks, or a new medium. It's not worth it. If, as the artist, you have some significant creative belief that a heretofore unknown process exists to take your work to a whole new level, then that may be an argument for creating a new edition.

Recognize, too, that once your edition is sold out, you're no longer making any money on it. The marketplace, in the form of those who bought your print, is now making money off your image by buying and selling it, increasing its value for their own gain. While that may be difficult for you to accept, instead consider that this reality also tangentially increases the value of work you produce in the future.

Also consider that you don't want to include sold-out editions on your website selling platforms. Doing so usually convinces prospective buyers that the best images are already sold, so they're now getting the lesser pieces. It seems logical to create the notion of scarcity, but in the end it doesn't work that way. You can show a few of your favorites or ones that have been really popular, but showing 20 pieces with 10 or 15 of them listed as sold out won't help your cause, it will hurt it.

Signing Your Work

As noted earlier, signing your work creates added value. A buyer knows you won't be able to sign the prints once you've died, so that establishes a value in scarcity.

There are several ways for you to sign your print:

- En verso: on the back
- Matte: on the matte around the print
- Bottom of print: outside the print area
- Bottom of print: inside the print area

It's critical that you actually place a pen to the paper, rather than using a digital signature. If you're signing the matte, it's common to use a pencil. If you're using pen, a pen that outputs pigment ink is important, because the writing doesn't fade as fast. An artist's nib pen with India ink is also a good solution. I have a print hanging on my wall where the artist's signature—done with a Sharpie pen—has faded to almost nothing. My only saving grace is that the photographer is a friend, so I'll have him re-sign it or provide me with a replacement.

One thing you should really do is settle on how you'll sign your name. If you were Richard Avedon, you could get away with simply "Avedon," but given that you're not, you should use your first and last name. If

you sign with your middle initial, make sure you always do that. Questions of authenticity often hinge on how something was signed.

Creating Certificates of Authenticity

Another way to establish a value and rarity to your images is to create a Certificate of Authenticity (CoA) for each image you sell. Some manufacturers, such as paper-maker Hahnemühle include uniquely coded holograms on the back of the print and an accompanying matching label for you to apply to your separately printed CoA. The CoA should include:

- Your name
- The CoA number (from the hologram, if you're using that, or one you assign)
- A description of the image and/or the image title
- What media you printed it on (watercolor, fiber, and so on)
- Ink type (as noted earlier, pigment inks carry a higher valuation)
- The printer type and/or the capture-device details
- Date of printing
- Edition size (such as 1 of 50 or 1/50)
- Print size

And, of course, there should be a line where you sign to certify it. If a separate person is handling your printing, you can also have your printer sign the CoA adjacent to the media/ink/printer details, if you'd like.

Re-Licensing Work That's Art

You need to consider how a buyer of your fine-art work will feel if they come across "their" photo in an advertisement. Likely, they'll consider that the valuation has dropped and will be upset. So, segment the work you're selling as art from that which you're licensing as stock.

Pre-Selling

Rodney Lough Jr. pre-sells prints before he even goes somewhere, thus funding his projects. If you have a following and you want to pre-sell two-dozen images at $2,000 each, you've now got $48,000 to travel to your destination and produce images. This isn't a likely scenario for many, but if 200 of your clients have paid $4,500 for a print, and you're giving them first crack at your work for $2,000 to the first two dozen, you'll more than likely get them on board. This is actually a pre-Kickstarter way of crowd-funding and has been effective for Lough for some time.

Determining Your Creative Value

Because there are so many unknowns and variables to a work, it's hard to get a handle on exactly what to charge. To understand it at its core, try breaking it down to a work's value per square inch. For example,

Peter Lik sells a 9.75×9.75 print in his online gallery for $195. At that dimension of approximately 95 square inches, the price works out to be $2.05 per square inch. Because we don't know Lik's hard costs to produce the print (that is, ink and printable media), this is a close approximation, but it's not exact. But for the purposes of this example, it works well enough.

Next, let's look at a standard 8×10 print. For a corporate client that needs an 8×10, we charge $25. An 8×10 of a group of people to memorialize an event isn't seen as fine art, but having a baseline from which to operate provides useful insights. So, an 8×10 is 80 square inches. At $25, that's $0.31 per square inch, thus the creative value is $0.31 per square inch. Arguably, an 8×10 for a bridal couple moves closer in the direction of art and usually does require a bit more work to be done to it. Many wedding photographers charge $40 for an 8×10. In this case, the creative value moves up to $0.50 per square inch.

By comparison, let's look at the creative value placed on prints sold as art—unsigned open editions at Art.com:

Size	Cost	Ink/Paper Cost	Total Creative Value	Per Square Inch
12×16	$44.99	$2.96	$42.03	$0.03
23×32	$79.99	$11.84	$68.15	$0.02
36×48	$129.99	$26.64	$103.35	$0.01

Unless you're getting into volume printing, you won't be able to enjoy the benefits of just factoring in the costs of ink and paper; you'll need to outsource your printing to a vendor. For example, a large format printer will run you about $4,500. A 13×19 print, according to the manufacturer's figures, will cost about $6 in ink to print (that's at $0.72 per square foot), and the paper will cost you $13 (that's at $1.50 per square foot). Thus, you're looking at a $19 hard materials cost, and there are quality printers doing that same print for $22 and $40. As such, with a $3 profit on the hard costs from the $22 print, you're looking at having to make and sell 1,500 prints to cover the cost of the printer.

Now let's have a look at how different items price out with varying creative value (CV) figures. When I began to research my own prices, I spoke with other photographers and asked them what they would sell a print for. In response, I got a wide range of prices. For example, one local photographer (L1) would sell a 13×19 print for $300 (a CV of $1.22 per square inch), and another local photographer (L2) would sell a 16×20 for $2,400 (a CV of $7.50 per square inch). In both cases, the prints were signed and numbered. The Lik figure on the next page is not for a limited-edition piece.

While I understand that fine-art pricing is excessively subjective, it is almost certain that some will take these methodologies to task, and that's fine. Even if some question the value of comparing the pricing of different photographers for the purposes of determining one's own pricing, the fact is that the prospective buyer often can't see beyond the price, so a consideration of others' pricing when attempting to formulate your own can be insightful and instructive.

A 16×20 print sells for:

Size	Hard Cost	CV @ $0.31	CV @ $0.50	Lik CV ($2.05)	L1 ($1.22)	L2 ($7.05)
16×20	$22	$100	$160	$656	$389	$2,400

Using the same CV, a 20×30 print sells for:

Size	Hard Cost	CV @ $0.31	CV @ $0.50	Lik CV ($2.05)	L1 ($1.22)	L2 ($7.05)
20×30	$35	$175	$275	$1,230	$730	$4,500

Because every photographer feels differently about the value of his work, I won't begin to suggest that you should charge $X for a 16×20. Instead, I think it's critical that you use a system to extract costs and establish a baseline charge for the creative contribution you've made, and then adjust (upward) from there. If you value your work at a rate of, for example, $25 for an 8×10, then it certainly stands to reason that a 20×30 should be, at a minimum, $175, but at the wedding CV of $0.50, it becomes $275, plus framing. Keep in mind that these figures don't factor in the value of the artist's signature or the increased value of a limited-edition print.

Another insight comes from a local photographer at an antiques fair. His pricing model for a 7×10 is $40. He sells two for $70 and three for $100, and each includes a matte but no frame. So his one-off price equates to the wedding print at $40, or $0.50 CV per square inch. This photographer repeatedly appears at antiques fairs, so presumably it's worthwhile to him at these rates. But what about framing?

Framing

Including framing is a double-edged sword, because on one hand, you're now selling something that's appealing because it's ready to hang; but on the other hand, if you've framed it in a way that isn't appealing to the prospective buyer (either for aesthetic reasons or because it doesn't match the other framed items she has), then you'll lose the sale. As such, one solution is to offer—in a retail environment—the same print both framed and unframed. By doing so, you appeal to the buyer who wants to "buy and hang" but also serve the client that wants to choose the frame herself.

Framing costs vary. I strongly recommend you consider outsourcing it. One excellent resource for framing is Furst Brothers in Baltimore. A dry mounted print, an attractive 16×20 frame, a 4" matte, wire, and glass will run you $74 at cost. Comparatively, you are reasonably able to mark up that price to, say, $210 without a problem. Certainly, you can consider other local solutions. Either way, you're looking at a $136 markup on top of your revenue from the creative value of your work.

Considering Other Pricing Factors

The art world is a crazy place where a piece of art valued by an auction house like Sotheby's at, say, $100,000 can end up selling for $750,000 or more. However, a number of factors go into establishing price. While previous sales history is a solid baseline, let's assume that you haven't yet established a track record for $1,000 16×20s.

Other pricing factors include uniqueness, size, color palette (black and white, duotone, full color, and so on), how an image is printed, the number of images in the edition, and so on. Consider what it might cost you to produce an image. If you set out to find an image of evergreen trees in a forest with a lot of character, with snowfall as an added element, it might take you an hour or two to think about it, plan, and head out. Then two to three hours to shoot it, another two hours to edit the images down to the signature image from the shoot, and then an hour to print it. So let's say you've got about eight hours in, and you value your time at $25 an hour. You're looking at about $200 plus materials cost. Keep in mind, this ascribes your time as a person whose valuation is based upon manual labor times and not any creative contribution.

The value of your work will undoubtedly be compared to others. Professional appraisers can value your work. You likely know about appraisers who come out and provide a valuation of your home. They do this in part by looking at the market, and also by comparing your home to other homes of a similar size and style. A $1,500 framed 16×20 of your family isn't valued as that much by your neighbor, who, when looking for a piece of art, places next to no value on having a portrait of your family on his wall. So, too, an appraiser won't consider all of the sentimental reasons why you think your home is valuable, such as birthdays celebrated in it or other memories made from your kids' childhood.

Objectivity is critical and should at least be the basis for how you value your work. Prospective buyers don't care that you waited all year for the sun to be in the perfect spot on the summer solstice and that the photo could only happen within about a two-minute window because you tracked the sun's path to be in just the right spot. They don't care that you had to climb a mountain to make an image from just the right vantage point and it took you two weeks to do. These subjective considerations mean something to you, but degree of difficulty isn't a consideration for most art sales. Just because it cost you $10,000 to make the expedition to that highest point in the world, that doesn't make your art worth $10,000. Art is worth what someone is willing to pay for it, and not a dime more.

As you look around at other comparables, you may find that an artist is asking for an ungodly sum but never getting it. Or perhaps he's getting his asking price on lower-priced pieces, but no one is buying higher-priced ones. This is a fine example of how the market has spoken, and that artist has overpriced some of his art. However, most people won't buy the most expensive piece. Instead, they'll see that a piece is $5,000 and think that's way too much, but they'll be willing to part with $2,000 for a smaller (or similar) piece.

Arbitrary pricing is the bane of your existence as an artist. Don't do it. Identify the value and then stick to it. Let your gallerist or rep engage in any reasonable negotiations. Friends and family tend to contribute to an arbitrary pricing model. In some instances, they are willing to overpay to support your pursuits or as patronage. In other instances, they expect to get a discount because of their relationship.

Another poor yardstick is assuming that the value of your work can be compared to what someone at a silent auction will pay for it. So, if you donate a framed print that cost you $250 to frame and $50 to print, and someone pays $3,000 for it, you might think you can mark up all your work $2,700. Not so. The reality is that the buyer is allowing her need to feel good about her support for the beneficiary of the silent auction to drive what she is willing to pay for your photograph.

Galleries and Representation

Most galleries will expect you to bring to them finished pieces ready to sell; they won't share with you the cost of producing prints or doing framing. Galleries also often take 50 percent or more of the sale price as a commission. Be careful, though. While a gallery will sell a piece of your art for $3,000, and you'll end up collecting $1,500 from it, be very cautious about accepting $2,000 on a private sale, even though it seems like a wise financial decision. Many galleries and those that represent artists have contracts that preclude private sales—or, in some cases, require that they still get their commission as if it was a sale they executed. So, a $2,000 sale on a piece that should have been $3,000 will still earn the gallery $1,500 and you'll end up with just $500. And don't think you can work behind the gallery's back; the art world is small, and your gallery or representative will find out. And when they drop you, everyone else will know why.

Markets

The art world where you sell to a collector either directly or through a gallery is but one outlet. Selling at local street fairs and traveling antique fairs is another. One major source of income is in the corporate or commercial world, where offices require images to fill empty walls with a theme. Sometimes, companies will commission a photographer to produce images of company activities around the world, and other times companies want black-and-white iconic images of the city in which the office is located. These corporate clients typically come to you via an office manager, or they may have hired a curator to identify photographers who make art that is appealing to the company. Consider that one floor of an office could easily call for 75 to 100 different images in sizes from 11×14 to 30×40, and even at quantity discounts, this could be a $60,000 to $100,000 sale. Doing research on commercial interior-design/renovation firms, finding out whom they use (or recommend) to their clients, and then beginning an outreach to them could pay huge dividends.

Chapter 23

Working with Nonprofits, Foundations, and Non-Governmental Organizations (NGOs)

Many people making their way through photography programs at institutes of higher learning come out with the idea that the work they produce will make the world a better place. Among their goals are revealing societal issues to the greater public or piecing together a story that perhaps was intended to remain unknown.

Often, these photographers see becoming a photojournalist as the easiest and fastest path to fulfilling these desires, and thus they seek employment in a newspaper setting. And indeed, for many years this was the case. Upon being hired, being assigned photo equipment and sometimes a company car, filling out the requisite HR paperwork, and being issued press credentials, young photographers found themselves documenting the plight of the community, seeing their images in the paper the next day, and then, if they were lucky, seeing public outrage and government officials reacting and making a change. There was a satisfying feeling that they were making a difference in the community and the world at large.

The swell of these inspired photographers coming out of school is not subsiding. Schools are turning out graduates, in many cases with reckless abandon, not considering the state of the photographic community they are presenting them to. Add to this the many highly experienced photojournalists who are finding themselves unceremoniously unemployed with little or no notice, and you have a veritable tidal wave of photographers looking to do good and effect change—and in the process earn a living. All along, these photographers must stay true to their journalistic standards as they move into this field.

Many of these photographers would bristle at the notion of, say, working for corporate America, creating the visuals for advertisements and shooting company handshakes, document signings, and CEO headshots. So, what's a photographer to do?

Many of these aspiring photojournalists—especially those who have found themselves on the unemployment rolls unexpectedly, with rent to pay and family to feed—see quick money in shooting weddings. I address wedding photography in great detail in Chapter 15 of *Best Business Practices for Photographers*, so I won't go into any more detail here. The next place these photographers turn is NGOs, nonprofits, and foundations. I've done a wide variety of work for nonprofits, foundations, and NGOs, and the advice in this chapter (as with many of the other chapters) is applicable to both still and video/motion work.

Getting Paid

Much of this book and its companion, *Best Business Practices for Photographers*, is about getting paid. This chapter is no different, but it addresses a few matters specific to the nonprofit/NGO/foundation world. You still have to be paid. You still own the rights to your work.

I understand that when someone is "doing good" with your photographs, it feels good to contribute. It also feels good to open your kitchen pantry and see groceries for the week. Don't give in to the feeling that your work should be free—let alone a suggestion by a client that they can't (or worse, they won't) pay for photography. Who do you think is paying them? Their work for the organization is of value five days a week. When you work for them, your work is of value as well. Don't sell yourself short.

As you contemplate how you would (or *if* you would) charge an NGO for your photography services, consider this: According to SimplyHired.com, the average NGO CEO earns $97,000 a year.[1] The reality is that NGO CEOs can far and away exceed that, earning more than $250,000 a year.

NGOs often have offices in prime downtown areas. Suppose that office costs $65 per square foot, per month. Let's say the office is 1,000 square feet. That equates to $780,000 a year just in office-space costs. Is your potential NGO client working in a downtown office building or a one-room apartment? If they have 47 employees in an office in downtown Manhattan, should they be asking you to work for free or paying you a pittance?

Additionally, understand that you never know where money is coming from and how much there is. Perhaps an NGO received a sizable donation from a multinational corporation looking to better their public image, and you only find out that that corporate monolith backed the project at the exhibit opening or when you see their logo on the back of a report, saying "This project was made possible through a grant from the Mega-Monolith Multinational Corporation."

In one instance, I was hired to do photography at a well-known charity that primarily serves food to the poor, but that also provides other services to those they serve, such as helping them get their resume together and apply for jobs. The project was an all-around feel-good project; however, the company that hired me produces operating systems and software that they were donating—along with 50 computers—to the charity for those needing to write resumes and cover letters. What to charge?

I'd say that a normal corporate rate applies, regardless of the venue. Often, part of a grant includes a requirement that professionally produced photographs and videography be used to document the arrival, installation, and use of the products, so that the donating company has a usable record of their contribution to show to their stakeholders.

In addition, what if you get hired by a charity like "Better Lives for Suffering Children," and you get there and are asked to be sure to document the aid workers using Samsung satellite phones. It may become clear to you that Samsung is expecting to get copies of those images to illustrate their contribution of $20,000 in satellite phones. Be sure to not only consider these facts as you develop a budget, but also work to ensure that the rights to use/distribute the photographs are granted only to the NGO/nonprofit/foundation and do not also include third parties. Or, if third parties are permitted, then understand that a corporate rate is very much applicable because it's almost the same as if Samsung had flown you into the field to do the work.

[1]Source: http://www.simplyhired.com/a/salary/search/q-NGO+CEO.

Perhaps if you have determined that your NGO rate for a 10-hour day of documentary photography is $1,500, and you're there for five days but part of your work includes the work for the phone provider, then you could make one day a $2,000 day. So instead of five $1,500 days, you would do four $1,500 days and one $2,000 day.

Further, if you're not charging a sustainable fee for your creative talents, you'll have a limited ability to make a difference over time. How unfortunate would it be if your talent was not properly compensated as a photographer, and thus it wasted away while you waited tables to pay your bills?

Through research, establish what your fees would be for a multinational NGO, a national NGO, and one where the CEO and entire board are volunteers. Be sure that, while the NGO may have rights to the images for specific purposes, you retain all rights to the images for your own use.

If an NGO tells you that everyone you will be photographing will have signed a model release, be sure to include in your contract that the NGO conveys to you all of the rights that the subjects were granted in those model releases—and get a copy of the model releases for your files. Get signed releases as you go if you can—and be sure they are in the local language and have both the local and English versions on the form. When I travelled to Japan for an assignment, I had my releases translated into Japanese before I left.

David Burnett, highly regarded photographer and co-founder of Contact Press Images, astutely noted on the matter of model release concerns (citing a famous image first published in *National Geographic* in 1985):[2]

> Steve McCurry's picture of the Afghan girl was perhaps the most famous of these: the haunting blue eyes, taken in a camp as part of a bigger reportage, and as he didn't have her name she became the iconic, nameless beauty of a refugee, only to be found nearly twenty years later. A good attorney could have easily wrangled a seven-figure settlement from the *Geographic*, as they had used her image on everything from advertisements, tip-ins [the annoying little subscription cards that fall out], posters, the list just goes on and on.

Does it seem out of place to you, and more along the lines of commercialism, that you, the journalist—the documentarian—must obtain these legal documents so the organization can use the images in ads and marketing materials? If so, then that should give you some indication that your images are worth more than a pittance, and you should be paid fairly when you are called upon to shoot an assignment for an NGO or even a nonprofit.

One of the first things that McCurry is said to have done is secure a retroactive release from the Afghan girl. He recounted how he had to be careful how much the *Geographic* compensated her because of where she lived and how that would be perceived by her community. He indicated that she and her family have enough to be well taken care of for a very long time.

As you contemplate the NGO as the unfettered answer to your documentary dreams of changing the world with your images, keep in mind that an NGO is a business, and you are a business. They must compensate you fairly for your efforts so you can remain in business. In the end, their business is helping people, and yours is making images.

[2] Source: http://werejustsayin.blogspot.com/2007/07/360-say-it-aint-so.html

Non-Governmental Organizations (NGOs)

The NGO has made it to the forefront of the minds of well-intentioned photojournalists hoping to change the world with their photography. Photographers get the opportunity to travel to faraway lands, usually in the third world, to document the plight of a population, region, or other disenfranchised group. The photos are immediately turned into online galleries and printed materials for fundraising purposes—to bring in more money to ostensibly do more good.

Before we go deeper into this topic, you should understand what an NGO is. PBS defines an NGO as "a nonprofit group largely funded by private contributions that operates outside of institutionalized government or political structures. In general, NGOs have as their agendas social, political, and environmental concerns."[3]

In the glossary of their Business Civic Leadership Center section on their website, the U.S. Chamber of Commerce (USCC) defined an NGO as "a group or association that is not directly part of a government body and that seeks to effect change for a specific cause or activity not commercial in nature. In many cases, NGOs operate for a charitable purpose and rely on donations from individuals, corporations, and foundations in order to operate."[4]

Are all NGOs charitable organizations? Well, their *work* may be charitable, as the USCC notes; however, their tax status may not qualify a donation to them as tax deductible. Further, as a photographer, your work for them is not tax deductible, except for your actual expenses. So, suppose you shoot for a week for them and burn them a CD with your images. The $0.50 cost of the CD is all that would be deductible, unless you had other receipts for expenses directly associated with that work.

The simple reality is that NGOs are just businesses, and they look appealing to work for because their business is helping people. NGOWatch (www.globalgovernancewatch.org/ngo_watch) is one resource you can use to do your research on an NGO, but there are many others. Where does their money come from? How much covers salaries/staff/office rent/overhead, and how much actually makes it out to the target beneficiaries?

How much accountability and transparency are there at the NGO you're considering doing an assignment for? A visit to the NGOWatch website will give you more insight into what NGOs are doing. The tagline of their website is "NGOs have positioned themselves as advocates of global governance and shapers of corporate and government policy. NGOWatch monitors these monitors to encourage transparency and accountability."

NGO work has been characterized by some as propaganda. Shifting from NGOWatch's "advocates of…corporate and government policy" to propogandist is a very fine line. Ansel Adams was characterized by William Turnage of the Ansel Adams Trust in the PBS American Experience series: "He and Edward Weston were criticized because they weren't photographing the social crises of the 1930s, and [Henri Cartier] Bresson said, '[T]he world is going to pieces, and Adams and Weston are photographing rocks and trees.' And Ansel was very stung by this criticism. He felt that documentary photography, unless it was practiced at an extremely high level, was propaganda, and he wasn't interested in that. He wasn't trying to send a message."

Yes, no less than Ansel Adams was concerned that "documentary photography" was almost always propaganda, and he was right.

[3]Source: http://www.pbs.org/wgbh/rxforsurvival/glossary.html

[4]Source: http://www.uschamber.com/bclc/programs/disaster/2008_disasterreport_glossary.htm

Perhaps stung by this criticism, in 1943 Adams turned his efforts for a period of time to Japanese internment camps during World War II. Adams's collection of images from that time are now part of a collection within the Library of Congress, called "'Suffering under a Great Injustice': Ansel Adams's Photographs of Japanese-American Internment at Manzanar." The Library of Congress characterizes his work and quotes Adams as such on their website:

> Adams's Manzanar work is a departure from his signature style of landscape photography. Although a majority of the photographs are portraits, the images also include views of daily life, agricultural scenes, and sports and leisure activities. When he offered the collection to the Library in 1965, Adams wrote, "The purpose of my work was to show how these people, suffering under a great injustice, and loss of property, businesses and professions, had overcome the sense of defeat and dispair [sic] by building for themselves a vital community in an arid (but magnificent) environment… All in all, I think this Manzanar Collection is an important historical document, and I trust it can be put to good use."

Working for a newspaper or other legitimate news outlet, you get sent somewhere to cover the story. Hopefully, you come away with great images from a great story. However, from time to time, the story isn't there or doesn't pan out. Maybe the plight is not as severe as first thought. However, when you're working for an NGO, your images must illustrate, with great intensity, the work that the NGO is doing and the difference that the NGO is making. If only there was more money/funding/time, more of a difference could be made. You go with a mission: to tell, in as vivid a manner as possible, the story of the good that the NGO is doing. This is *not* documentary photography, this is activist photography, also known as propaganda.

This is not to say that you have manipulated an image or that your image has lied. However, you must consider that if you aren't telling the whole truth, then to what degree are you lying? The minute you slant your perspective from neutral observer to purveyor of propaganda, you need to realize you are no safer from challenges of having a political agenda than FOX News or CNN.

In addition, it is important to consider what the expectations are when, as a journalist, *your only avenue into a country* is via an NGO trip. Occasionally, as was the case with the Congo a while back, the only way into a country is with one of the United Nations NGOs on their flights. In the travel/tourism trade, this is called a *familiarization trip*, or a *fam trip*. The visit is carefully orchestrated so that travel journalists get to see the best—and only the best—of the destination. Is this only avenue into the country *just* an inbound and outbound channel, and you are then free to do your job, or are you shepherded around by the NGO? If your trip is to see how an organization is making a difference, that might be one thing; however, if your trip is to get a real sense of what's going on in that country, you likely won't see everything you need to make an honest and balanced assessment of the situation.

As NGOs are becoming the object of desire for photojournalists with a story to tell, you must be careful about giving away your creative talents. It's one thing to donate your time doing physical labor, where once you stop the heavy lifting, your assistance pauses. However, donating your intellectual property is far and away a much bigger deal. NGOs need to understand that even if you give them the right to use the photos on their website and in their newsletter, those images can't be used in advertising or be sold without your permission. NGOs must be educated about your contributions and the value you bring to the table. Discussions about how great photography can really tell the story—honestly—to possible donors is key. One or two images can seal the deal on tens of thousands of dollars to be given in a single donation.

It's okay to want to change the world or make a difference through your photography. However, the key is to keep a close watch on the integrity and honesty you bring to the coverage, as it can be easy to cut a corner here and there. If you're not careful, that four-sided square of integrity could end up looking more like a circle.

Working with NGOs

When proposing to work with or for an NGO, you'll need an NGO portfolio. I know this sounds like a no-brainer, but showing your corporate work, weddings, or even your photojournalism work won't cut it. Although it's a variant of documentary photography, NGO photography is a different breed than photojournalism, and just because you can shoot as a photojournalist, that doesn't mean you can shoot as an NGO photographer.

For example, as a photojournalist you might be in a position to make an image of a mother comforting a very sick child in a third-world country. That's a great photo for the newspaper, but what you need for the NGO is not an image showing the suffering alone (and that the family is experiencing it alone), but rather an image showing an NGO worker engaging with the subjects and alleviating the suffering.

To further the point, as a wedding photographer or commercial corporate photographer, when was the last time you wrote a good caption? Dare I say never? For the NGO, a caption identifying everything you can in the image is critical—including the GPS data from your camera showing exactly where the photo was taken. The best caption answers the who/what/when/where/why in the image. It's not enough to say:

> Young woman washing clothes in the Yangtze River.

Instead, you should write:

> Hui Zhong Chan washes her family's clothes as the sun rises along the Yangtze River in Wushazhen, China, Monday, February 29, 2014. One of Chan's many responsibilities in the family is doing the laundry each day. (GPS: +30° 39' 23.72", +117° 17' 31.14")

Perhaps the GPS data is overkill and isn't appropriate for the actual caption. However, especially when you're out in what seems like the middle of nowhere, this data can really be useful for your own documentary purposes and to provide context to the image for the NGO.

In addition, you can't have the mindset of a photojournalist in terms of doing what you want when you want. Just because you can take a photograph doesn't mean you should. If someone tells you not to take photographs and you're a photojournalist, you may well ignore that instruction. If you're working for an NGO, following those instructions is in most (if not all) cases more important than the great photographic opportunity that appeared in front of you (and then disappeared with you having not gotten the shot).

Flexibility, a lack of attitude, and being able to persevere in adverse situations without complaint are key. Remember, you're likely there for a week or a month. The NGO workers you're working with have been living in these conditions day in and day out for months or years. It's critical to show a little humility and a lot of respect for them, especially when you'll be heading back to "civilization" in a week or two, and you can be certain that news about your attitude and being easy (or difficult) to work with will make it back to your client before you are wheels-down on your home-country soil. And, don't be surprised if the fact that you were difficult to work with not only means you won't be working for them again, but also adversely affects whether the client wants to pay your entire bill or get some form of a discount.

Previously, NGOs had little regard for the use of photography. Charts and graphs filled their annual reports, with a few photos thrown in. In today's visual world, the photos are growing larger and the charts and graphs smaller, and in many cases the adage "a picture is worth a thousand words" can mean that a picture replaces many paragraphs of text in a quarterly bulletin or on a webpage. Photographs can also be used for NGO gallery openings, where donors can be feted and plied (after a few drinks) for further contributions.

Keep in mind that many NGOs, especially the smaller ones, may not understand how to maximize your photographs. Larger ones with dedicated marketing departments will, though. If you're working with a smaller NGO, sometimes you can demonstrate the value you bring to the project by outlining some of the things they can do with your images to maximize the benefit of their investment in you.

The December 2008 issue of *Popular Photography* contained an article called "NGOs to the Rescue." The article stated: "Don't think of it as a place to get a job; think of it as a potential resource to help you mount a personal project." Those times have changed. In that same article, the magazine cites NGOs as "the 8th largest economy in the world, worth more than $1 trillion a year globally." Indeed, those figures have grown significantly since 2008. The money is there for major projects.

The Duke University Guide to NGOs (http://docs.lib.duke.edu/igo/guides/ngo_guide) and the Directory of Development Organizations (www.devdir.org) are two good starting places to identify NGOs that might be a good fit for you.

Foundations

As noted earlier, your client is the NGO, and you have to do what they tell you, on their deadline, with their mission as the driving force. But is it possible for you to dream up an idea and obtain funding for your vision of bringing that idea to life on someone else's dime?

Yes. Foundations can help.

Foundations make grants—that is, money you don't have to pay back. It's a gift; however, you have to do with that gift what you said you would. If you said you wanted to document the plight of the Appalachian people with the goal of producing a book, then that's what you have to do.

To obtain funding from a foundation, it may be necessary to establish a separate legal and tax entity that is a charitable organization. This costs money, of course, but can make it easier to obtain funding and grants from foundations. Alternatively, you can partner with an existing organization that has a track record already and seek a grant through the preexisting nonprofit, with the money that comes in when the grant is won earmarked for the work you plan to do.

You can find more information at the Foundation Center (www.FoundationCenter.org), where there is a database of the many grants available in the United States. Similar resources are available in other countries.

Nonprofits

There are a number of types of organizations that can be termed a "nonprofit," which is nothing more than an IRS classification. If you really want to understand this classification, do a search online for "IRS Publication 557." The organizations are:

- Charitable organizations
- Churches and religious organizations
- Political organizations
- Private foundations

A 501(c)(1) organization is a corporation that comes into being by way of an Act of Congress. While they don't file annual returns with the IRS, many of the contributions are not exempt from taxes unless their purpose is solely to serve the public.

Then there's the 501(c)(2) corporation, and you likely won't encounter them, because they typically serve as entities that do little more than manage and own property for a group that is classified as exempt.

The vast majority of nonprofits fall into the 501(c)(3) category—from churches to charities, foundations serving the poor, and even those advancing scientific causes. At the end of this chapter, I'll list the vast majority of organization types and their definitions according to the IRS.

Let's quote chapter and verse from IRS Publication 557, and I'll note a few examples of each:

501(c)(3)

An organization may qualify for exemption from federal income tax if it is organized and operated exclusively for one or more of the following purposes.

- Religious.
- Charitable.
- Scientific.
- Testing for public safety.
- Literary.
- Educational.
- Fostering national or international amateur sports competition (but only if none of its activities involve providing athletic facilities or equipment.
- The prevention of cruelty to children or animals.

To qualify, the organization must be a corporation, community chest, fund, articles of association, or foundation. A trust is a fund or foundation and will qualify. However, an individual or a partnership will not qualify.

Examples. Qualifying organizations include:

- Nonprofit old-age homes,
- Parent-teacher associations,
- Charitable hospitals or other charitable organizations,
- Alumni associations,

501(c)(3) continued

- Schools,

- Chapters of the Red Cross,

- Boys' or Girls' Clubs, and

- Churches.

- Child care organizations. The term educational purposes includes providing for care of children away from their homes if substantially all the care provided is to enable individuals (the parents) to be gainfully employed and the services are available to the general public.

- Instrumentalities. A state or municipal instrumentality may qualify under section 501(c)(3) if it is organized as a separate entity from the governmental unit that created it and if it otherwise meets the organizational and operational tests of section 501(c)(3). Examples of a qualifying instrumentality might include state schools, universities, or hospitals. However, if an organization is an integral part of the local government or possesses governmental powers, it does not qualify for exemption. A state or municipality itself does not qualify for exemption.

So, working for the American Red Cross would be working for a charity. The American Red Cross reported assets of $3,777,961,000 for 2012, and net assets after liabilities of $1,595,223,000. One of the advertising and marketing firms that help nonprofits is the Russ Reid Company. In their marketing materials listed online (http://russreid.com/2013/02/american-red-cross-integrated-marketing-campaign/), consider the language in the marketing approach:

> We needed to test an entirely new approach to fundraising in order to gain share of holiday and year-end giving.

The outline goes on:

> Americans see the Red Cross as the organization they count on in a disaster. They're motivated by urgent needs and human suffering… We were also mindful that donors are bombarded with heart-tugging fundraising appeals during the holidays… We know donors identify with this compassion. It's what motivates them as well.

> That's why the campaign images show Red Cross volunteers delivering food and a hug to a hurricane victim, providing a shoulder to cry on for someone whose house just burned down, or comforting a frightened child in a shelter. In each case, we captured the moment when a victim's face began to change from despair to hope—evoking a feeling of gratitude or relief that the Red Cross was there.

Then the outline details how they sourced the photographs and maximized their benefit and impact:

> To call attention to these emotional moments, we placed a translucent square frame around the "heart" of each photo. In TV and web banners, the frame fades up over the photo. The frame captures the "Red Cross moment" when heartbreak turns to hope.

Every image communicates authenticity. We used existing photos—shot in crisis situations, of actual volunteers and the people they helped. The photos aren't perfect, but they're real.

This creative solution also enabled us to save money on TV and print production costs.

Make no mistake about it, working for and with the American Red Cross is big business, but instead of making widgets, they are trying to get more money to help people. That's okay, but in this case they are trying to save money by licensing existing imagery rather than putting a photographer in the field during disasters.

Alumni associations collect millions of dollars from former students hoping to maintain a connection to their alma mater and their "glory days" of college. Hospitals that are structured as nonprofits (as almost all of them are) have CEOs that make millions and employ doctors that are among the highest paid in the country. Just because these groups are nonprofits, should the organizations that pay them expect a discount from you?

The list goes on and on.

Below are some excerpts of the 501(c)(4) requirements for an organization to meet. I am sure it's dry reading, but it's important because you want to be sure that you understand what the various organizations you're working with are doing and how they are doing it, within this category:

501(c)(4) (Excerpts)

If your organization is not organized for profit and will be operated only to promote social welfare to benefit the community…the organization's net earnings must be devoted only to charitable, educational, or recreational purposes. In addition, no part of the organization's net earnings can inure to the benefit of any private shareholder or individual.

Examples. Types of organizations that are considered to be social welfare organizations are civic associations and volunteer fire companies.

Social welfare. To establish that your organization is organized exclusively to promote social welfare, you should submit evidence with your application showing that your organization will operate primarily to further (in some way) the common good and general welfare of the people of the community (such as by bringing about civic betterment and social improvements).

An organization that restricts the use of its facilities to employees of selected corporations and their guests is primarily benefiting a private group rather than the community. It therefore does not qualify as a section 501(c)(4) organization. Similarly, an organization formed to represent member-tenants of an apartment complex does not qualify, since its activities benefit the member-tenants and not all tenants in the community. However, an organization formed to promote the legal rights of all tenants in a particular community may qualify under section 501(c)(4) as a social welfare organization.

Political activity. Promoting social welfare does not include direct or indirect participation or intervention in political campaigns on behalf of or in opposition to any candidate for public office. However, if you submit proof that your organization is organized exclusively to promote social welfare, it can obtain exemption even if it participates legally in some political activity on behalf of or in opposition to candidates for public office.

501(c)(4) (Excerpts) continued

Social or recreational activity. If social activities will be the primary purpose of your organization, you should not file an application for exemption as a social welfare organization but should file for exemption as a social club described in section 501(c)(7).

Retirement benefit program. An organization established by its members that has as its primary activity providing supplemental retirement benefits to its members or death benefits to their beneficiaries does not qualify as an exempt social welfare organization. It may qualify under another paragraph of section 501(c) depending on all the facts.

First, it's important to note that in the case of a 501(c)(4) organization, most donations are not tax deductible, even though the organizations are still considered nonprofits. Dues paid to the organization may be deductible as a business expense, but not much else is. Many of the political organizations that take donations (with no obligation to disclose who the donors are) fall into this category—meaning they can take out ads and produce commercials using donor money. Their political efforts typically attack a presidential candidate and end with the tagline, "This ad is not endorsed or associated with {Candidate Name}." Almost all of these organizations are "advocacy" organizations, so if you're a big fan of a particular candidate or issue, then by all means seek them out; but understand that even though they're a nonprofit, they often have deep pockets.

Knowing the difference between the various 501-type organizations is important. Tax status of labor organizations can affect your ability to take deductions and also to realize the nature and extent of what they can do.

501(c)(5) - Labor, Agricultural and Horticultural Organizations

Labor Organizations

A labor organization is an association of workers who have combined to protect and promote the interests of the members by bargaining collectively with their employers to secure better working conditions.

Agricultural and Horticultural Organizations

Agricultural and horticultural organizations are connected with raising livestock, forestry, cultivating land, raising and harvesting crops or aquatic resources, cultivating useful or ornamental plants, and similar pursuits.

Every labor organization falls into this category, and I have yet to find a labor organization that calls out "give us a discount, we're a nonprofit." On the contrary, my experience has been that labor unions are willing to pay a premium and respect the value you bring to the project. Many of these organizations appreciate that their members who earn, say, $40 an hour for a job are often being undercut by nonunion workers willing to do it for $25 an hour, so they not only respect a fair wage, they also are supportive of the challenges many photographers face.

Chambers of Commerce and Boards of Trade are among those that are 501(c)(6) nonprofits, yet a Chamber of Commerce is made up of members, most, if not all, of whom are profit-centered companies.

501(c)(6) - Business Leagues, etc.

[These] organization[s] must be primarily engaged in activities or functions that are the basis for its exemption. It must be primarily supported by membership dues and other income from activities substantially related to its exempt purpose.

A business league, in general, is an association of persons having some common business interest, the purpose of which is to promote that common interest and not to engage in a regular business of a kind ordinarily carried on for profit. Trade associations and professional associations are considered business leagues.

Chamber of commerce. A chamber of commerce usually is composed of the merchants and traders of a city.

Board of trade. A board of trade often consists of persons engaged in similar lines of business. For example, a nonprofit organization formed to regulate the sale of a specified agricultural commodity to assure equal treatment of producers, warehouse workers, and buyers is a board of trade.

Chambers of commerce and boards of trade usually promote the common economic interests of all the commercial enterprises in a given trade community.

Real estate board. A real estate board consists of members interested in improving the business conditions in the real estate field. It is not organized for profit and no part of the net earnings inures to the benefit of any private shareholder or individual.

Professional football leagues. The Internal Revenue Code specifically defines professional football leagues as exempt organizations under section 501(c)(6). They are exempt whether or not they administer a pension fund for football players.

Because a Chamber of Commerce is made up of businesses, all of whom need to be profitable (for the most part), the notion of "we don't have any money; we're a nonprofit" shouldn't come up very often. And the United States Congress allowed for the National Football League to have status as a nonprofit under this category, yet they pay a premium for visuals and appreciate very well the power of great photography.

Some of the entities that fall into the 501(c)(7) category that are listed as nonprofits seem, at least in this category, to be a bit on the edge of fair. I don't understand why a country club gets to be a nonprofit, and I surely would not be giving a country club the same consideration of nonprofit status as I would an animal rescue league when identifying how and why I would work for them. This is how the IRS looks at 501(c)(7) exempt organizations:

501(c)(7) - Social and Recreation Clubs

If your club is organized for pleasure, recreation, and other similar nonprofitable purposes and substantially all of its activities are for these purposes…Typical organizations that should file for recognition of exemption as social clubs include:

- College alumni associations that are not described in chapter 3 under Alumni association,

- College fraternities or sororities operating chapter houses for students,

- Country clubs,

- Amateur hunting, fishing, tennis, swimming, and other sport clubs,

- Dinner clubs that provide a meeting place, library, and dining room for members,

- Hobby clubs,

- Garden clubs, and

- Variety clubs.

The next time you hear your local country club try to get a discount by telling you they're a nonprofit, ask them if instead they'll do an exchange: your services for a membership in the club. When they tell you no, it's because they recognize the value the membership has. Your work has value too, and a few great photographs can increase the membership rolls by the club—why not add you in in exchange for your valuable photography?

Fraternities and sororities look to gain new members through powerful visuals on their websites and in brochures. It's not just about who throws the best parties anymore. Don't be fooled by a "we're a nonprofit" claim in these instances.

501(c)(8) - Fraternal Beneficiary Societies

A fraternal beneficiary society, order, or association must file an application for recognition of exemption from federal income tax on Form 1024. The application and accompanying statements should establish that the organization:

- Is a fraternal organization,

- Operates under the lodge system or for the exclusive benefit of the members of a fraternal organization itself operating under the lodge system, and

- Provides for the payment of life, sick, accident, or other benefits to the members of the society, order, or association or their dependents.

The local Moose Lodge needs photography too, yet they and others under the 501(c)(8) category should pay or get their local retired member to shoot the work.

Domestic Fraternal Societies 501(c)(10)

A domestic fraternal society, order, or association must file an application for recognition of exemption from federal income tax on Form 1024. The application and accompanying statements should establish that the organization:

- Is a domestic fraternal organization organized in the U.S.,

- Operates under the lodge system,

- Devotes its net earnings exclusively to religious, charitable, scientific, literary, educational, and fraternal purposes, and

- Does not provide for the payment of life, sick, accident, or other benefits to its members.

Recently I did an assignment for a religious order during a church service, and the marketing director told me, "I don't need any photographs that don't show our [logo] in the foreground or background." That was a very honest statement. It also underscores that these types of nonprofits are just as interested in marketing and the visual results of your work as anyone else.

501(c)(4), 501(c)(9), and 501(c)(17) - Employees' Associations

This section describes the information to be provided upon application for recognition of exemption by the following types of employees' associations:

A voluntary employees' beneficiary association (including federal employees' associations) organized to pay life, sick, accident, and similar benefits to members or their dependents, or designated beneficiaries, if no part of the net earnings of the association inures to the benefit of any private shareholder or individual, and

A supplemental unemployment benefit trust whose primary purpose is providing for payment of supplemental unemployment benefits.

We've done work for organizations such as the Rural Electric Telephone Cooperative and other companies that are co-ops. They still need photography, and they should still pay corporate rates even though they are exempt under a nonprofit status.

501(c)(12) - Local Benevolent Life Insurance Associations, Mutual Irrigation and Telephone Companies, and Like Organizations

Each of the following organizations apply for recognition of exemption from federal income tax by filing Form 1024.

Benevolent life insurance associations of a purely local character and like organizations.

Mutual ditch or irrigation companies and like organizations.

Mutual or cooperative telephone companies and like organizations.

A like organization is an organization that performs a service comparable to that performed by any one of the above organizations.

A credit union is just a bank owned by those with deposits—it's still a bank. Would you give a bank some charitable consideration? Here's the delineation of 501(c)(14) organizations:

501(c)(14) - Credit Unions and Other Mutual Financial Organizations

If your organization wants to obtain recognition of exemption as a credit union without capital stock, organized and operated under state law for mutual purposes and without profit, it must file an application that includes the facts, information, and attachments described in this section. In addition, it should follow the procedures for filing an application described in Application Procedures in chapter 1 of IRS publication 557.

Federal credit unions organized and operated in accordance with the Federal Credit Union Act, as amended, are instrumentalities of the United States and, therefore, are exempt under section 501(c)(1). They are included in a group exemption letter issued to the National Credit Union Administration. They are not discussed in this publication.

State-chartered credit unions and other mutual financial organizations file applications for recognition of exemption from federal income tax under section 501(c)(14). The other mutual financial organizations must be corporations or associations without capital stock organized before September 1, 1957, and operated for mutual purposes and without profit to provide reserve funds for, and insurance of, shares or deposits in:

- Domestic building and loan associations,

- Cooperative banks (without capital stock) organized and operated for mutual purposes and without profit,

- Mutual savings banks (not having capital stock represented by shares), or

- Mutual savings banks described in section 591(b).

501(c)(19) - Veterans' Organizations

A post or organization of past or present members of the Armed Forces of the United States must file Form 1024 to apply for recognition of exemption from federal income tax. You should follow the general procedures outlined in chapter 1 of IRS publication 557. The organization must also meet the qualifications described in this section.

Examples of groups that qualify for exemption are posts or auxiliaries of the American Legion, Veterans of Foreign Wars, and similar organizations.

To qualify for recognition of exemption, your application should show:

That the post or organization is organized in the United States or any of its possessions,

That at least 75% of the members are past or present members of the U.S. Armed Forces and that at least 97.5% of all members of the organization are past or present members of the U.S. Armed Forces, cadets (including only students in college or university ROTC programs or at armed services academies) or spouses, widows, widowers, ancestors, or lineal descendants of any of those listed here, and

501(c)(19) - Veterans' Organizations continued

That no part of net earnings inure to the benefit of any private shareholder or individual.

In addition to these requirements, a veterans' organization also must be operated exclusively for one or more of the following purposes.

To promote the social welfare of the community (that is, to promote in some way the common good and general welfare of the people of the community).

To assist disabled and needy war veterans and members of the U.S. Armed Forces and their dependents and the widows and orphans of deceased veterans.

To provide entertainment, care, and assistance to hospitalized veterans or members of the U.S. Armed Forces.

To carry on programs to perpetuate the memory of deceased veterans and members of the Armed Forces and to comfort their survivors.

To conduct programs for religious, charitable, scientific, literary, or educational purposes.

To sponsor or participate in activities of a patriotic nature.

To provide insurance benefits for its members or dependents of its members or both.

To provide social and recreational activities for its members

Summary

As is likely now much more clear about NGO's, nonprofits, and foundations, the tax-exempt status that allows organizations to call themselves a "nonprofit" really is just that—a tax status. If you have a family member who suffers from a debilitating disease, then perhaps offering a deduction in your fees as a way to give back to a matter you are close to personally is of value. If you had a personal experience with being down on your luck and now are doing better, perhaps the organizations that were there to help you get back on your feet are worthy recipients of your donated (or fee-reduced) time. Or, if you have a personal connection to organizations that help out pets or other animals, and that deep commitment to furthering their cause is important, then donating or providing fee-reduced services to them may be of value. However, simply feeling obligated to reduce your fees or work for free (or for photo credit) because someone called you and asked about your "nonprofit rates" isn't fair to you. There has to be a personal connection for you; otherwise, they're just another business that needs great visuals, and they should be charged accordingly.

Chapter 24

Valuing Video (or Motion) Production as an Adjunct to Still Photography: Know Your Limits

This is not meant to be a chapter on how to shoot, how to edit, or even how to get a client who wants you to work with video/motion. This chapter is all about the business side of things and knowing your limits with regard to the work required. That's not to say you shouldn't take on a project with a video/motion component, but if you have any doubts at all, you should assemble a skilled team that can make up for your not-yet-ready-for-prime-time skill set so you can bring the project to a successful completion.

Many photographers will spend the remainder of their creative career operating quite happily in the one-man-band scenario outlined later in this chapter. You may be perfectly content doing the "Can you do this project for $1,000?" or "Can you do this project for $3,000?" productions until you head off into the sunset years of your life. This chapter aims to give you the tools to do so happily, efficiently, and with as little hassle as possible. It also aims to give you the tools, language, and thought process necessary to add in various team members and processes where time and budget allow or the level of production calls for it. So, if you're reading a part of this chapter and are thinking, for example, "I'll never need a focus puller," that's all well and good, but knowing that those roles exist is important. This chapter is just as much about providing the insights and considerations necessary for the person transitioning into motion as it is about providing those considerations for the person who's been doing motion for several years and may be looking to grow what they do into larger productions. It covers a lot of ground by design, and with an intent to be as comprehensive as possible.

Let me provide a little background. In 1983, many communities were being sold on the value of something called "cable television." It offered hundreds of channels at a time when we had just three networks. The problem was that in order for there to be cable television, there had to be a cable. In fact, there had to be cables to every house. The way cable companies sold communities on this—the idea of ripping up every sidewalk in town—was to also offer community access television, programmed and produced by the community for the community. They also offered equipment and training to use the equipment.

At the time, I was a junior in high school, and learning the ins and outs of a 3/4-inch camera and videotape recorder (because at that time the camera was separate from the recorder) for free was an offer too good to refuse. We also learned how to use editing boards to do in-studio programming for the community. Such was my first professional experience with video.

My senior year brought me the opportunity to videotape and edit our high school production of Michael Jackson's "Thriller," which was all the rage at the time. I also did my own "making of" video showing the behind-the-scenes of how the senior class came to make the production.

Since that time, of course, much has changed. I won't give you a history lesson on Betacam, early digital, and so on. Following my video work (which, from this point forward, I'll refer to as *motion*, to differentiate from my still photography work), I spent from about 1989 until the present day pursuing my passion of still photography. Yet, motion work has always held a special place in my heart and creative mind. I've occasionally been asked to produce motion work for existing clients over the years, and it has always been a wonderfully creative opportunity and a significant change in my thinking and approach.

In thinking about returning to motion, in 2000 I began reacquiring the tools to do so, from the latest cameras to lavaliers, and further fleshed out my continuous-light-source lighting kits to serve video needs. Then, in the months after 9/11, a client of mine who brought schoolchildren to Washington for educational tours saw a drop in the number of parents willing to send their children to DC. This client asked me if I would produce a video showing just how safe DC is and how much fun the kids have. We were to interview parent chaperones and deliver a seven-minute video that could be put onto DVDs and videotapes and given to skeptical parents (and even some school administrators).

In the arena of motion work, the extent and variety of items to charge for are vast. The buzzwords and job titles can be unusual and foreign, such as best boy to key grip. And with dozens of more seemingly obvious jobs, such as camera operator, sound technician, producer, and production assistant, there are myriad different job descriptions and responsibilities, which means there are volumes of pricing considerations. The question then becomes, where do you set your own limit in terms of the comfort zone you can work in? And once you know that, how do you establish reasonable pricing models?

For example, certain factors (should) adjust the hourly wage of a camera operator if he has to work in a wet environment or one where there is smoking. Risky environments or excessive hours also increase what someone earns. "Danger pay" usually doesn't even enter the category of consideration until you're working on the highest-budget pictures, but it is worth considering informally as you work up a budget for a project.

On many productions—often feature films or high-end commercials—the entire project is a union production, and rightfully so. However, a union production is out of the league of the still photographer evolving into motion and for smaller motion shops. As such, throughout this chapter I will share union rates with you only as guideposts for your non-union production, because they are very informative. Countless experts on the subject of value-to-cost have considered union rates, along with reasonable costs of living. And while union rates can be higher than non-union rates, that's not always the case. For example, it's possible to hire a director of photography (DP) at $500 a day on a $100,000 non-union industrial production; however, union pay scales only require the DP to earn $300 a day on a $1,000,000 feature. Knowing what the union rates are will help you formulate your rates for your own production, as it varies from project to project.

In this chapter, I won't explain the hundreds of jobs that go into large productions. Instead, I'll discuss several common jobs in a motion production, explain them, define their job descriptions, and price them out individually, by job.

Please take note that I am outlining multiple different jobs and production levels. A two-person crew is very different from the dynamics and cost of a 10-person crew. The point here is, how do you scale from doing it yourself and add on people in a responsible manner that covers the costs within the production budget and delivers the end product the client expects. While this chapter may appear to be geared toward larger

productions, that's not the case. This chapter covers most of the additional jobs that you could well hire out to be done by others, allowing you to focus on the overall project.

Who's Calling You?

It is rare that an administrative assistant will call you to discuss the details of a project. Whereas in still photography work (for, say, headshots or an event being covered), whoever is in charge may dictate, "Find us a photographer for our ribbon cutting/headshots," for motion work usually you're in contact with an in-house marketing or creative department person, or someone from the company's outsourced advertising agency, depending upon the level of production.

If you're talking to a secretary or an administrative assistant, it may just be a cursory "Are you available on these dates?" or "Do you have some time in the next month?" During the course of your conversation, you'll soon be asking questions about the project that the assistant can't answer. That's when you need to connect with someone in the marketing/creative department who can share with you what they're looking for.

Questions to Ask Those Calling

Here are a few questions you can ask to get a good feel for what the client needs, so you can properly estimate the project:

- *Can you tell me what you envision as the finished video?*

 Related to this, you'll also need to know the required deliverables, the number of final products, and the duration of each. This question engages the person's creative mind and helps ensure you're talking to the right person. Often storyboards are already done, so ask for those.

- *Are we producing graphics or animation as well?*

 Anything but live action falls under the category for graphics or animation—everything from chyron, to Keynote/PowerPoint graphics, to charts, to graphs. You can engage a highly skilled graphics producer and/or animator if need be. Because many videos have these sorts of features, knowing what part (if any) of this you're responsible for is key.

- *Will the person/people/objects we will be filming be stationary, or will they be moving around?*

 Not only does this help you know how (or if) you'll need to include a tripod, it also informs you to what extent you need to light a space—just one area for the stationary subject or the entire area they'll be walking through? It also can help you understand whether you'll need a Steadicam or other motion-stabilizing equipment. Tripods, dollies, jibs, and other tools to facilitate quality motion production are a necessity when people are moving around.

- *How many days/hours do you think this project/production will take to complete?*

 Often a client will say, "We only need a two-minute piece; you probably can get everything you need with about 30 minutes of interviews and about the same amount of B-roll, right?" Wrong (usually). So many factors go into the project that what you're really looking for is whether the client has a reasonable understanding of what they need and how long it will take to produce. Yes, 30 and 30 for the above scenario will work for a really generic, basic production. However, it's likely that many other things will go into it. Asking this question gives you a feel for what the client is thinking (which is often an underestimation).

B-Roll

B-Roll refers to secondary or supporting footage. Suppose you're interviewing a man about woodcarving as an art form. You get a segment where he explains how he chooses his wood before he starts. He goes on to wax poetic for three minutes and then returns to a nice concise 10-second comment on how long it takes him to finish a piece. To edit those two pieces together, you might begin with the camera on him talking for five seconds; then cut to the subject walking in the woods, looking for the right piece, for seven seconds; then fade to a seven-second piece where he's beginning to carve before coming back to him for the last five or so seconds. The footage you shot in the woods and of him carving is called B-roll.

There's a historical reason why it's called B-roll. The current crowd thinks it stands for "background roll," but old-schoolers know it had to do with 16mm film footage and the secondary "B" tape deck in an editing suite.

- *During the interviews, do you see this as a multi-camera shoot or just a single camera?*

 It's all too common in the news business for a single camera to go out and do an interview with a reporter, and then once the meat of the interview is shot, the camera operator will step back and shoot a wider two-shot of the interview subject and reporter, sometimes from both angles, which gives the editors the ability to edit the interview for content. This is a really rough way to make a shot work, but in the news business it's done all the time. In other arenas, having three cameras—one head and shoulders of the interviewer, one of the interviewee, and a third showing both of them—is a common and thorough production choice allowing for maximum angles to choose from. This is a common setup for network and cable news broadcast productions, and can be very beneficial when you need to make a longer interview feel more interesting, because you can break up the view more easily.

- *How many locations will we be shooting in, and are they near one another?*

 Setup and breakdown times can rapidly consume a day. Is this shoot all to be in one building on one floor, or will it be in multiple locations around the world? The considerations are endless, and you need to know what's expected of you.

- *Are our interview subjects experienced and/or enthusiastic about being interviewed, or will this be something we'll need to really work with them on? And how many are we doing?*

 Generic answers such as "Oh, a few people" and "Oh, I think they're all excited" need to be fleshed out more. Nail down the number as firmly as possible and get a flavor for the experience level. Also, you'll want to know if your subjects are somehow being compelled to participate and if they've had past negative on-camera experiences, especially if it's a corporate executive who thinks he knows everything or a child who just won't listen. Sometimes you get both of those challenges in the same subject.

- *Who will be on location with the crew and me?*

 This is really important because it lets you know if the stakeholders and decision makers will be on set and reviewing and approving what's being produced. If they're not, then you need ironclad paperwork that says you're the one who decides whether the interview went well—or as well as can be expected. The last thing you need is a client telling you that you have to go back to a subject on your dime to get the correct concise talking points because you missed them. This is also important because you need to know what level of production you'll need. You might need more production trailers or more catering (or a higher level of catering) than you originally thought you needed.

- *How much time will I have with my subjects?*

Knowing whether you have a five-minute window with a busy company executive or all day with the proprietors of a mom-and-pop corner store makes all the difference in how you will plan and execute a production.

- *Do you need or want any post-production, editing, or review capabilities on the spot?*

Whether it's an edit suite with a satellite truck, a production RV with rough-edit abilities, or even a director's tent with playback, these additions to a production cost money, and knowing what the client needs or expects can help you avoid misunderstandings. You may be able to review an interview through the viewfinder or on the back of a camera's LCD screen, but your client may be expecting a hooded 27-inch HD monitor under a black tent for playback.

- *Do you have any scouting images of the locations and headshots or other images of our interview subjects?*

Asking this question can often lead to a scouting trip or even tech scout days. In larger productions, scouting is a given, and frankly, if all budgets allowed, it should be a given on all productions. However, it often gets cut, so you then need to work with still images from a local scout you send out or images that the client has of the facilities. Few things are worse than walking into a conference room with tungsten-balanced lighting, only to find that the room is lined with floor-to-ceiling windows, it's a bright, sunny day, and even the blinds don't knock down enough light to work with. Headshots help you know what you're working with and whether you need hair and makeup.

- *Do we need hair and makeup?*

There are times when I can sell a client on not needing hair and makeup on a still shoot if budgets are right, because we can do what needs to be done in post-production. Not so, as you likely know, in motion. Hair and makeup should be a required line item, and a client should have to ask to have it be taken off and explain why. Perhaps you're following a client as they traipse around a news event and there won't be many close-ups of them, or they want to look "organic and natural," so they opt not to have makeup.

- *Will we be eating on location or should I arrange catering?*

The saying goes that "an army travels on its stomach," and this could be applied to a production as well. Few things can grind a production to a halt like a cranky sound technician, camera operator, or client. Even if the client doesn't want catering, $20 spent on a few bottles of water and some energy bars and sweets will go a long way. However, you'll want to avoid a situation where you're crossing a meal time and the crew scatters in all directions looking for food. In the end they'll all likely want to bill back those expenses to the production, so why not just bring in catering and let everyone break bread over the same table? This also fosters cohesion among the ranks, and conversations over the meal are often about the production, so it becomes an effective working lunch all around.

- *What does the set (or environment) of the video look like?*

This helps you understand whether you're coming into an empty studio, a hotel conference room, a rowdy sporting event's pregame activities, an office or a production line, or a dangerous setting. It also helps you understand if you'll need to dress the set, fabricate one yourself, or just use what you find on site.

- *Do you feel like there should be some form of music carrying through the piece?*

Music can make a huge difference in setting a mood or creating an energy during a piece. In fact, this is why some news broadcasts don't allow music—it can be perceived as altering viewers' mindsets

while they watch the piece. However, for many productions, even light music can make a huge difference in keeping viewers' attention. Some resources begin at about $30 a track for a web-only license, and good music can cost upwards of $200 a track for the same web license. Two resources are Killer Tracks and The Music Bed; however, their web licenses average around $500. Alternatively, you could go directly to an artist, and that would likely start near $500; however, you can expect to pay a starting rate of $1,500 to $2,000 for final scoring. Regardless of how you choose to score your production (or prepare a budget for the project), be absolutely certain you have the licensing documentation and keep a copy on file. For one package I did, there just wasn't the right feeling and mood available, so we produced a simple piece in Apple's GarageBand software that was perfectly suitable to the client's needs. Sources for music abound; I'd suggest starting with Triple Scoop Music, Broken Joey Records, Killer Tracks, The Music Bed, or Pump Audio and go from there.

- *Where will we be filming?*

 In some instances, this question doesn't need to be asked because it's obvious. However, if you're filming a Q&A session with a company executive, knowing whether the shoot is overseas, in-country, or down the street from you is critical. You must factor in travel time, travel fees, customs paperwork for your equipment, and work visas.

- *What budget are you trying to work within?*

 Note that advice about this was covered extensively in *Best Business Practices for Photographers*, so I won't go into depth here. However, asking this question really does give you a flavor for what the client is looking for.

- *Do you have any sample videos you'd like us to emulate?*

 Sometimes the client has a look, feel, or genre in mind, and this helps them to start thinking about how the finished video will look. It also gives you an idea about the style and depth of the piece they are looking for. When they call us for still photography work, for example, many clients say, "I need a portrait just like the guy in the uniform on your website," and I know immediately what they're looking for. Asking the client for a few URLs of videos they've seen allows you to break down whether they want the graphics or chyron, the number of locations, interviews versus lots of B-roll, and so on. Also, if the client has a number of other videos they have already shot from around the country, you can emulate a similar lighting style and duration to provide the client with continuity when the pieces are viewed in succession or appear on the same webpage, bringing cohesion to their look and feel.

A Sampling of Production Types

There are countless project types and uses for motion content. Here are just a few:

- **Focus groups.** This typically is one camera and an operator who is doing very simple documentation of a focus group. There's very little creativity involved. Getting it properly lit (usually ambient light) and in focus with correct framing is about all you're worried about.

- **Video news releases.** These can range from simple projects to intense projects with sets and models.

- **Media training of staff.** These are typically one-camera productions where a skilled interviewer (usually an on-air reporter in a past career) sits in an interview process where you're rolling in a studio setting of some sort. The seasoned interviewer asks a series of questions, and as they are fumbled by the subject, you can roll the tape back and run playback with a stop-start series so the subject

learns what he really looks and sounds like on camera. Usually the footage never sees the light of day, and there's no editing.

- **Meetings (both documentary and for image magnification).** In some instances, you're just rolling a camera without any recording happening, so that the people in the back of the room or with an obstructed view can see what's happening at the podium. Your camera feed is running into a switching board that is operated by an editor or a producer. In other instances, you're rolling to tape, and the finished footage (as it was shown on the screen) is packaged for resale or to provide as a web production at a later date.

- **Investor presentations.** These can be some of the most extensive internal communications products, where far-flung investors can't be bothered to come to the company and see what's going on, so the company produces slick presentations for either prospective investors or those who want to be sure they've invested wisely. In some instances, your presentation will be a package shown at a shareholders' meeting. It can take weeks or months to pull these together, and there are often many re-edits as legal departments mull over every sentence, word, and visual.

- **Internal communications.** Sometimes this can be as simple as "A message from our CEO," with the CEO opining from behind her desk. One camera, a light or two, and that's it. Sometimes it's a sit-down interview with senior executives about the vision and direction of the company, so that all employees are working toward similar goals. Be sure to find out whether you'll need a teleprompter and a teleprompter operator for a busy CEO. Others may also need a teleprompter, but CEOs often want at least the option of using one. They will get frustrated quickly, and you usually don't have a lot of time for them to do take after take. It's common to spend hours setting up for a 10-minute shoot. Be prepared.

- **Sales and training materials.** Often this can be as simple as shooting a speaker in a basic room and then switching between the speaker and her PowerPoint presentation in the final edit. However, it can also include extensive video of proper technique on, say, the assembly line, how to wear the safety equipment and uniform, and how to hold the tools to avoid things like carpal tunnel syndrome.

- **Product launches.** These can be among the most elaborate productions, because it's the sales pitch for the product to gain attention. Whether it's a video destined for YouTube and hopefully viral fame or the documentation of a product launch event, a lot goes into these.

- **Web videos or podcasts.** Web video is more of a platform than a video type. However, there are people who want to put their marketing materials on the web, so when they say "web videos," what they're saying is "marketing videos." That said, keep in mind that many of the "TV safe" framing advice falls out the window. What you see in your viewfinder is what's going to show on the web; however, many of these videos can get repurposed for television viewing, so staying within "TV safe" limits future-proofs your productions.

- **PR events.** Typically, these are one- or two-camera operations covering what's happening at the podium, cutaway shots of the audience looking on, and interviews with the principals. Often these types of events call for a rapid edit, so you and the client will likely be headed off to an edit suite to produce a package that will be distributed same day.

- **News coverage.** For the most part, what you see is what you get. You shouldn't be manufacturing news coverage, so document what you see. Storytelling does come into play here; however, you're often limited to 15 to 30 seconds or *maybe* 1 to 3 minutes, allowing for time for a reporter standup, voiceovers, and so on. A package destined for website distribution is usually one to three minutes in length. Sometimes it's exactly the same as PR events, except that the end client is a news outlet instead of the people who held the event.

- **Storytelling.** While news coverage is covering the local politician, fire, or protest, storytelling is very different. Documenting a story about suffering, triumph, or success through adversity or a moving message often takes a period of time. Sometimes they're the one- to three-minute features near the end of a news broadcast; however, there is the opportunity for two to five minutes if the piece is destined for a website. Sometimes the piece might be 22 minutes and 22 seconds, the common duration of a piece that becomes exactly 30 minutes once interspersed with the requisite number of commercials.

There are, of course, many other production types, feature films to live multi-camera events with satellite trucks bouncing your production off a satellite in the sky. I can't possibly cover them all, and there are volumes of material out there on those larger events.

Contract Examples

Make absolutely certain that the client understands the terms of the contract. Don't hide things in six-point type. Many clients who don't have an ongoing relationship with a motion-producing vendor don't understand the process involved in getting from idea to finished piece. Changing the storyline or direction can change music cues and cause you to need to start from scratch.

This section provides several examples of contracts—one is for media training, one is for a very small event, and one is for a five- to seven-minute documentary. Names of crew, subjects, and/or companies/organizations have either been redacted or changed.

A short film on
Professor █████████

A **Harrington+Richardson** production

A video proposal by
John Harrington
Harrington+Richardson Productions
2500 32nd Street, SE
Washington DC 20020

August 24, ████

Purpose of the video

To underscore the high value students receive at ██████████████
██████ as personified by Professor ██████████ -- an incredible 21st century educator, leader and mentor—a gentle giant who invites others to join him and make a difference.

To convince viewers ████ is the right place to send students where they would mature to decision-making graduates -- fully equipped and prepared to meet the challenges of the future.

Target Audience

1. Prospective students and parents
2. Current students -- to validate their educational circumstances
3. alumni -- as part of fundraising

SYNOPSIS

The Video features a vigorous 84-year-old ████████████. He is bright, articulate and caring --adored by both students and long-ago graduates now in the work force and successful in their jobs. We see him on campus walking comfortably among the students and staff – each encounter with unhurried greetings and a smile. The video highlights his remarkable accomplishments as a teacher and a mentor to thousands, and how ████████████ has contributed greatly to the university in the Washington DC area. Today ████ is a competitive, world-class academic institution with a solid foundation for future growth.

The Story is told by an off-camera narrator and on-camera short sound bites on Professor ████'s philosophy and unique ways of helping young people find directions and courage to pursue their dreams.

On-camera interviews of Professor ████ bring out his passion for education and enduring friendships with students and graduates. He is truly an inspirational leader. The video is designed to instill confidence that his unwavering approach of maturing students works … maturing them into independent, analytical thinking individuals that are prepared to meet the demands of the workforce they will join upon graduation.

In short sound bites, successful ████ alumni including Congressman ████████ and award-winning author ██████ attest that their achievements are rooted in their experience at ████.

While the video features an extraordinary educator, it also presents The ████████████████ as a special place with a rich tradition and

modern academic programs. During this transformative period in the students'
lives WJU provides a friendly nurturing atmosphere. In the heart of Washington
students are guided by educators with a strong focus and firm hand toward
individual critical thinking -- preparing them for future challenges.

Usage:

1. Distribution to HS counselors
2. Direct distribution to prospective students and parents
3. YouTube, with links to current students for sharing with siblings or
 friends
4. Social media applications

By-product of video production:

1. Acquisition of new Hi-Def footage of the campus, classrooms and
 student activity – a valuable resource for future video production, and
 historical footage.
2. Archiving of in-depth on-camera interviews of Professor ▇▇ in HiDef.
3. BluRay data disks of all source footage and AIT datatape archive of the
 project source and edit files

SCOPE OF WORK

H+R will:

- o Be the sole contractor and POC for the entire video project;
- o Conduct research and expand project synopsis to a shooting outline;
- o Work with ▇▇ ▇▇▇ to locate photographs and footage that will
 be used in the video; and to select outstanding alumni in the VA-DC-
 MD for short testimonials on camera;
- o Coordinate with ▇▇▇, ▇'s Executive Producer and principal
 POC, all campus production requirements and scheduling;
- o Undertake, manage and direct all research, scripting, production and
 postproduction work

Key personnel/firms involved:

John Harrington/H+R Productions. (Contractor) – writer/producer/director

▇▇▇▇/▇ Communications, Inc. – concept developer/project
adviser
▇▇▇/▇▇ MULTI-MEDIA – DP for special video shots
▇▇/EFX – Post-Production

PRODUCTION
Format: **High Definition Video**

Schedule:
August 28/29
- o On camera sit-down interview with Professor ███ featuring his colleague Professor ███ who would elicit different responses from Professor ███.

August/September
- o Research photos and videos of Professor ███ from ███ archives

September 13
- o Site survey at ███ by writer-producer-director John Harrington and director of photography ██████ to determine exterior campus shots; discuss with ████████ and select classes, labs, student activities and others to be filmed, and produce shot list and schedule.

September 17
- o Complete shooting script/storyboard based on research and interviews gleaned from interviews with Professor ███.

September 21-22-23 or October 3/4/5
- o Exterior shots of Professor ███ on campus with students and staff; wide close up shots of him walking the green fields
- o "Beauty Shots" of the campus at sunrise and sunset by; shots of the campus with students enroute to classes; interior shots of classrooms and general student activities including academics, sports, social – by specialty video equipment such as steadicam, cranes and dollies.

EDITING
September-October
Logging of and transcription of interviews; selection of shots and music; Rough cut to final cut, narration, graphic animation, etc.
Style
a combination of marketing and documentary styles using new interview footage, new campus b-roll, ███ supplied video and photos.
Length
5-7 minutes
October 31
- o Approval screening by ███
- o delivery of final products 10 days after final approval

DELIVERABLES
- o 1 Digital Betacam master tape
- o 5 DVD copies
- o Compressed broadcast quality file for FTF delivery
- o BluRay data disks of all source footage

o AIT datatape archive of the project source and edit files

PRICING SUMMARY
o Total Estimated Production Cost -- $44,496.00
o Breakdown of cost is attached
o Invoice for first payment is attached

Payment Schedule

$23,247	50% of project cost upon acceptance of this proposal
$10,624.50	25% of project cost upon completion of location shoots
$ 5,312.25	12.5% of project cost upon start of editing
$ 5,312.25	12.5% of project cost upon delivery of all products

ACCEPTANCE
Please sign this document below and fax to my attention (John Harrington) at 202-544-4578.

Accepted by _____ _____

, VP for Institutional Advancement (Date)

HR HARRINGTON + RICHARDSON
P r o d u c t i o n s

December 23, ▓

Via email: ▓

Dear ▓,

Thank you for selecting **H+R Productions** to provide video support to your media project on Saturday January 11, ▓ at the ▓ Hotel, ▓, Washington, DC.

As requested, **H+R Productions** will:
1. provide a video camera unit with a camera person, audio as well as lighting equipment to videotape a series of mock one-on-one interviews;
2. be ready to immediately play back the video footage on a H+R Productions provided TV screen for review by the client instructor and trainees;
3. provide above services from 2 to 5 p.m.

The cost for the above services is $1195 plus parking fees.

Cancellation fees: with 2 days or more advance notice - no charge
within 24-48 hours - 50% of cost
less than 24 hours - 100% of cost

If in agreement, please sign and date this letter below and email back to me.

Sincerely,
John Harrington

Accepted and agreed by

_____ Date_____

2500 32nd Street SE Washington DC 20020 www.Harrington-Richardson.com (202) 544-4578

HR HARRINGTON+RICHARDSON
P r o d u c t i o n s

John Harrington September 23, ██
John Harrington Photography
2500 32nd Street, SE
Washington DC 20020

Via email: john@johnharrington.com

Hi ███,

Here's our cost estimate for the video production and photography of the
80th birthday party of ████████████████

Saturday Sep 21st, ███
████████

Video
$ 795 cinematographer and HD camera gear
$ 495 audio/lighting assistant
$ 695 4-hour video edit

$1985 - video package

If approved H+R Productions video crew will arrive at
████████████ at 1700 for brief by the event coordinator. Thank you for considering H+R
Productions for this special event.

Cancellation fees: with 2 days or more advance notice - no charge
within 24-48 hours - 50% of cost
less than 24 hours - 100% of cost

If in agreement, please sign and date this letter below and email back to me.

Sincerely,
John Harrington

Accepted and agreed by

_____ Date_____

Being the Subcontracted Motion Photographer

If the client is not yours, and you were called to be a member of the crew, the rates for being "the crew" and handing over the raw footage at the end of the day vary. I'm starting here just to give you an idea about what you can expect to be paid and what you're expected to bring along. It's important to understand that many productions—especially those in the motion industry—expect a "work made for hire" work arrangement if you are the contributing crew member, which means that you're not making any relicensing fees from your work. In motion photography this is the norm—not so in stills—so be prepared for that.

Your fee for a day (some do a half day, but I'd advise against it) should be just for you, the creative talent behind the camera. The myriad cameras, camera accessories, lights (hot lights as spots, hot lights in softboxes, LED panels, two lights, three lights, hair/rim light, and so on), audio (wired or wireless, multi-box versus wild sound, for example), and whether you want a full-size or a mini camera come into play. So that means it's you, plus whatever add-on equipment the job calls for. Following is a package price for a very limited kit and crew, so be sure to identify what the client is looking for exactly, before you turn up without a 100-foot XLR (audio extension) cord, and that's how far away from the mult box you are.

On Half Days versus Full Days

If you're asked for your rate and you quote $950 a day plus equipment, and you get asked "Okay, what's your half day rate?" you know the client is trying to go cheap. Resist the urge to agree to a half day. Rare indeed is the occasion when a half day works. If it's an 8 a.m. to noon job, then maybe you can book out the rest of the day to another client that wants a half day, but that's not likely. Usually, it's more like "Ten to noon, but we need you here at eight to set up" or it's "Five to nine, but we need you here at three to set up." Hey, wait—that's not really a half day anymore.

The reality is that your drive time to and from any given job, plus the setup, plus the actual work and the waiting around to get released by the client means that a half day is almost never a half day in a way that can allow you to generate revenue from the other half. So, stick with your whole-day rates. Be sure to define what your whole-day rate is—usually 10 hours portal to portal. Also be sure to define what your overtime rate is, because if you get a bad interview subject late in the day, for example, things could go over.

When doing post-production and editing, providing a line item like this:

Up to 20 hours @ $100/hr = $2,000

Looks better than this:

2 days @ $1,000 each = $2,000

The hourly characterization provides more information about how many hours you'll be working, not that you charge $1,000 a day. This also helps when you have to go over because an indecisive client keeps asking for more revisions.

On the occasion that you're the subcontracted photographer and the client just needs you for a few hours, then perhaps a half-day rate might work; but wherever possible, resist the urge, because it'll cost you.

Aspect Ratios

Hopefully you already know this, but if not, here are the points about aspect ratios that you need to know. You also need to know from your client what deliverable they want.

- **4:3.** A 4:3 aspect ratio is (or was) standard for old televisions, pre–flat screen. Some TVs and broadcasts still use that.
- **16:9.** 16:9 is closer to the aspect in a movie theater—it's wider. Almost all flat screens now use this ratio, and this is the direction motion is going. If you're not sure, use 16:9.
- **Letter-boxed.** If you've shot in 16:9 and now it's being played back on something other than a 16:9 screen, you'll be showing some form of black bars across the top and bottom—an aspect called *letter-boxed*. This isn't a capture standard; it's how what you captured would be played back.
- **Pillar-boxed.** If your footage is 4:3—whether that's how you shot it or you're working with older footage—when this aspect ratio is played back in a 16:9 format, there will be black bars on the left and right, called *pillars*. Again, this isn't a capture standard; it's how what you captured is played back.

Side-cropped or squished? Footage shot in 16:9 that for whatever reason needs to be shown in 4:3 will be *side-cropped* or *center cut,* meaning you'll lose the left and right sides of the footage. If important elements on the sides are cropped out during a scene, it's also possible to use *pan and scan,* which means that there will be a pan left or a pan right within the scene to capture that action/subject and, if need be, pan as the object moves throughout the original 16:9 frame. Squished is exactly what it sounds like—a widescreen 16:9 scene is disproportionately compressed on the left and right. Not a flattering look, but it may in some instances be necessary.

Cameras also vary, so be certain you're all speaking the same language. The last thing you want to do is hand over a format that's completely wrong for the client's needs. There are formats such as NTSC, PAL, and HD, whereas there are resolutions (or formats) such as HD/HDV and codecs such as ProRes, H.264, DVCPRO, and so on. Then there's the *wrapper* in the form of the deliverable format—.mov, .avi, .mp4, and so on.

First know what you're capable of delivering with your current cameras, and then once a client has a format need different than you normally provide, look into that format before quoting rental charges and identifying availability for the equipment.

In Washington DC, the rates are pretty decent for a single crew. By the way, when the word "crew" is used, it can be a crew of one (just the camera operator), two (common—just the camera operator and a sound technician), 10, or even dozens. In these instances, I'm using the term "camera operator" not as a separate title, distinct from a director of photography, but rather as a commonly understood characterization of what the person does. On most small productions, the DP is also the person operating the camera.

There are a number of resources for crews online. The cheapest you'll find a two-person Betacam SP crew (for 10 hours a day, portal to portal, which gives you about 8 hours of on-site work) with two lights and two channels of audio is about $1,250. Adding in HD or digital capture will add about $300 to that. In Washington DC, New York City, and Los Angeles, your base rate would be $1,450 for the same crew shooting SP, and adding in $300 again for the HD or digital option. These are for NTSC work. If it's available, you can count on an additional $300 for a crew that will give you PAL standard.

At the end of the job, you hand over the memory card "masters" and send the bill. However, once you hand over the masters, your leverage to ensure your bill gets paid diminishes drastically, so be careful. If you're doing more than that, such as editing, be certain to add that in on an hourly basis.

The One-Man Band

There are thousands—dare I say tens of thousands?—of jobs and projects for the one-man-band operation, or the one-man-band and his assistant. This type of production is distinctly different from being the subcontracted motion photographer, as outlined in the previous section. In that instance, there's a great deal more production involved, from pre-production conversations about the project scope, to editing, to audio considerations, to final package duration(s), to graphics, to music, and so on. While you may be a one- or two-person operation, you are essentially delivering the same finished product as a larger production, just with fewer people. Yet, those "fewer people" are still filling all of the individual roles the larger ones are, so be sure to factor those things into your production estimate. I hesitate to start quoting prices on these projects, because while you can start at the rates previously cited for the subcontracted crew, the package price goes up from there when you add in all the producer responsibilities, editing, and so on. Keep in mind that while many prospective clients come to the one-man operation attempting to save money, you should not cut corners to deliver a cheap product. Cheap clients result in cheap productions, which beget more cheap clients and cheaper productions. For example, if you believe the project calls for hair and makeup, don't let your client convince you otherwise.

Some clients looking to book a one-man band expect you to have at least a basic kit of equipment, and it can be hard to convince them to agree to a basic camera rental, lighting, or basic sound equipment. However, one way to do so is to break out the rate for your time and your kit rate, and then total them at the bottom. Either way, the client will pay the rental for the equipment—from you or from the rental house.

Determining what the rental charge would be for a single camera, a shotgun microphone and/or two lavalier microphones, two focusable hot lights, and a decent video tripod with a fluid head will be a good starting point. Once you've determined these rates—from a rental house—starting with that plus your hourly rate will give you a good idea what your bare-bones, bottom-line rate should be. Once a client starts specifying HD, Red, 4k, lots of lights, lots of audio, and so on, you can start talking about rentals. Later in the chapter, in the "Equipment Rental" section, I'll address a few different rental charge examples.

Clients also may balk at your one-man operation becoming a party of two or three. If you are working with a stationary subject, it may be easy to do the sound and lighting yourself, and having a sound technician and production assistant to set lights is a luxury. However, don't let yourself be pressured into cutting corners that will ultimately affect the quality of your production or cause you to look disorganized, overwhelmed, and unprofessional on the shoot. If you do, you find yourself spread too thin, and you'll make mistakes that will ultimately reflect poorly on you.

It is also very easy to get caught in a spiral of editing and re-editing that can cost you days and days of production. Be absolutely certain to provide a set amount of editing time based upon the client's finished project needs, and allow for up to X number of re-edits (the proper term is *revisions*) before additional hourly charges apply. Many contracts include three rounds of edits over X number of days, plus X amount of revisions over X number of days (or, alternatively, total hours), and after that it's billed by the day or the hour. When the client that wanted a three-minute finished package calls after that final cut is delivered and wants a broader 15-minute package of the same story/event, the estimating starts anew, and costs are billed hourly, usually with a minimum. Some agreements call for two passes of edits, and then $1,000 per pass after that, and this tends to cut down on the endless client changes. If there's a tweak—say, a lower-third job title is wrong—that's not the same thing, and that's something that, in a good back-and-forth client relationship, you can consider as a courtesy correction and not charge your re-edit charge. If the client is being difficult, then that contractually obligated charge certainly can apply.

There are ways to cut back production costs, one of which is to simplify the final edit, eliminating the fancy opening and interspersed graphics and animations that the client initially wanted. Especially if the client isn't sitting over your shoulder, watching the clock tick on hour by hour, keeping the client apprised of how many hours you've worked and having clear communications about edits will go a long way toward ensuring that the client won't balk at the bill after all is said and done.

Commonly, you'll deliver a rough cut for client review as a part of your normal (and included) editing process. Delivering the cut privately via YouTube or Vimeo with a password is a common practice. For some clients, however, it might be better to show the cut to them in person or do a screen-share while they're on the phone. This can help calm any client knee-jerk reactions to the piece's unfinished look, as well as help the client understand why you made a certain narrative or visual decision.

After you've provided the cut for review, the client will get back to you with their changes. If they made comments during the phone call, be sure to note those in an email to be sure you got them right and so you have a paper trail to point to if there are future issues.

You'll make those changes, and then the client may come back and want a few small additional changes. You might make them out of the goodness of your heart, even though it takes another hour. Then, when you deliver what you think is a final cut, the client may call because someone higher up in the food chain has requested significant additional changes contrary to what you had previously been told to do. At that point, you're charging by the hour for editing time. It's important to document these changes via a signed change-order document that outlines what's being changed and what's being charged. The last thing you want is to do all the work, send in a bill, and then have an issue with your bill!

In some shorter documentary work being commissioned by newspapers, there is a lot of pressure to place a single price on an entire project. So, if you're working on deliverables destined for this market, understand that the client may well request that you either cut back a story or flesh out a piece a bit more. There can also be the mindset that editing time is billed a half rate relative to what you charge to shoot. If you are the camera operator at $600 for 8 hours (separate from equipment rental charges), that's $75 an hour. Union rates for a Tier 2 editor (more on this below) are $72.40 an hour, and many non-union editors charge $125 to $250 an hour. Keep these things in mind and resist attempts to value at half the rates of an editor relative to the camera operator.

Another occasional occurrence is when a company refreshes their logo, so all the logos in the videos you produced need to be swapped out. How would you charge for this? Or, if an entire video looks great but one of the executives has left the company, how much should you charge to reshoot the same messaging and drop the new executive in, change the lower-third computer graphics, and redeliver? This would fall into an hourly editing rate padded to add in the time for the back-and-forth consulting and uploading/transfer.

One of the most critical questions you can ask a prospective client is, What budget are you trying to work within? You can then go from there. When the client says "I don't know" or "I don't have a budget," use your experience to identify what you'll need to do the job right and line item each expense you expect. Then, immediately after you send the estimate, you'll want to call the client and discuss it. You'll want to explain and justify any line items they don't understand the importance of.

If, on the other hand, the client states a budget, it becomes your job to plug in the variety of necessary expenses for the project and see where your figures are compared to the client's budget. You can use the figures listed later in the chapter for editing, shooting, and so on to flesh out the production costs.

Often when you get a call from a non-profit or an NGO, many newspaper still photographers who are making the transition to motion and are working on short documentaries for clients—whether they be non-governmental organizations or nonprofits—need to recognize that comparisons between an NGO and a small regional corporation doing a "commercial" project highlighting their product or service are fair. An NGO's "product or service" is doing good for a segment of society, and they generate a great deal of revenue—and pay their employees well in many cases—to that end. For those who want to focus on charging less for an NGO than for a corporate endeavor, we addressed those issues in Chapter 23.

The Value of the Storyteller

I won't for one minute suggest that a young, talented motion photographer fresh out of school is worth the same as someone with 10 years of experience. It's just not the case. There is significant value in what I'll term the "value of the storyteller."

It's hard to put a price on what a seasoned storyteller brings to the table, but it's often among the biggest assets. It's clear storytellers are worth at least the base rates listed in this chapter, and then some. That "some" is the unknown. Often their value is in a track record of successes. In fact, it's possible for seasoned still-photographer storytellers to carry substantial value even if they are fresh into the realm of motion. The limitations of their motion knowledge can be more than made up by their experience in the field or when they are coupled with a seasoned DP who has extensive motion experience, for example.

Sometimes, creating a compelling storyline requires significant research on the subject matter. Reading books to prepare for an interview can be time consuming. When it comes to interviewing a subject, often asking just the right questions can garner a 15- to 30-second sound bite that would've taken five times longer without the right background research to call out the answer needed.

Sometimes the value of a storyteller comes from their unique vision. The challenge, of course, is how to identify that vision. A storyteller's ability to connect with a client and build rapport is critical. The best storyteller finds a way to move the narrative forward while getting out of the way of the story.

Additionally, while the client may think they know how to tell a story, they're no more a storyteller than you are a graphic designer who knows how to design your website or marketing materials. Ultimately, the client has final cut, but part of your value is that you will argue (politely) for your point about how to tell a story. If it's a package where the less-than-enigmatic CEO or organization president just has to be seen on camera as a talking head, over a needed expansion of the moving story that is the core of the piece, then make your case. That's why they hired you—to tell the story. Or, when a client tells you that they need six to eight interviews in a three-minute production, you need to tell them it's just not going to work—especially if it isn't. The poor quality of the finished result will reflect poorly on you.

When you hear that a major motion picture is being directed by Spielberg or Lucas, you know there will be a premium on their time, compared with the director of just one or two Oscar-winning movies or a first-time director. While both Lucas and the first-timer are entitled to a minimum Directors Guild of America (DGA) fee based upon the value of the production, the first-timer may not get a percentage of the profits, whereas you can expect Lucas will. So, too, should the director of your production make at least the rate of a good camera operator, but identifying the further value they bring is as much art as it is math.

Larger Productions

Some of the positions in this section may not be applicable to your project. Let me reemphasize the point made earlier in this chapter: Many photographers and motion producers will be perfectly happy never having to hire in any of the different crewmembers outlined below, and that's fine. If, however, you do say,

"I can't be focused on framing the image at the same time as I'm trying to track the runner coming toward me," then hiring a focus puller for your project is something you'd like to know is possible. Or, for example, if you're documenting an athletic event or a protest and you're putting together a news or feature on what occurred, then a stylist isn't likely to be on your production call sheet. However, you may decide you want to storyboard what you're looking for beforehand.

Some productions are non-union or can get a union waver, if their entire budget is below a certain value. If the people appearing in the production are union, they may well need to get a union waiver to appear in a non-union project.

The International Alliance of Theatrical Stage Employees, Moving Picture Technicians, Artists, and Allied Crafts of the United States, also known as IATSE, was founded in 1893. While there isn't an agreement that sets forth what is considered a low-budget production, the ranges by the various unions go between $500,000 and $10,000,000. So, as long as you're under $500,000, IATSE doesn't really get involved, and the request is to negotiate the rates but "be fair." That said, the Screen Actors Guild (SAG), for example, considers a low-budget production for a short film to be $50,000. There is no waiver available for a SAG performer to appear in a non-SAG production—this is their primary mandate, and they strictly enforce this.

The point here is that there are various ways to consider a project "low budget," and as your production size and costs escalate, you'll need to be very aware of your obligations. The last thing you want is to have a production shut down on the first day of shooting.

In this section, I'll provide you with an a la carte set of costs to consider. It's also worth considering that if you're just going out to do a small project yourself (and maybe with an assistant), you're fulfilling all the roles that often can be filled by other people, thus you're doing the job of many people.

For example, when doing still photography work (as we went into in detail in *Best Business Practices for Photographers*), there's the fee for the photography and the fee for the post-production work done on the images afterward. That's comparable to the post-production/editing done on motion work. Each of these items should be priced as separate line items, if for no other reason than to educate the client about the different services you're providing. However, if you're turning up solo to a shoot, having line-itemed a camera operator, a sound technician, and a lighting director, there will be a problem. Instead, list "Camera, Sound, Lighting" and the combined rate you've chosen, which will be much easier to explain.

Camera Operator

This is you, and this is not you. I realize that might sound confusing, but what I'm trying to convey is that the camera operator is likely not you unless you're the one-man-band operation, in which case it could well be you. However, understand that this is often the role of a trained camera operator. If you're reading this as a still photographer and you believe that now that you have a camera that captures motion, and that you're capable of using it at a professional level, trust me when I say that's not likely. The mental switch from still to video is like going from driving an automatic all your life to suddenly driving stick. There are so many things to think about that it's just not the same, and it requires practice.

As for the rates for a camera operator, there are union rates and non-union rates, and the Local 600 union has a rate card for specific roles.

For a non-union day rate, which is of course anything other than the union rate (a union day, which is considered 10 hours, with an overtime rate 1.5× the hourly rate, is between $550 and $1,000 per day for one person, just the camera operator, not including camera or lighting or grip rental) if you're new to the

business, you should hopefully be looking at between $250 and $500 a day, yet many will try to pay you less. Unless you can see some good reason to accept less, don't.

If you're a Steadicam operator, you're looking at a bit of a premium. Some resources suggest you can expect between $1,200 and $1,600 for a 10-hour non-union day; however, $700 to $1,200 is a common rate for the operator only. Depending upon how the Steadicam kit is outfitted (wireless, external monitors, and so on), the added equipment rental charge can be from one thousand to several thousand dollars.

On the East Coast, while low-budget rates can go down to $18 an hour, the Local 600—the union that governs cinematographers—has a sampling of rates from the "Basic Agreement" rates, as of July 2012:[1]

Within the Corridor[2]

International Cinematographers Guild Local 600 Amendment Agreement	Studio Minimum Rates	
	Schedule D Daily Employees	Schedule E Weekly Employees
Occ. Code	Daily 8 Hours 1 1/2 after 8 hours	Weekly Guarantee 5 Consecutive 40 Hour Days
No. Classification	Per Day	Per Week
1901 Director of Photography	$802.00	$3,430.57
1911 Camera Operator	$627.26	$2,524.31
1931 Still Photographer	$499.09	$2,006.88
1941 1st Assistant Photographer	$413.20	$1,677.20
1951 2nd Assistant Photographer	$327.21	$1,551.39
1971 Film Loader	$275.68	

Source: International Camera Guild "Local 600" Amendment Agreement.

The above rates change if the work is done outside of that region, or for different work. In this case, these are the rates in a studio environment. Here, the camera operator makes $78.41 an hour. Outside of the corridor, the rates drop to $59.53 an hour for a single day and $54.55 an hour for five consecutive days.

For a pilot, the hourly rate works out to be $70.75 within the corridor and $48.36 an hour on a one-off single-day project. It drops to $53.48 per hour for a weekly project.

For long-form television rates, the one-off hourly rate for a daily project is $52.58, and for a weekly deal it drops to $43.22 an hour.

As I cite these rates, understand that there are a number of significant factors at play. The Local 600 has very solid rules (and really good reasons for why) that they have used to determine how and why these rates

[1]Source: International Camera Guild "Local 600" Amendment Agreement, 9/17/2012.

[2]The corridor is defined as Connecticut, Delaware, Maryland, Massachusetts, New Jersey, New York, Pennsylvania, and Washington DC.

apply, and what they apply to. While I've only cited the East Coast rates and the "outside the corridor" rates, they're comparable to other jurisdictions, so these should get you in the ballpark. The other area is what's called the 13 Western States: Arizona, California, Wyoming, Nevada, Idaho, Colorado, Utah, New Mexico, Hawaii, Alaska, Oregon, Washington, and Montana.

One last point to keep in mind, according to the union book, the director of photography is not actually allowed to operate as the camera operator (except in special circumstances on a union production), but that doesn't mean they don't. Most DPs are expected to (and do) operate the equipment these days; operators alone are a luxury few can afford. I only point this out because these are two different roles, and when they are delineated and done by different people, they have very different pay scales on a union production.

Sound Editor/Technician

On a union production, the Tier 1 rates (smaller productions) are listed in the IATSE contract as "subject to negotiation." Their midrange Tier 2 productions list, for the Los Angeles area, a sound editor as earning $2,086.60 a week (defined as 48.6 hours), or $42.93 an hour. This is, as you're coming to understand, plus any and all equipment. If you're bringing in just the person, these are reasonable rates to pay them to operate your equipment (that you own or rent). However, consider that many skilled sound technicians have their own gear, and making a package deal with them is often a good idea. If you are moving up to larger productions, as of 2013 the hourly wage for a sound editor is $51.50.

Lighting Director

The lighting director often carries responsibilities that bridge between the director of photography and the chief lighting technician. As of January 2013, a lighting director on a union project earns $23.11 an hour on a discounted Tier 1 (to use the union scale card) project. In Los Angeles, on a midrange Tier 2 project, as of 2013 the hourly rate is $30.40.

Focus Puller

The focus puller's job is exactly what it sounds like: He focuses the camera, maintains the camera and lenses, and keeps the image on the screen in focus. So, when a subject walks toward a stationary camera, the focus puller tracks the subject, "pulling" the focus as they move. A common task for a focus puller is when you have a subject speaking a few feet in the distance, facing the camera, and another subject close to the camera—say, in profile. As the dialog goes back and forth between the two, the focus puller ensures that the person speaking is in focus, "pulling" and "pushing" focus between the two people speaking. A non-union focus puller (often referred to as the first assistant camera operator, or 1st AC) can earn between $350 and $550 per 10-hour day. Check the rates for first assistant photographer in the "Camera Operator" section earlier in this chapter to get a good idea of what a focus puller would be paid on a union shoot. Keep in mind though, that while it says first assistant photographer, it is more likely referred to as 1st AC.

Production Assistant

Non-union production assistants (commonly referred to as PAs) do any number of things. Sometimes they mark the beginning of a scene with a clapper, sometimes they lug cables and set up lights, and so on. If you've never really worked on a set before, you're looking at between $125 and $175 a day non-union. You're essentially an extra body to support everyone else. Someone with three to six months or more of experience in this role can command $175 to $250 a day, again non-union.

A PA should be a given on any shoot you're doing, even the small ones. Few things are more embarrassing than showing up sweaty and with rumpled clothing because you've been struggling with a cart full of equipment. First impressions are everything. Hire a PA even on the smallest of shoots; it will make your life so much easier.

Producer

The role of producer is one you've likely been fulfilling already, similar to how you're the president and CEO of your company with just one employee—you. There are a number of different sub-producer roles as well. The producer shepherds the entire production from start to finish and is involved in the financial aspects of the production, as well as putting together the "above the line" team.

Executive Producer

You'll almost never find an EP on the location of a movie or major production. However, if you're doing a film in the corporate world, the EP is likely the client, and he may feel it necessary to be there. For example, if you are hired by XYZ Widgets to produce a piece about how the widgets make your life better, the employee of XYZ Widgets who hired you and approved your budget is best considered the EP. Often the EP is either funding a portion of the production (in commercial productions where there is an expectation of a return) or lending his name to a production to help bring talent together (often for a piece of the action as well). EPs tend to be less involved in the day-to-day decisions.

Director

If you've got one person who's filling the role of director for your production and the rest of the positions are all fleshed out with individual people serving in those roles, you are likely getting close to the limit of what this book delivers as best practices and insights. Directors earn a wide range of incomes and command hefty fees, and there are many factors involved. Often, if you're producing a project for a commercial or corporate client, they fall into the category of director, because they're calling the shots about what they want in the film. They're the ones who approve the storyboards beforehand and the final cut afterward. They ultimately have to answer to producers' expectations and budget realities as well.

Often the director is also the executive producer. As far as the Directors Guild of America, or DGA, is concerned, rates often fall to minimums and can go up from there. On a union production, with a Tier 3 or Level 3 motion-picture of $2.57 to $3.6 million, a director's minimum salary is $75,000 a week with a minimum of 13 weeks. This equates to $1,875 an hour. However, at the lowest scale, a so-called second second assistant director earns $649 a week, or $162.25 a day, as of 2013. That said, the rates for the director on any project with a budget of less than $2.6 million are subject to negotiation, with no required minimum rates.

Hair and Makeup

In small productions, the same person does makeup and puts finishing touches on a person's hair, removing flyaways. A decent makeup person will run you $475 to $600 a day, and they'll likely limit that rate to up to about six people. You can plan on a dusting that takes the shine away to take 5 to 10 minutes, and a good makeup person will keep the subject in the chair for 20 minutes or so. Be sure to consider the need for good, even light where this is happening, if you're working on location. Some makeup people will bring a portable mirror ringed with soft light bulbs if you ask. They'll often do the hair touchups, too.

Having a separate hair person is a luxury in many instances; however, sometimes, it's a requirement. A hair person separate and distinct from a makeup person is usually priced the same or comparable. No hair person is expected to come in and do a full cut and style on site. If the shoot calls for the talent to change styles, you'll have undoubtedly addressed this with your client, gotten clearance, and paid the necessary fees to the talent agency to change the talent's look. Even something as simple as changing their hair color is a big deal that requires preapprovals. For this level, it's often best to send the talent to an off-set salon.

Stylist

As the size of your production grows, having someone you hire to manage the wardrobe and look and feel of your set can be very useful. Often you'll have a wardrobe stylist and/or costume design, as well as a set stylist to decide whether the chairs, for example, should be folding chairs or overstuffed high-back leather chairs—and in either case, what color is appropriate.

A wardrobe stylist ensures that the colors worn by the various people on set don't clash. If you allow people to choose their own clothing, the people in red will stand out, for example. Also, the wardrobe stylist will ensure that there are no logos (unless approved by the manufacturer) on shirts.

Typically, a wardrobe stylist will get the various sizes of clothing that the talent will wear and bring a selection to choose from. Depending upon the arrangement, you may have to pay for them to shop beforehand, and then return the clothes the next day. Be cognizant of whether this is acceptable to the store where the stylist is getting the clothes from. Often a wardrobe stylist will have arrangements with stores to do this, but some won't. How you choose to work with a stylist on this matter is up to you.

A set stylist can be an invaluable resource. In one instance we had a production where the shoot was outside a home in a suburban neighborhood. The house was great but needed some sprucing up. A trip to the local garden nursery by the set stylist and her assistant brought back a truckload of flowers that they planted so the home looked better (see Figure 24.1). If your production allows for it, having someone responsible for the look and feel of each scene can be really useful.

Figure 24.1 *A stylist and stylist's assistant work on set to beautify a property.*

A prop stylist can be invaluable when you're doing work where a prop like a bottle of apple juice is visible. On one shoot, we didn't have the rights to use the labeling and trademarked names on a product that would be in the shot, so a prop stylist was hired to craft new labels—not just for that one product, but an entire aisle shelf area where a dozen products would be visible in the shot (see Figure 24.2). The last thing we needed was to have a company like Kraft or Ocean Spray see their logos in the background of the production we were working on and send a cease and desist order to us, followed up by a possible lawsuit. A prop stylist will run you between $600 and $900 a day, depending upon where they are and how involved the project is. They will usually give you a quote for your project once you outline the details.

Figure 24.2 *A stylist has re-created generic labels for the entire aisle of products for this shoot. The foreground example shows a proprietary apple juice bottle on the left and the generic apple juice bottle on the right.*

On Talent

Often when someone hears "talent" in reference to a person who appears on camera, the perception is that the talent is a model or an actor. This is not always the case. The word talent is used to describe whoever appears on camera, whether it's a hired professional actor or any person appearing in a scene or a sit-down interview. Talent can also be a voiceover artist who is providing audio commentary. Selecting just the right voice, such as a deep baritone male voice versus an upbeat, cheery, young female voice—can lend a very different feel to the production.

Graphics, Animation, and Chyron

If you feel comfortable using something as basic as Keynote or PowerPoint to produce several bullet points for a motion presentation, feel free to just use the rates for a post-production editor for these types of simple graphical needs. However, it's highly likely that your end result will show the lack of professionalism. Understand that there are basic and advanced chyron capabilities in software such as Final Cut Pro and Adobe Premiere; however, if your client wants you to start using a separate application, such as Apple's Motion or Adobe After Effects software, that's an entirely different knowledgebase and should be a separate line item for the client to review and approve. It is reasonable to assume that a good Final Cut Pro/Premiere editor will know how to do chyron within that software; however, don't assume that a good FCP/Premiere editor is capable in Motion. In Premiere Pro, they don't use chyron; they refer to it as "title," while in Final Cut Pro they call it "text."

Post-Production Supervisor

This is where costs can skyrocket and misunderstandings can really get between you and a client. Post-production charges are all over the place. They can be as low as $125 per hour and up to $250 per hour for a decent editor, and they can reach $1,000 an hour for someone *really* good. It goes up from there. Consider that these rates are what it would cost to be in the edit suite, not just the rate for the talented person doing that work.

The misunderstandings come in when there's not a clear understanding of how long the finished piece needs to be, how many re-edits the client gets (if they're not in the editing room with you), and so on. Consider if you're covering a three-hour conference with two cameras and six presenters, each doing a 30-minute talk. Are you expected to deliver a finished three-hour edit? Did you remember to get the PowerPoint/Keynote presentations so you can cut from the speaker to their slides at the right time? Or, instead, are you expected to deliver a 10-minute highlight reel with 90 seconds of highlights from each speaker, plus a 15-second introduction and a 15-second wrap up? Who's providing the graphics? More importantly, who's going to select the sound bites cutting 30 minutes down to 90 seconds?

In a union production, your editors will come from the Motion Picture Editors Guild, also known as the Local 700. According to the IATSE agreement, on a Tier 2 production, an editor makes $2,896.12 a week, or $72.40 an hour. Again, this is for the talented person doing the work, and does not include the value that having the equipment would bring.

There are a number of ways to estimate how many hours of editing you'll need based upon how many hours you've shot. However, those are not always perfect. If you've shot linear tape and have to ingest in real time, then start with however many hours of footage you shot (or plan to shoot). If you're shooting non-linear video, then there's just the time to copy and properly log your video (that is, you don't have to ingest it in real time), so there may well still be a need to review the footage in real time, especially if the person doing the editing is different from the person who shot it. He will have no idea what content is where—that is, unless you included the cost of a producer who logged time-codes while the footage was being captured. Often the hourly cost of a field producer is less than the hourly cost of an editor, so having a field producer to log tapes and time-codes is a good investment.

Many people will tell you that getting one minute of usable final footage takes about an hour of editing. However, if that one minute is coming from four hours of footage, that's really not going to be accurate. To a degree, you'll want to estimate as close as possible given your editing skills and how many hours of footage

you expect to produce. After a few projects, you will have a far better picture of the amount of time it takes you—with your skills, computer capabilities, and export abilities—to price out a project. Just be sure you're charging for it.

One point about the editing process: You may well need voiceover talent. The value of a good voiceover person can't be understated. Someone with the wrong voice can ruin a video. And especially where footage is missing, a voiceover can bridge the gaps with a few sentences. The voiceover typically comes in late in the editing process, where you have a rough cut. You can use friends if appropriate to the situation, and there are many resources online where you can hire professional voiceover talent.

Example: Multi-Camera Event Coverage

When we've done multi-camera event coverage, our first deliverable is the unedited raw footage from the main camera. We deliver this either on a DVD or on a secure video website, such as Vimeo. And then we wait. Sometimes the client is quick to get back to us with their edit decision list (EDL), where they'll say:

> Speaker A:
>
> From 12:17 to 12:32 : 0:15 Beginning with "We want to show you…" ; ending "and that's it."
>
> From 14:02 to 14:47 : 0:30 Beginning "the most concise way…"; ending "for you to do."
>
> From 21:20 to 21:35 : 0:15 Beginning "another challenge is…"; ending "solving it for everyone."
>
> From 29:28 to 29:58 : 0:30 Beginning "To sum it up…" ; ending "Thank you very much."

Often it's easy to provide the client with a tracking sheet to assist them in logging what they want as excerpts from the remarks. Often when the speakers have prepared remarks, it's easy for them to provide the speech and just identify what lines they want. Often the client will have someone listening along and making notes that are key to their needs. Sometimes, you'll have a field producer logging comments and the time-codes on footage as you go to make things faster in the editing suite.

Once the package is close, we'll deliver a rough cut without any graphics. We consider it to be pretty close to finished. Once the client approves this, we'll add in graphics and apply/update any small changes the client has from their rough-cut review.

We'll deliver the finished 10-minute piece, and that's that. The client makes all of the decisions about edits and sound bites, at their expense and on their timeline. It takes less time for us, and we don't have to sit there in real time, re-watch the presentations, and start and stop to make notes about what we think is best. We'll invariably get it wrong, and then the back and forth continues.

When the client wants a completely new package that's three minutes or an expanded one that's 30 minutes, the process (and billing) starts all over again.

Example: Single-Camera Soft News Event

In a smaller production, suppose it's just you shooting the footage with an editor, and you're covering an event of some sort. When we were doing coverage of the PhotoPlus Expo tradeshow, we went into the show not knowing whom we were going to interview or what products we would find on the tradeshow floor. What we *did* know was that we'd need an introductory 10 seconds to say, "We're here at day one of the PhotoPlus Expo. Let's head down to the show floor and see what's new." We'd also need some B-roll of wide shots shot from a balcony overlooking the show floor and the crowds, and then two or three shots from ground level looking down an aisle with people milling about. Then, for each booth in which we were interviewing someone, we'd need a wide shot of the booth with people looking at the products. And 30 to 60 seconds of an interview with whomever the company wanted to demonstrate the product, as well as a close-up of the product. We would repeat this two or three times. Then, at the end, we'd do an exit segment—something like, "Well, those were a few highlights from today's PhotoPlus Expo. We've featured Company X, Company Y, and Company Z, and their new and interesting products. Tomorrow we'll talk to several of the seminar speakers about their presentations."

We'd fade from the introduction to the overall shot, then to the first pitchman. To break up the 60 seconds the pitchman was speaking, we would cut two or three times to a close-up of the product, and we'd fade between each of the shots using the ground-level B-roll. Then we'd use the wrap-up segment to close out the package. All together, the package would be about four minutes long.

Example: Single-Camera Hard News Event

Suppose you're tasked with covering a protest that starts in a park where a stage has been set up, followed by a march to City Hall. Your finished product is likely less than three minutes. You have no idea what's going to happen, although you know who the VIP speaker is. You'll have a 10-second introduction, such as, "We're here in the town square, where the mayor-elect will roll out his platform for his coming term," followed by a medium-framed segment of the crowds looking on approvingly, a wide shot showing the size of the crowd, then a few snippets of the speech highlights, and finally a wrap-up by the on-air talent. Your shooting time will likely fall into the $1,450 range, and then there's your editing time. If you had a producer (add in $650 for the day) who logs the tape and notes the time-code where the highlightable remarks are, you'll save a significant amount of time editing, which will get the piece to air faster and cost less in editing time.

Production Resource Guides

Most major metropolitan areas have departments dedicated to promoting the city in movies, TV shows, and so on. Often they're called something like the Office of Film, Video, and Entertainment, as is the case in Washington, DC. These entities put out production resource guides that can guide an out-of-town company in finding crew, soundstages, post-production services, production support services, and so on. Many of the postings in these guides are paid advertisements by the providers themselves, but they often list their credentials, credits, links to their website, and so on. This can give you a good feel for who else is in the business, as well as whom you may be able to subcontract for. Doing an online search for "{your city name} production services directory" will yield your local directory, or it will show that there isn't one. If the latter is the case, although you're on your own, you also know where the closest one is to draw on the resources you don't have.

Equipment Rental

As still photographers, it's expected that your $1,000 assignment fee includes you bringing your own photo equipment. Not so with many motion projects. As outlined earlier, when we talked about the one-man band, there is a degree of expectation for a basic package of equipment, but beyond that everything gets a rental line item.

When shooting stills, you're probably bringing two bodies, at least three lenses (wide, midrange, and zoom), two flashes, and an external battery. But at what point does it start to get specialized or specific enough that you can't be expected to own (and include for no additional charge) other equipment? Do you own a 300mm, 400mm, or 600mm lens? What about studio lighting? Twelve-foot silks? How about shooting tethered? Working underwater? What if you're doing a shoot that requires five cameras pre-positioned at a venue, all triggered via remotes? Are you expected to own seven cameras? At some point as a still photographer, you likely said to a client, "We'll have to rent equipment for this" and included it as a line item on the estimate. That's how it's been from the beginning for motion.

In motion, the first line item is the camera. There are myriad formats. Not only will you need to know whether the client wants 4:3 or 16:9 for the aspect ratio, you'll also need to know whether they want HD—and if so, which flavor (720p, 1080i, 1080p, or 4k)—and be sure to specify what frame rate too. If you already own a camera that does the format they want, great.

Here's a sampling of the line item charges to rent various cameras:

- Canon 7D $90/day
- Nikon D800 $150/day
- Canon C300 $450/day
- Red Epic $750/day

Don't forget that those rates are just for the "brains"—the camera body alone, plus basic accessories to make it work. It doesn't include lenses, external monitors, sound equipment, and so on.

As you build-out the specifics of what a client wants, list every item. You don't want to get caught in a situation where the client has told you the project is some B-roll along with interviewing one person, so you list "Sound equipment - $250" and bring along one wireless lavalier or a handheld mic, and then the client ends up wanting you to capture the audio of two or three people speaking interchangeably. Be sure to list "Sound equipment - $250 (2 wireless lavalier microphones and 2 receivers)," and then when the client adds a third person, you know you'll probably need a sound technician to manage the multiple receivers and mix them down onto the two audio tracks (or one).

You'll also want to include how many cameras you're bringing. In some instances—say, a wedding—you'd include your main camera at the back of the hall, an overall camera from above showing a wide or medium angle, and then a third cut-away camera near the front, framing the couple taking their vows with the first row looking on. That's three cameras, so be sure to list that and charge for it.

At some point, you'll be using rental equipment so often that it may make sense for you to just buy it. Don't then turn around and not include the rental cost for that equipment in your estimates! You are now carrying the cost of what you were renting before, and you want to recoup that cost over your future rentals. If a light kit costs you $120 to rent, and you are renting it once a week, after about six months you might as well have bought it, so consider this when renting regularly.

The Production Sheet

H+R PRODUCTIONS		CALL SHEET/PRODUCTION REPORT		DATE
2500 32nd Street, SE Washington DC 20020		PROJECT TITLE		SHOOT DAY X OF Y
(202) 544-4578 Fax (202) 544-4579		JOB #: 20140101		

CLIENT: Name / Address 1 / Address 2 / Phone / Fax

HOTEL: Name / Address 1 / Address 2 / Phone / Fax

CREW CALL: 00:00

SHOOT LOCATION: Name / Address 1 / Address 2 / CREW PARKING: Directions / TRUCK PARKING: Directions

BREAKFAST: 00:00

WEATHER: Description / High/Low / Description 2 / Sunrise/Sunset

AGENCY: Name / Address 1 / Address 2 / Phone / Fax / Contact 1 / Contact 2

CLIENT CALL: 00:00

HOSPITAL: Name / Address 1 / Address 2 / Phone

AGENCY CALL: 00:00

CREW

POSITION	NAME	CELL	OTHER	CALL	OUT
DIRECTOR					
PRODUCER					
PROD. SUPERVISOR					
ASST. PROD. SUPER.					
ASSOC. PRODUCER					
ASSOC. PRODUCER					
CAMERA DEPARTMENT					
DP					
CAMERA OPERATOR					
1ST A.C.					
DIT					
ELECTRIC DEPARTMENT					
GAFFER					
BB ELECTRIC					
ELECTRIC					
ELECTRIC DRIVER					
GRIP DEPARTMENT					
KEY GRIP					
BB GRIP					
GRIP					
GRIP DRIVER					
ART DEPARTMENT					
ART DIRECTOR					
LEADMAN					
PROPS					
ART PA					
VANITIES					
STYLIST					
HAIR/MAKE-UP					
SOUND & SCRIPT SUPERVISOR					
SOUND					
BOOM OPERATOR					
SCRIPT SUPERVISOR					
OTHER CREW MEMBERS					
LOCATIONS					
CRAFT SERVICE					
MOHO DRIVER					
MOHO DRIVER					
PA (PICKUPS)					
PA					
PA					

TALENT

ROLE	NAME	PHONE	OTHER	CALL	OUT

VENDORS

ITEM	VENDOR	PHONE	CONTACT	CALL	OUT

PRODUCTION NOTES

PRODUCTION SUMMARY

FIRST SHOT: / LUNCH: / FIRST SHOT AFTER: / 2ND MEAL: / CAMERA WRAP: / LAST MAN OUT:

CAMERA: / STARTING INVENTORY: / TOTAL FOOTAGE: / ENDING INVENTORY: / NOTES/COMMENTS:

Figure 24.3 *Here is a blank call sheet. They can be more elaborate or less. This one is fairly standard.*

Once you have more than about three people working on a project, you'll need a production worksheet. The worksheet lists call times, wrap times, last-man-out times, and so on. Many production worksheets also include the day's weather, sunrise and sunset times, directions, the nearest hospital, contact numbers, and so on. If you're going to multiple venues or you have a schedule to interview a variety of people, a production worksheet listing the venues, the subjects, and their contact numbers may be beneficial, even if it's just you and an assistant.

When it comes to production sheets, never assume everyone who needs one has one, even if it was emailed to them. One of the roles of a production assistant is to make the calls to confirm everyone got it, and it didn't get caught in someone's spam filter.

The Model Release

In almost all uses of video, and wherever possible, you should get a model release from anyone who appears on camera. However, if it's a broad crowd shot, it may not be necessary—or feasible—to do so. If the end use of the video is for a news broadcast or it's editorial in nature, a release is rarely necessary, but it's common for news media to ask for releases for minors. Typically, you'll want to get a release from your subjects before you invest the time and effort into shooting. Further, getting the release beforehand also ensures that if the subject doesn't like what she said, you've already gotten the release and permission to use it. In this era of overly litigious people, some news outlets are being extra cautious and asking for model releases from everyone, as well as getting the subject to sign a release for any visual assets she provides.

Adult Release

In consideration of the engagement as a model, and for other good and valuable consideration herein acknowledged as received, upon the terms hereinafter stated, I hereby grant to John Harrington ("Photographer"), his/her legal representatives and assigns, those for whom Photographer is acting, and those acting with his/her authority and permission, the absolute right and permission to copyright and use, re-use, publish, and re-publish photographic portraits or pictures of me or in which I may be included, in whole or in part, or composite or distorted in character or form, without restriction as to changes or alterations from time to time, in conjunction with the my own or a fictitious name, or reproductions thereof in color or otherwise, made through any medium at his/her studios or elsewhere, and in any and all media now or hereafter known, for art, advertising trade or any other purpose whatsoever. I also consent to the use of any printed matter in conjunction therewith.

I also consent to the use of any printed matter in conjunction therewith.

I hereby waive any right that I may have to inspect or approve the finished product or products or the advertising copy or printed matter that may be used in connection therewith or the use to which it may be applied.

I hereby release, discharge and agree to save harmless Photographer, his legal representatives or assigns, and all persons acting under his permission or authority or those for whom he is acting, from any liability that may occur or be produced in the taking of said pictures or any subsequent process thereof, as well as any publication thereof.

I hereby warrant that I am of full age and have every right to contract in my own name in the above regard. I state further that I have read the above authorization, release and agreement, prior to its execution, and that I am fully familiar with the contents thereof.

Dated: 3 | 3 | ▮

Signature

Print Name

Address

Ba A▮ MD 2/015

City State Zip

Phone #: 4/0 ▮

Witness: ▮

Print Name: ▮

Minor Model Release

In consideration of the engagement as a model of the minor named below, and for other good and valuable consideration herein acknowledged as received, upon the terms hereinafter stated, I hereby grant to John Harrington ("Photographer"), his legal representatives and assigns, those for whom Photographer is acting, and those acting with his authority and permission, the absolute right and permission to copyright and use, re-use, publish, and re-publish photographic portraits or pictures of the minor or in which the minor may be included, in whole or in part, or composite or distorted in character or form, without restriction as to changes or alterations from time to time, in conjunction with the minor's own or a fictitious name, or reproductions thereof in color or otherwise, made through any medium at his studios or elsewhere, and in any and all media now or hereafter known, for art, advertising trade or any other purpose whatsoever. I also consent to the use of any printed matter in conjunction therewith.

I hereby waive any right that I or the minor my have to inspect or approve the finished product or products or the advertising copy or printed matter that may be used in connection therewith or the use to which it may be applied.

I hereby release, discharge, and agree to save harmless Photographer, his legal representatives or assigns, and all persons acting under his/her permission or authority or those for whom he is acting, from any liability by virtue of any blurring, distortion, alteration, optical illusion, or use in composite form, whether intentional or otherwise, that may occur or be produced in the taking of said picture or in any subsequent processing thereof, as well as any publication thereof, including without limitation any claims for libel or invasion of privacy.

I hereby warrant that I am of full age and have every right to contract for the minor in the above regard. I state further that I have read the above authorization, release, and agreement, prior to its execution, and that I am fully familiar with the contents thereof.

This release shall be binding upon me and my heirs, legal representatives, and assigns.

Dated: 2-29-▮▮▮

▮▮▮▮▮▮▮▮▮
Minor's Name

▮▮▮▮▮▮▮▮▮ Crofton, MD 21114
Minor's Address/City/State/Zip

▮▮▮▮▮▮▮▮▮
Father/Mother/Guardian's Name

▮▮▮▮▮▮▮▮▮
Father/Mother/Guardian's Signature

Phone #: 202-▮▮▮▮▮▮

Witness: ▮▮▮▮▮▮

Print Name: ▮▮▮▮▮▮

Storyboarding

You've sat up at night imagining all the visuals in your head. You know exactly how it's going to look: the camera angles, the fast cuts to the rhythmic beat of an upbeat music track, the long tracking shot as the convertible meanders up the coastline on a bright, sunny day, the moody lighting at a warehouse late at night as a door opens to let in a beam of light as the main character's shadowy silhouette enters. Yes, these are all very descriptive. I can see them in my head. But how can you tell this story to the people working with you? How can you convince a prospective client that your vision is a good one—and in keeping with theirs?

If you're sent to do a story by a trusting client, sometimes the storyline is just in your head, and you're working with an assistant who knows exactly what you're thinking. You know you need cutaway shots and transition shots, and you find a storyline within that effort. However, even in those fluid situations, it helps to have a plan sketched out for the shots you need, so that when you're back in the editing room you don't have a huge hole in your project.

Storyboarding often looks just like a comic strip, but much more advanced. There are many more panels in a storyboard. Whenever a camera angle changes, you have a new panel in the storyboard. In some instances, the storyboard is presented as an animation. These cost more but can really help sell a production. If a visual representation isn't necessary, a spreadsheet is a great alternative. In one column, put the layers (or chapters) of your story. The second column can have the narrative or what you expect the subjects to say in the A-roll. The third column can include your planned visual assets, B-roll, or commentary on a unique way you want to shoot the A-roll.

If you don't feel like you can handle the storyboarding, a number of businesses do just that very well. There are also a number of iPad apps that allow you to build rough storyboards. Don't sell your storyboard short; it's often what can help your client see what you visualize in your head and ensure that you and the client are on the same page for the final visuals.

Rights and Clearances

Everything from logos to trademarked products that appear in the background of what you're shooting has to be cleared. Any of the various elements that appear in your production were created (and in some cases copyrighted or trademarked) by their respective owners. Any music you use has to be cleared. A TV show running in the background or even in a shot itself has to be cleared.

A rights and clearances coordinator in New York City earns an average salary of $77,000.[3] However, this is often done by a law firm. Why? Well, here are a few examples:

- In your production, a husband and wife are watching a PBS television show about the Cold War. The fact that they're watching this show makes your viewer feel like these people are well-educated and deep thinkers. Conversely, if the wife is watching, say, a Jerry Springer episode that shows guests getting into a brawl onstage, viewers' opinions will be significantly different. These are two examples of exactly how a TV show running in the background of your scene can alter people's opinions about the people in the scene and can set a mood or feeling. As such, you can see why there is intrinsic value in that content. In the former example, rights and clearances would have to be obtained by

[3]Source: http://www.indeed.com/salary/q-Rights-and-Clearance-Coordinator-l-New-York,-NY.html

both PBS and/or the production company that produced the piece for PBS; in the latter case, rights and clearances would have to be obtained from Jerry Springer's production company.

- In your production, a young child is listening to a performance of Beethoven by the National Symphony Orchestra, doing so with his eyes closed and moving a hand as if he were conducting. The suggestion? That the child is an academic who is studying the classics. Instead, imagine the child listening to the latest Miley Cyrus or Katy Perry track at full volume while he bangs on the walls of the bedroom that he feels constricts him. This, too, would create a different reaction in your viewer about just who is in the frame of your production. You'd need rights and clearances from the artist's record label in the latter, but only from the National Symphony Orchestra in the former, because Beethoven's music has entered the public domain. The NSO still owns copyright to their performance of that music, but the music itself is in the public domain.

Licensing Music

One of my biggest pet peeves is watching what is probably a really great video piece and having it ruined by a soundtrack that includes a popular song that, in almost all circumstances, was used without a license and thus is infringing on that artist's copyright. There are *performance* rights—the right to perform the music live or play a CD in a restaurant—mechanical rights—the right to reproduce the music onto a CD or DVD—and *synchronization* or *sync* rights—the right to use a piece of music in a TV show or other motion picture production.

In the Beethoven example, his mechanical and sync rights have lapsed, as have the live performance rights requirements. However, if you use a recording that the NSO did, that recorded performance has performance rights over the music if it is played in a restaurant or used in a film at a later date.

There are certain royalty-free performances of music for which copyright has lapsed. Often performances by a military band or orchestra can be free of copyright restrictions, because they are government employees. However, you'd have to be the one to capture the audio of their live performance in order to own copyright to that performance.

- In your production, you are capturing environmental audio of a crowd of sports fans getting pumped up before a game. In the audio, clearly audible, is Queen's "We Will Rock You," followed by the baritone voice of Michael Buffer saying, "Let's get ready to rumble!" If your production is for editorial purposes—say, the sports front of the website of the local newspaper or a sports magazine—you likely wouldn't need rights and clearances. However, if the production was for commercial use, then you'd need clearance from Queen's record label, the sports league that owns the trademarks depicted on the clothing worn, and even Michael Buffer, who owns the rights to his well-known phrase.

- In your documentary production, subjects are dancing to a particular song. Perhaps it's a documentary on fans of roller rinks or on the struggles of a group of aging World War II veterans. In both cases, the background music would require rights and clearances if you're doing much beyond watching the documentary yourself. If it's destined for the Discovery Channel or Oprah's OWN Network, you'll need rights and clearances, and you'll be certifying and indemnifying to those networks that you have all the clearances you need and that if they get sued, you'll cover the costs of that lawsuit.

If you're using music you didn't compose in your production, you don't have the right to do that, and you likely will get sued. At the least, whatever online presentations of your work are out there will get hit with a DMCA (*Digital Millennium Copyright Act*) takedown notice for a copyright violation. Every music publisher and every television production house uses services that scour the Internet looking for the audio and video patterns of their productions. Automated search robots do this 24/7/365. It's not worth the risk.

It's important to understand that the person or company you hire to do rights and clearances (R&C) is charging you a fee to do the R&C—the fees for elements within the production that require clearances will be separate. So using 30 seconds of a Top 40 song may be $4,500; however, the R&C team will charge you $500 to do the work necessary to obtain those rights.

Of critical importance: Wherever possible, do *not* shoot everything and then look to get rights and clearances after the fact. You can see this happen in many reality TV shows, where, say, someone in the show is wearing a baseball cap that's blurred out. In those cases, the R&C people couldn't get permission to use the logos, or the company that owns those trademarks wanted too much money, and it was easier to just blur them out. This might work in a reality series, but in a documentary, film, or other commercial/corporate production, this would stick out like a sore thumb.

Many companies will give you a free assessment of whether R&C is recommended for what you're looking to do. They will also give you an estimate of the costs to do the work, and they may even be able to offer you recommendations that are less costly than those you initially proposed for your production. Do an Internet search for "rights and clearances services" and then give several a call. If a decent lawyer charges you $250 an hour and wants a $5,000 retainer to take on a project, those figures are likely not far off for an R&C service provider.

Lastly, there's a little thing called *footage assurance*, which is a form of indemnification insurance that protects you if you're unable to clear or obtain permissions from people you either can't locate or can't identify. It's not always available; however, it is typically an option from the company you're paying for R&C services.

Talking Rights with Your Motion Client

Rights, including copyright, in the video world are in many cases different from those in still photography. There is a much greater expectation that the client owns all rights to the video. However, there are many questions that you need to ask—or specify yourself as terms in the contract.

Here are a few of the questions you can ask (or specify in your paperwork) on this subject:

- *Can I use the video in my portfolio/reel?*

 Some clients have proprietary information or products in videos you would be producing, or they don't want a video destined for internal use shown externally. If the rights granted to the client are not exclusive (that is, you grant them nonexclusive rights), then this answers that question. However, you should include a clause in your contract that specifies that regardless of the rights you grant the client, you retain the right or the client grants you the right to use the finished production in portfolio/reel examples of work capabilities. This could be on your website or your Vimeo/YouTube channel, too. Again, you'll want to ensure that the language in your contract gives you a clear answer to this question.

- *What about a second cut of the video that's different but uses the same assets?*

 Often you'll like a specific cut of the production and deliver it as the rough cut, only to be told by the client that things need to change. You know that from a creative/visual perspective it's the best cut, but for political or client messaging needs, they want it changed. Saving your rough cut for yourself and then delivering the new cut with the client's edits may produce a result you're not as happy with, but the client is. The question of using the first cut comes into play because the client may not want a different version out in the public domain. There may be proprietary information in your cut that can't be released. Specifying to a client that the rights they have are to the specific finished final cut is key, because then a second version that you produce from the same assets is not encumbered by those restrictions. Don't use this right to thwart the spirit of the agreement, however, as that's not good or right, even though it may be legal.

- *Who owns the rights to the B-roll, outtakes, or unrelated footage?*

 Suppose you're on location at a venue and you shoot some B-roll that ends up not being used. Do you own it? Can you use it in other projects? What if you're on location documenting activities at a news event, and some other unrelated news event takes place? If you shoot footage of that, who owns it? Can you use it for something else? Specifying to the client that their rights are to the final finished project helps to answer this question. Generally speaking, you should begin at the starting point that you retain all rights to all scenic stock B-roll and time-lapse footage, but that you'll include in any delivery of raw files that footage for the client's use as well. If a client asks for all rights to the finished product and all outtakes and any other footage shot while on their property or while on assignment for them, then that's different. You could grant them exclusivity to the finished product and nonexclusive rights to the outtakes and B-roll as a compromise during negotiations. But presenting your contract that outlines these nuanced points is critical, because it's highly likely that whatever the client presents to you is going to say "transfers all rights, including copyright, to everything."

- *What if the client wants to let someone else use the video?*

 Suppose you're working for an NGO to document how their workers are giving vaccines in a third-world country, and you deliver a finished product to the client. Can that NGO, because you've granted them all rights exclusively, turn around and allow the pharmaceutical companies that make the vaccines to use the footage in commercials, marketing materials, and so on? Specifying in your contract that the rights are granted to the client only and are not sub-licensable or transferrable to a third party would help eliminate that possibility.

- *What if the client wants me to use their existing footage and/or assets (graphics, animations, and so on), but I believe that doing so will degrade the finished product?*

 Ultimately, this comes down to who has final-cut authority. Typically, the person paying the bills has the authority, unless you've specified otherwise. As such, sub-par content can be dealt with that way. However, specifying this in the contract is important. Of equal importance is ensuring that the client has the right to convey to you that material. It's crucial to have a clause in the contract where the client assumes liability and affirms that they have secured any rights to any material they provided, and that will "save and hold harmless" you and your company should there be an issue, including covering any legal fees, judgments, or settlement figures. Further, you should ensure that you can use the final product with this third-party content on your website/portfolio/reel.

Rights to Stills from Your Motion Project

Most still photographers are told that you can't handhold anything below 1/60 of a second, and generally that's true. However, truly seasoned professionals can get much closer to a second-long exposure, and pretty much everyone needs a tripod. Further, even with a tripod, motion becomes apparent in a still image below about 1/60 of a second for most things, and once there is fast action in front of your lens, the shutter speed needs go higher and higher.

Setting aside specialized cameras that shoot thousands of frames a second for what will ultimately be slow-motion or stop-action motion results, most motion cameras capture somewhere less than 30 frames a second, so in many instances an individual "frame" of motion footage will have something that's blurred. However, when you see it as part of a moving image, it's not noticeable.

Because cameras are now much more capable, 60 frames a second is becoming normal. And, as you will recall, that begins to return to the realm of stop-action for a still image. The resolution of HD and especially 4K video means you've got a decent-resolution file to do many things with. As such, addressing whether the client has the rights to the motion picture is one thing; however, you'll also want to specify whether a client has rights to the individual frames and can thus pull still images from the finished piece.

Don't underestimate the importance of allowing (or precluding) this and specifically addressing it in your contracts. By default, you should preclude it.

Following is a clause that would clarify this:

> Client has all of the rights as enumerated above to the finished motion project in the manner intended. A physical element, standalone image, standalone file, still image, frame grab, or frame enlargement may not be extracted or accessed from the motion project for use outside of the motion project without a separate licensing agreement.

Note that the phrase "extracted…for use outside of the motion project" is intended to allow, say, YouTube or Vimeo to extract a thumbnail to display in search results or on a client's webpage, because that extracted image is still being used within the motion project.

The Society for Cinema and Media Studies took the position that "frame grabs" from a motion project are likely considered fair use. A 2013 article by Ken Wissoker, entitled "The Future of the Book as a Media Project," notes:

> There is a good fair-use argument for the short clip that is included in an e-publication for the purpose of critical discussion—in the same way that most publishers in the field consider frame enlargements to be fair use.

When it's for critical discussion, yes, but used as a separate and distinct licensable still image? No, that's not the same. Much of the Society's efforts were geared toward film studies and academic purposes, but it illustrates that many people are considering this matter, and while their uses would largely be related to critical discussion of motion picture projects, once a still image is extracted from a motion picture, it could gain a life of its own unless your contract specifically precludes uses beyond the motion project you're producing.

Producing Stills and Motion at the Same Time

Don't. Just don't. Don't try. Practically anyone who has ever tried has said that one or the other suffers. If you are primarily shooting the project for stills purposes, but they need a minute or two of motion that is effectively B-roll that can be shot at any time, then maybe, but it's almost never that easy. Even if your job is to roll on the speaker at the podium with a locked-down camera on a tripod at the back of the room while you shoot stills around the room, inevitably one of the speakers will decide he wants to speak with a lavalier and walk around onstage.

Scouting and Tech Scouting

If you've never been to a proposed location before, hiring someone to scout the location and send back shots showing the venue is *critical*. You can use something like Google Earth to scout a venue from an aerial perspective to locate nearby parking lots, resources such as a shopping mall, a nearby airport, and so on. However, there are few things more useful than having an actual person at the location show you what you'll be seeing. You don't want to find out in person on the day of the shoot that the location is inaccessible or no longer there.

Whenever possible, work to make sure the budget allows for a tech scout. This allows the department heads of your crew to actually visit the location and scout the technical aspects of the shoot. It's invaluable to be able to visualize backgrounds, where a generator truck or grip truck can park, aerial obstructions such as power lines that would affect a camera crane or aerial lighting truck, and so on, provided it's in the budget.

Keep in mind, you're paying the day rate for each of the crew going on the tech scout, so be sure to include that in your budget. It's worth every penny.

Paying for On-Location Sets

You can't just roll onto someone's private property and start filming. Even if you're using a handheld camera, if you're on private property you're almost certainly trespassing, unless you have permission to be there. It's critical to have something in writing proving that you're allowed to be there. The National Park Service and local and state governments also have film commissions that coordinate film productions—and charge a fee.

It's common sense that when you're coming onto someone's private property, you'll likely interrupt the natural flow of business given the large size of your crew. So not only do you need to compensate the business owner for lost revenues from that interruption, but you should also compensate him for the fact that you are using his property as a backdrop for your production. There's value in that—if the business owner didn't allow you to use his location, you'd have to pay to create something equally appealing on a sound stage or in a studio somewhere.

Suppose, for example, that you're filming in someone's office for a production for him. In that instance, there's no need to compensate the person. However, if you're taking over parking in the loading dock or in front of the building, or you're using other vacant floors or offices, then you'd pay a location fee to the building owner.

In one instance, we were working on a production that was for a story on grocery items. The production wasn't for the grocery store itself, so they were paid a location fee to allow us in to work. We worked while the store was open, so there were times when the aisles had to be kept clear, and thus inconvenienced shoppers could not get the items they wanted. This is a very reasonable reason why you'd pay a location fee.

Location fees can vary. It can be as little as $1 to establish a legal contract between the production company and the property owner or as much as tens of thousands of dollars—it really just depends. I point out the $1 fee because you'll want to ensure that before you roll into a location and the store manager is sick or says he changed his mind, you have a contract specifying that you can be there; otherwise, you'll be paying the crew for their day and you'll be a day delayed in production. Or maybe there was a misunderstanding about to what extent you would be there, so spelling it all out in writing is critical. Doing so for a $1 fee sets forth a legal contract.

However, $500 to $5,000 are not unreasonable location fees. Be sure to include a location fee line item on any contract where you think you might be in a location other than on the property of those who hired you to do the filming. Once the client sees this, they may offer solutions for a venue that is free to them instead.

Figure 24.4 *Here is an example of how much a production can take over a location. The produce section of the grocery store has been completely taken over by the production. Everyone in this photograph is either crew or an actor. This would significantly impact the store's ability to generate revenue during the duration of our shoot and would inconvenience customers who might then shop elsewhere and not return.*

John Harrington - Property Release Page 1 of 1

Property Release

For good and valuable consideration herein acknowledge as received, the undersigned, being the legal owner of, or having the right to permit the taking and use of photographs of, certain property designated as *1967 Pontiac Le Mans*, does grant to **John Harrington** ("Photographer"), his heirs, legal representatives, agents, and assigns the full rights to sue such photographs and copyright same, in advertising, trade, or for any purpose.

The undersigned also consents to the use of any printed matter in conjunction therewith.

The undersigned hereby waives any right that he/she/it may have to inspect or approve the finished product or products, or the advertising copy or printed matter that may be used in connection therewith, or the use to which it may be applied.

The undersigned hereby releases, discharges, and agrees to save harmless Photographer, his/her heirs, legal representatives, and assigns, and all persons acting under his permission or authority, or those for whom he/she is acting, from any liability by virtue of any blurring, distortion, alteration, optical illusion, or use in composite form, whether intentional or otherwise, that may occur or be produced in the taking of said picture or in any subsequent processing thereof, as well as any publication thereof, even though it may subject me to ridicule, scandal, reproach, scorn, and indignity.

The undersigned hereby warrants that he/she is of full age and has every right to contract in his/her own name in the above regard. The undersigned states further that he has read the above authorization, release, and agreement, prior to its execution, and that he/she is fully familiar with the contents thereof. If the undersigned is signing as an agent or employee of a firm or corporation, the undersigned warrants that he is fully authorized to do so. This release shall be binding upon the undersigned and his/her/its heirs, legal representatives, successors, and assigns.

Dated: 3 | 3 | ▮▮

Signature

Print Name

Address

Bel Air Md 21015

City State Zip

Phone #: *410* ▮▮▮▮

Witness: ~~▮▮▮▮~~

Print Name: ~~▮▮▮▮~~

http://www.johnharrington.com/forms/proprel.htm 3/3/▮▮

Figure 24.5 *A property release grants the rights to use the property for the purpose and fees outlined, whether it's someone's house, car, or other property.*

Production RVs and Star Trailers

Regardless of where you're shooting—and especially if you're on location and subject to the elements—getting a production trailer is important to consider. In fact, they're also an important consideration for on-location still photo shoots.

Figure 24.6 *For this shoot we had two production trailers—the one in the fore-ground left for the talent, and the one in the distance for the production staff.*

Figure 24.7 *Inside the talent production trailer is workspace for a laptop, while makeup does touchups and paperwork can be reviewed. The wardrobe stylist is set up in the rear of this particular production trailer.*

RVs can serve a very valuable purpose. Typically, when you have wardrobe changes during the shoot, you'll need a place for the clothing racks and for the wardrobe stylist to work in, and you'll need somewhere for the talent to change. In addition, when you're on a remote location shoot, the trailer solves the problem of where to go to the bathroom. You can truck in portable restrooms, but at that point you're better off just getting a trailer.

The seating areas in the front of the RV serve as a place for hair/makeup to do their job and as a waiting area for talent not yet needed on set. Also, the booth-style seating can be a workspace for the client to share. Alternatively, you can get a separate trailer for the client and one for your team.

A separate trailer can serve your production team well. There are RVs set up specifically for production, where the comfortable booth-seating-around-a-table is replaced with desks and other workspaces, just like a mobile office.

A client production trailer can allow the client to work separately from your team and the talent preparations. They also get their own Internet connection, and you can provide a higher caliber of accommodations for them if the need calls for it.

Lastly, there's the "star trailer," appropriately named because it accommodates the stars. I won't even begin to go through all of the examples, but nowadays there are top-of-the-line custom-made RVs that expand left/right and even some that become two-story trailers. Comparing trailers has become a parlor game for the top celebrities. There are trailers that rent for tens of thousands a day and one-off custom million-dollar trailers. Typically, the level of star trailer you need will be dictated by the star's contract.

Otherwise, your budget will determine what and how many you can afford. At the very least, including one is a good idea; otherwise, try starting with one for the client, one for you, and one for the talent. You can always scale back from there.

A production RV typically starts at $500 a day and can go to $1,000 a day, plus mileage (usually somewhere around the standard IRS rate), gas (usually not marked up, but these things get about five miles to the gallon), plus about $5 or $10 an hour to run the generator, and there's always a cleanup charge of $50 to $100. Lastly, for $60 to $75 a day, you'll get wireless Internet. Some RVs come equipped with copiers, too, at a rate of $35 or so per day. Oh, and you have to pay to have the driver on hand, which, if it's a union job, is union scale; otherwise, you're looking at about $300 a day for the driver.

All in, you're looking at a base charge of about $1,000 per day. If you're keeping your driver overnight, you can expect to cover his meals and lodging plus a per diem. Of course, you can get a weekly rate, too—so instead of, say, $1,000 a day, it could be $2,200 for a week, plus gas/driver/etc.

Myriad companies offer these services all over the country. Try an online search using "production trailer" and then the city or state you're going to be working in. Almost all of these companies will travel to a destination for you if there's no one nearby.

Generators

When you're working on a small production in an office building or a fast-moving on-location shoot, plugging into a few wall outlets or using portable batteries is your best solution. However, when you're rolling in many lights and other power-hungry devices, bringing in a generator can solve many problems. The last

thing you want is to be on a location with a number of people and have a circuit blow and not be able to find the circuit panel—or the building engineer to get your power back on. Sometimes the generator is just a small one; other times it's mounted on a truck.

The category of "portable generators" are essentially the same as you could buy at a hardware store like Home Depot or Lowe's for around $800. To give you an idea of rental charges, here are a few examples:

Portable Generators

45 amps	$80 daily	$240 weekly
80 amps	$125 daily	$375 weekly

Towable Generator on a Trailer

165 amps[4]	$200 daily	$600 weekly
1,800 amps	$500 daily	1,500 weekly

Generator Mounted on a Truck

165 amps	$300 daily	$900 weekly
1,800 amps	$575 daily	$1750 weekly

Figure 24.8 *Here a generator is brought in to provide power beyond what the wall outlets can handle, which helps avoid tripping circuit breakers and later getting a bill from the location owner for all the power that was used.*

[4]A common household has a 100-amp panel serving the entire house. 165 amps is essentially eight 20-amp outlets available.

Catering

If you're doing a small production where you're interviewing three to five people in a hotel room, catering is simple. At the beginning of the day, either a producer (if it's a really small three- to four-person production) or a production assistant (if you've got five to ten people) will ask everyone what they'd like from a nearby carry-out restaurant. They call/email/fax the order in and go pick it up at the appointed time. Also, be sure to start the day with a case of water bottles and some snacks. They're the best insurance that everyone will stay happy throughout the day.

If you add clients into the mix, you'll want to step up your catering game. More than once a client has been heard to say, "Oh, book so-and-so! I love who they have catering—the food is amazing!"

Practically every restaurant will cater. Heck, even Costco and Sam's Club offer catering platters. Consider that a sandwich, chips, and a soda from Subway is about $10. So, for a five-person crew, be sure to add in $50 to $75 for meals/catering.

You shouldn't expect the crew to pay for their own lunch or bring in a box lunch. From that point, price points of $35 to $100 per person are not unusual to pay a catering company, which will give you a higher level of service and food. It all depends, and the easiest thing to do is call two or three restaurants or catering companies and ask them for a quote. Doing this will give you a good idea of minimums and per-person costs, and you can ballpark the figure.

On a day-long production, having a catering person on set to prepare food throughout the day means that everyone gets fed and stays happy. On larger productions (and certainly union ones), meals are scheduled every so many hours. Many productions actually use an optional breakfast to encourage (bribe?) crews to get to the set early, so everything starts on time.

Figure 24.9 *On this set, we were working in a suburban community throughout the day and over several mealtimes, so having onsite catering (at right) adjacent to the set (at left) ensured that production could continue through the day.*

Grip Trucks

Yes, you likely own a few cameras capable of shooting video, and maybe some sound equipment, too. You may even own a few softboxes that work with continuous light sources; but in the end, if you need light stands, scrims, big softboxes, HMI lights, flags, ladders, apple boxes, and so on, getting a grip truck is your best bet. Where else can you get more than a hundred pieces of equipment for about $500 a day?

Rates range from $350 to $650 a day for a basic grip truck. The $350 grip truck is like a midsized U-Haul truck, and the $650 grip truck is a tractor-trailer type. The rates can (and do) go up, but this is about what you can expect to spend.

Figure 24.10 *Here is a typical grip truck on set with a wide variety of tools for lighting. Every truck is packed differently, but you'll always get a list of what comes with the truck (and what they expect will be in it when you return it).*

Travel Expenses

You'll want to specifically address travel expenses in your budget conversations. Unless the project is in your same locale, there will be travel expenses associated with your project. Most clients just assume they will cover them; however, will they cover the expenses by having you include them in the budget you propose, or will they book your travel for you? I've had many clients want to book the travel separately on my behalf because it makes it easier to get the project budget approved.

If everyone bidding on the project is including travel, that's one thing, but if you're the only one, it will make your estimate look much higher. We often specify: "The estimate provided does not include travel for air, hotel, car rental, or meals. We will coordinate with client travel agency for services and client will be billed separately, and we will include on our final bill any incidental travel expenses or expenses that were not covered by client travel agency." Often there are excess baggage charges, carnet charges, crew parking, transportation to or from the location, and so on, and these can add up quickly.

Need Money? Finance It!

Many emerging motion producers are looking to produce well-meaning projects, but the projects also have to at least have the potential to break even or net a profit. How can you accomplish this?

For any specific movie, a limited liability corporation (LLC) can be set up. Once it is determined that, say, the production needs $100,000 to be completed, shares of that production are sold. In this instance, perhaps the minimum share value is $1,000. Some financiers might want to buy more than a single share, and sometimes the production company that is making the movie will take a few shares themselves, so they can show they have "skin in the game." Once the shares are sold, production can begin.

While there are myriad ways to calculate shares and repayment schedules, one typical way is that, in the case of the $100,000 production, the first $120,000 goes back to the shareholders of the LLC, and then for every dollar after that, the production company takes half and the LLC takes half, dividing up their half proportionally among the shareholders relative to their percentage investment. So, a $1,000 shareholder on a $100,000 production stands to gross $1,600 if a movie in which he invested $1,000 earns $200,000—a 60 percent profit. Here's how that would break down:

Original share value + 20% profit + 1/100 of the 50% of $80,000 = total recoupment

$1,000 + $200 + $400 = $1,600

In this scenario, the LLC is owned by the shareholders, but it is controlled and managed by the production company. Some production companies will turn over a "producer credit share" to key employees in a production. So, say the cinematographer gets a portion of the producer's credit. For the production company's 50 percent of the $80,000 in profit, they might give the cinematographer 10 "producer credits," so he'd get $4,000 when that film hits $200,000. This is one of many ways that profits can be divided as a movie earns money.

Another option—and one that is gaining popularity—is crowd-funding. For example, many rising musical acts—especially indie bands not tied to a label—are using crowd-funding, paid for by their loyal fans, to cover the costs of their music videos.

A few full-length motion picture projects have also been successfully crowd-funded—*Veronica Mars* is one. So this is an option as well.

If you're thinking about financing a movie or another for-profit production, make sure all the paperwork is done by a lawyer, and be sure that everything is up front.

The Power of Saying No

When a client comes to you, they've decided you're capable of what they're calling you for. Likely they've seen your work elsewhere. If the productions on your website are all projects that had as a minimum a $2,500 budget, with several being the $10,000 kind, when the question of what budget the client is trying to work in gets as a response "We have $750, maybe $1,000," you need to outline for them that the projects they reviewed on your website all had budgets higher than that, and that you can't possibly deliver that level of production at those rates.

Over time, you will find yourself getting more selective about the clients you want to work with. This comes from the experiences you have where the client just doesn't understand why it should be more than $1,000 for the project, then as a result expects endless rounds of edits, and then when all is said and done seeks final approval from a Board of Directors who don't understand the value of the visual storyteller and how to move along a narrative to get the messages of the organization in. The old adage that "too many cooks spoil the broth" is very applicable here. It may be that you need to say no to the client, or at least say no at the outset. It can often be the case that the more you say no, the more the client wants you.

Getting Paid

When the contract is signed, don't start spending money until you get a deposit. A 50 percent deposit is fair, reasonable, and normal before you begin outlaying production expenses such as booking travel, signing subcontractor contracts for other services, and so on. Deliver the rough cut, and it is fair and reasonable to expect final payment prior to delivering the final cut.

The notion of the final payment being made prior to the delivery of the final cut is reasonable because the client has seen the rough cut and knows that there are going to be a few more changes prior to final cut, but that the majority of the work has been done. You can deliver and then invoice and wait 30, 60, or 90 days if you are so inclined. It is all in your comfort level with the client. If they are a recurring still-photography client that now wants you to produce motion, then extending to them 30-day payment terms may be workable for you. However, many photographers will expect the wire transfer to clear or the check to have arrived (and clear) before releasing the file. Remember, this isn't the $500 client that is delaying paying you for 60 days; this could be the $3,000 or $10,000 job, and you can't afford to be waiting months for those types of checks to come in.

Recommended Reading

Donaldson, Michael. *Clearance & Copyright: Everything You Need to Know for Film and Television.* Los Angeles: Silman-James Press, 2008.

Donaldson, Michael and Lisa Callif. *The American Bar Association's Legal Guide to Independent Filmmaking.* American Bar Association, 2011.

Honthaner, Eve Light. *The Complete Film Production Handbook.* Waltham, MA: Focal Press, 2010.

Litwak, Mark. *Contracts for the Film & Television Industry*, 3rd Edition. Los Angeles: Silman-James Press, 2012.

Chapter 25

Step-by-Step: QuickBooks and Downloading Bank Statements

Until recently, we were manually inputting our banking transactions into our QuickBooks software, and it was tedious, to say the least. Being off by even a penny or transposing a number wreaks havoc on balancing your books. We were doing this manually because we built our system to do it that way when the ability to download banking transactions wasn't robust and didn't include our financial institutions. But times have changed.

In this chapter, I'll walk you through how to set up QuickBooks to download bank statements and categorize expenses. If you're using other software, the process is relatively similar.

Setting Up Online Banking

From the Banking drop-down menu, select Online Banking Setup, as shown in Figure 25.1.

Figure 25.1 *Select Online Banking Setup from the Banking drop-down menu in QuickBooks.*

The dialog box gives you two options: Direct Connect and Web Connect, as shown in Figure 25.2. The Web Connect choice is where you download your bank statement in a QuickBooks-compatible format and then import it into QuickBooks. Once your banking transactions are imported, the end result is the same as if you downloaded them directly; it's just that doing it via Direct Connect is easier, because all of the downloading happens within QuickBooks. Your banking institution may charge a fee for this level of access. If your bank has designated your checking account as a business account, they often will allow you to download your information into a QuickBooks format. However, if your account is designated as a personal

account, they may only allow you to download the information in the personal software solution format, Quicken. The banks do this (in large part) to prevent businesses from using personal (that is, cheaper) bank accounts for business purposes. Wherever possible, Direct Connect is best; however, if that's not available, then Web Connect is your alternative.

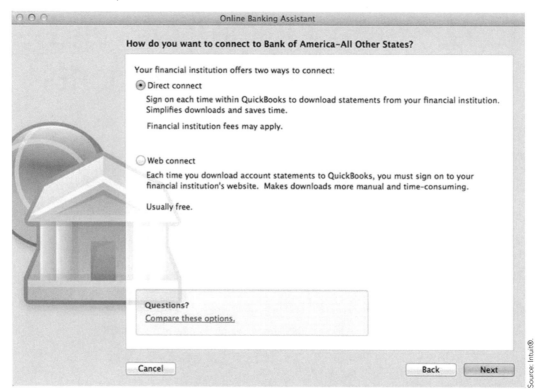

Figure 25.2 *Here you are presented with two options: Direct Connect and Web Connect. As the dialog box notes, Direct Connect is faster, whereas the Web Connect option requires more work.*

In Figure 25.3, you can see that I searched for Citibank and found that Citibank offers access to your financial information only via Web Connect.

The dialog box in Figure 25.4 informs you that you have to download the statement(s) and then import the information. Doing so is fairly simple and straightforward.

We happen to use Bank of America, which offers both Web Connect and Direct Connect options. Figure 25.5 shows their web page explaining exactly how to do it.

Go back to the Banking drop-down menu and choose Online Banking Setup. Then choose Direct Connect and click Next. In the dialog box that appears, type Bank of America. This returns three choices, as shown in Figure 25.6. Sometimes you have to guess at the appropriate one. In this case, it's obviously not Bank of America Fork, but it could be either the generic Bank of America or Bank of America – CashPro. We'll go with the generic one and then click Next.

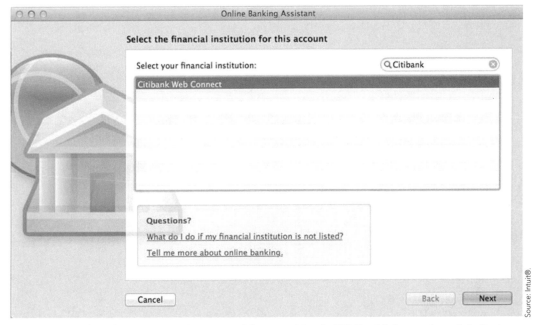

Figure 25.3 *When choosing Direct Connect and then searching for "Citibank," the search result indicates that Citibank is available only as Web Connect.*

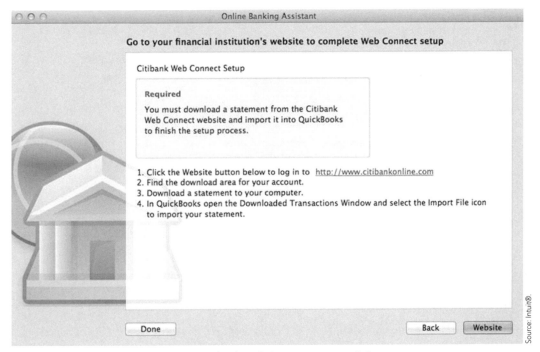

Figure 25.4 *Instructions for accessing Citibank Web Connect are provided.*

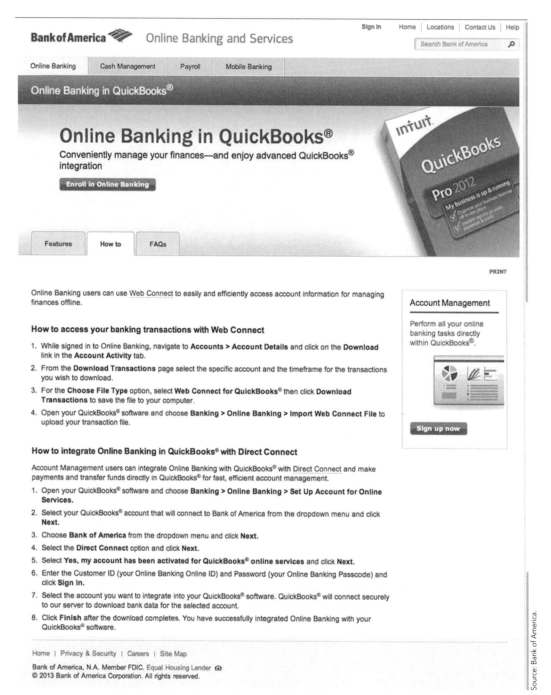

Figure 25.5 *The Bank of America website showing that Bank of America allows for both Direct Connect and Web Connect.*

Here is that dialog box:

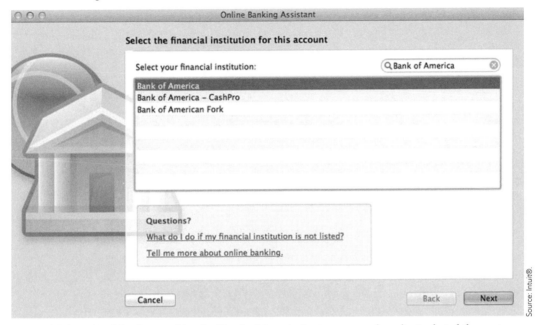

Figure 25.6 *In QuickBooks, searching for "Bank of America" returns several results. I selected the most applicable one.*

By default, most banks have online access to your account disabled for security reasons. For Bank of America, we had to make a phone call to have them activate our online service access. The next dialog box, shown in Figure 25.7, asks you to confirm that you've activated your online access. After doing so, select Yes and then click Next.

Enter your Customer ID and password in the resulting dialog box, shown in Figure 25.8, the same way you would do it in a webpage. QuickBooks has simply made its own dialog box to interface with the bank's webpage. I encourage you to check the box allowing your password to be added to your keychain (on a Mac) so you don't always have to enter it.

In the dialog box shown in Figure 25.9, you'll see a message that the software is updating your account list. During that time QuickBooks will be connecting and identifying your account(s) that can be accessed.

After QuickBooks has identified your account(s), you'll get a list similar to the one shown in Figure 25.10. QuickBooks has identified an account, the account number, and the type of account (usually a checking account) that it can connect to.

However, you haven't yet told QuickBooks where you want to store the information you download, so you'll need to click Select an Account and then choose New to set up that account. If you already have your account in the system, it will be listed here, and you can download into an existing account. In Figure 25.11, we're downloading into a new account we'll set up.

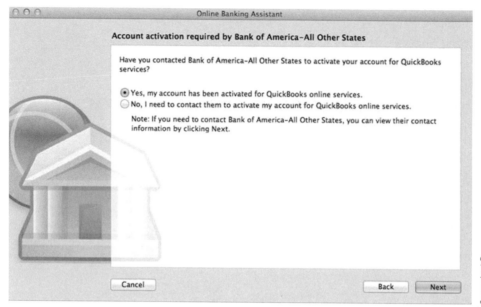

Figure 25.7 *For security reasons, your bank may want to authenticate that you want to allow QuickBooks to access your financial records. This screen ensures that you've activated the online access features for your bank account.*

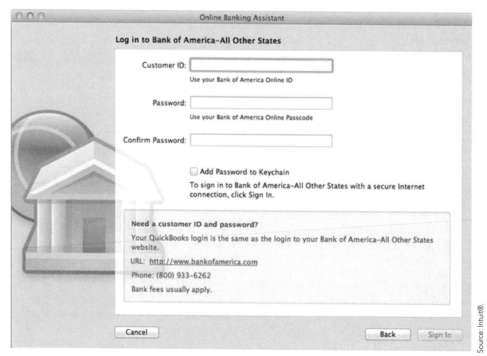

Figure 25.8 *Once you've activated your online banking features by contacting your bank, this screen is where you'll enter the information received from the bank.*

Figure 25.9 *After you enter your user ID and password, QuickBooks begins the process of connecting to the bank. Note the Updating Account List indicator at the bottom of the box.*

Figure 25.10 *Once the account(s) have been identified, they will appear in the box.*

Figure 25.11 *Select New from the Store in the QuickBooks Account drop-down menu to create a new account to download into.*

The dialog box shown in Figure 25.12 allows you to set up the banking information in QuickBooks, including the opening balance. I've included the QuickBooks Guide information on the right for additional insight.

Now that the account is set up, you'll see that you can select the account you just set up as the destination for your downloaded transactions, as shown in Figure 25.13.

Once you click Next, the software affirms you've set everything up and then directs you to click Done to proceed to the Downloaded Transactions window (see Figure 25.14).

Before we proceed to that window, Figure 25.15 shows what that account looks like in your QuickBooks ledger with a $1,000 opening balance.

As you can see in Figure 25.16, the Downloaded Transactions dialog box now shows a series of checks, bank deposits, an ATM withdrawal (and the associated $2.00 fee for using a non–Bank of America ATM), and a wire transfer.

Figure 25.12 *In the New Account dialog box, enter the relevant and applicable information and click OK.*

Figure 25.13 *Once you've created the new account that is enabled for online banking, you will see it listed as an option in the Store in the QuickBooks Account drop-down menu. Select that, as shown here.*

Figure 25.14 *As shown here, you will get a confirmation that your account has now been successfully set up for online banking.*

Date	Number	Payee		Payment	✔	Deposit	Balance
	Type	Account	Memo				
12/04/13					✔	1,000.00	1,000.00
	DEP	Opening Balance Equity	Account Opening Balance				
12/04/13	Number	Payee		Payment		Deposit	
		Account	Memo				

Ending balance 1,000.00

Record Restore Splits ☐ 1-Line

Sort by Date, Type, Nu...

Figure 25.15 *Your banking ledger will show an opening balance equity as you had entered it in the New Account dialog box in Figure 25.12.*

Figure 25.16 *The Downloaded Transactions dialog box.*

In this dialog box, the bank only sees, for example, that check #1087 was written for $367.50. It does not match that with anything that is currently in the system, so either I hand-wrote the check and have yet to enter it into my banking ledger, or it was a cashier's check that I had the bank issue.

Check #1096 was written from QuickBooks, so the software knows who the payee was. (I have blurred it here.) If I had written a check to this vendor before, it would have identified it as a Matched transaction and the circle between the Payment and Deposit columns would be a solid circle instead of an outline of a circle. It also would've assigned the proper expense account to it.

The last transaction, to a credit union for $642.87, was not a check, it was an automated monthly payment, so Bank of America knows who the payee is. And, because this same payee and amount are in my Quick-Books from the past, the software also has automatically assigned the associated expense account to it. You'll see more of this in Chapter 26, "Step-by-Step: QuickBooks and Downloading Credit Card Statements and Charges."

The more you use QuickBooks to download, the faster it gets, and thus you can spend less time on the ac-counting side of the business and more time on everything else that demands your attention.

Chapter 26

Step-by-Step: QuickBooks and Downloading Credit Card Statements and Charges

As with our banking information, until recently we manually input our credit card transactions into our QuickBooks software, and it was tedious, to say the least. In fact, it was more tedious than dealing with the banking statements! We're talking hundreds of transactions a month, from the $1.25 parking-garage charge to the $3,000 charge from a camera store and everything in between. Being off by even a penny or transposing one number wrought havoc on balancing our books; more transactions meant more risk of an error.

The reason we input our transactions manually is because we built our system to do so when the ability to download the transactions wasn't robust and didn't include our credit cards. Banking institutions came on board with the ability to download first, but it took longer to be able to download credit card transaction information.

In this chapter, I'll walk you through how to set up QuickBooks to download credit card transactions and categorize expenses. If you're using other software, the process is likely similar. Let's get started.

Just as you would to set up a bank account, from the Banking drop-down menu, select Online Banking Setup, as shown in Figure 26.1.

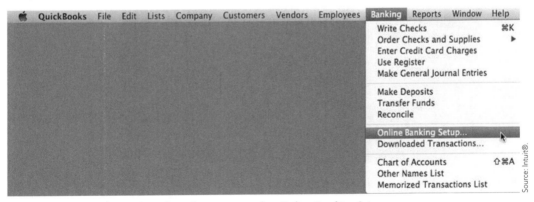

Figure 26.1 *From the Banking drop-down menu, select Online Banking Setup.*

There are three ways to download your credit card information into QuickBooks.

- The easiest way is to have QuickBooks directly connect to your financial institution to download the information. American Express allows this; however, check to confirm that you have the right "flavor" of American Express card, as some allow downloads and others don't. For example, you can download if you're using the American Express for Business credit card.

- In some cases, your credit card company will allow you to download a QuickBooks-compatible file. It's an extra step, but it's still not too difficult to do.

- The third method is a pain, but it's doable. If your credit card company allows you to download a different file format—such as a file for Intuit's sister application for personal bookkeeping, Quicken— you can convert that file with an extra step. Just like photographers have JPEG, TIF, and PNG file formats for photographs, so, too, does Intuit have different file formats. The QIF format is for Quicken, and QIB is for QuickBooks financial data formats. In this chapter, I'll walk you through each.

Direct Connect Download Option

In this example, we will search for American Express, which results in two choices. I've selected the first, as you can see in Figure 26.2.

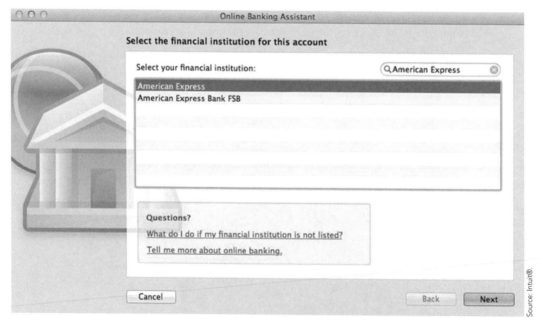

Figure 26.2 *Typing in "American Express" returns two results. The one that includes "Bank FSB" is for a bank that is a federal savings bank, and not the American Express credit card company.*

American Express offers both Direct Connect and Web Connect options, as you can see in Figure 26.3. I'll choose Direct Connect.

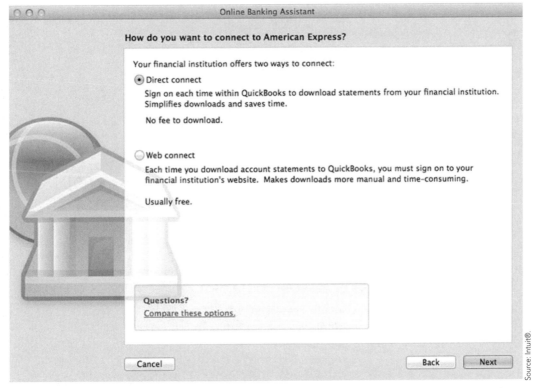

Figure 26.3 *Select Direct Connect, as it will save you time. It may be that some American Express card account types do not allow for Direct Connect. If that is the case, then you would choose Web Connect.*

For security purposes, you'll want to call your credit card company and activate your ability to directly connect and download your transactions using QuickBooks (see Figure 26.4).

Once you've done that, you can log in to American Express, as shown in Figure 26.5.

If you haven't activated online access or you've done something wrong, QuickBooks will let you know you've made an error, as shown in Figure 26.6.

Once QuickBooks has connected, you'll see your credit card number appear in gray in the Account Number field, as well as the word Creditcard under Account Type, as shown in Figure 26.7.

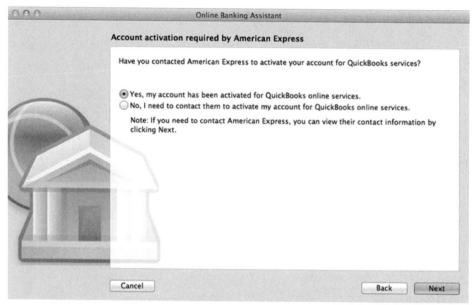

Figure 26.4 *For security reasons, American Express doesn't activate QuickBooks online services by default. You need to contact them to activate that access. Selecting Yes here indicates that you've done that.*

Figure 26.5 *Enter the Customer ID and password provided by American Express.*

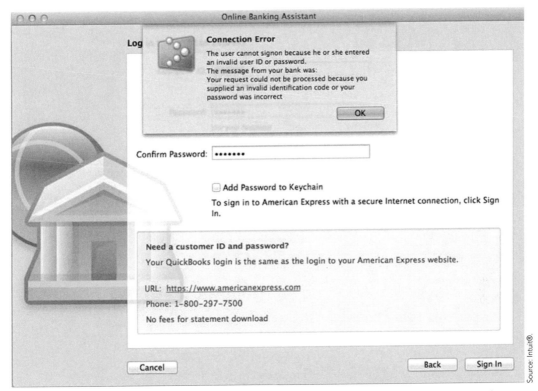

Figure 26.6 *You will get an error, as shown here, if your Customer ID or password is wrong, or you have not set up online services.*

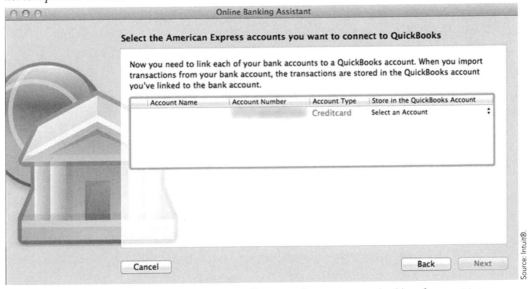

Figure 26.7 *Once you're signed in, QuickBooks will retrieve the account number(s) and account type, as shown here.*

Now you'll need to tell QuickBooks where you want the downloaded transactions to go. Click Select an Account and choose New, as shown in Figure 26.8.

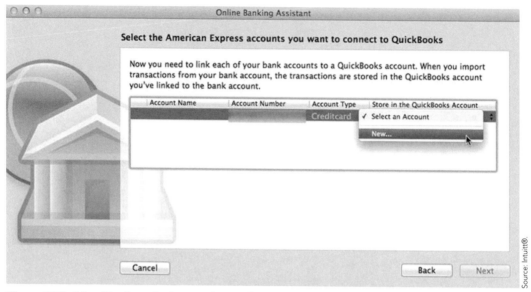

Figure 26.8 *Select New from the Store in the QuickBooks Account drop-down menu.*

Next enter the account information in QuickBooks, as shown in Figure 26.9.

Figure 26.9 *In the New Account dialog box, enter the relevant and necessary details and click OK.*

Click OK, and you'll be taken back to the previous dialog box. Now when you click on Select an Account in the Store in the QuickBooks Account column, you'll see American Express, as shown in Figure 26.10. Click on this.

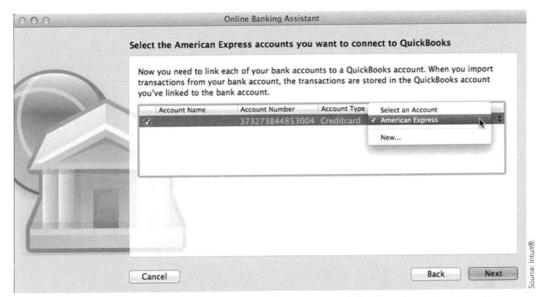

Figure 26.10 *Once you've returned to the Online Banking Assistant dialog box, choose American Express from the Store in the QuickBooks Account drop-down menu. Then choose Next.*

Click Next, and you'll see a dialog box that confirms you have successfully set up online access for American Express (see Figure 26.11). Click Done.

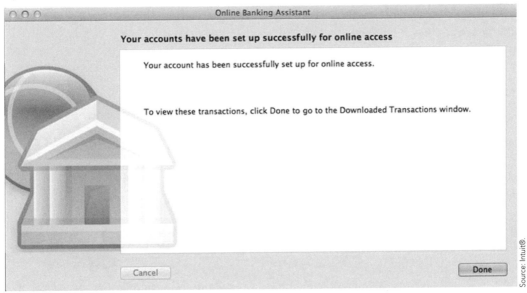

Figure 26.11 *This dialog box confirms that you've successfully set up this account for online access.*

Alternatively, from the American Express website shown in Figure 26.12, you can see that you can download your card activity for Quicken, Microsoft Money, or QuickBooks; as a QIF (short for Quicken Interchange Format) file; or as a CSV file (a comma-separated value file, which is a common universally interpretable format that can be read by Excel, among other software). It's also important to note that for American Express Business cards, you can have multiple card members—one for each person in your business. So downloading will always retrieve all the card-member transactions. However, as you can see in Figure 26.12, you can also download by individual card member. (Note the link in the middle of the page.)

Also, as with most credit card companies, you can go back about a year.

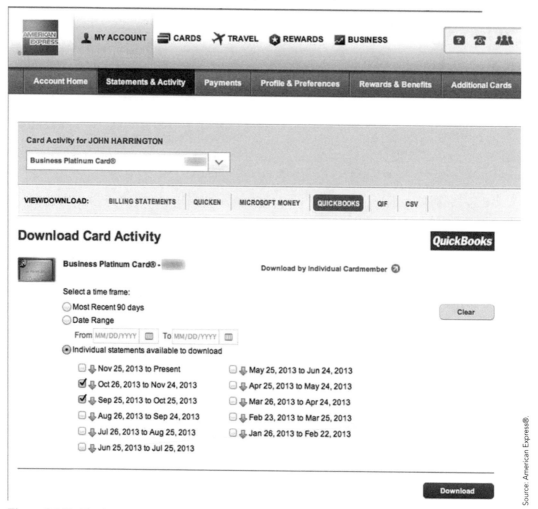

Figure 26.12 *The American Express website, showing how you can download other file formats and individual statements.*

Later in the chapter, once we've addressed the other options to get transactions into QuickBooks, I'll review how to handle and categorize those transactions.

Web Connect Download Option

In this example, one of our credit cards does not allow for Direct Connect like American Express does. Our MasterCard credit card is an affinity card issued by Barclays Bank.

Just as you would to set up a bank account, from the Banking drop-down menu, select Online Banking Setup, as shown in Figure 26.13.

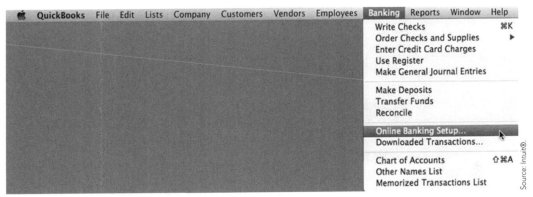

Figure 26.13 *From the Banking drop-down menu, select Online Banking Setup.*

When I type Barclays, only one choice comes up, as shown in Figure 26.14.

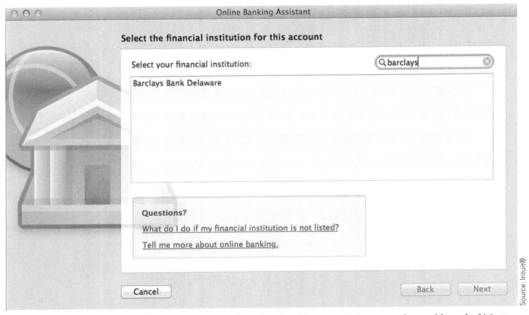

Figure 26.14 *Typing in Barclays as the financial institution (that is, not typing in the card brand of Master-Card or Visa) returns their listing.*

Choose that option and click Next. That will take you to instructions telling you that you need to download the transactions and then import the information into QuickBooks using the Import File option (see Figure 26.15).

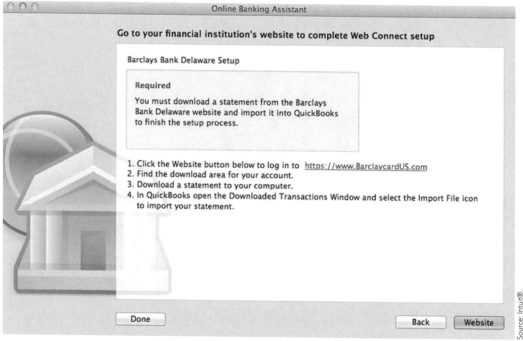

Figure 26.15 *This screen indicates that you must download the statements from the bank's website because no Direct Connect option is available.*

The Next button changes to Website; clicking on that launches the web browser and takes you directly to the Barclays website. Using the login information you would normally use to access your credit card account online, there will be a Download Transactions option, as shown in Figure 26.16. For Barclays, you can download a date range in the format of your choice. I've chosen QuickBooks Versions 2010 and Above. This will download a QIB file.

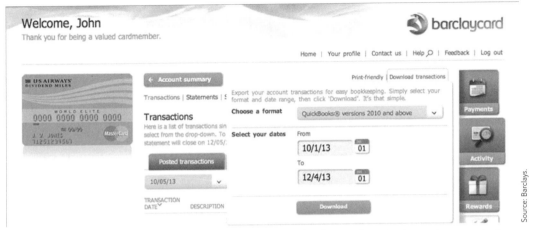

Figure 26.16 *Once you're signed in to the Barclays credit card website and navigating to the screen to download statements, you can choose the format of file you want along with a date range.*

Later in the chapter, after I've addressed the other options to get transactions into QuickBooks, I'll review how to handle and categorize those transactions.

Downloading, Converting, and Importing Transactions

Some financial institutions don't have Direct Connect or Web Connect options. In our case, our Bank of America Visa affinity card doesn't offer either choice to get our transactions into QuickBooks. I've been told this is because Bank of America does not designate the card as a "business" card, and they don't want people to use "business software" to manage the transactions. Because Bank of America doesn't offer the affinity card on the business side, we'll use this card and work around their limitations.

First, visit the Bank of America website and download the statement in a format they do allow—one for Intuit's personal finance software, Quicken. They also offer other formats, but for this example we want their QIF format. See Figure 26.17.

Download the statements to somewhere you can keep track of them in case you need them in the future—perhaps the same location as your QuickBooks data. I've chosen to name the files with MonthYear_XXXX. qif, where XXXX is the last four digits of the card.

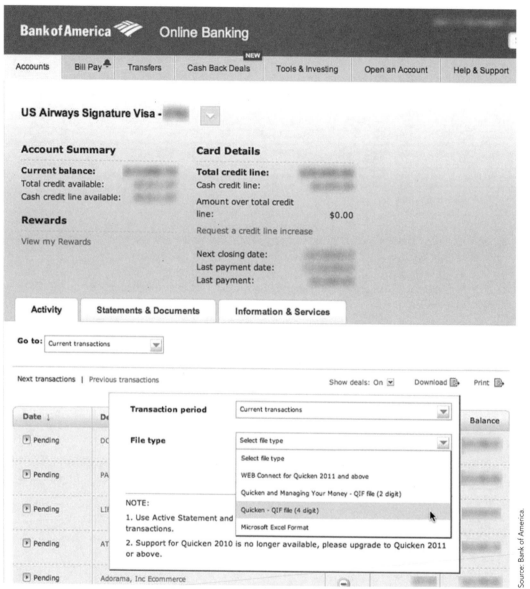

Figure 26.17 *In the Accounts tab for Bank of America, there are several options once you click on the Download link to choose the file type you want.*

Next, I use a very simple piece of software that does the conversion (see Figure 26.18). It's called QIF2QBO, and it's made by ProperSoft (www. Propersoft.net). It currently costs $37 and is worth every penny in time saved manually entering transactions. You can select multiple files and combine them into one importable (QBO) file. Some software options ask you to upload the file, and they convert it and send it back to you. I don't trust those applications because I have no idea what they're doing with my data. With QIF2QBO, the entire conversion takes place on your computer.

When you launch the QIF2QBO software, a very basic window comes up (see Figure 26.19). Click Browse.

Figure 26.18 *The application icon.*

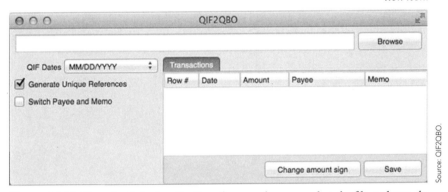

Figure 26.19 *The only dialog box for the software, where you select the file and save the results.*

A dialog box will ask you to select which QIF bank files you want to convert. As shown in Figure 26.20, I've selected the two files I downloaded.

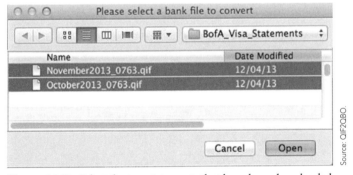

Figure 26.20 *Select the two statements that have been downloaded in the QIF format from the bank.*

After you bring the files into the software, you can review the transactions. My transactions are listed with the dates and payees in Figure 26.21. You can see transactions from a trip I took to San Antonio, Texas—parking charges, a meal charged to my room, other dining options, and my monthly charge for OnStar, related to my business vehicle. Click the Save button and save the newly created QBO file.

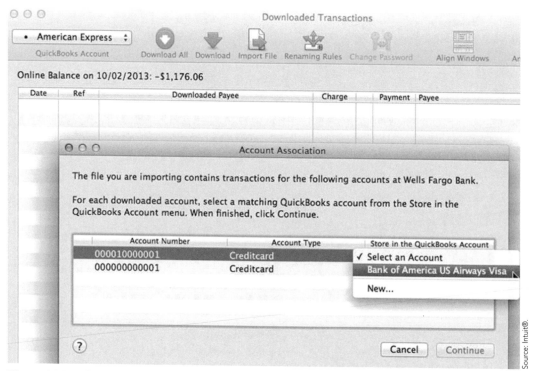

Figure 26.21 *The resulting window showing the transactions before clicking Save.*

With the QBO file saved, return to Downloaded Transactions from the Banking drop-down menu, and then choose Import File and navigate to the QBO file you just created. You'll get a dialog box in which you can select the account you want. In Figure 26.22, I've selected Bank of America US Airways Visa as the destination for the transactions.

Figure 26.22 *The dialog box where you can select the account you want. I've chosen Bank of America US Airways Visa.*

Click Continue to import the downloaded transactions.

Now, let's move on to how to handle and categorize downloaded transactions.

Managing Downloaded Transactions

Regardless of how you downloaded your transactions, they all end up in the holding area called Downloaded Transactions until you actually assign them an expense category and add them to various categories. The more you do this, the smarter QuickBooks gets in terms of knowing what category you want. However, you still have to confirm that a category is correct.

For example, suppose you regularly order your inkjet printer supplies from Adorama. Once you've assigned the Printing Supplies category to those purchases, then every time you download a charge for Adorama, QuickBooks will automatically attempt to assign it the next time. However, it won't actually go to that category of expense until you confirm this is what you want the software to do. This can be very helpful; suppose you're reviewing the auto-assigned purchases, and you see a $6,000 charge assigned to Printing Supplies. You can be pretty darn sure that's not correct, and then you can think back and say, "Oh, right, I had just purchased my new Nikon camera. That's what this is; I need to reassign that expense to be Photo Equipment Purchases so it is properly categorized." This is the power of the auto-assign-but-review-to-approve feature.

Let's walk through some things you can do with the downloaded transactions.

As before, from the Banking drop-down menu, choose Downloaded Transactions (see Figure 26.23).

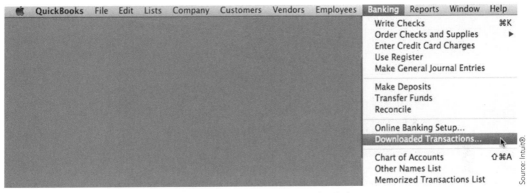

Figure 26.23 *From the Banking drop-down menu, choose Downloaded Transactions.*

You'll see a blank window if there are no transactions in that account that you currently need to match, as shown in Figure 26.24. You can choose Download All, and the software will download all the transactions it can via Direct Connect. This is the case with banking transactions, too.

Or, you can select from the QuickBooks Account drop-down menu, shown in Figure 26.25, and choose different credit cards to download individually by clicking Download (if it's Direct Connect) or choosing Import File for Web Connect or converted/imported files.

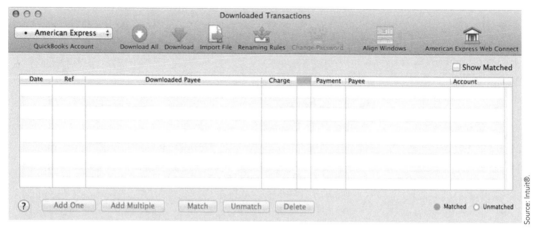

Figure 26.24 *A blank Downloaded Transactions window before you download the latest transactions or import them. If you had any transactions from a previous download that you had not matched, they would be listed here until you match them.*

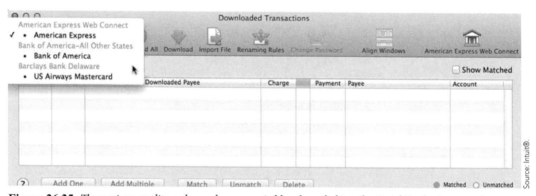

Figure 26.25 *The various credit cards you have are visible when clicking the QuickBooks Account drop-down menu in the upper-left corner of this dialog box.*

Once the files have been downloaded, you'll see a dialog box telling you how many have been imported. In this case, it was 48, as shown in Figure 26.26.

Take note that a number of transactions were automatically changed from, say, FEDEX along with the FedEx air bill and their 800 telephone number, to simply FedEx. The same is true with a gas purchase from Shell Oil and so on. QuickBooks elegantly handles all of this, as well as assigning accounts where it has had them assigned in the past.

We'll focus on purchases from Papa John's Pizza, State Farm Insurance, and Balducci's, because QuickBooks doesn't know how to handle those, and it leaves the Payee section and the proper expense category blank. We need to assign those this time, and it will use what we assign this time to handle the transations next time.

To change something like this, you'd click into the Payee category and type Papa John's Pizza, as shown in Figure 26.27. The all-capitals text "PAPA JOHN'S 00722.com 301-490-72" will be changed to just Papa John's Pizza in the credit card account ledger.

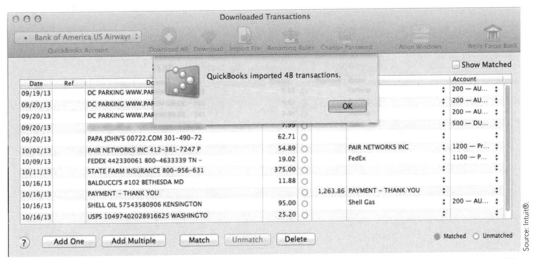

Figure 26.26 *Once transactions have been downloaded, you'll be told how many there were, and they will appear in the dialog box for you to begin matching.*

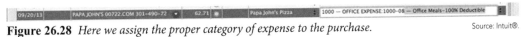

Figure 26.27 *Here we are changing the Payee to be a more encompassing "Papa John's Pizza,"* Source: Intuit®.
which would include multiple purchases from the chain. Each chain store has a different description on the credit card statement, and we just need to know it was from the chain overall.

Because I've previously purchased from Papa John's Pizza—just not as indicated in the downloaded description—QuickBooks knows to assign this to the category of Office Meals – 100% Deductible, and it auto-fills this as I begin to type, as shown in Figure 26.28.

Figure 26.28 *Here we assign the proper category of expense to the purchase.* Source: Intuit®.

Next, I'll do the same for State Farm Insurance. The downloaded description is "STATE FARM INSUR-ANCE 800-956-631," which I don't need. Once I start typing, QuickBooks auto-completes to show State Farm, as shown in Figure 26.29. Pressing the Tab key takes me to the Account column, and where I can auto-assign this to insurance, as shown in Figure 26.30.

Figure 26.29 *Here we assign a specific State Farm transaction to a general State Farm payee.* Source: Intuit®.

Figure 26.30 *Here we assign the category of expense to the proper insurance subcategory.* Source: Intuit®.

The next transaction is for a restaurant I hadn't been to before, where I ordered takeout items to bring back to the office. I don't need to know the restaurant's location and that it's restaurant #102 in the Balducci's chain; I just need Balducci's. So I type that, and when I press the Tab key, QuickBooks wants to know more information, because I've never been there before. So, I click Quick Add, as shown in Figure 26.31.

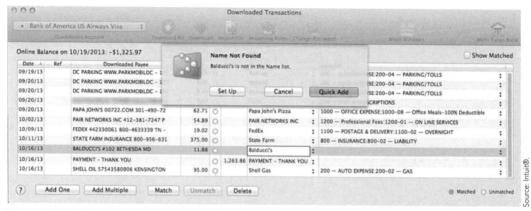

Figure 26.31 *When a vendor/payee is not found, QuickBooks gives you the opportunity to add that payee. In this case, I've chosen Quick Add.*

In the next dialog box, I confirm that Balducci's is a vendor, and then click OK and move on to the Account column (see Figure 26.32).

Figure 26.32 *Select Vendor and click OK.*

Now I assign Balducci's to the same category of expense as Papa John's Pizza, as shown in Figure 26.33.

Figure 26.33 *After creating the new vendor, assign the proper expense account category to the purchase.*

Renaming Rules of Downloaded Transactions

The renaming I did made things clearer in my credit card ledger, and those renaming rules are accessible from the Renaming Rules icon in the Downloaded Transactions section. They can become a very powerful tool. For example, every time I book a flight on American Airlines, it shows up as "AMERICAN 12345678," where the lengthy number is usually the ticket number. And traveling around the country, I go to a variety of FedEx Office locations to ship to/from; every time I charge something there, the company name and store number appear in the charge description. QuickBooks can handle all of that easily.

Figure 26.34 shows a list of a few of the items in my renaming list.

Figure 26.34 *The Renaming Rules window with a listing of the names of the payees that were downloaded on the right, and then how we want that payee listed in our expense ledgers on the left.*

You'll note that ADORAMA INC becomes Adorama. And because I paid my dues to the trade organization American Photographic Artists via PayPal, the transaction shows up as PAYPAL *APA, which I chose to rename as APA National. Two different purchases via Apple's online store and iTunes I simply assigned to Apple, and when I go to a specific brick-and-mortar Apple Store, even though the store number is listed in what is downloaded, I simply list it as Apple Store in my credit card ledger.

The next step in the renaming process is to handle changing payees.

Every time I purchased something from Calumet Photo, they identified their name as CALUMET followed by what I can only guess is an invoice number. If I was tracking a particular charge for some reason that might be useful, but I'd rather simply list it as Calumet Photo. So selecting "if downloaded payee {contains}" causes the software to then auto-fill in the transaction we are clicked on. See Figure 26.35.

In Figure 26.36, I've removed the series of numbers, so as long as the letters "CALUMET" are in the Downloaded Payee information, it will just become Calumet Photo.

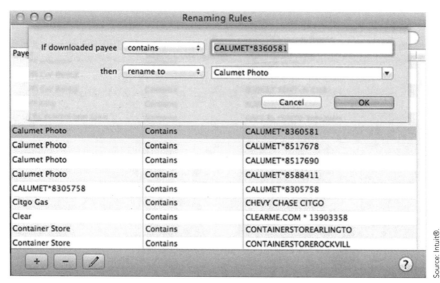

Figure 26.35 *Double-clicking on the top listing for CALUMET*8360581 allows me to change the renaming rule.*

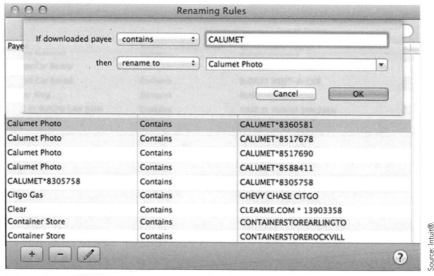

Figure 26.36 *Removing the transaction identifier that Calumet appended to the end of each transaction means that any transaction that just contained "CALUMET" would be renamed to "Calument Photo," as shown here.*

As time permits, you'll be able to customize the renaming rules for all sorts of things, which will make downloading and assigning categories much faster.

Index

Like the Book?

Let us know on Facebook or Twitter!

facebook.com/cengagelearningptr

www.twitter.com/cengageptr